W9-APU-255

W9-APU-255

CHAGALL

Chagall
DISCOVERED

FROM RUSSIAN AND PRIVATE
COLLECTIONS

CONTRIBUTORS:
Irina Antonova, Andrei Voznesensky,
and *Marina Bessonova*

HUGH LAUTER LEVIN
ASSOCIATES, INC., NEW YORK

DISTRIBUTED BY
MACMILLAN PUBLISHING COMPANY, NEW YORK

Selection and catalogue by *Marina Bessonova*
Designed by *Mikhail Anikst* and *Kirill Selvinsky*
Translated from the Russian
by *John Crowfoot* and *Alex Miller*

Printed in the U.S.S.R.
© 1988, Sovietsky Khudozhnik Publishers, Moscow

CONTENTS

FOREWORD

In 1973 during his visit to Moscow, Marc Chagall spent several hours in the Pushkin Museum of the Fine Arts. He attentively studied the museum's displays and devoted more than an hour to the wonderful collection of drawings by Matisse, an artist with whom Chagall had been friendly and whose work he valued highly. At that time he said that he would be happy to see a large exhibition of his own paintings in the Pushkin Museum—he very much wanted to show Soviet viewers the work he had done in France. To our great regret this plan was not carried out during his lifetime. It is thus with a yet deeper feeling of responsibility towards the memory of a great artist that we are today making his dream a reality.

This exhibition has been long awaited, particularly by those who know and love 20th century art. It is not just their age but also their aesthetic outlook that explains this public interest: people want to hear and listen to the voice of their era, and relive the dramatic process whereby new artistic forms and images were created and established. The Pushkin Museum has constantly striven to satisfy this natural desire to know and understand the art of our time in all its varied manifestations.

It has not always been easy. Nevertheless, today's exhibition has been preceded by the showing of works by many of Chagall's splendid contemporaries. Among them there have been exhibitions of Picasso and Matisse, Léger and Marquet, Masereel and Dunikowski, Bourdelle and Barlach, Siqueiros and Rivera, Permeke and Erni, Favorsky and Chekrygin, Kollwitz and Kent, Munck and Morandi. The 1981 exhibition *Paris-Moscow*, in particular, was a triumphant celebration of 20th century art.

Our Chagall exhibition marks the centenary of his birth and continues this series. However, it also has its own story. Regrettably the heritage of this universally-acclaimed master was for a number of years forgotten in the Soviet Union. It shared the fate of an entire range of great cultural achievements that until recently were only with difficulty accessible to the Soviet viewer. Therefore the Chagall Exhibition today is not only a major artistic event but a vivid expression of the improving moral and aesthetic climate within our country; it is a moving lesson in truth, when lost values are restored.

Mark Chagall belongs to the glorious group of rebels and dreamers whose work in the early decades of the 20th century marked the beginning of a new era

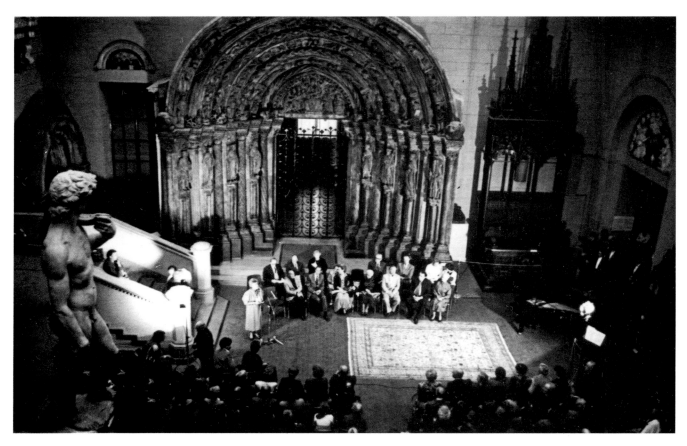

The Chagall Exhibition
at the Pushkin Museum of Fine Arts
in Moscow. 1987
Above: Opening of the 1987 Moscow Exhibition
Below: Valentine Chagall
and the Soviet poet Andrei Voznesensky

in the arts. Russia's artists, writers and musicians made a very significant contribution to this universal process, and were themselves innovators in many fields. This was hardly surprising since the country was on the brink of a great social revolution.

As it turned out, Chagall spent most of his life in France. However, like Rakhmaninov, Chaliapin and Bunin, he remained a distinctively Russian artistic phenomenon. In a century of 'total' influences, Chagall imitated no one and no one, incidentally, attempted to follow him. His artistic conceptions were enigmatic, the means he used to get to the heart of things was highly original, and his dialectical approach unpredictable. All this made his art inimitable. He remained unshakeably faithful to his own principles and origins and this accounts for the unique character of his work. He drew his strength and inspiration from the simple rituals of everyday life in his native Vitebsk, the natural surroundings of his childhood, and the unadulterated sources of folk art.

For almost eight decades the artist created his own mythical world in which Biblical tradition, images from popular folklore, figures from the circus and the fairy tale, and everyday items blended to form a fantastical alloy. Chagall belongs to a class of artist that has always been a rarity throughout history. Such magicians and fantasists move us and stir our awareness by displacing the familiar and expected and, combining all in a 'magical chaos', immerse us in a world of illusions and visions. The driving force in their art is the unbounded fertility of the imagination. "It is possible that there is a mysterious fourth or fifth dimension," wrote Chagall, "and we don't just see it: intuitively, it gives birth to an equilibrium of plastic contrasts that astonishes the viewer's eye with its new and unusual relations."

Among Chagall's artistic predecessors could be mentioned the disconcerting works of Bosch and the sarcastic vision of Goya; among writers, we may recall the sinisterly ironical Hoffman, the mysterious Edgar Allan Poe and, of course, Chagall's own great countryman Gogol. The Russian writers and artists Bulgakov, Chekrygin and Platonov were also gifted with fourth-dimensional vision... Louis Aragon once compared Chagall's contradictory vision of the world to that expressed in Shakespeare's *Midsummer Night's Dream*. For all the differences dividing these great artists and writers they all share an element of irony that is an essential part of their work. Yet as Nabokov wittily remarked, "a single hissing consonant divides the comic aspect of things from their cosmic aspect". The art of such painters, wrote the same author, is directed "towards those mysterious depths of the human soul where the shadows of other worlds pass by like the shades of nameless and soundless vessels."

Chagall is a master of the decorative metaphor. This is what gives meaning to his poetics. However, there are no allusions, allegories or rebuses in his art. It is filled with genuinely poetic symbols and does not require speculative intellectual exercises from the viewer but a responsive mind and soul.

The artist retained a tender affection for the country of his birth. Among his idols he named Rublyov, Vrubel, Gogol, Blok and Tchaikovsky. He always joyfully received countless Soviet guests at his house in the south of France, and in the 1960s he executed a series of lithographs devoted to Mayakovsky which he gave as a gift to the Pushkin Museum in Moscow.

One hundred years have now passed since the birth of Chagall. He was a great painter, an ironic and good-hearted storyteller—a merry person with sad blue eyes who helped us to keep smiling and recall our childhood...

IRINA ANTONOVA
Director
The Pushkin Museum of Fine Arts, Moscow

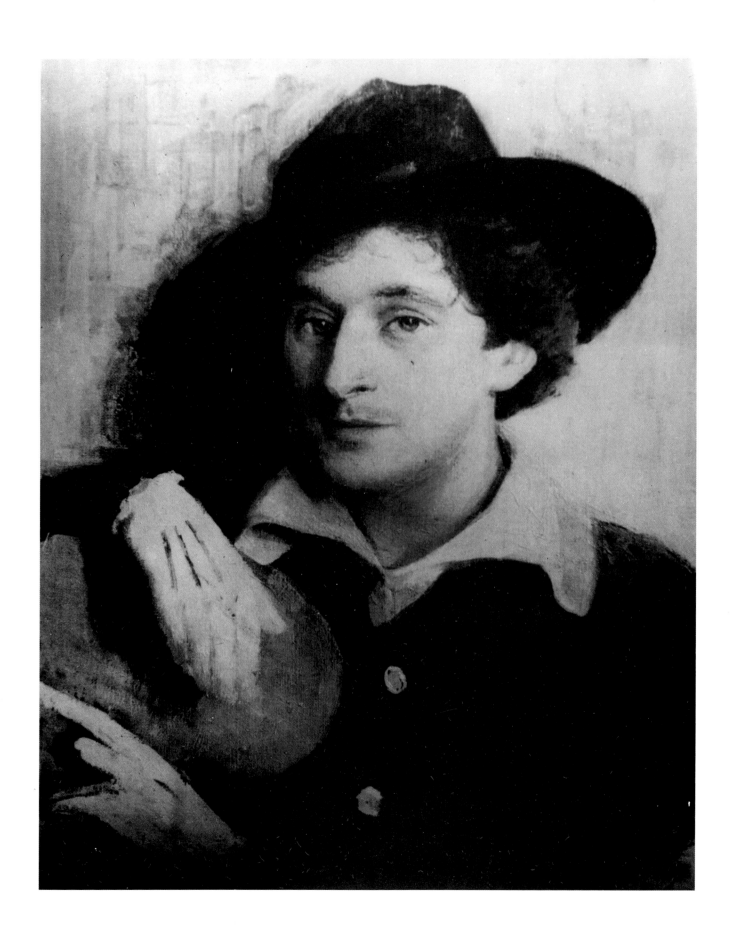

Portrait of Marc Chagall by Pen. 1906—8
Byelorussian Museum of Fine Arts, Minsk

CHAGALL'S GALA

ANDREI VOZNESENSKY

I congratulate you on home-coming, Marc Chagall, genius of the age, blue patriarch of world painting!

At last we have lived to see his genuine resurrection.

At long his masterpieces are being viewed in the exhibition rooms of the Pushkin Museum by his country-people, for whom he painted. In a true sense Chagall never really separated from his country. Be it Paris, New York, Saint-Paul-de-Vence, his country always kept blossoming on his magic canvases. His Eiffel Tower stands on chicken's legs, as if coming out of folktales of his land.

He called Paris his second Vitebsk.

I remember him returning briefly to Moscow in 1973. He had come by invitation of the Ministry of Culture. His hotel room was piled with baskets of flowers and ceremonial gifts. But the blue-eyed master of genius, his mane of hair snow-white like the frost patterns on the window, sobbed over a simple nosegay of cornflowers—it was the colour of his childhood in Vitebsk, the humble, enchanting flower whose radiance he splashed over the stained-glass windows of the whole world from Tokyo to the Metropolitan Opera House in New York.

It was then that I wrote a poem for him.

CHAGALL'S CORNFLOWERS*

Your face is all of silver like a halberd,
your gestures light.
In your vulgar hotel room
you keep pressed cornflowers.

Dear friend, so this is what you truly love:
Since Vitebsk, cornflowers have wounded
and loved you—those wildflower tubes
of squeezed-out
 devilish
 sky-blue.

* Translated by Vera Dunham and H. W. Tjalsma.—*An Arrow in the Wall, Selected Poetry and Prose by Andrei Voznesensky*, New York, 1983, p. 97f.

An orphaned flower of the burdock family,
its blue has no rival.
The mark of Chagall, the enigma of Chagall—
a tattered ruble note at a remote Moscow station.

It grew around St. Boris and St. Gleb,
around guffawing speculators with their greasy fingers.
In a field of grain, add a patch of sky.
Man lives by sky alone.

Cows and water nymphs soar in the sky.
Open your umbrella as you go out on the street.
Countries are many, the sky is one.
Man lives by sky alone.

How did a cornflower seed chance to fall
on the Champs-Elysées, on those fields?
What a glorious garland you wove
for the Paris Opéra.

In the age of consumer goods there is no sky.
The lot of the artist is worse than a cripple's.
Giving him pieces of silver is silly—
man lives by sky alone.

Your canvases made their escape
from the fascist nightmare, from murder,
the forbidden sky rolled up in a tube,
but man lives by sky alone.

While God failed to trumpet
over the horror,
your canvases rolled up in a tube
still howl like Gabriel's horn.

Who kissed your fields, Russia,
until cornflowers bloomed?
Your weeds become glorious in other countries,
you ought to export them.

How they hail you, when you leave the train.
The fields tremble.
The fields are studded with cornflowers.
You can't get away from them.

When you go out in the evening—you seem ill.
Eyes of the unjusty condemned stare from the field.
Ah, Marc Zakharovich, Marc Zakharovich,
is it all the fault of those cornflowers?

Let not Jehovah or Jesus
but you, Marc Zakharovich, paint a testament
of invincible blue—
Man Lives by Sky Alone.

A year ago, after I had recited these lines in New York's purple-seated Carnegie Hall, I was given a letter written in a very fine hand. It was signed *Bella Chagall.*

On the next day, dressed with a student's simplicity, she told me about her grandfather's last moments. He died in his own home amid the greenery of Saint-Paul. Marc Zakharovich was in his wheelchair and passed away as he was being taken by lift up to the second floor. He died with a faint smile on his fine, beet-root lips; he died soaring up to the sky, flying.

Across his pictures sail horizontal fiddlers, tradesmen, lovers. He has joined them.

Sky and flight were the main condition of Chagall's brush. It is unlikely that any artist was a poet in so literal a sense as this son of a Vitebsk herring warehouse clerk. Cornflower-blue log-houses, red cockerels, green, forbidden sows, pregnant cows, enigmatic, sarcastic goats—everything is seen with the eye of the poet. No wonder Apollinaire loved him. In Aragon's home I saw Chagall's autographs on the title-pages of monographs with vignettes and drawings in coloured inks, framed and hung on the wall.

On the threshold of the present merging of heaven and earth, on the threshold of the space age, Chagall made heaven part of ordinary life, but he set the daily life of the little towns at liberty in the sky. The space dogs Belka and Strelka, crossing the horizon with their tails up, could have been Chagall's own subjects.

I first met Marc Zakharovich Chagall in February 1962, recorded by the date under his first presentation drawing: a pale blue girl embracing a lamb is flying over the Eiffel Tower. After that, we met fairly often, if one remembers the distance between Moscow and Paris, either in his little flat over the Seine or in the house of his daughter Ida, who was the angel of his exhibitions; later in the south, where his muse and wife, Vava (Valentina Grigorievna) brought an Olympian harmony into the bustling life of the twentieth century.

I visited the Master every time I went to France. He often reminisced about Mayakovsky and recalled the poet's inscription in a book of his. It was strange to know that this quiet, modest, tactful man with the white brushes of eyebrows, who would roll his eyes in mock horror if anyone mentioned his fame, was once a resolute commissar of revolutionary art in Vitebsk.

What a joy it gave him to study with me the photographs he had received of his native street, although his house, alas, as was thought then, had not been preserved, or, to be more correct, had lost its porch, had gained new buildings and was scarcely recognizable.

Blue butterfly of Chagall, how you drained yourself of your strength, flying across the Carpathians, the Pyrenees, across world sadness and the oceans!

All of Chagall was radiant: he looked aetherial and seemed to be apologizing for his celestiality.

He was unselfish.

He once invited me to go with him to Zurich for the unveiling of his blue stained-glass windows in the cathedral. He had again done them free of charge, as a gift to the city, as a gift of the blue sky from the window. In this, too, he was a poet.

He illustrated Gogol's poem, *Dead Souls*—what a poetic, Russia flies outside the window in those engravings! He saw poetry in a life that ordinary people find monstrous: he made poetry out of everyday existence and disclosed a new kind of beauty: rubbed clean of the dust by his gaze, objects glittered like black diamonds.

He worked every morning till the end of his days. Enormous canvases were his life and, perhaps, prolonged his flying time on this earth.

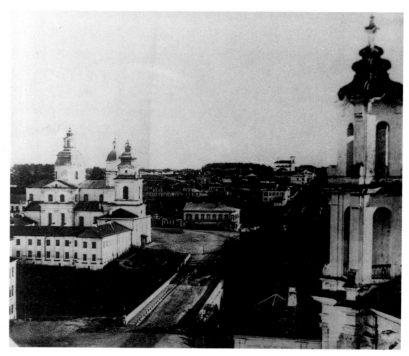

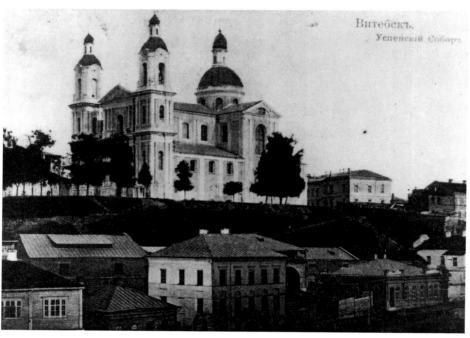

Upper left: Building of the Vitebsk Art College
founded by Chagall in 1918
Upper right: Vitebsk. Early 20th-century photograph
Below: Cathedral of the Assumption in Vitebsk
Early 20th-century postcard

He would beam happily, like a child, as he showed the orders, diamond stars and silk ribbons presented to him by royalty and presidents.

He was brave, this quiet, surprised-looking man. I once happened to be witness to this. In the summer of 1973 I was giving recitals in Paris. Chagall's tragic painting for my poem, *The Call of the Lake*, was used by Editions Gallimard for the cover of my book. At that time, the artist had accepted an invitation from the USSR Ministry of Culture and had agreed to visit us. I repeat, this was his first visit after leaving in the twenties and unfortunately, as it happened, the last. He kept asking what Moscow was like now. Were there cars on the streets? He remembered Moscow during the devastation of the twenties. The flight was booked for Monday, on an Aeroflot plane.

Alas something terrible happened on the Saturday. Before the eyes of thousands of Parisians, during a demonstration at the Paris air show, the beautiful 'TU' crashed in the sky. Our test-pilots were killed. I had been talking to them the day before. The moment of the disaster had been filmed and was shown in slow motion several times on the TV screen. We studied those pictures with horror again and again.

In *Chagall's Cornflowers*, I described it as follows:

> With you in heartrending slow-motion
> we saw how for and before all
> the Tupolev fell from the skies of Paris.
> Six men were left in the sky.

Attempts were made to dissuade Chagall from flying on a 'TU'. He was advised either to cancel the flight or travel by Air France. Chagall left by 'TU' on the Monday.

I flew to Moscow several days after his arrival. He left with Vava and Nadya Léger.

When he came to our *dacha* in Peredelkino, Chagall stopped in the middle of the path, held out his hands and stood stock-still. "This is the most beautiful landscape I have seen in the whole world!", he exlaimed. What kind of landscape had the Master seen? An old leaning fence, fallen trees, a fir and nettles run riot. But how much poetry, how much soul there was in that scrap of landscape, how much alarm and mystery! He had revealed it to us. He was a poet. Had he remembered the gullies of Vitebsk, perhaps? I repeat, he called even Paris a second Vitebsk. Not by accident did he love Vrubel and Levitan.

> One year I shall surely visit,
> if it's not the heart's delusion,
> something new to ancient Vitebsk
> known as the Chagall Museum.

I wrote those lines a long time ago.

My acquaintances merely laughed sceptically, taking it for black humour. But one should not sigh for museum, one should do at least something to create them. All the inhabitants of Vitebsk whom I met are agitating for the eternalization of their great countryman's memory. True, some are agitating with caution. "We will create one if they pass a resolution above..." Vasil Bykov, the well-known Byelorussian writer, angrily reproaches his fellow-countrymen for taking so long to organize a museum.

On 15 February 1944, a New York newspaper published Chagall's letter lamentation *To My Native Town, Vitebsk*: "It is a long time since a last saw you, my beloved town, and found myself among your fenced streets.

15

You didn't ask in pain, why I left you for so many years when I loved you. No, you thought: the lad's gone off somewhere in search of brilliant unusual colours to shower like snow or stars on our roofs. But where will he get them? why can't he find them nearer to hand?

In your ground I left the graves of my ancestors and scattered stones. I did not live with you and yet there was not a single one of my pictures in which your joys and sorrows were not reflected. All through these years I had one constant worry: does my native town understand me? do her inhabitants understand me? When I heard that misfortune was knocking at your gates I envisaged an awful picture: the enemy had found his way into my house on Pokrovsky Street and was smashing her windows.

As human beings we cannot stand by quietly and calmly until the planet is reduced to ashes. It was not enough for the enemy to burn the towns in my pictures, where he slashed to pieces—no, he had to come and burn my own town and house. His 'doctor of philosophy' [i.e. Goebbels], who wrote some 'profound' words about me, has now come to you, my native town, to throw my brothers into the Dvina river from the bridge: he has come to burn, shoot and 'observe with a crooked smile through his monocle'..." 'Crooked'— Mandelshtam's favourite word! Fascism destroyed works by Chagall at a book-burning orgy in Mannheim.

I arrived in blizzard-swept Vitebsk on the eve of 1987. They were setting up a gigantic, dark, still undecorated and mysterious fir-tree in the square. What did one want to see on the tree? A tiny Chagall museum in the New Year, which was to be his gala year.

We drive to Dzerzhinsky Street, formerly 2nd Pokrovskaya, where the artist's single-storeyed house has miraculously survived. It is of red, narrow bricks, with four windows in white surrounds. The frames are painted cornflower blue. A dog, of whom it says on the gates that we should beware, pulls frenziedly on his chain at the sight of Chagall's admirers. The artist was not, in fact, born here, but outside Vitebsk in the village of Lyozno, where his uncle had a barber's shop; but the infant was immediately taken to town.

The present owner of the house, who introduces himself to us as Zyama, is a housepainter on pension; as a little boy before the war, he heard eyewitnesses yarning about the shaggy artist who once lived here. The ceilings are high. There are photographs of Zyama on the wall in his war orders and medals. Behind the glass of the bookshelves there is a kitch portrait of Stalin. The shelves are lined with subscription editions of Fet, Esenin, Akhmatova and contemporary verse. The owner's wife worked in the book trade. Zyama says there used to be a door in place of the window on the left. And, indeed, we can see the traces of a bricked-up opening outside. The door and the porch have been demolished, and so it was hard to recognize the house in the photograph. The restorers of the future museum will have some work to do, though not a great deal.

The war razed 93 per cent of Vitebsk to the ground.

An American commission considered it impossible to build on the same site and recommended to build on another side. Providence, however, preserved the artist's house and the pseudo-Empire mansion that dated back to the beginning of the century and served as the premises of Unovis, the studios of Malevich and El Lissitzky.

Lunacharsky's Mandate No 3051 can be read in the town archives: "Comrade Artist Marc *Chagall* is appointed Commissar for the Arts in the Vitebsk gubernia. All revolutionary authorities should give Comrade *Chagall* every co-operation." We read a decree by the commissar dated 16 October

1918: "All persons and institutions in possession of easels should hand them over temporarily to the Arts Commission for use in decorating the town of Vitebsk for the October festivals. Gubernia Commissar for Fine Arts Chagall."

I see an old documentary film: sparkling with time, it records the celebrations of the first anniversary of the October Revolution in Vitebsk, with festival decorations by Chagall. Townsmen in great-coats or narrow-shouldered overcoats, with big moustaches and with ribbons in their buttonholes, step past on parade, waving their broad-brimmed hats to us. The women carry sticks for walking on stilts. The streets are festooned with garlands; there is a panel by Chagall called *War on the Palaces* and another showing the coat of arms of Vitebsk, with a merry tuba player astride a green horse instead of a sword-bearing knight. The streamers bear uncompromising and naive formulae: *Discipline and work will wear down the bourgeoisie* or *Revolution of words and sounds.*

A demented, Suprematically-painted tram sweeps by.

In those years, the thirty-three-year-old artist wrote to Pavel Ettinger, an old correspondent with Rilke: "There were many posts, pigs and fences in Vitebsk then, and artistic talents slumbered. I tore myself away from my palette. I sped to Petersburg, Moscow, and the Art School was built in 1918. Within its walls were 500 youths and girls... Apart from myself, the teachers were Dobuzhinsky, Puni, Malevich, El Lissitzky, Pen and myself. There is a drama group at the school which recently put on Kruchyonykh's *Victory over the Sun* in the town. (Opera by Matyushin.—*A.V.*)"

To save them from starvation, all of them, Tatlin, Falk and others, were invited to Vitebsk by Chagall. The town became a centre of the revolutionary intelligentsia.

"Just think, the whole roof had been torn off Russia, and we and all the people found ourselves under the same sky. Freedom!," exclaimed the hero of Pasternak's novel *Doctor Zhivago*. "It could be said that two revolutions happened to each person: one that was private and individual, and another that was experienced in common. It seems to me that socialism is a sea into which these personal, separate revolutions should flow, a sea of life, a sea of individuality. The sea of life, I said, of that life which can be seen in paintings, a life transformed by genius."

Such was the atmosphere of the time. Today, this passage about the 'two revolutions', about the revolution inside each person, is taken to mean that without inner freedom there is no universal freedom. It is with this inner freedom that the creator begins. How necessary this is to the young of today so that contemporary Chagalls, Konchalovskys, Filonovs and Ivan Leonidovs might be discovered! This life transformed by genius is what appeals to us in the canvases at this exhibition.

When he came to Vitebsk, Eisenstein was astounded: "The main streets here are covered with white paint on red bricks. And green circles run riot over the white back-ground. Orange squares. Blue rectangles. This is Vitebsk in 1920. Kazimir Malevich's brush has passed over its brick walls." Alas, the strong-willed Malevich soon became the spiritual overlord of Vitebsk. Chagall's pupils changed over to him. Artists don't hit it off with one another. Mandelshtam once challenged Khlebnikov to a duel, and Blok called out Andrei Bely.

The formulae of Suprematism were alien to Chagall's passionate broth, its ingredients mixed together out of everyday life. Once, on returning after a trip to Moscow, Chagall found that the inscription 'Free Academy' over the door of the school had been replaced by 'Suprematist Academy'. His pupils had

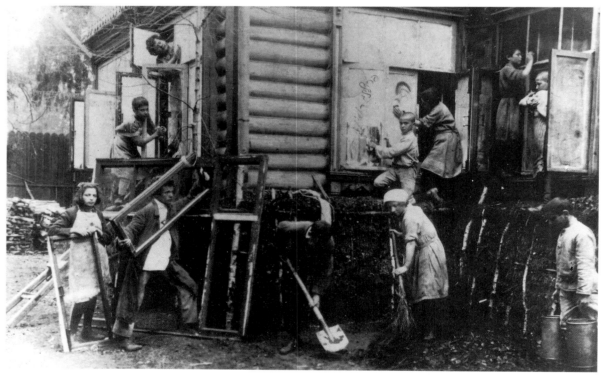

Above: Chagall teaching war orphans
at the Malakhovka Colony. 1921—22
Below: Spring-cleaning at the Colony. 1921

betrayed him. The offended artist left his home town and, two years later, his homeland.

Only the Vitebsk archives have preserved Order No 114 of 29th July 1920: "As a result of his removal to Moscow, artist Chagall, manager of the Graphic Art Studio of the Art Department, is relieved of his post. The temporary management of the Graphic Art Studio is transferred to artist Romm, manager of the Museum Section." The manuscript of Romm's very interesting memoirs has been preserved in which he accuses Chagall of despotism and other sins. Who can judge artists? Their canvases, I think.

Back in 1936, Chagall wrote home as follows: "I am considered 'international' all over the world and the French are glad to put me in their departments, but I regard myself a Russian artist, and this is agreeable to me." However, in the Great Soviet Encyclopedia we read: *Marc Chagall, French artist.*

Looking at the remaining cubes of the little houses 'on Peskovatiki' and in the old quarters of the town centre, you understand the source of Chagall's sensuous manner. Yes, he studied under Cézanne too, and the Cubists had an influence on him, but it was in exactly that way that the solidly coloured planes of the timber houses in Vitebsk covered the hills and gullies. The present exhibition shows how the artist's style changed. He understood Cubism 'with his belly'. Later came the Mozartian lightness of the flying compositions. All this awaits research in depth.

After the publication of one of my essays about the artist, I received a letter.

"I want to tell you something about Marc Chagall that you probably don't know. He was our drawing master in 1922, in the Malakhovka Labour Colony, where we children, together with our teachers, washed floors, baked bread, did the kitchen chores and pumped water from the well. M. Chagall worked with us. We children were habituated to work and art and had been brought up to be decent people. Chagall was nice to me and I was friends with his daughter Ida. She also was a pupil at the Malakhovka Colony. Very few of us colonists are still alive, but we will remember our dear teacher for the rest of our days. For M. Chagall's 90th birthday, we colonists sent him snapshots in which he was photographed with us. He was touched by our birthday greetings and replied that he remembered us all, that he was now rich and famous and would never forget our Malakhovka Colony where he lived on the second floor with his Bella and slept on an iron bedstead... I am a Labour Veteran. Once again, thank you for your note about our dear teacher and great artist.

I. Fialkova."

That, it transpires, is what was behind the idyllic pale blue of the great canvases. Work in the Malakhovka and Third International War Orphans Colonies. And that was what was hidden behind the enigmatic golden-haired Ida, in whose salon 'all Paris' foregathered, from André Malraux to Madame Pompidou—the hard Malakhovka childhood and the chapped-faced friends from the orphanage! And from there came the artist's suffered global visions— not a mixture of France and Nizhni Novgorod, but of the universally human and Vitebsk—the hunger of the Malakhovka ragamuffins.

The staff of the regional studies museum have in their keeping twelve canvases by Pen, a master of the Repin school and Chagall's teacher. He was later taught by N. Roerich, by the seigneurial Bakst and by the French, but Pen was the first. How kindly the great pupil remembered him! The pupil who betrays his teacher betrays above all himself and the light within him.

"I remember myself as a mere boy climbing the stairs to your studio. I waited for you in fear and trembling—you were to decide my fate in the presence of my

late mother... We have not been blinded. Whatever extremity may take us a long way from you where trends in art are concerned, your image of the honest toiler and artist and my first teacher is nevertheless a great one. I love you for this." The letter was written in 1921.

The museum keeper, a woman, liberates from its official envelope a Parisian postcard dated 7 January 1937: "Vitebsk. To the artist Ju. M. Pen. How are you faring? I haven't had a word from you for a long time, and how is my beloved town? Understandably, I wouldn't recognize it... And how are my little house in which I spent my childhood and which you and I painted together?..."

The other words have perished, cut out of the postcard with the stamp by a philatelist. If only he had known that those words on the back of a piece of cardboard were more precious than any stamp!... Fragments of sentences have survived: "When I die... I promise you... Devot..." Did the postcard ever reach Pen? In that year, the old master was murdered with an axe.

Pen cannot be written to any more, but in 1947 Chagall wrote to the same Ettinger whom, forgetting Pen, they now call the artist's only correspondent in this country.

"In Paris, in the Musée national de l'Art moderne, I am now having a big retrospective exhibition of almost forty years' work. The press writes that it is an enormous success. It's the first time they've exhibited a living artist in an official museum in general, and a Russian artist in particular. And although I have had to live a long way from my homeland, I have remained spiritually loyal to it. I am glad that I have been able to be of a little service to it in this way. And I hope that I'm not considered a stranger in my own homeland. That's so, isn't it?"

True, he once sadly let slip in a letter: "My pictures have gone all over the world, but in Russia, evidently, they don't think about and haven't taken any interest in my exhibition..." You walk round the room today, and the artist's dull, bitter words ring in your ears.

When he visited us in June 1973, he presented the Pushkin Museum of Fine Arts with about a hundred sheets of his work and was disappointed when, for the occasion of his visit, they merely put on a modest exhibition of lithographs and pictures from the back rooms of the Tretyakov Gallery. After the exhibition, several pictures were left on permanent display.

When he arrived, Marc Zakharovich dreamed of a meeting with Vitebsk and was dreading it. Of course, the trail of his childhood Vitebsk has gone cold. War destroyed much of it, and in the fifties, the town's famous cathedral silhouette was destroyed. Alas, while taking the air on the hotel balcony, the Master caught a chill and the journey was out of the question.

But how did it happen that the artist's homeland proved to be the only one of the civilized countries where not one of his albums had been published and where there had not been a single retrospective exhibition of his paintings? His name and works were, idiotically, banned for many long years. The whole world knows about Vitebsk from Chagall's pictures and from the fact that he was born there, but in the town itself there is neither a museum nor a street named after him.

It is time to publish a worthy album and a monograph on the Master. The research work published by Tugendhold and Efros towards the end of the second decade of the century are unavailable now and, alas, incomplete. They cover only the first period of his work.

A few brick houses from Chagall's paintings are still left in Vitebsk. In the old Vitebsk brickwork, the joints are turning pale blue—there was a secret to the mortar mix which accounts for the colour. A fine mesh of sky seems to show

through the brick frontages. I break off a flake of the mortar; perhaps chemical analysis will solve the riddle of this cornflower blue that occurs everywhere in Chagall.

The importance of painters is not merely a matter of museums and history. The artist gives a fresh view of things. He develops intuition, stimulating discovery and illumination in other spheres too. Why else do our savants hold their own exhibitions of Filonov and other artists?

I had occasion to translate poems by Michelangelo. They are written in convex, sculptural stanzas. A poem by Picasso is an analytical rebus. All his life, Chagall wrote verse not only in the metaphorical but in the direct sense. His poems are the same graphics in which the inhabitants of Vitebsk and blue goats fly through the air. They are modest and realistic in technique. I have written several variations on his poems. As far as I know, he published his poems twice in 1968, in 238 copies with 23 coloured and 15 black-and-white autolithographs. In 1975, this composition was republished in expanded form.

At Saint-Paul in 1970, Chagall gave me a presentation volume of his poems mixed with paintings and drawings. "For a poet friend," he wrote in it, and he drew a muse setting free a flying heart like a bird from the palm of her hand. His poetry is unrhymed and set amidst painted images. Strongly represented in the poet's cadences, as in the frenzy of his brush, are motives from "Jewish folk culture, Byelorussian folk art and the Russian *lubok*" (D. Likhachev). And so the green face of the rabbi in the poem becomes a green face with a bump like a potato.

The paintings, so precious for their colours, and the nostalgic verses with their pre-Christian Biblical background, and the aetherial drawings—all are united by the same thing: Chagall's poetry.

Let the white-haired Master's poems flit like butterflies through today's unprecedently large exhibition in honour of Marc Chagall, who has finally returned to his home country.

THE LOFTY GATES

My homeland is within my soul
You understand?
I enter it without a visa.
When I feel lonely, it can see.
It lays me down to sleep.
It tucks me up, like a mother.
Green gardens grow within me.
Mournful, serrated fences.
Long, crooked streets.
Save that there are no houses.
Within them is my childhood.
And, like it, they are utterly destroyed.
The former residents fly through the air.
Where are their dwellings?
In my dilapidated soul.
That's why I smile so weakly,
as does the weak sun in the northern sky.
And if I weep—
it is the rain weeping.
Once upon a time,
I merrily bore two heads upon my shoulders.
Once upon a time,
those heads of mine would laugh,

covered over with a blanket of love.
Oh, they have died, like a rose's keen fragrance!
I seem to walk forever to the Gates,
I walk forwards, even when going back,—
the Lofty Gates rise up ahead of me.
Gates are walls flung open wide,
the spent thunder passes the night in there,
and lighting flashes with a splitting sound.

Two heads turned, two faces of the turn, look, flying today, through the halls of the Pushkin Museum.

WHITE STEPS

I wander through a world like a dark forest,
Sometimes on my feet and sometimes on my hands;
A faded leaf flies down from heaven to earth.
I am afraid.
I paint the world locked in the grip of slumber.
When heavy falls the snow upon my forest,
The pictures are transmuted into dreams.
How many years have I stood in their midst?
I've spent my life in prescience of a miracle.
I'm waiting here—when will you encircle me, then,
So that the snow
 may come down
 like a ladder.
I'm tired of standing—let us fly together
Up into heaven by the little white steps!

The Prophets, and Jesus, and all his *message Biblique*—something very personal and domestic, passed through the innards of Vitebsk. The poetry also betrays the artist's striking modesty. Picasso laughed as he told me how he, Chagall and Matisse hired a potter's studio. The self-assured Europeans quickly threw and baked their pottery and went to see how the Russian was doing. Chagall was embarrassed; he could not work in front of people and he created nothing until his comrades had gone away. Creation for him was a mystery; not a craft, but a miracle.

At the present exhibition, Chagall in gala retrospect, the viewer will for the first time see canvases that have been confined for many years to the repositories of our museums. This Chagall is the most important one to me, the Chagall of the Russian Period, as Zabolotsky is for me the poet of the *Columns* period, while Pasternak is the poet of *My Sister, Life*. It is a dense, active colour, the spellbinding biology of colour and spirit, the psychology of colour, strongly national motives, Biblical not only in colouring, but in the passion of a spirit that knew the Parisian school and brought it round to its Vitebsk interpretation. Its crazy blue stare is the tragic cornflower of the Universe.

The present Marc Chagall exhibition is a result and triumph of *glasnost*. During the centenary celebrations, the capital's papers and magazines carried articles and reproductions of his works. On the Master's birthday, millions saw a Central Television screening of the French film, *Marc Chagall, Artist and Poet*. It took one of the top places in a viewers' opinion poll. The Byelorussian writer Alexievich wrote after seeing the film: "If we had known such people, had known more about them, many dramatic events in our history and life might not have happened, and

we may have been different". A monograph by Alexander Kamensky is under preparation. For objectivity's sake, it must be said that many articles have appeared in which the artist's work is described as 'malicious slander' and in which attempts are made to alienate him from his native culture. They are virtually answered by a letter from a war veteran who took part in the liberation of Vitebsk and shed his blood for it. "Happy is the man who has lived to see an open and honest time... to this day, they have tried to ignore a great artist who has gained world-wide recognition, a fellow-countryman of ours who has never ceased to value, honour and love his Homeland!.. In that case, why not write that Rakhmaninov was an American composer, Chaliapin was a French singer, and Bunin was not a Russian writer, since they spent part of their lives abroad and did not die in their native country?.." This is the view of a man from the depths of the people. This same opinion of the people is expressed by such leading lights of the cultural world as Academician Likhachev, the writers Bykov, Kaverin, Nagibin, Semyonov, the conductor Rozhdestvensky and others, in this way perpetuating the appraisal bestowed on the artist by Mayakovsky and Akhmatova.

The generous Valentina Grigorievna brought fifty canvases, amongs them the famous *Lovers over Saint-Paul*. Eleven canvases are from Ida Chagall's collection.

"And the impossible is possible"—these words by the blue Alexander Blok never leave the mind at the present preview. The impossible was achieved by a Master of genius, and the impossible has been achieved thanks to the efforts of those who organized this unique exhibition.

The impossible has now become possible.

Congratulations on your return, Great Master!

I congratulate our painting and world painting, I congratulate the viewers, I congratulate us all.

I congratulate our centenary on Chagall's century!

Marc Chagall in the 1920s

THE MASTER
FROM
VITEBSK

MARINA BESSONOVA

Marc Chagall was the last of the renowned 'old' masters of the 20th century. He lived so long that it seemed as if he himself would open the exhibition commemorating his centenary. We can only turn to Picasso for comparison when considering the powerful artistic impulse that for eighty years poured out such a variety of works: paintings, engravings, stage sets and finally, during Chagall's last years, stained glass and mosaics. He established himself as a painter at a time of bold Cubist experiments, at the very birth of the 20th century's new pictorial culture. When he died there was no one like him, a master and a wizard still conjuring with paint in our own days, which are far less conducive to profound meditations before the easel.

Like Matisse and Favorsky he left the world his Book: the vivid narratives in engravings that give his version of Gogol's *Dead Souls* and of the Bible. Together with Picasso, Léger, Matisse, Le Corbusier and Melnikov he spent the second part of his life as an artist transforming the medieval Gothic cathedrals and creating contemporary churches. His stained glass windows are scattered throughout the world and, glittering in their steel frames, will remain just as much an everlasting monument to our culture in the eyes of future generations as those other famous structures—the Chapel of Dominican Nuns in Vence, the 'Temple of Peace' in Vallauris, the pilgrimage chapel of Ronchamp, the house in Biot, or Melnikov's tower-house on Krivoarbatsky Lane, in Moscow.

Like Tatlin, Mayakovsky and Blok, Chagall has left his own distinctive image of that most profound upheaval of our epoch, the Russian Revolution: people in craftsmen's overalls striding across the globe or soaring high above it.

Finally, he was the only one of the 20th century giants to boldly offer the world his own *message biblique*. With this enormous cycle of canvases, forming an entire museum in themselves, he stretched his hand across the centuries to the nameless masters of Medieval Russia and Europe and in so doing ceased to be Marc Chagall and became instead the Master of Vitebsk.

Major works have been written about Chagall and continue to appear. This is the first large retrospective exhibition since his death. It is right and fitting that it is taking place in the land of his birth: for in his late works the image of old Vitebsk, like a coat of arms, was always present as a reminder of his Russian origins.

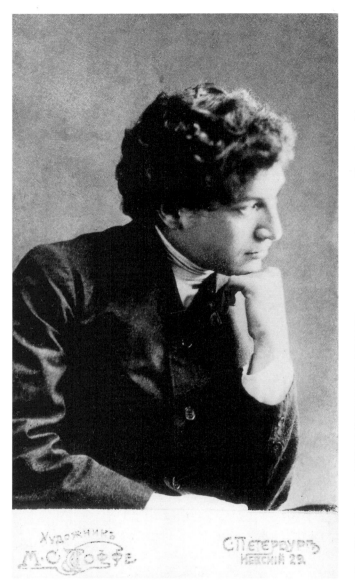

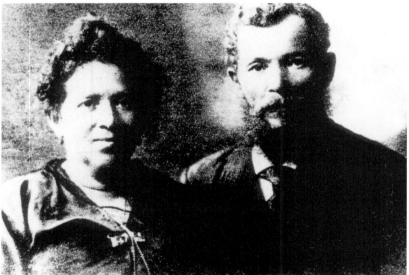

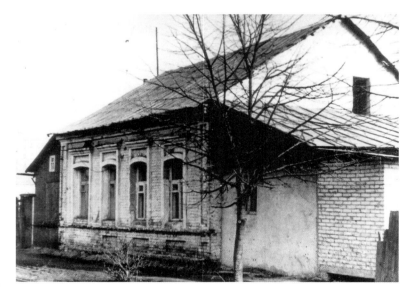

Left: Chagall in St. Petersburg. *C.* 1909
Upper right: Chagalls' house in Vitebsk
Early 20th-century photograph
Lower right: Chagall's parents
Below: Marc Chagall's house in Vitebsk

In an early surviving study in oils we can already detect the hand of a natural artist and draughtsman. This portrait of an old woman with a basket of knitting was apparently begun in Vitebsk when he was still being instructed by Jehuda Pen, a pupil of Ilya Repin. One has an involuntary urge to compare it to the old men and women depicted by the teenage Picasso. They were both interested in their young days in all that was physiognomically striking and 'pitiful'. The young Picasso, however, had received a strict academic training. By contrast, the boy from Vitebsk was less restrained. The expressiveness of the patches of colour and writhing strokes and flourishes with which he covered his painting was in tune with the European plastic vision of the time. Born several years after Picasso, Chagall caught up with him in seven-mile strides clutching his palette in his hands. Without knowing when this work was produced, it is quite clear that it was painted after van Gogh and Toulouse-Lautrec.

A year later Chagall completed the *Little Parlour*. By now he had studied with Roerich, Dobuzhinsky and Bakst, and this little interior is an astonishing work, both for its expressive depiction of the furniture which is rocking as if swept by a hurricane, and for its intense, purely Fauvist colours. The *Little Parlour* could easily have hung beside the works of Matisse, Derain and Braque in the Fauvist room at the *Salon d'Automne* in Paris. How can we account for this? Naturally such a rapid assimilation of European artistic culture cannot be attributed solely to the talent of the young artist. Here, once again, we must pay tribute to the new system of artistic instruction in Russia before the First World War. In Moscow and St. Petersburg alike it was free from academicism and openly receptive to all that was new and progressive in the West.

This is probably why Chagall found his feet so soon after arriving in Paris. Confronted by the mature Cubism of Picasso and Braque, the next step in artistic development after Fauvism, he adopted this most complex plastic language as his native and natural element. Yet if the professionalism he had acquired in Petersburg enabled him to freely accept Cubism, not everyone could have established an independent artistic personality within this alien and fully formed system which was already intoxicated by its own technical virtuosity. Nevertheless, the first canvases Chagall painted in Paris (*The Village and I*, and *To Russia, Donkeys, and Others*) astonished the Cubist poets Apollinaire and Cendrars and thus Picasso himself, the founder of the movement. Chagall's powerful voice was heard not only in Paris, but in Berlin as well where he was invited to participate in an exhibition of young Expressionists. Even before he became famous in Russia, therefore, the earliest works by Chagall were recognized throughout Europe.

Talented young artists from different countries flocked to Paris, drawn like fearless moths to the bright and purifying flame lit by Apollinaire and Picasso. Many were fated to be consumed by this fire. Modigliani spread his wings and burst into flame; Otokar Kubin's works ceased to stand out among the universally high quality of the Expressionists and Cubists; the skilled stylists Kisling and Fudjita took their place in the history of art, but only as representatives of the Paris School. Yet when Chagall was declared to be the head of that same school in the early 1930s this was already an honour for the school and not for Chagall.

He was immediately able to rise above national particularity and colourful exoticism although his cows, donkies, old women with milkpails and Orthodox church cupolas were irresistibly attractive to his viewers.

Mature Cubism teaches us to look at the world not only with binocular but also a certain 'rotational' vision; we delve into the very essence of the way shapes are formed. This discovery was also far from the cold and calculated rationalism that some modern researchers are inclined to attribute to French Cubism. But in the

paintings he made in the early 1910s Chagall blew apart these pasted collages of forms as if he had detonated a powerful shell. His bodies had not yet lost their dense weightiness although they had become transparent, and they flew in all directions as if borne on a strong explosive wave. Léger and Apollinaire were soon to see these nightmarish scenes in real life in the trenches of the First World War. Evidently Apollinaire sensed a certain powerful prophetic force emanating from the canvases of the young artist from Vitebsk: Chagall would not allow the 'blazing flame' (of which Apollinaire had written in the first manifesto of the new art in history) to be extinguished.

We find evidence of the atmosphere of that unrepeatable era when Chagall first soared over the Eiffel Tower, in his portrait of the poet Mazin. The figure appears to have been hacked by some blunt instrument from a single block and, illuminated by nervous brush strokes, sits in a traditional Cubist pose. Gritting his teeth, Mazin raises a triangular glass filled with a devilish liquid to his mouth, his hand like the little wing of a roughly-carved wooden angel. On the poet's knees rests a notebook reminiscent of a tablet covered with cuneiform letters. Chagall's poet is the embodiment of the coming era's new aesthetics: praised by Cendrars, Apollinaire and Mayakovsky (and hoarsely debated by young poets and artists in the cheap lodgings of Montparnasse), they frightened and repelled those who loved all that was exquisite and refined. Yet once he had joined that enthusiasm at the feet of the Eiffel Tower and tasted the bitter wormwood-flavoured absinthe from its triangular bottles and glasses, Chagall was already irrecoverably 'poisoned' to the end of his days, by this magically intoxicating new vision of the world. Many years afterwards, and trembling with emotion, Hemingway would write of a similar experience.

Chagall's ability to transform everyday activities into miraculous happenings also did not escape the sharpened perceptions of Europe's *avantgarde* painters. This was one of Chagall's main artistic qualities and had already found expression in his early years. In Paris the scenes he had witnessed during childhood in Vitebsk and Lyozno passed before his eyes. In *Birth* everything glorifies the miraculous appearance of a new life. The composition shows the new mother in the foreground, facing away from the infant as in icons of the Nativity, and the colour scheme relies on sharp geometrical contrasts between light and shade. The midwife, partially concealed by the edge of the canvas, holds the glowing kerosene lamp high above her head like a torch: the bright light cuts through the gloom of the cellar with its menacing semi-circular window beyond which reigns darkness. The father bearing the dazzling infant in his arms hovers at the foot of the bed in the depths of the picture; and his small figure helps define the particular 'miraculous' space that transforms the interior of this cramped and tiny room.

The First World War interrupted Chagall's Parisian discoveries. He returned to his native town where he became involved in the tense pre-revolutionary life of Russia. On his travels between Vitebsk, Petrograd and Moscow he observed scenes from soldiers' lives away from the front and the first disfiguring scars of war: refugees from the villages of Byelorussia, and wounded soldiers marching alongside the new conscripts. Together with the trench sketches of Léger and Zadkine, the verse written at the front by Apollinaire, the engravings of Goncharova, and Barbusse's *Under Fire*, Chagall's drawings and watercolours were an indictment of that senseless and inhuman war. In his sad artistic chronicle of the first pan-European madness Chagall adopted the role of the humble observer and memoirist. However, the entire range of emotions of that time found expression in his series of studies and drawings: they depict the genuine tragedy of the new conscripts (whose faces, 'merging into one', show that they are doomed) and, at the same time, the sarcastic grimace of the wounded soldier who squints at

us with his one good eye from a pen-and-ink drawing in the Tretyakov Gallery.

All researchers have noticed a sharp increase in the everyday themes illustrated in Chagall's art in the years of war before the Revolution. For this there may be many explanations. The artist was once again involved in a familiar environment with its own colourful and lively daily existence: after the dreams of Paris, his heart was stirred by the joy of recognition. Then, confronted by an advancing and alarming reality, he temporarily abandoned his visionary approach. Finally, a major event had occurred in Chagall's private life. Marriage to Bella and the birth of Ida had brought with them the simple human desire to depict his loved ones again and again, recording the hours and days of their happy existence together. This was how his landscapes and his interiors with portraits of Bella and the diminutive Ida came into being: they sit at the *dacha* round a table laid with plates of ripe wild strawberries, or in front of a window that opens onto a clearing in the woods or reveals the overgrown garden. These were the views of the Russian landscape that were so dear to him, and which he would miss with acute nostalgia abroad. In the late 1920s and early 1930s he became fully aware that he would never return to his native haunts; he missed them deeply and began to visit Switzerland where the snow-covered distant mountains and the majestic fir-trees somehow reminded him of his lost homeland. The starkly naturalistic landscapes he painted of Peyra-Cava in the French Maritime Alps stand out among the symbolical and allegorical canvases of his second Parisian period.

In Chagall's early Paris canvases Vitebsk flew in dismembered fragments across the sky but in 1914 it descended to the earth, once again whole. In the *Newspaper Vendor*, one of Chagall's masterpieces, the mournful figure appears like a vision before us while behind him there stands an old Russian town with its main street and square framed by small wooden houses and dominated by the vast Church of the Prophet Elijah.

Yet alongside these scenes of daily life at the dacha and in Vitebsk there run a parallel series of symbolic portraits. Chagall depicted 'red' and 'green' Jews, many-coloured rabbis praying or meditating over the Scriptures and, duplicating their ritual solemnity, there also appeared a series of heads belonging to 'blue' and 'green' lovers. It is as though colour has ceased to be simply a means of emotional expression for the artist and, while still sealed in its tubes, has escaped his control and is already dictating the subject of his next painting. It is in these pre-revolutionary paintings that we should look for the sources of the colourful visionary approach that shaped all Chagall's subsequent work.

It was then he painted *The Birthday* which became a model for all his following works. A pair of lovers have become weightless and rise in a swirling ecstatic movement within the space defined by the room. The interior is filled with many petty domestic objects and recalls paintings by the Dutch Old Masters where a real everyday setting is reproduced in detail but each item also has a hidden meaning. An urban room is thus transformed before our eyes into a place where miracles can happen.

Chagall's marriage gave his art a new theme, the possibility of uniting earthly and heavenly love. And in his post-revolutionary paintings the first to embody that 'cosmic' upheaval were a pair of lovers. In the vast canvas, *Over the Town*, they soar over Vitebsk supporting one another, as if 'restraining' their thrusting flight into infinity. They are constrained to the earth's surface with difficulty: in the universally famous *Promenade* Bella spins around the artist's arm like a satellite, just about to leave this world. Bold lovers alone are permitted everything and Chagall, seated on his wife's shoulders, reaches into the heavens to share a toast with the angels flying by (*Double Portrait with Wineglass*, 1917).

Henceforward and forever after, the theme of free and eternal flight above

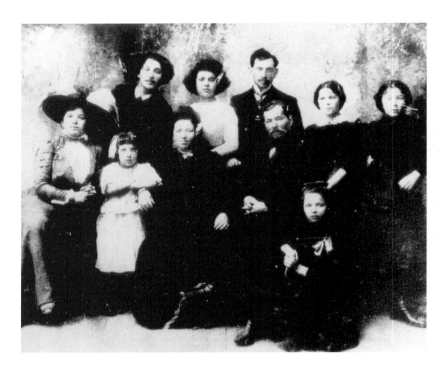

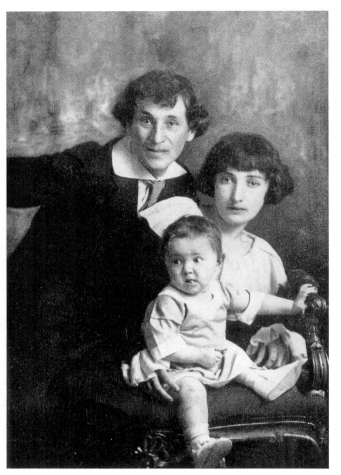

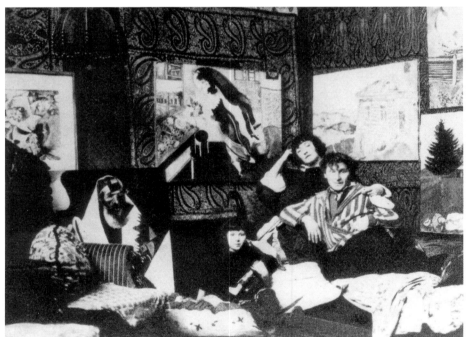

Upper left: Chagall (upper left) with his parents,
sisters and uncle in Vitebsk
Upper right: Marc Chagall, with Bella and Ida. 1917
Below: Chagall and his family in the studio on
the Avenue d'Orléans in Paris. 1923—24

the world was established in Chagall's work; his figures soar happily or sadly depending on the moral condition of the world above which they hover.

In the paintings of his first return to the French capital, Chagall's happy artists and their muses hang suspended in the sky between Paris and Vitebsk. Young lovers, tightly embracing, soar serenely among bouquets of lilac above the Seine; they are surrounded by animals which somersault in the clouds and plump Cupids gazing with amazed child-like expressions. This heavenly sphere raised high above the earth exists outside time and operates according to its own laws. The flying musicians play wonderful fairy-tale melodies, and the faces of the Bride and Groom, crudely sketched as in childrens' drawings, reveal their surprise at the beauty of the universe. In these compositions Chagall involuntarily embodied the ancient beliefs of the Hassidim that the cosmic mysteries would only be revealed to the ecstatically joyful.

However, the gaze of these lovers and angels is more and more frequently directed towards the earth. Chagall's heavenly travellers, after all, are always flying above the world. In a painting from the late 1930s the Groom fearfully clutches the scared Bride to himself: with alarm the heavenly wanderers observe three candles rising from the earth and the many-coloured flame that embodies the souls of those crying out for help. In his paintings from these fateful years in European history, Chagall shifts the time setting from the scented summer twilights to dusk (or what the French call *entre chien et loup*): in this failing light the vilest crimes are committed and terrifyingly senseless inversions begin to appear, the forerunners of nightmares, like the striding lamp-post or the human figure with the head of a bird of prey. In the frozen winter streets of Vitebsk an artist stands forlornly before his easel, a palette in his hand, and an angel descends to him with the face of his beloved but dressed in bloody garments. In the *Self-portrait with Wall Clock* the clock has begun, as if sighing, to sweep about the room waving the arms it has grown, while the tragic scene of the Crucifixion appears before the artist on his easel-mirror. In this period Chagall's paintings were dominated by the snow-covered Russian village and a strange disembodied being, the *Soul of the City*: this snowstorm with a tender woman's face whirls above the earth and catches in its cold embrace the Bride with a 'blue' face who falls unconscious, letting drop her festive bouquet.

During the evil years of fascist triumph the image of Russia in Chagall's works changed substantially. In the paintings that date from before the First World War, from the years of the Russian Revolution, and his second Paris period we can see a dual interpretation in the artist's perception of his native Vitebsk. The town recalls a large village and is shown either as the scene of miraculous transformations—a small universe filled with mysteries, the artist's spiritual home—or as a provincial backwater and symbol of Gogol and Saltykov-Shchedrin's Russia, a realm of make-believe, and a stage for the theatre of the absurd. It was no coincidence that Chagall completed his painting *Over the Town* in 1918: contemporaries understood the flight of the enormous couple above a toylike, wooden and fenced-in Vitebsk as a direct symbol of the revolution and the liberation of the human soul from petty-bourgeois restrictions and parochialism. Here Chagall's artistic approach comes closest of all to Mayakovsky's revolutionary lyrics in which he scourged the petty bourgeoisie.

However, in the works he painted at the end of the 1930s and in the 1940s we begin to see quite another Vitebsk as the town became the embodiment of all of suffering Russia. The small town with its little wooden houses and brick-built churches becomes a focus of the artist's inner world and an emblem of his poetics, alongside the mediterranean castle of Saint-Paul-de-Vence and the Eiffel Tower. These symbols, like insistent visions and daydreams, are to be

found in all Chagall's works right up to his very last canvases. His version of Jacob's Dream is actually set in Vitebsk and the 'ladder into heaven' with angels ascending and descending rises above the wooden roofs of the town.

Alongside Vitebsk there is another integral part of Chagall's iconography that is inseparably linked in his mind with Paris, his second home: the Eiffel Tower. Today this structure still strikes some as awkward as it looms over the houses and churches of the city, a rather forceful and naive expression of the raptures first felt at the future possibilities of engineering. However, the tower was hymned by Apollinaire and has firmly entered the poetic lexicon of the 20th century: "Shepherdess, o Eiffel Tower ..." It is as if Chagall had taken up Apollinaire's lines in his very first views of Paris and repeated them in all his subsequent works. His Eiffel Tower reminds us most of all of a gentle springtime shepherdess whom we consciously identify with the Bride in her wedding dress. Here Chagall stretched out his hand to yet another artist, a man whose works influenced all the budding artists of our time in one way or another, 'le Douanier' Rousseau. This naive artist had been discovered by the *avant-garde* painters of Paris and Chagall could not help but know his works; from his very first days in the French capital he had been acquainted with Rousseau's supporters, Apollinaire and the Delaunay couple.

It might seem that the two painters had nothing in common. Rousseau was an eccentric official from the modest Paris suburbs of the turn of the century; when he was already middle-aged he had begun a second life as a painter. Chagall, on the other hand, was young and professionally trained and from his youth onwards had experienced every tragedy of our time. Yet for all the opposition between their methods and stylistic approach, and the differences between their lives and national cultures, the inner and thematic kinship between these two artists is obvious. Both Chagall and Rousseau pursued the images of their daydream visions. They both acknowledged that their inspiring muses were their faithful partners in life. The names of his two wives are engraved on Rousseau's palette in his famous programmatic *Self-portrait with Landscape*. Two muses, two wives, likewise accompany Chagall on his eternal flight between Vitebsk and Paris. The mysterious nude with hair let down on a scarlet couch is, in Rousseau's imagination, directly transferred from the bedroom to the heart of an exotic jungle. In Chagall's canvas a young naked newly-wed bride lying on a red divan floats above enormous bouquets of cultivated and wild flowers that resemble the groves of paradise.

Robert Delaunay seized on the Eiffel Tower in Rousseau's self-portrait as an emblem and the Cubist exhibition was full of his multi-coloured silhouettes of its enormous steel girders. Yet only Chagall managed to create a 'living' image of the tower and, in so doing, produced a vision of such poetic power that it gave rise to an entire trend or leitmotif in French (or rather Parisian) art in the 1920s: from the ballet, *Les Mariés de la Tour Eiffel*, written by the famous musical 'Six' led by Darius Milhaud, to the film-comedy *Paris qui dort* by René Clair.

Was Rousseau really so 'naive', after all? The novel theme he had introduced into European art gave us a great many new and talented artists. Was the magical world of 'naive' perceptions quite inaccessible to a refined professional like Chagall? Yes and no: it would be stretching the point to give a simple answer to this question.

The century is now drawing to a close. And if in our own time, amid the roar and screech of machines and the fuss and pressure of everyday life, we hear ugly steel constructions suddenly sing out with a human voice we shall remember: it was Marc Chagall who breathed life into them and gave them a human face.

CHRONOLOGY,
WITH MAJOR
EXHIBITIONS

1887

7 July: birth of Marc Chagall in Lyozno, a village near Vitebsk, Byelorussia; his father is a clerk at a herring warehouse.

1906

Leaves the Jewish elementary school. Studies at Pen's school of painting in Vitebsk.

1906—7

Winter: moves to St Petersburg. Spring: attends the School of the Imperial Society for the Encouragement of the Arts directed by Roerich who took an interest in Chagall.

1908

Leaves that school in July. Short period at Saidenberg's private school. Enters the Zvantseva Art School; his teachers were Léon Bakst and Mstislav Dobuzhinsky.

1909

Study under Bakst is continually interrupted by lengthy stays in Vitebsk, where he paints most of his large pictures. Meets Bella Rosenfeld, his future wife.

1910

April—May: pictures in an exhibition of work by pupils of the Zvantseva School at the offices of the journal *Apollon*, St Petersburg. Autumn: Bakst prepares scenery for the ballet *Narcisse* (planned for the 1911 season of Diaghilev's *Les Ballets russes*) with Chagall's help. August: departure for Paris. Lives in a studio in the Impasse du Maine. Visited by Bakst. Attends two art schools—*La Palette* under Le Fauconnier and Segonzac and La Grande Chaumière.

1911—12

Moves into a studio in the artists' settlement in Montparnasse known as *La Ruche* (The Beehive). Meets Cendrars, Max Jacob, Apollinaire, and the artists Léger, Modigliani, La Fresnaye, Delaunay. First participation in the Salon des Indépendants and Moscow *Donkey's Tail* in March, and at the Salon d'Automne.

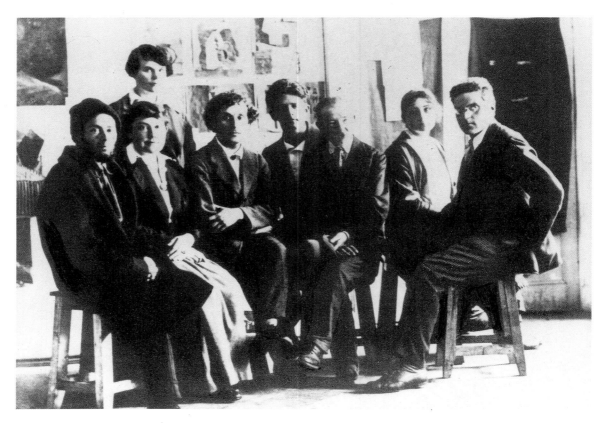

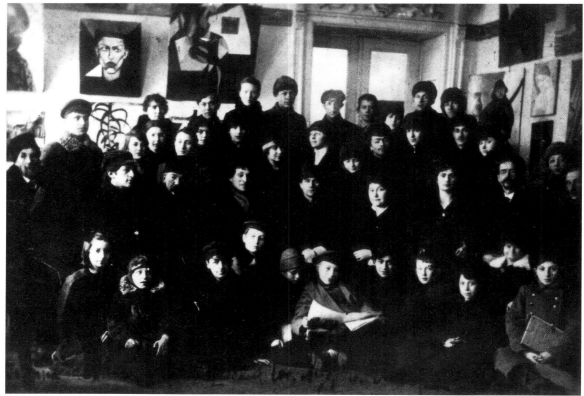

Above: Vitebsk Art College, summer 1919:
Chagall seated, third from left;
El Lissitzky next to Vera Ermolaeva;
third from right, Pen
Below: Chagall (seated fourth from left, in second row)
among the teachers and students
of the Vitebsk Art College. 1919

34

1913

April: three pictures at the *Target* (Mishen) exhibition and in *Der Sturm* gallery, Berlin.

1914

April: Salon des Indépendants, Paris. May: leaves Paris for Berlin. Apollinaire introduces Chagall to Herwarth Walden who gives him an important exhibition at his *Der Sturm* gallery with Kubin (April—May).
15 June: Chagall returns to Russia leaving Berlin after attending the opening of his one-man show.

1915

March: shows 25 works at the spring *avant-garde* exhibition in Moscow, called *The Year 1915*. Marries Bella at Vitebsk; later, moves to Petrograd where his work in the Office of War Economy exempted him from military service.

1916

Birth of his daughter, Ida. November: contributes to the exhibition of the *Jack-of-Diamonds* group of *avant-garde* artists, Moscow, and that of Contemporary Russian Art in Petrograd.

1917

February and October Revolutions in Russia. Takes part in exhibitions in Moscow and Petrograd. After the October Revolution returns to Vitebsk. Contributes to the exhibition of local artists.

1918

August: is appointed Commissar for the Arts in Vitebsk and region with powers "to organize art schools, museums, exhibitions, lectures on art, and all other artistic ventures within the limits of the city and region of Vitebsk". Organizes a 'Red Festival' to mark the first anniversary of the October Revolution, using 15,000 m of red bunting in a celebration. Founds an art school and a museum.

1919

April—July: the First Free State Exhibition of Art, Petrograd Palace of Art (the former Winter Palace). Spring: Dobuzhinsky, Puni and Pen teach at Vitebsk art school, to which the Petrograd authorities (IZO Narkompros) send a new rector, Ermolaeva. El Lissitzky and, in November, Malevich join the art school staff. Runs the Free Painting Studio. Autumn: after a quarrel with the Suprematists, first resignation, subsequently withdrawn.

1919—20

Works for the Theatre of Revolutionary Satire, Vitebsk.

1920

May: definitely resigned as Director of the Vitebsk Academy. Invited by Efros and Granovsky, moves to Moscow.

1920—21

Designs for the stage. Murals entitled *Love on the Stage* for the auditorium of the new Kamerny Jewish Theatre, Moscow: sets and costumes for *The Miniatures* by Sholom Alechem.

1921

June: exhibition of the murals for the Kamerny Jewish Theatre.

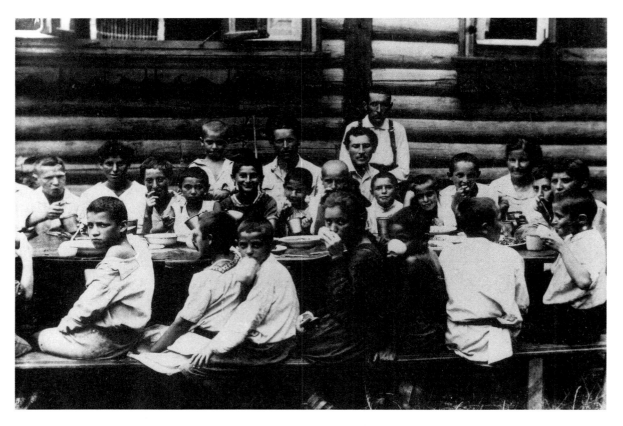

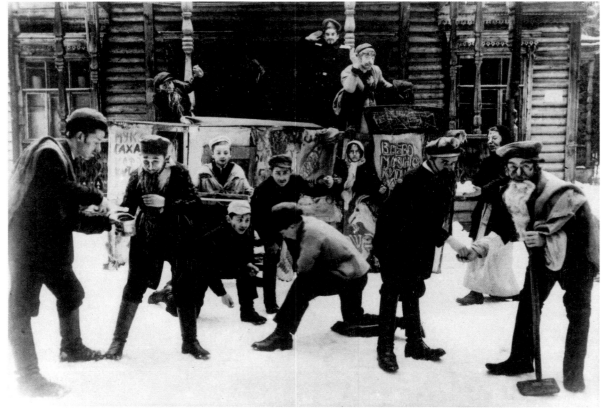

Above: Chagall (third from left in the last row)
with children from the Colony
Below: Children of the Colony taking part
in a theatrical production

1921—22

Teaches at two colonies for war orphans, Malakhovka and Third International, near Moscow. Lives in one of them (Malakhovka). Begins writing *My Life*.

1922

Contributes to the exhibition of the *World of Art*, Moscow. Leaves Russia via Kaunas where he exhibits pictures which he brought with him, going on to Berlin, where his wife and daughter join him. Stays in Berlin where he in vain tries to find his pictures. October: two pictures in the First Russian Exhibition at the Van Diemen Gallery, Berlin. Etchings for *My Life*. Lithographs and woodcuts. Cassirer invites him to make a series of etchings for *My Life*.

1923

One-man show in Berlin. *Mein Leben* portfolio of etchings published in Berlin by Cassirer. Settles in Paris again. Vollard orders from him ninety-six etchings as illustrations for Gogol's poetic novel *Dead Souls*. Meets Paul Eluard and Max Ernst. Refuses to join the Surrealist movement. Exhibition of theatre decorations in Moscow.

1924

First Paris retrospective (*Œuvres de Marc Chagall*, 1908—1924) at the Galerie Barbazanges-Hodebert. June: Brittany. Works on etchings for Gogol's *Dead Souls* (until autumn, 1925). Exhibits in Brussels and New York.

1925

Begins the 100 illustrations for La Fontaine's *Fables*, commissioned by Vollard (until 1927). Summer at Montchauvet. Begins long series of gouaches with landscape motifs. Exhibitions in Cologne, Dresden, Paris and Zurich.

1926

First exhibition in New York at the Reinhardt Galleries. On commission from Vollard works on a series of gouaches on the theme of circus. Exhibits in Chicago and Paris.

1927

Sends a set of plates (ninety-six etchings) for Gogol's *Dead Souls* to the Tretyakov Gallery, Moscow. *Cirque Vollard* gouaches. Exhibits in Paris. Contract with Bernheim-Jeune. Recognized as a leading painter of the Ecole de Paris.

1928

Etchings for the *Fables* (late 1928 to early 1931). Exhibits in Paris.

1929

His autobiography, *My Life*, is translated into French (published in 1931). Exhibits in Brussels and Cologne.

1930

At Peyra-Cava, Alps-Maritimes. 100 gouaches to illustrate 100 fables of La Fontaine exhibited in the Galerie Bernheim-Jeune, Paris, and also in Brussels and Berlin. Exhibits in New York.

1931

Travels to Palestine, Syria and Egypt. Journey to Palestine is a preliminary for *Bible* etchings, on which work continues until 1939 and again from 1952 to 1956. Frequently visits Switzerland since the countryside there reminds him of Russia. Exhibits in Paris and San Francisco.

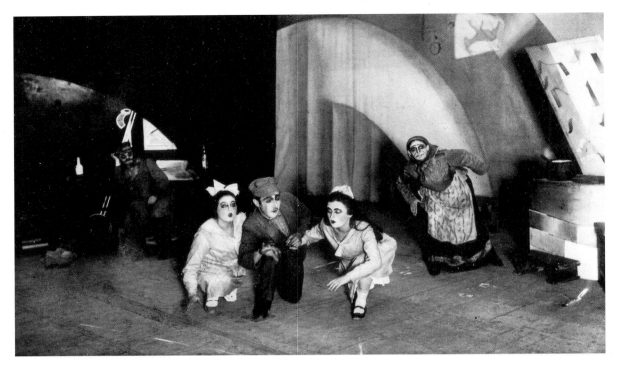

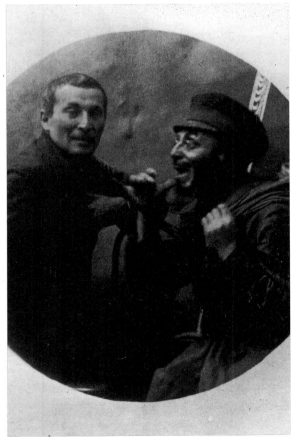

Above: Scene from *Mazeltov* (Michoels is in the centre)
at the Jewish Theatre in Moscow, with Chagall's scenery. 1921
Lower left: Chagall and Michoels (in the centre)
amidst actors of the Moscow Jewish Theatre
in Berlin. 1926
Lower right: Chagall and Michoels as Reb Alter
during the rehearsals of *Mazeltov* at the Jewish Theatre
Moscow, 1921

1932—37

Various important journeys—Holland (1932), Spain (1934), Poland (1935). Stay at Villeneuve-les-Avignon and journey to Italy (1937).

1932

Exhibits in Amsterdam and The Hague.

1933

Large retrospective at the Kunsthalle, Basle. *Auto-da-fé* of his pictures at Mannheim by order of Goebbels.

1934

Exhibition in Prague.

1935

Visits Vilna; is struck by the isolation of Jews in the restricted ghettos of Poland. Exhibitions in Brussels, London, Paris and Vilna.

1936

Exhibition in New York. Spends the summer in the Jura and winter in Haute Savoy.

1937

Takes French citizenship, an event linked with the growing persecutions in Nazi Germany. Enjoys the Exposition Universelle in Paris. Exhibitions in Paris and Philadelphia.

1938

Exhibition in Brussels, London, New York.

1939

Carnegie Prize. Leaves Paris for the south of France where he moved his canvases in September when the Second World War broke out.

1940

January: takes his work back to Paris for an exhibition at the Yvonne Zervos' Galerie Mai. Received an invitation from the Museum of Modern Art in New York to leave France for the United States; this invitation extended also to Matisse, Picasso, Dufy, Roualt, Masson, and Ernst.

1941

Moves to Marseilles. April: arrested but released on the intervention of the American Consul General and Head of Emergency Rescue Committee. May: moves to Lisbon. 23 June: landed in New York as the Germans attacked Russia. November: retrospective at the Pierre Matisse Gallery, New York.

1942

Summer: sets and costumes for Tchaikovsky's ballet *Aleko*, and, with the choreographer Léonide Massine, on the ballet itself, for the American Ballet Theatre. August: spends a few weeks in Mexico. September: première of *Aleko*. Exhibitions in New York and Washington.

1943

Michoels and Itzik Feffer are sent by the USSR on cultural mission to New York where Chagall sees them each day. September: death of Bella. For several months Chagall is unable to work; he gathers the first part of Bella's memoirs commenced

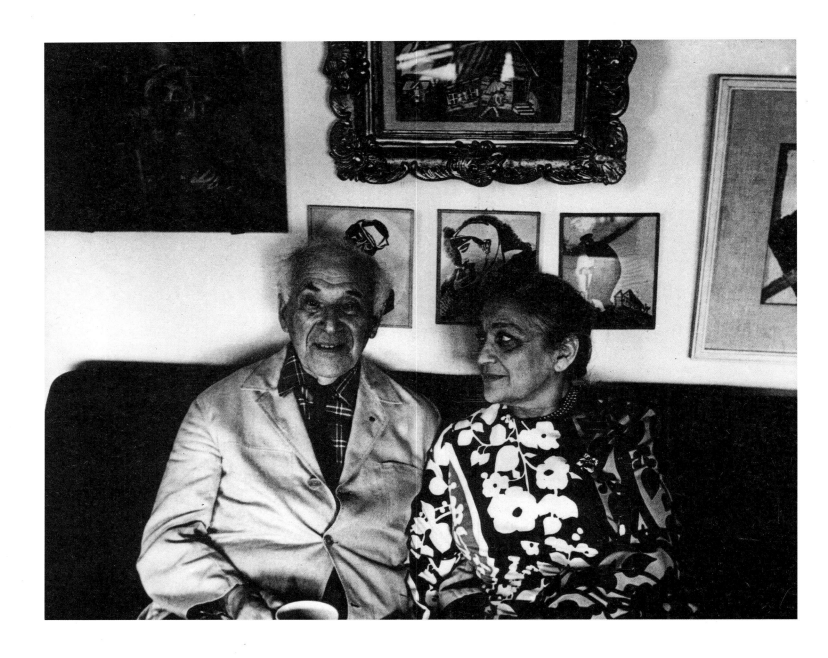

Marc and Valentine Chagall
Moscow, 1973

in 1935 in the volume *Brenendicke Licht* (Burning Lights). Exhibitions in New York. Executes etchings.

1945

Sets and costumes for Stravinsky's ballet *The Firebird* for the American Ballet Theatre. Exhibitions in Boston, Chicago, Los Angeles, New York and Paris.

1946

At High Falls (until 1948). Summer, first postwar contact with Paris. Retrospective exhibition in the Museum of Modern Art, New York and in The Art Institute of Chicago. Begins to illustrate the *Arabian Nights* (published 1948): his first colour lithographs.

1947

Exhibition at the Musée national d'Art moderne, Paris: the first of many retrospective exhibitions in Europe after the war.

1948

Graphics Prize at the XXIV Biennale, Venice (30 illustrations for Gogol's *Dead Souls*, La Fontaine's *Fables*, and the *Bible*). Definitive return to France. Exhibition at the Stedelijk Museum, Amsterdam, the Tate Gallery, London, in New York and Cologne.

1949

Saint-Jean-Cap-Ferrat period. Provides murals for the Watergate Theatre, London. Exhibitions in Chicago, Lucerne, Paris and Düsseldorf.

1950

Starts doing pottery. Exhibition in the Galerie Maeght, including pottery. Moves to Vence. Makes ten wash drawings for Boccaccio's *Decameron*. Retrospective exhibition at the Zurich Kunsthaus. Exhibits in Bergamo, Berlin, Brussels, Eindhoven, New York, Nice, Paris and Rome.

1951

September, at Drammont. Second visit to Israel; retrospective exhibition in Bezalel National Museum of Art, Jerusalem. Carved his first sculptures. Exhibitions in New York, Stockholm and Turin, Bern, Brussels.

1952

Marries Vava (Valentine) Brodsky. Made gouaches on honeymoon in Greece following a commission by Tériade for illustrations for Longus' *Daphnis and Chloë*, published in 1961. At Rome, Naples, Capri (several visits to Italy in the following years). Exhibits in Amsterdam, Basle, Berlin, Lausanne, New York, Nice, Paris, Rome, Cagnes-sur-Mer, Chicago and Geneva.

1953

Visits London. First retrospective in Turin at the Museo Civico, Palazzo Madama. Starts working on the *Paris Series* (until 1956). Exhibits in Milan, California, and Vienna.

1954

Second trip to Greece. Exhibition at the Galerie Maeght, Paris, and in Liége.

1955

Begins work on the Biblical cycle. Exhibits in Cannes (Premier Festival International de la Céramique), Hannover and Rome.

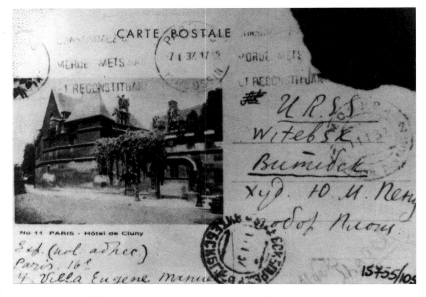

Upper left: Chagall signing his 1920 scenery
for the Jewish Theatre
at the Tretyakov Gallery in Moscow. 1973
Upper right: Chagall making his *Lyrical Self-portrait*
Moscow, 1973
Below: Postcard from Chagall
to his Vitebsk teacher Pen. 1937

1956

Retrospective exhibitions at the Kunsthalles of Basle and Bern. Exhibits in Brussels, Mannheim, New York, Nice and Paris.

1957

Third visit to Israel. Executes large wall ceramic *The Crossing of the Sea*, two marble bas-reliefs (*The Bird* and *The Deer*) and two stained-glass windows for the baptistery of church at Assy, Savoy. Exhibition of his engraved work at the Bibliothèque nationale, Paris. Retrospective exhibitions of paintings and drawings in Amsterdam. Exhibits in Brussels, Basle, Jerusalem, New York, Paris, Turin, Salzburg, Saõ Paolo.

1958

Gives a series of lectures in Chicago and Brussels. Sets and costumes for Ravel's ballet *Daphnis and Chloë* by the Paris Opéra. Paints maquettes for stained-glass windows for the Cathedral of Metz. Exhibits in Brussels, Chicago, Cologne, Frankfurt, Geneva, New York, Nice, Paris, Vevey, and Vienna.

1959

Given the title Doctor Honoris Causa by the University of Glasgow. Retrospective in Paris, Munich and Hamburg. Exhibits at Cologne, Glasgow, Edinbourgh, Pittsburgh, Ravenna. Honorary Member of the American Academy of Arts and Letters.

1960

First window for the Cathedral of Metz. Works on stained-glass windows for the Hadassah Hebrew University Medical Centre, Jerusalem. Exhibits in Bern, Copenhagen, Frankfurt, Reims (stained-glass windows, sculpture, and graphic work). Paints murals *Commedia dell'arte* for the foyer of the theatre in Frankfurt. Honorary Degree from Brandeis University, United States, and the Erasmus Prize at Copenhagen.

1961

Windows for Jerusalem. Exhibition of stained-glass in Paris and New York (*Chagall—The Jerusalem Windows*). Exhibitions in Düsseldorf and Knokke-le-Zoute.

1962

January—February: journey to Israel for inauguration of the Jerusalem windows. Completion of second window for the Cathedral of Metz. Honorary citizen of Vence. Exhibits in Cannes, Geneva, Switzerland, Nice and Paris.

1963

Retrospectives in Tokyo and Kyoto. Visits Washington. At the suggestion of André Malraux, French Minister of Culture, begins to work on the ceiling of the Paris Opéra (inaugurated autumn 1964). Model for ceiling of the Opéra, Paris. May: journey to Washington, to address Congress on Behalf of the Centre for Human Understanding. New series of large paintings for Biblical Message.

1964

Trip to New York for the inauguration of the *Peace* window at the United Nations building, N.Y. State, as well as for the church at Pocantico Hills.

1965

Honorary Degree from Notre-Dame University, Indiana. Sets and costumes for Mozart's *Magic Flute*, and murals for the new Metropolitan Opera, New York.

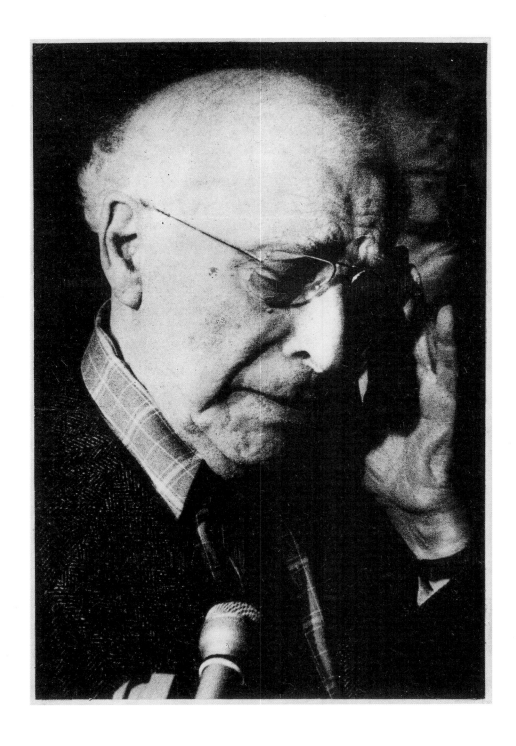

Marc Chagall. Moscow, 1973

1966

Moved from Vence to Saint-Paul-de-Vence, near Nice. Eight windows of the *Prophets* installed at the church at Pocantico Hills.

1967

Retrospective in Zurich and Cologne for his eightieth birthday. Exhibition of Chagall's *Biblical Message* at the Louvre, Paris. *Hommage à Chagall* at the Fondation Maeght, Saint-Paul. Exhibition *Chagall and the Theatre* at Toulouse. Commission for a memorial window for All Saints' Church, Tudeley, Kent.

1968

Trip to Washington DC. Exhibits at the Pierre Matisse Gallery, New York. Completes the stained glass for the triforium in the north trancept at Metz Cathedral. Designs a mosaic for the University at Nice.

1969

Foundation stone laid for the Musée Message Biblique, Nice. June: trip to Israel for the opening of Knesset building in Jerusalem, with floor and wall mosaics and three tapestries by Chagall. December 1969—January 1970: large retrospective *Hommage à Marc Chagall*, exhibition at the Grand Palais, Paris.

1970

Retrospective of graphic work at the Bibliothèque nationale, Paris. Inauguration of the stained-glass windows in Fraumünster church in Zurich. Illustrates poems by Andrei Voznesensky.

1971

Exhibition of lithographs in Zurich. Wall mosaic for the Musée national Message Biblique, Nice.

1972

Four Seasons mosaic commissioned by the First National Bank of Chicago. Exhibition in Budapest. Designs stained-glass windows for Musée national Message Biblique, Nice.

1973

June: visits Moscow and Leningrad; exhibition of lithographs at the Tretyakov Gallery, Moscow. Gives seventy-five lithographs to the Pushkin Museum of Fine Arts, Moscow. 7 July: inauguration of the Musée national Message Biblique Marc Chagall, Nice. Preparation of the model of the stained-glass windows intended for the Reims Cathedral.

1974

Exhibition of graphic work in East Berlin and Dresden. Inauguration of the glass windows at Reims Cathedral. First temporary exhibition at the Musée national Message Biblique Marc Chagall, Nice. Travels to Chicago for the unveiling of his mosaic.

1975

Works on lithographs for Shakespeare's *The Tempest*. Publication of *The Odyssey*, containing eighty-two lithographs.

1977

Awarded the Grand Cross of the Légion d'Honneur. Visits Italy and Israel. Works on stained-glass windows for the Art Institute of Chicago. Exhibition at the Louvre, Paris.

1978

Exhibition at the Palazzo Pitti, Florence. Inauguration of stained-glass windows at Saint-Etienne, Mayence. October: unveiling of the window at Chichester Cathedral, Sussex.

1979

Exhibition of paintings 1975—78 at the Pierre Matisse Gallery, New York, and of Psaumes de David in Geneva.

1980

Exhibition of the *Psaumes de David* at the Musée national Message Biblique Marc Chagall, Nice. Exhibition of prints and monotypes at the Musée Rath and the Gallery Patrick Cramer, Geneva.

1981

Print retrospective at the Galerie Matignon, Paris. Inauguration of third series of windows at Saint-Etienne, Mayence. Lithograph exhibition at the Galerie Maeght, Paris. Exhibition of recent work at the Galerie Maeght, Zurich.

1982—83

September—December 1982 and January—March 1983: retrospective at the Moderna Museet, Stockholm and the Louisiana Museum of Modern Art, Denmark. Exhibition of illustrated books at the Gallery Patrick Cramer, Geneva. Exhibition of paintings at the Pierre Matisse Gallery, New York.

1984

June—October: *Œuvres sur Papier* travelling exhibition at the Musée national d'Art moderne, Centre Pompidou, Paris. July—October: *Vitraux et sculptures: 1957—1984* exhibition of designs and maquettes for stained glass at the Musée Chagall, Nice. July—October: *Marc Chagall, rétrospective de l'œuvre peint*, exhibition in honour of the artist's ninety-seventh birthday at the Fondation Maeght, Saint-Paul. November—December: exhibition at the Museo Campidoglio, Rome. November 1984—February 1985: retrospective exhibition at the Galerie Beyeler, Basle.

1985

28 March: death of Marc Chagall at Saint-Paul-de-Vence.

PLATES

PAINTING

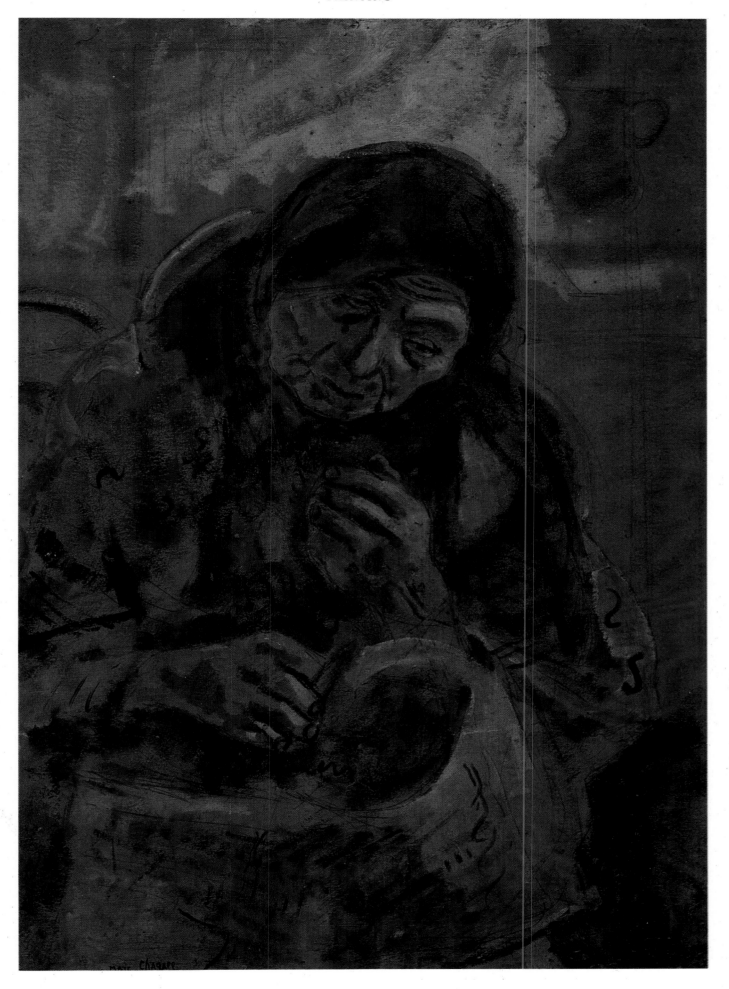

Woman with Basket (Peasant Woman). C. 1906
CAT. NO. 1

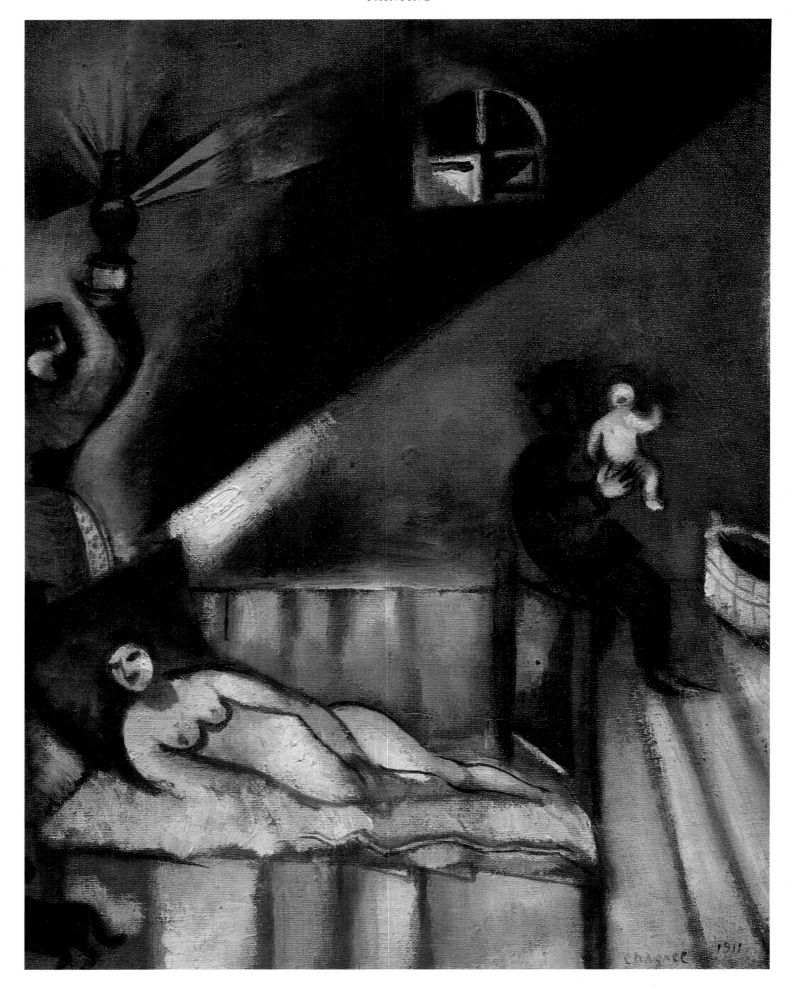

The Birth. 1911

CAT. NO. 4

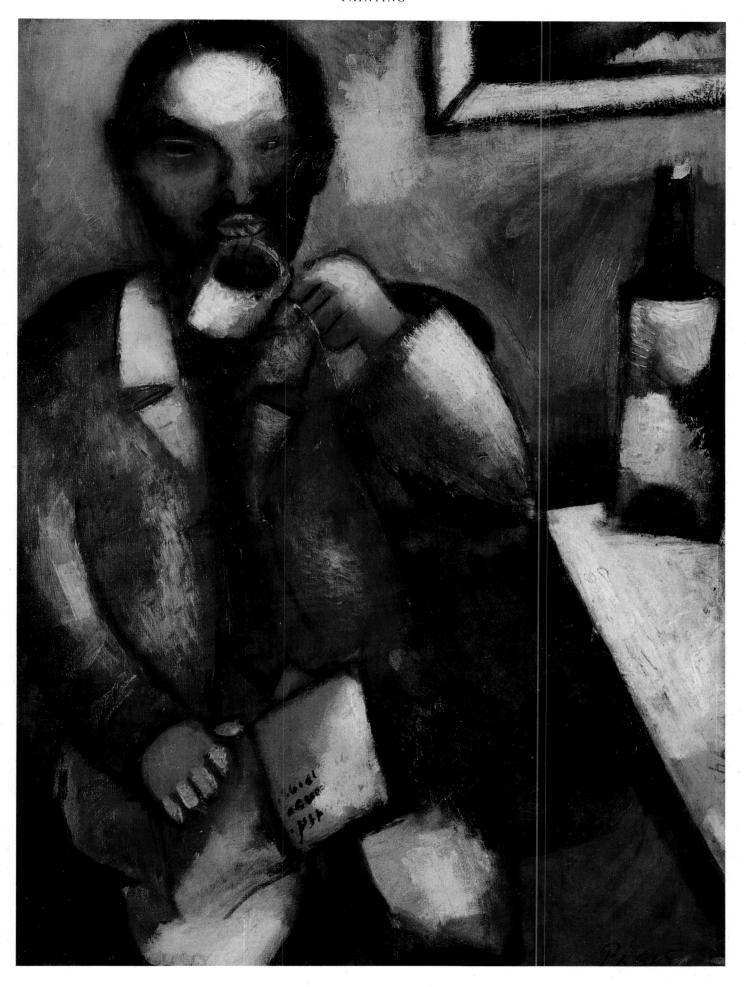

The Poet Mazin. 1911—12

CAT. NO. 5

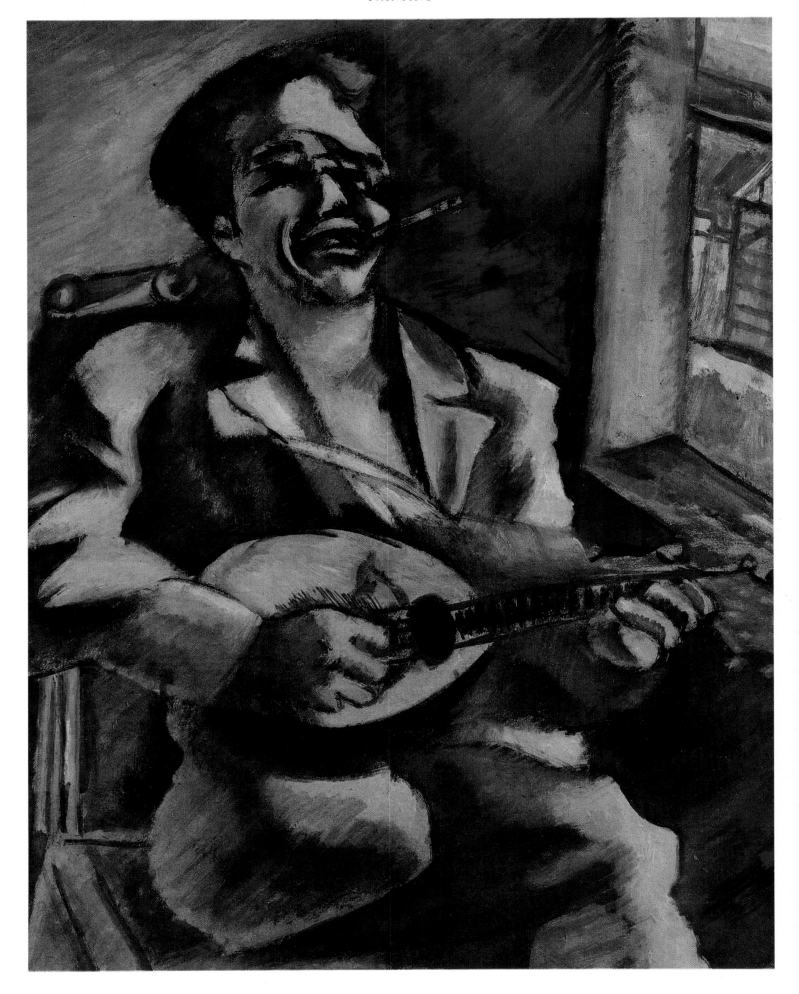

David with a Mandolin. 1914

CAT. NO. 15

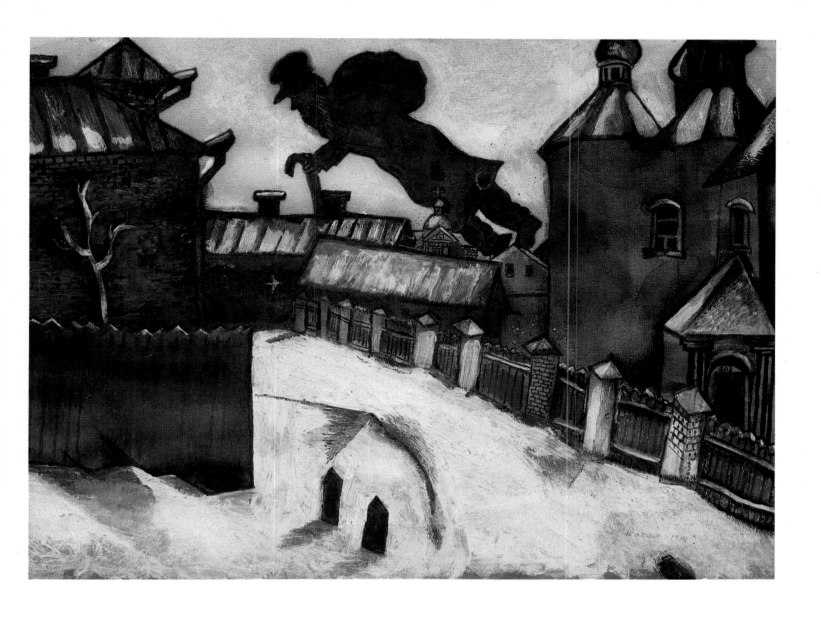

Study for *Over Vitebsk*. 1914
CAT. NO. 12

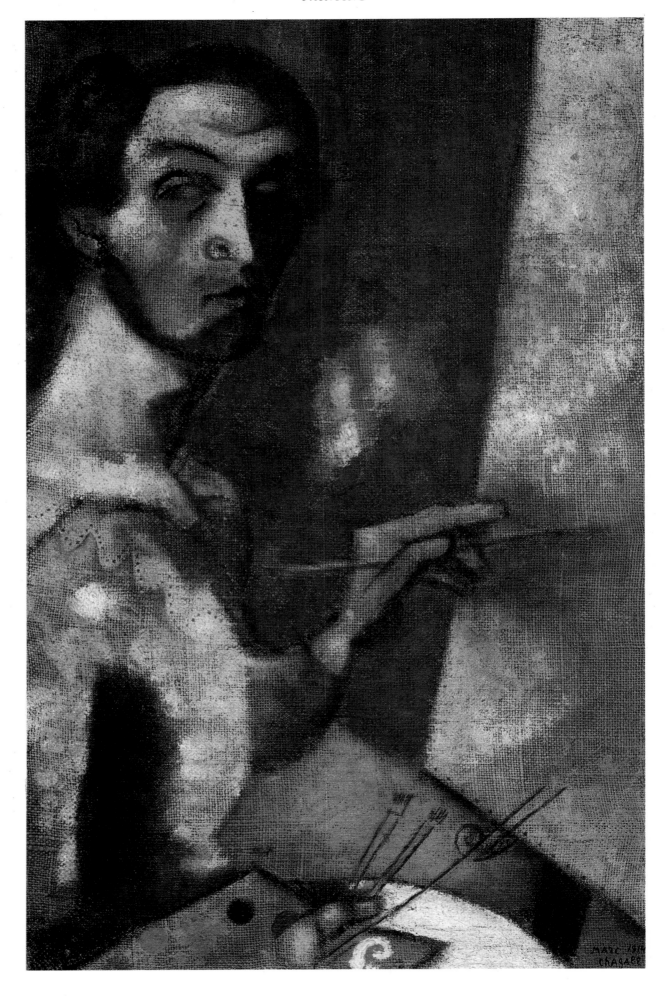

Self-portrait at the Easel. 1914

CAT. NO. 7

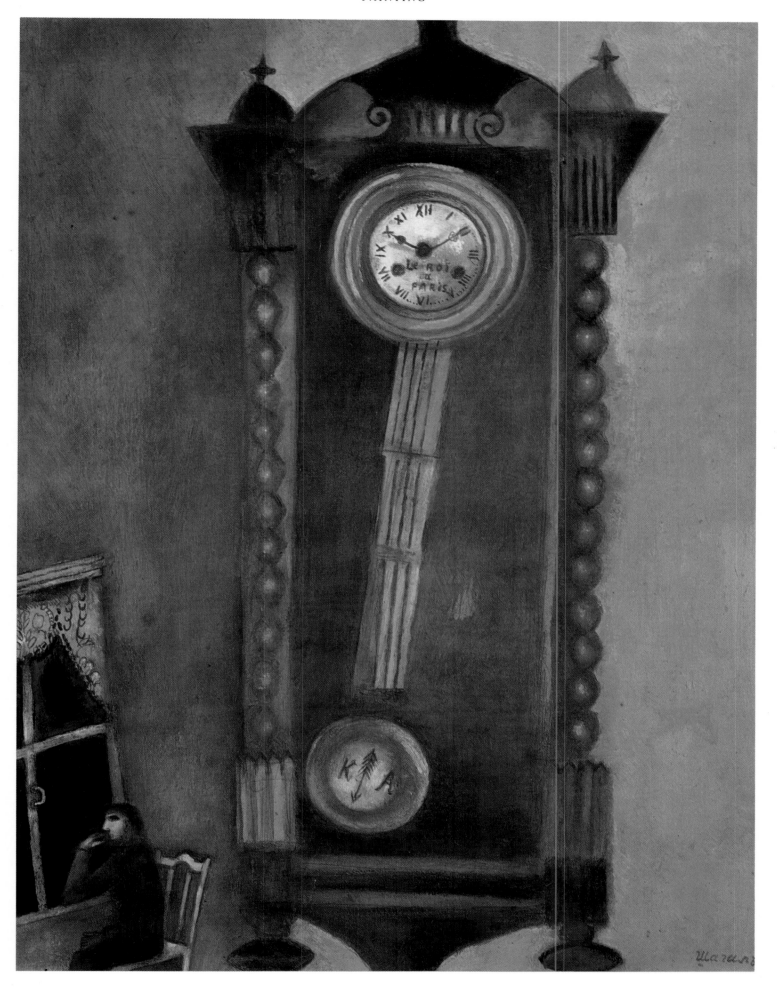

Clock. 1914

CAT. NO. 8

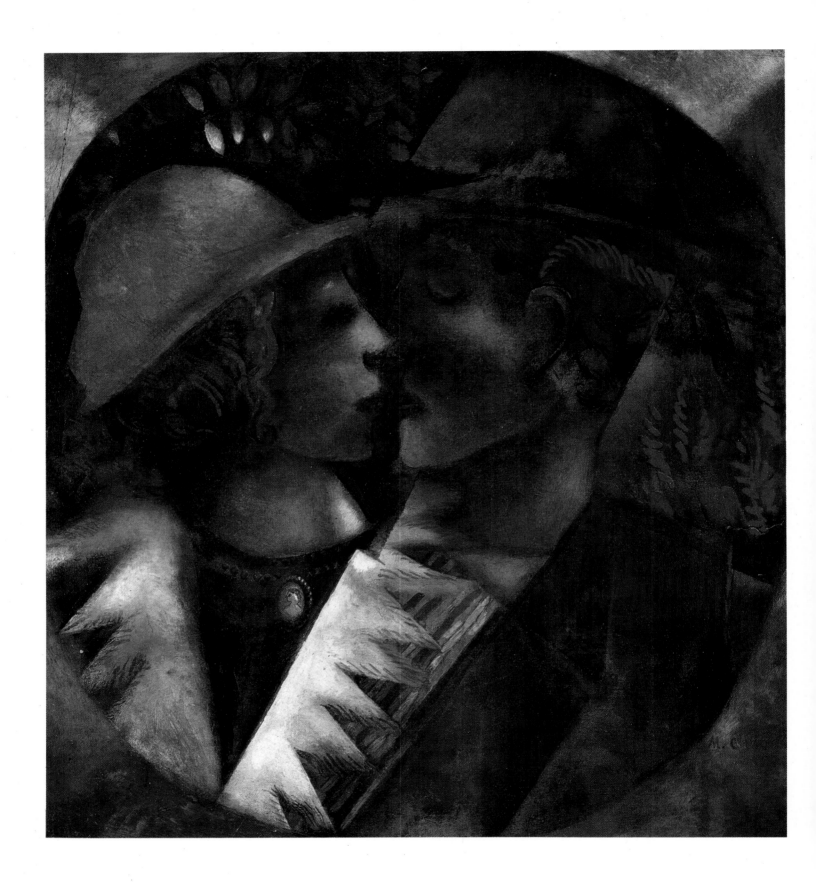

Lovers in Green
CAT. NO. 9

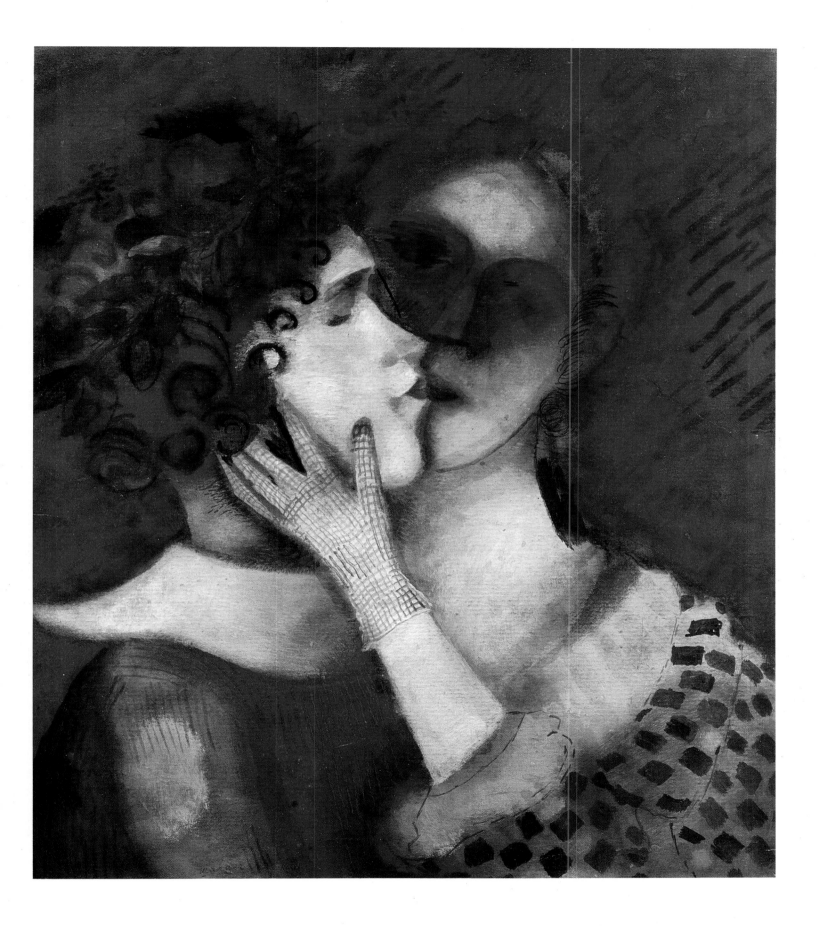

Lovers in Blue. 1914

CAT. NO. 10

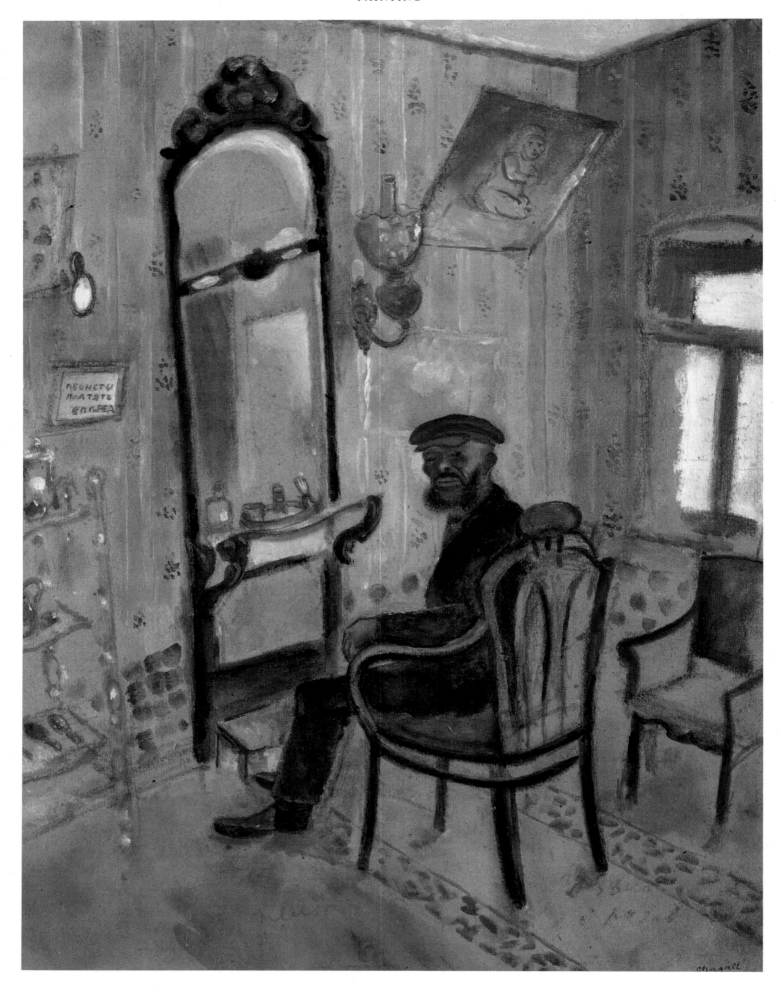

Uncle Zussy (The Barbershop). 1914
CAT. NO. 11

Little Parlour. 1908

CAT. NO. 2

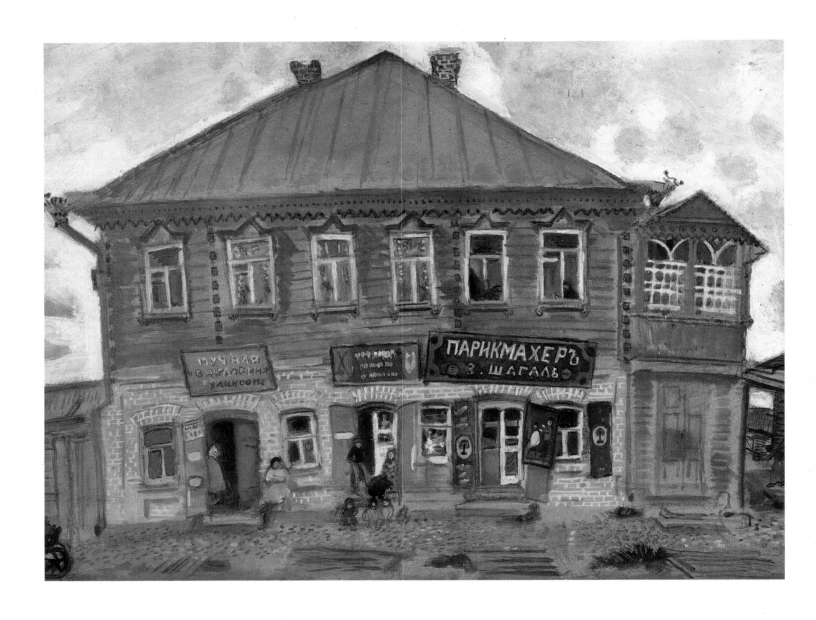

Uncle's Store in Lyozno

CAT. NO. 13

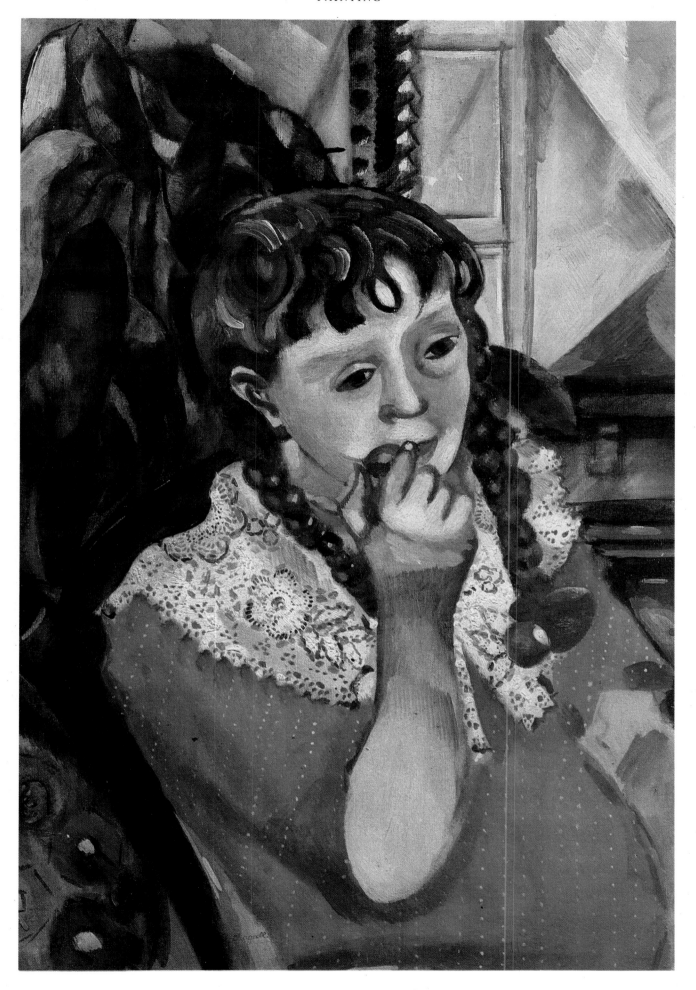

Mariaska. 1914

CAT. NO. 16

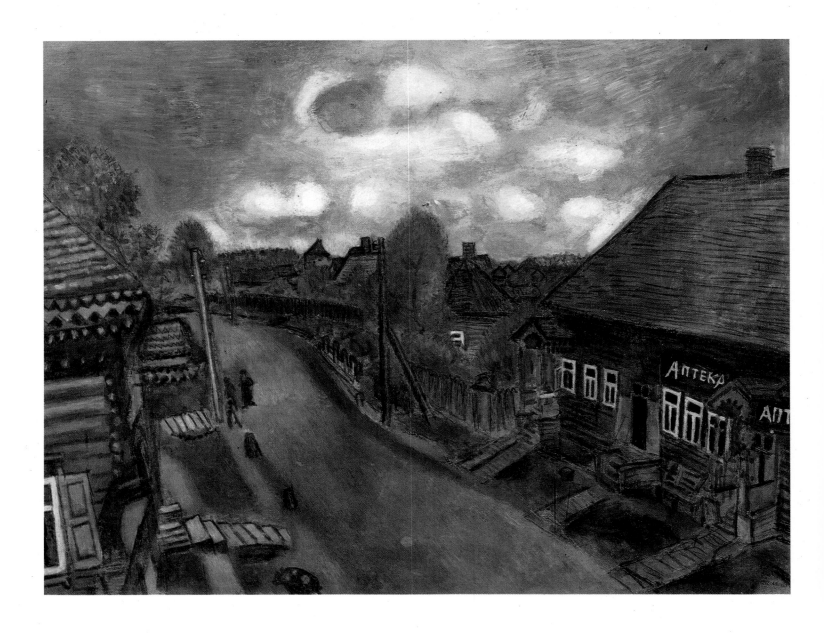

Vitebsk Chemist's
CAT. NO. 14

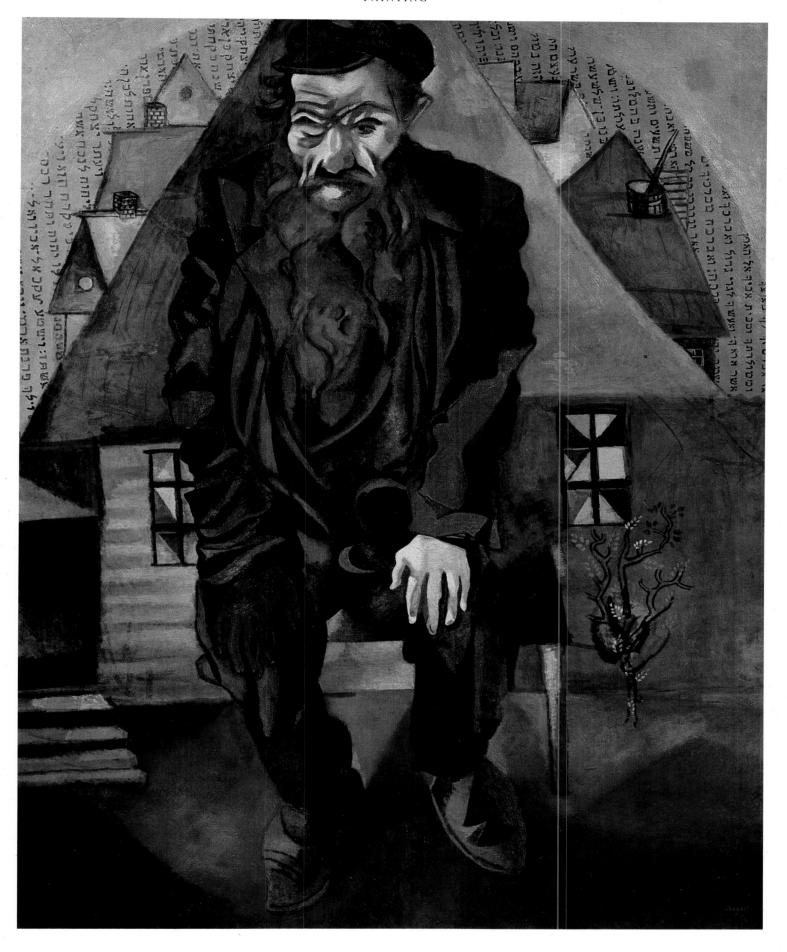

Jew in Bright Red. 1915
CAT. NO. 17

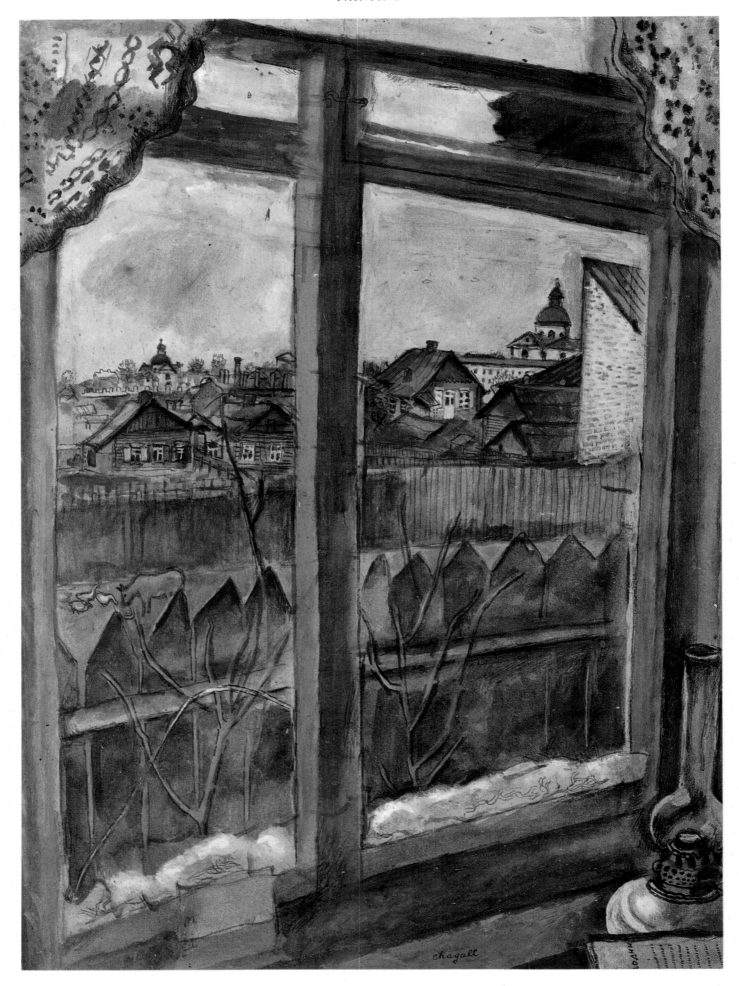

View from Window. Vitebsk

CAT. NO. 18

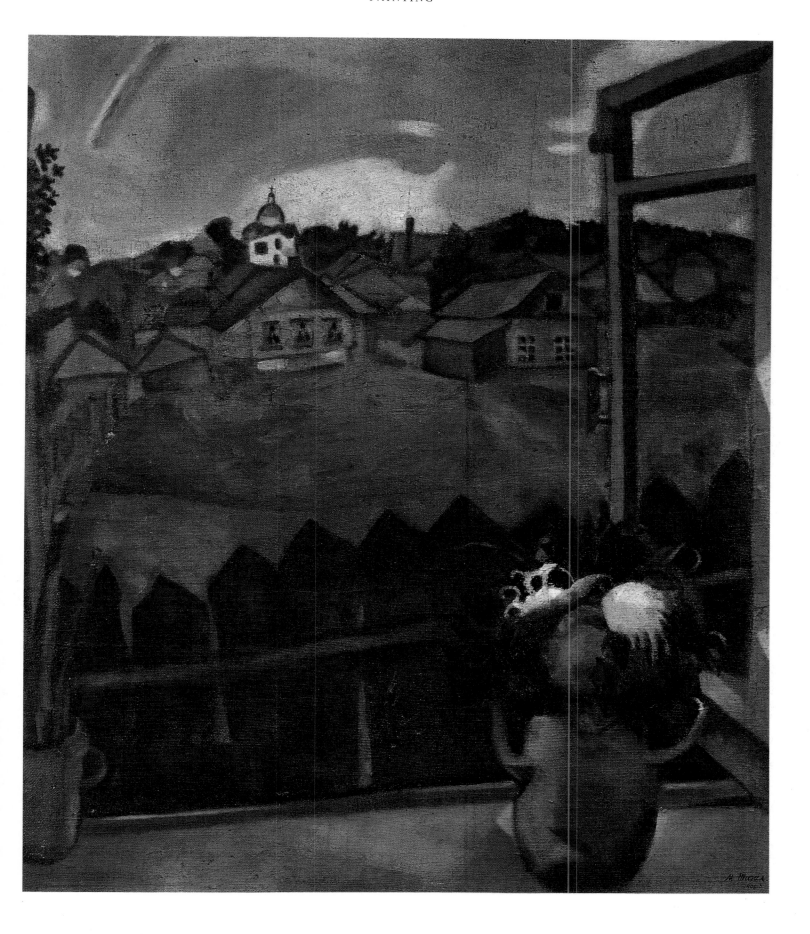

The Window. Vitebsk. 1908

CAT. NO. 3

65

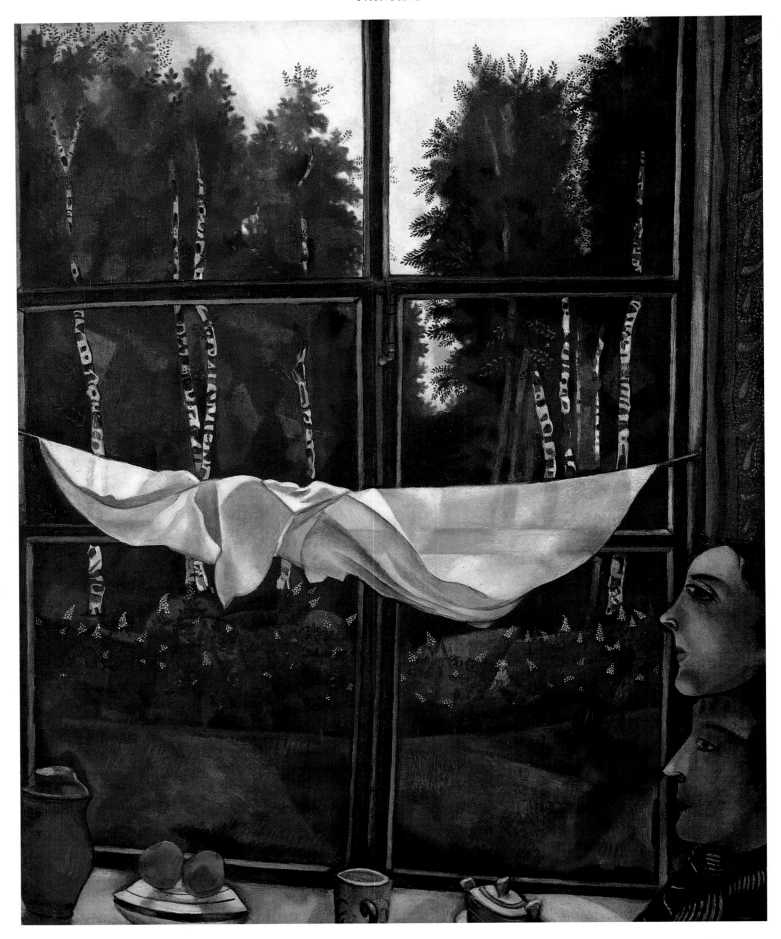

Window in the Country. 1915
CAT. NO. 19

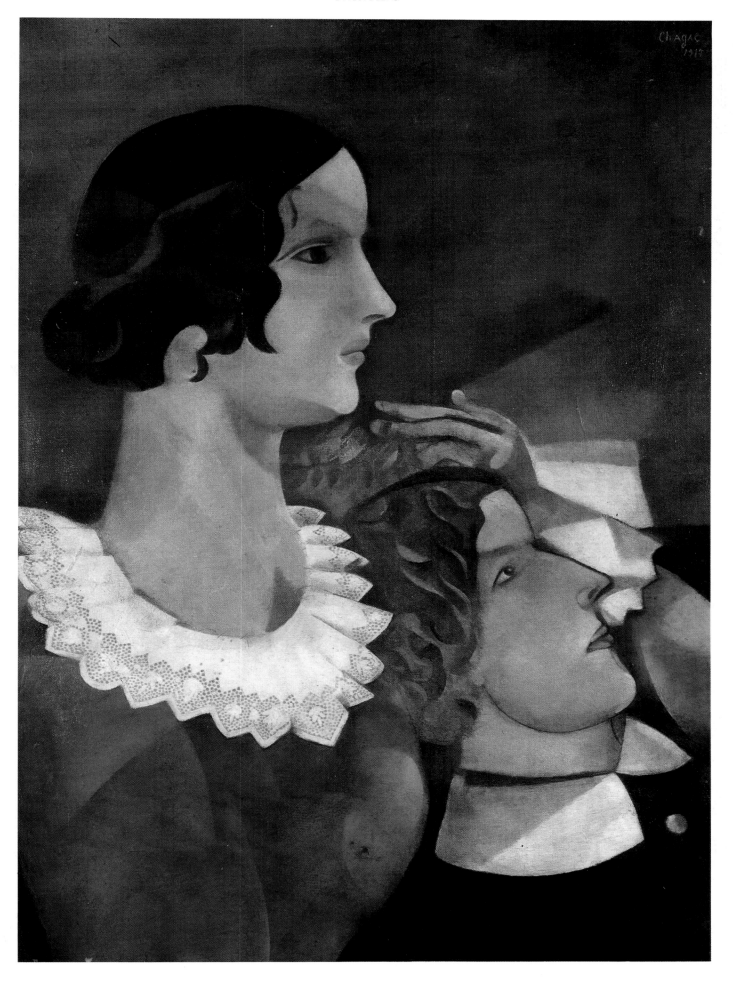

Lovers in Grey. 1917
CAT. NO. 27

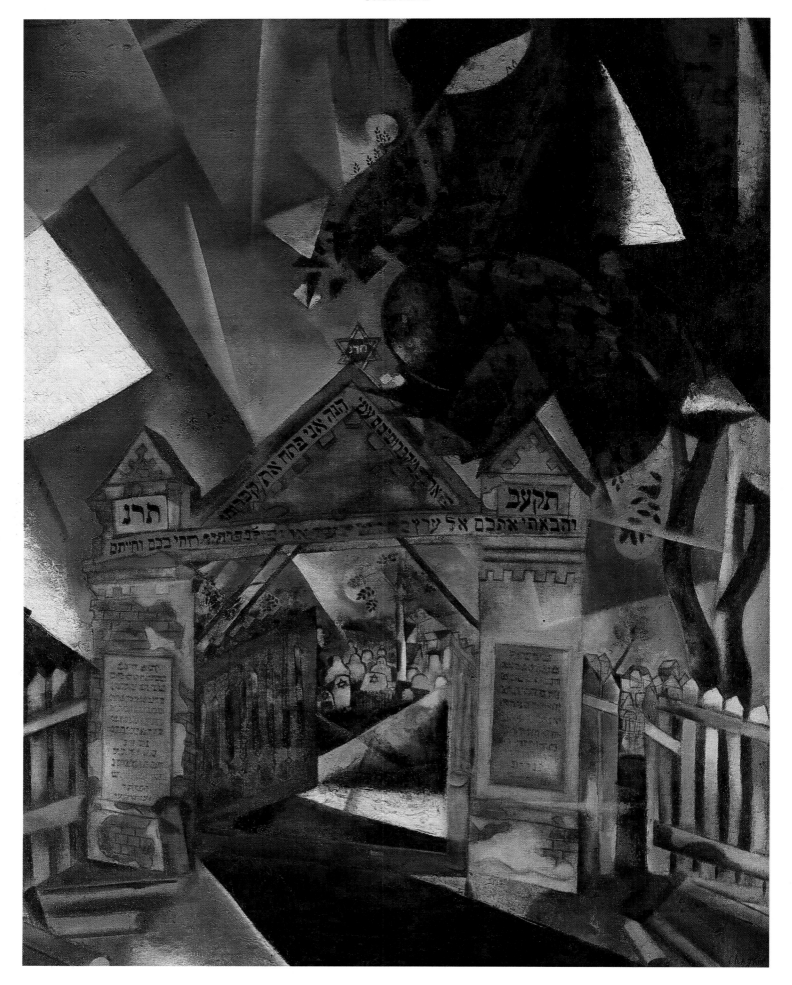

Cemetery Gates. 1917
CAT. NO. 26

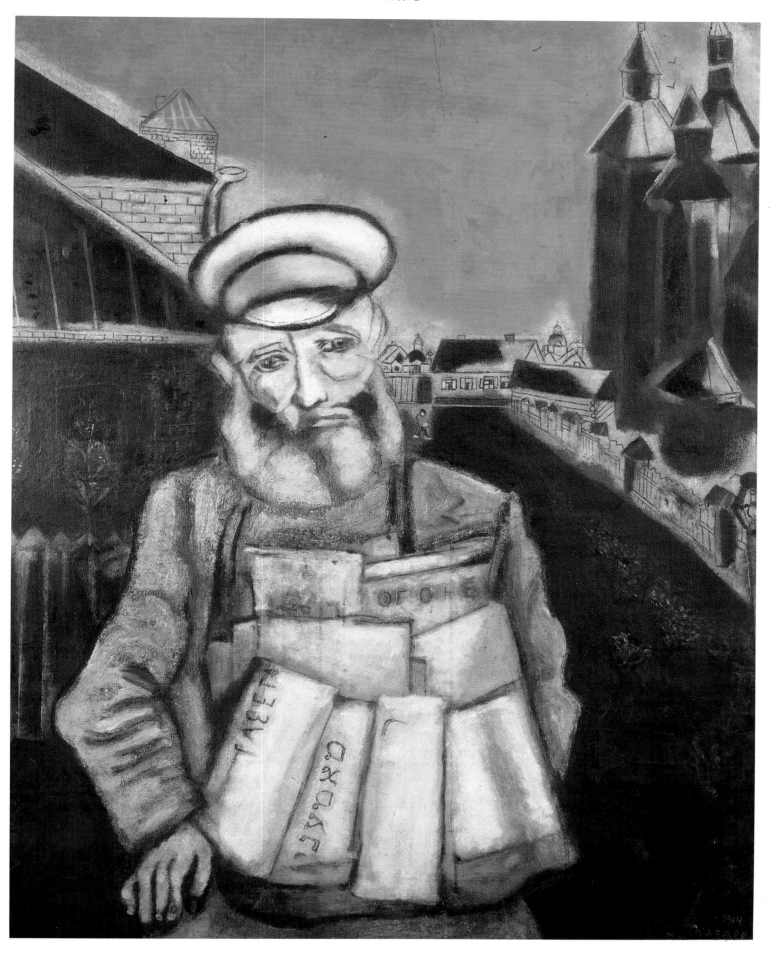

Newspaper Vendor. 1914

CAT. NO. 6

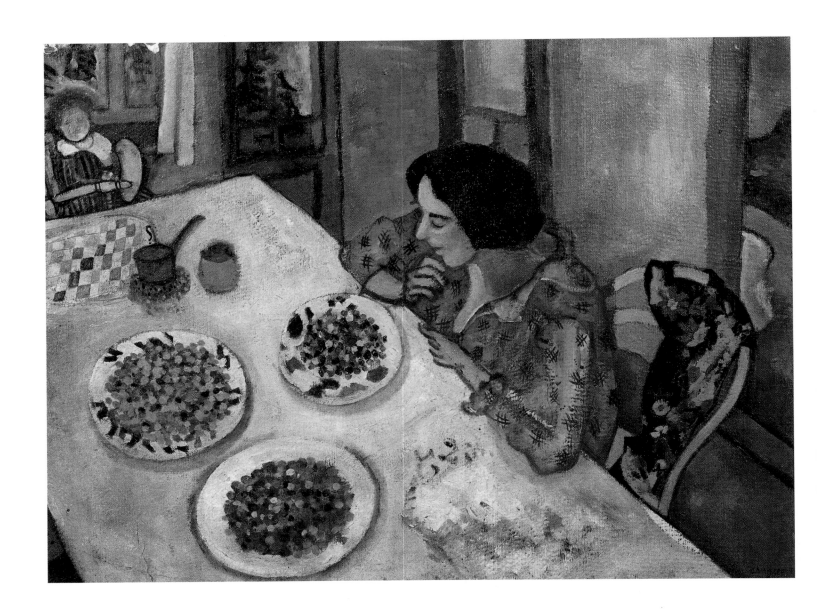

Strawberries. 1916

CAT. NO. 22

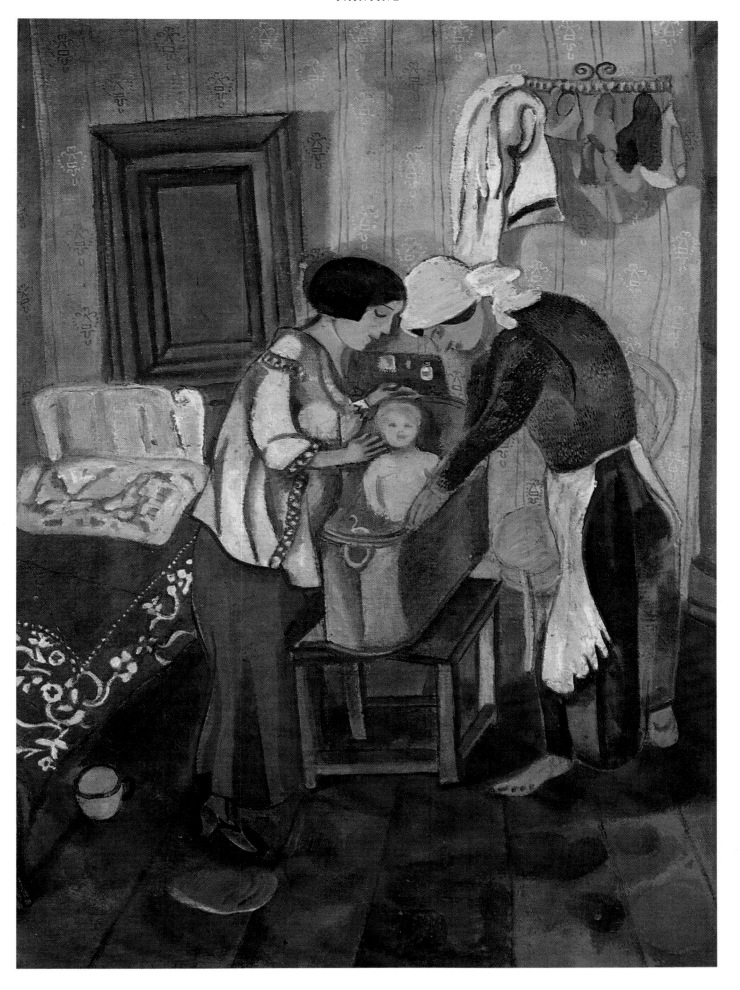

Baby's Bath
CAT. NO. 23

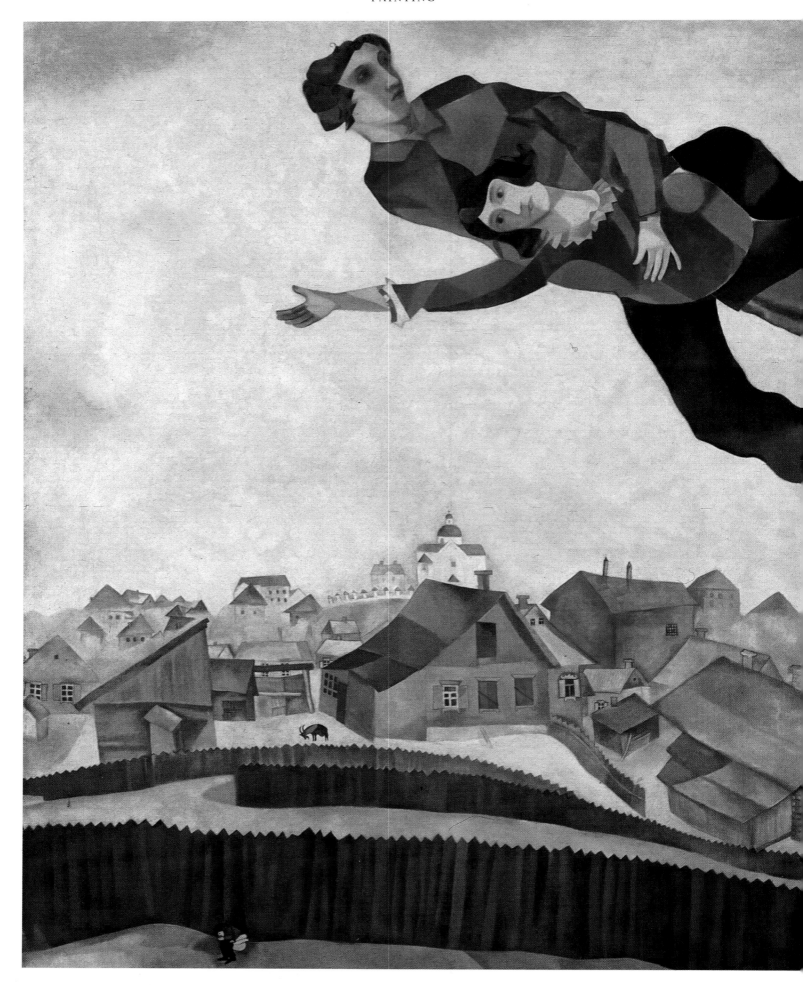

Over the Town. 1914—18
CAT. NO. 24

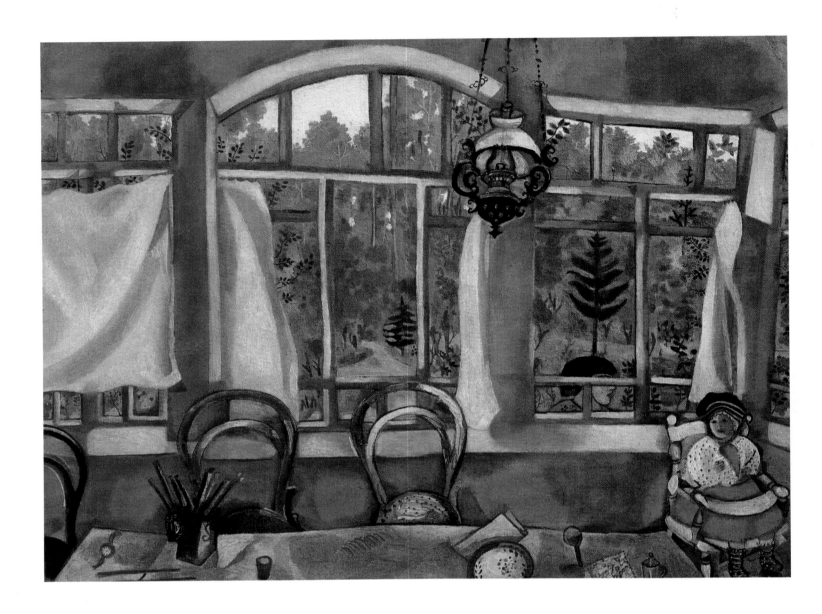

View on the Garden. C. 1917

CAT. NO. 25

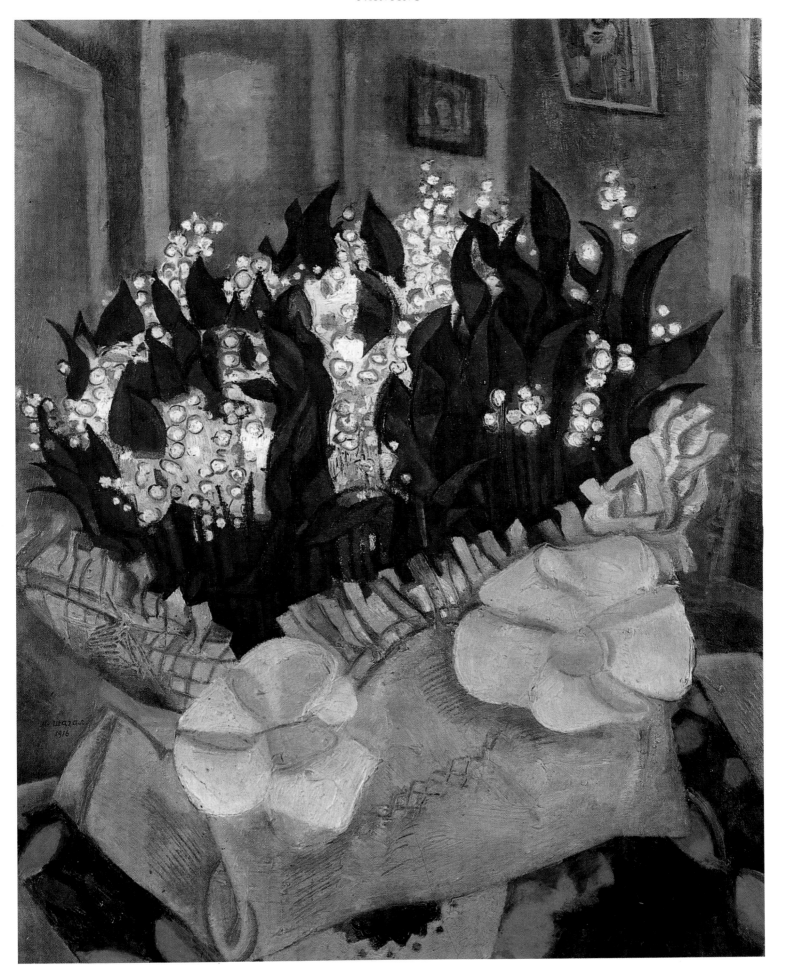

Lilies of the Valley. 1916
CAT. NO. 21

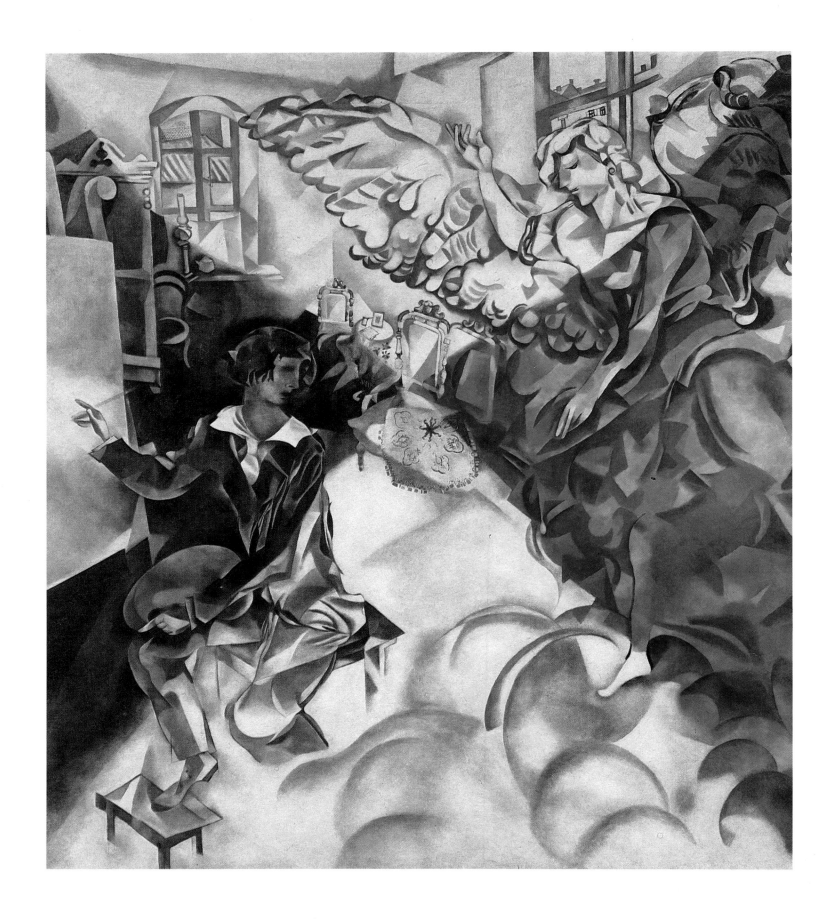

The Apparition. 1917—18

CAT. NO. 29

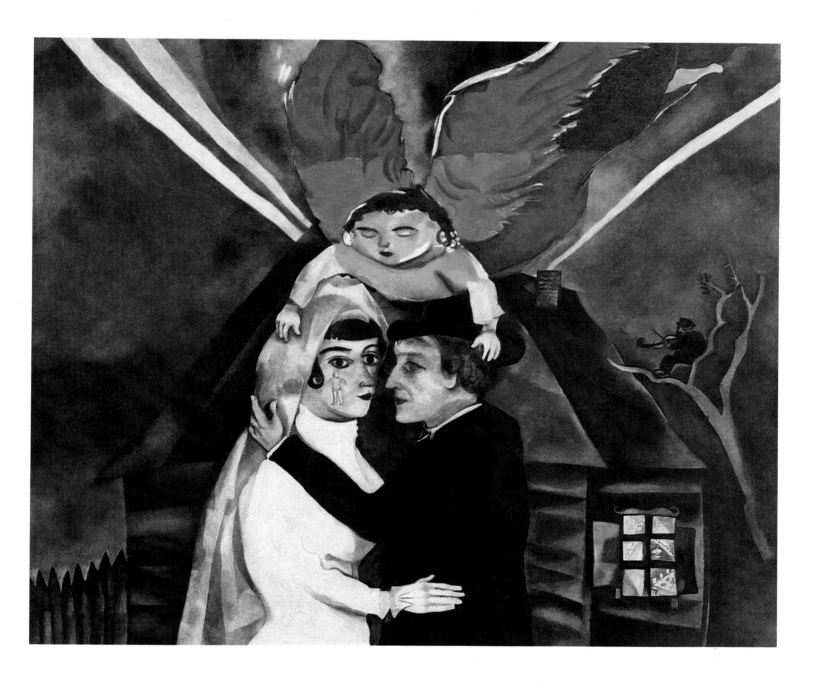

The Wedding. 1918
CAT. NO. 30

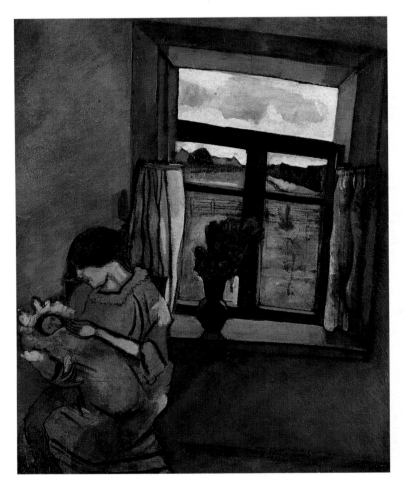

Bella and Ida at the Window. 1916
CAT. NO. 20

Behind the House. 1918
CAT. NO. 31

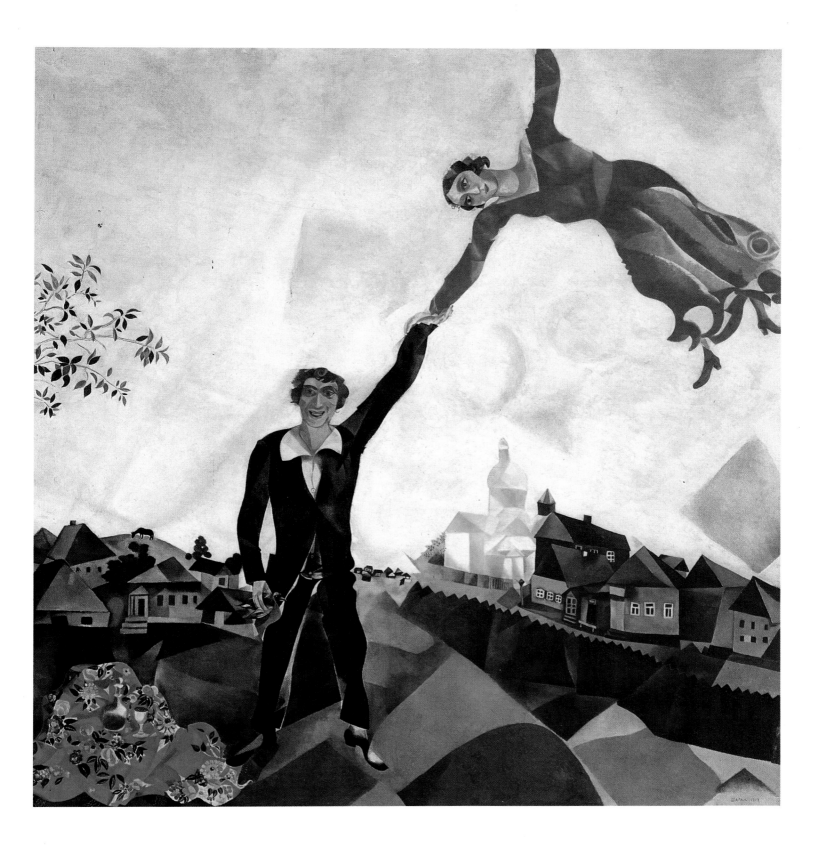

The Promenade (The Walk). 1917—18

CAT. NO. 28

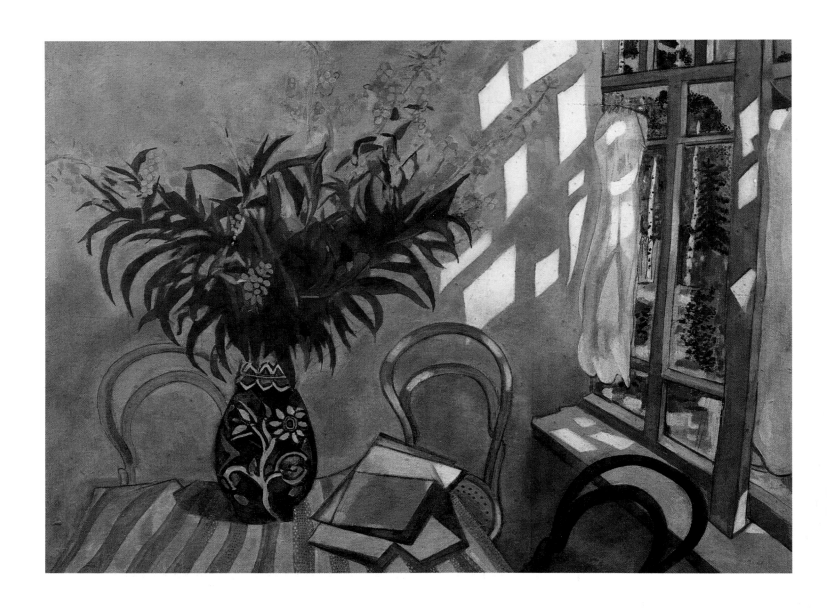

Interior with Flowers. C. 1918

CAT. NO. 32

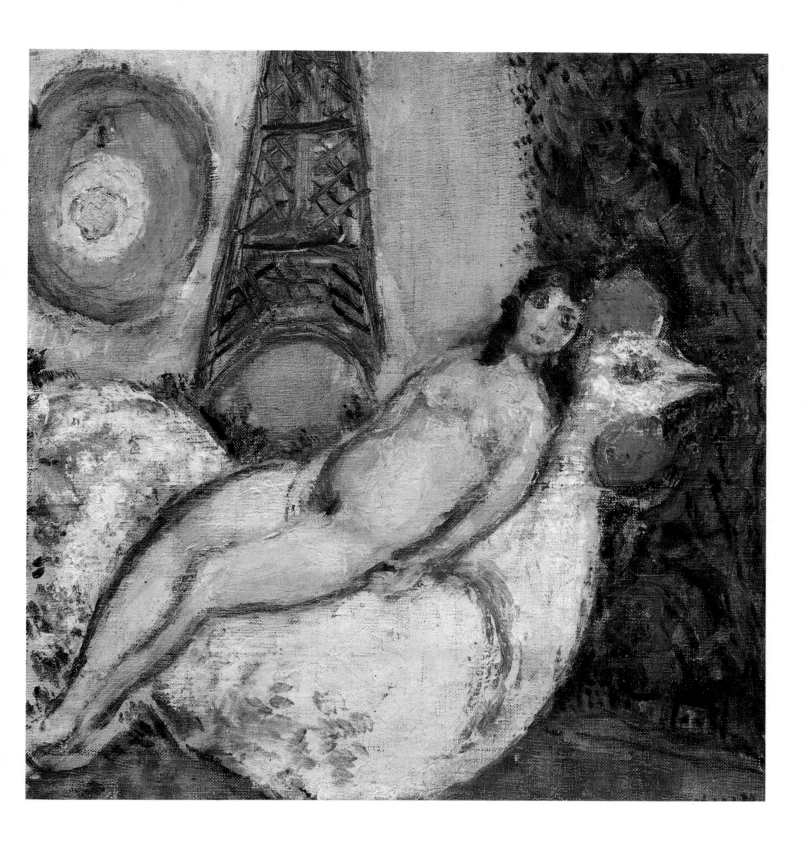

On the Rooster. 1925. Study

CAT. NO. 34

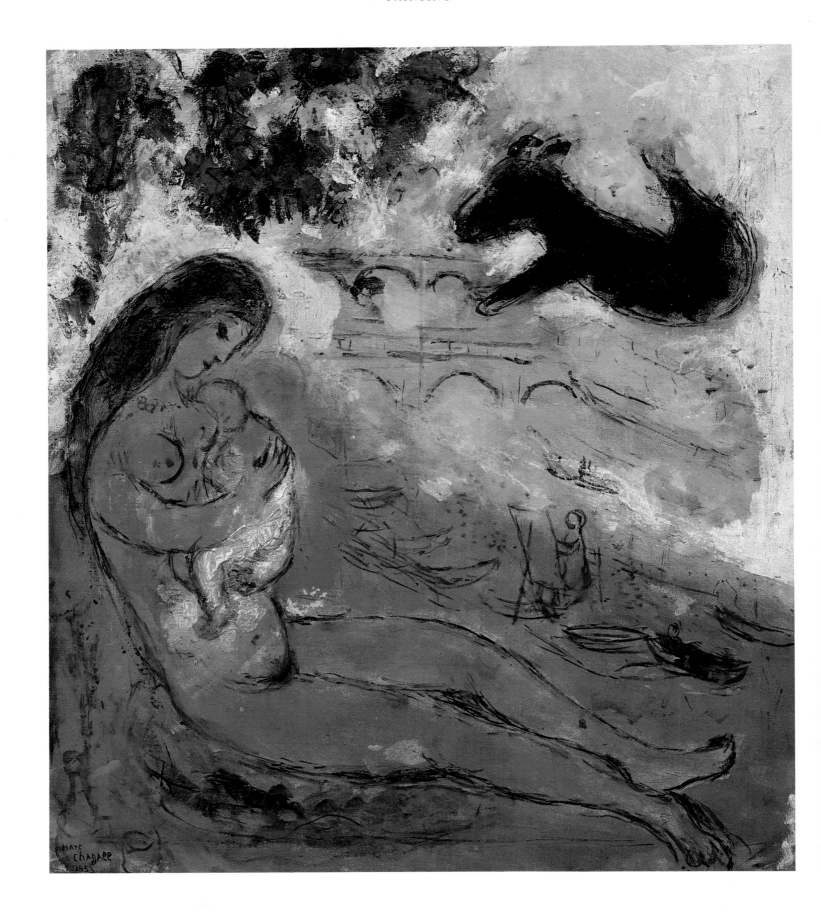

The Banks of the Seine. 1953

CAT. NO. 44

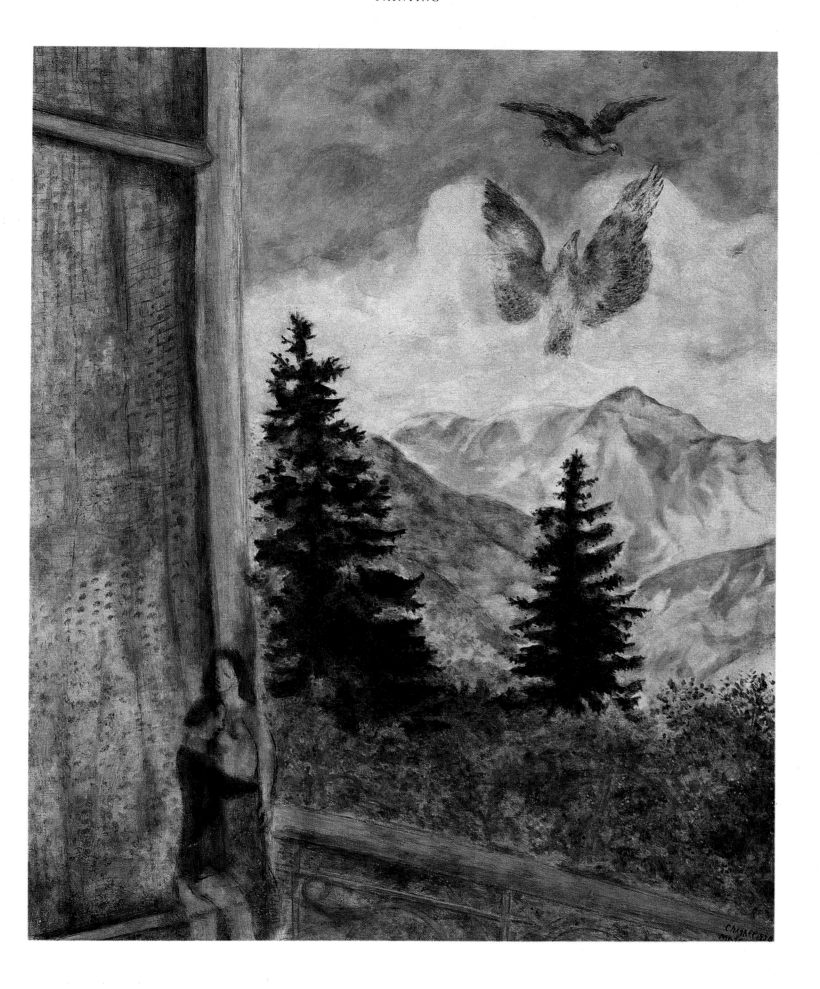

Peyra-Cava Landscape with Eagle. 1930

CAT. NO. 37

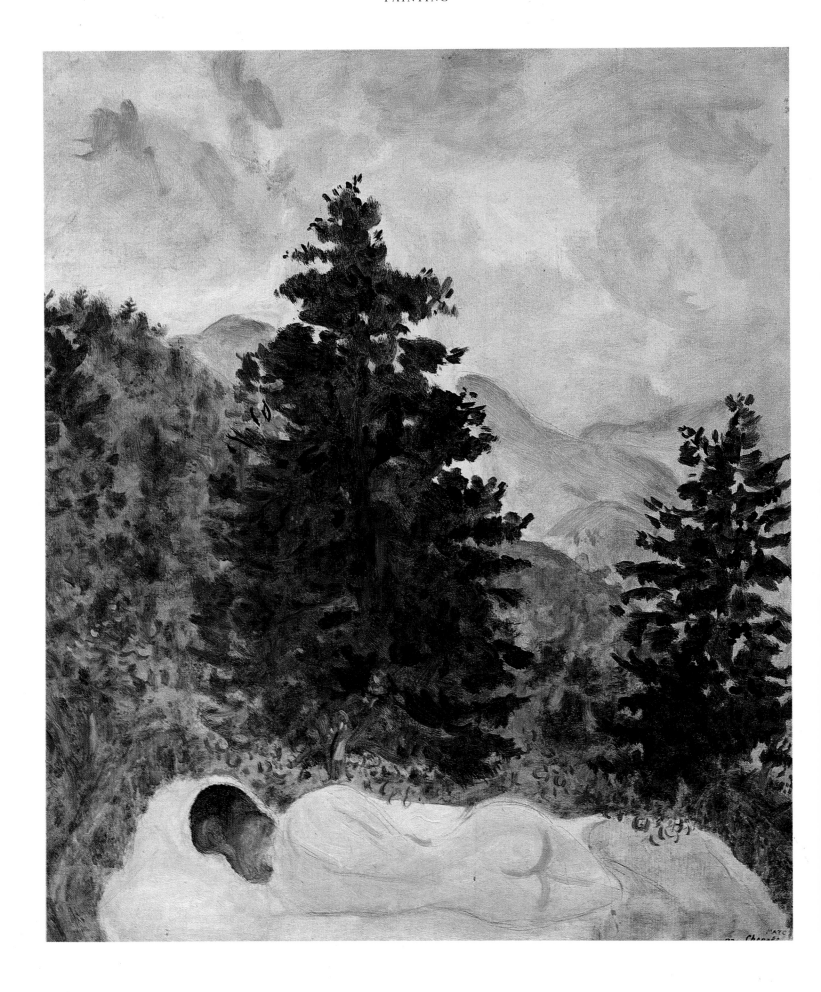

Nude in Peyra-Cava Landscape. 1931

CAT. NO. 38

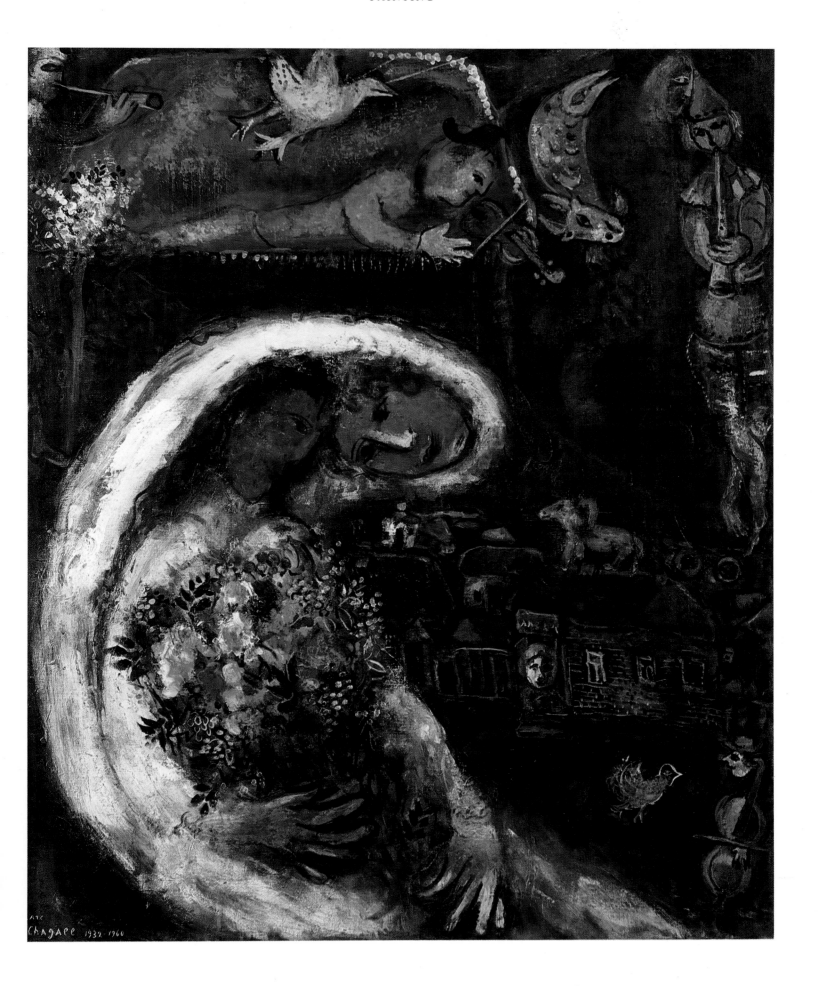

Bride with Blue Face. 1932—60

CAT. NO. 39

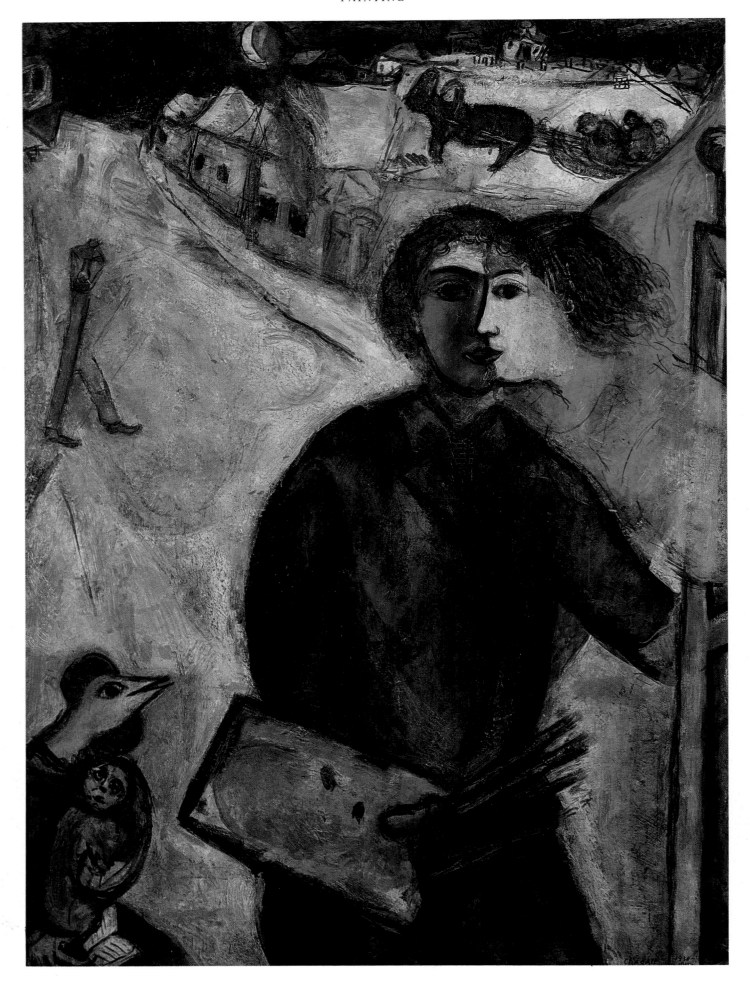

At Dusk (Entre chien et loup). 1938—42

CAT. NO. 40

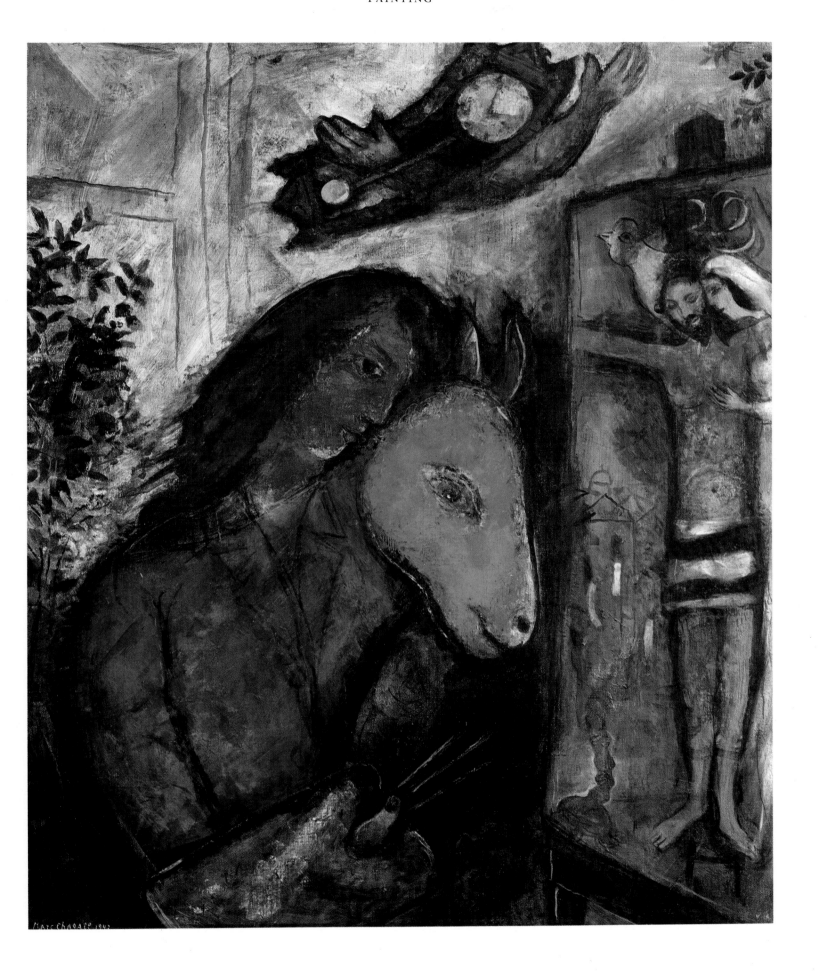

Self-portrait with Wall Clock. 1947
CAT. NO. 41

87

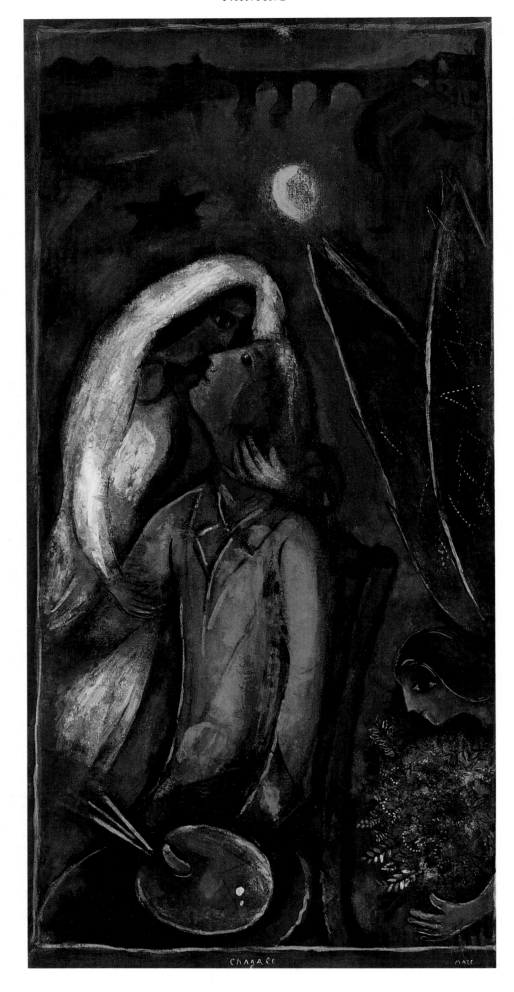

The Lovers with Bridge. 1948
CAT. NO. 42

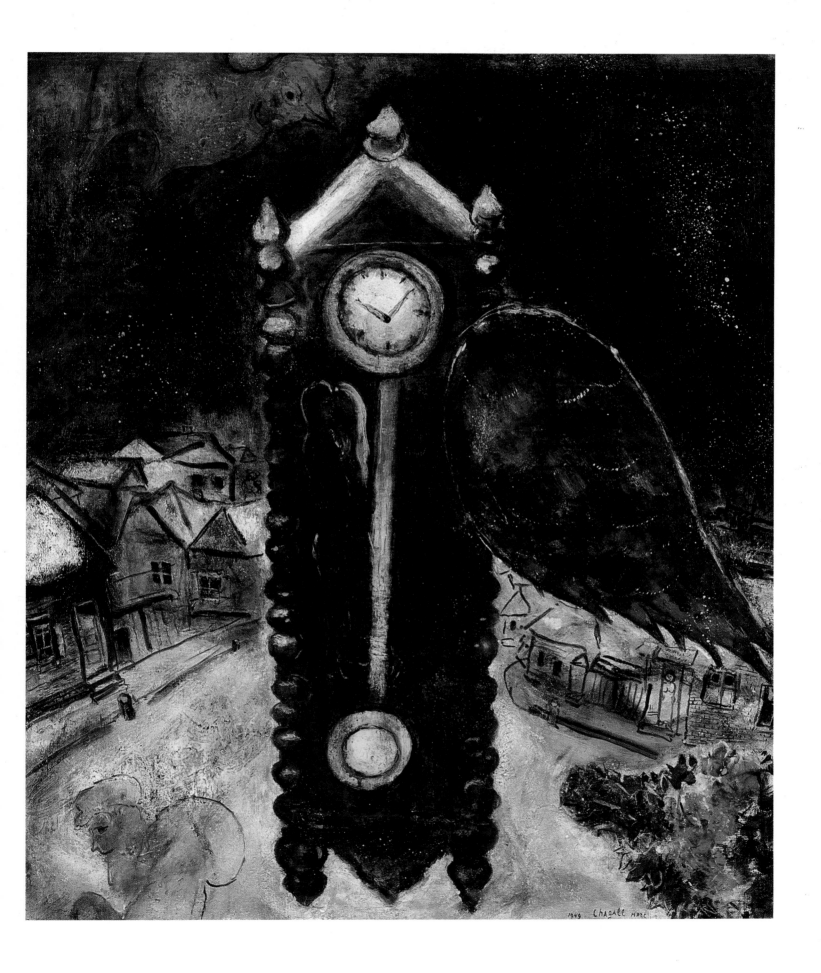

Wall Clock with Blue Wing. 1949

CAT. NO. 43

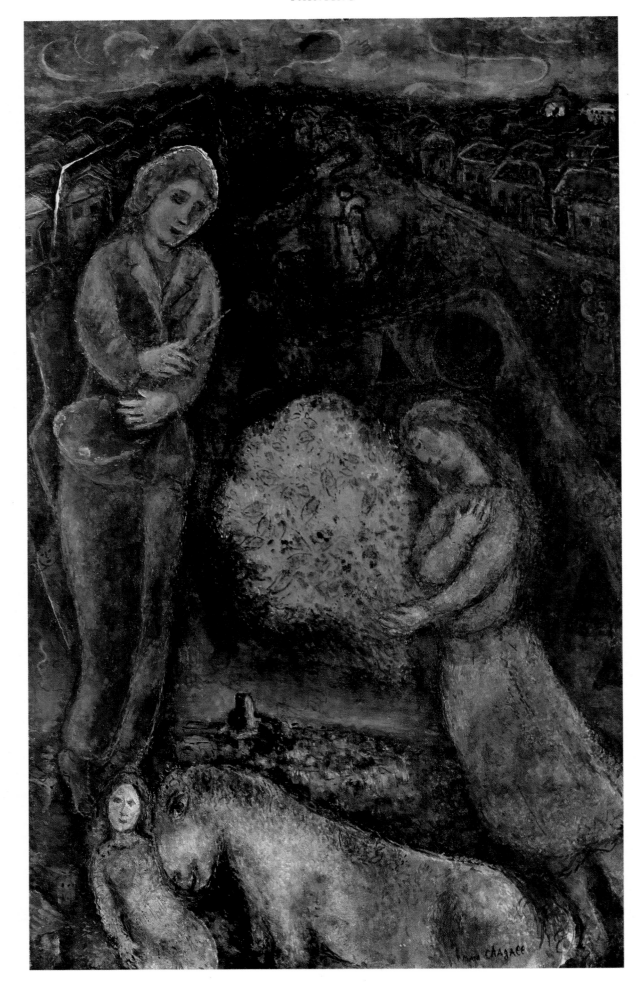

Half-moon over Vence. 1977

CAT. NO. 72

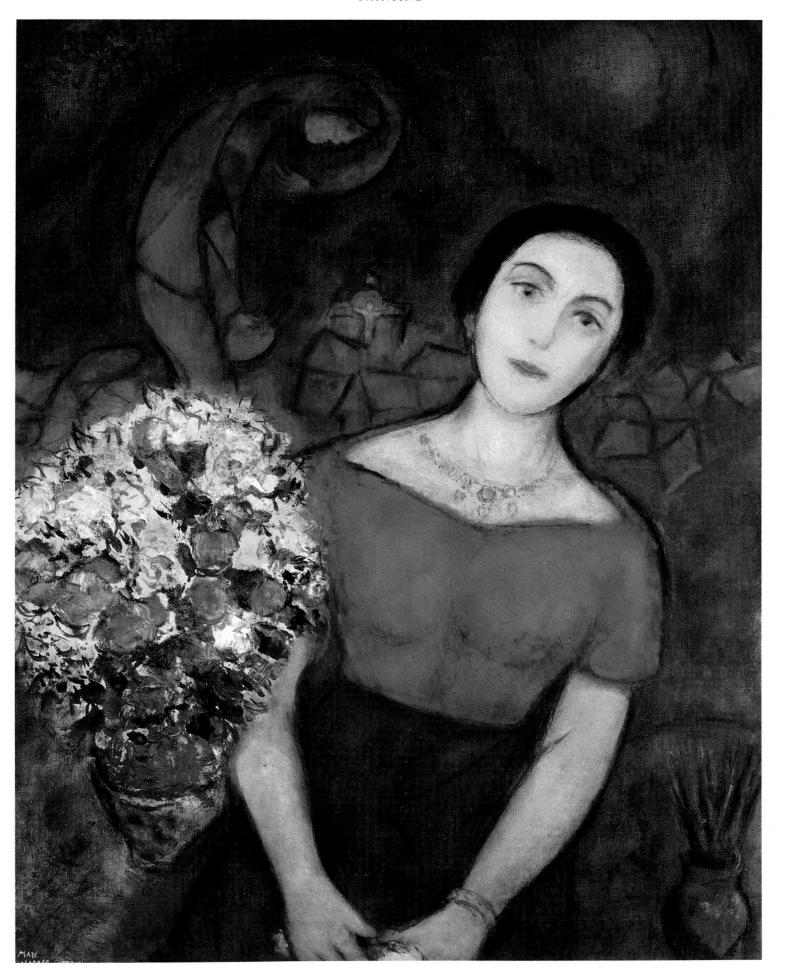

Portrait of Vava. 1953—56

CAT. NO. 45

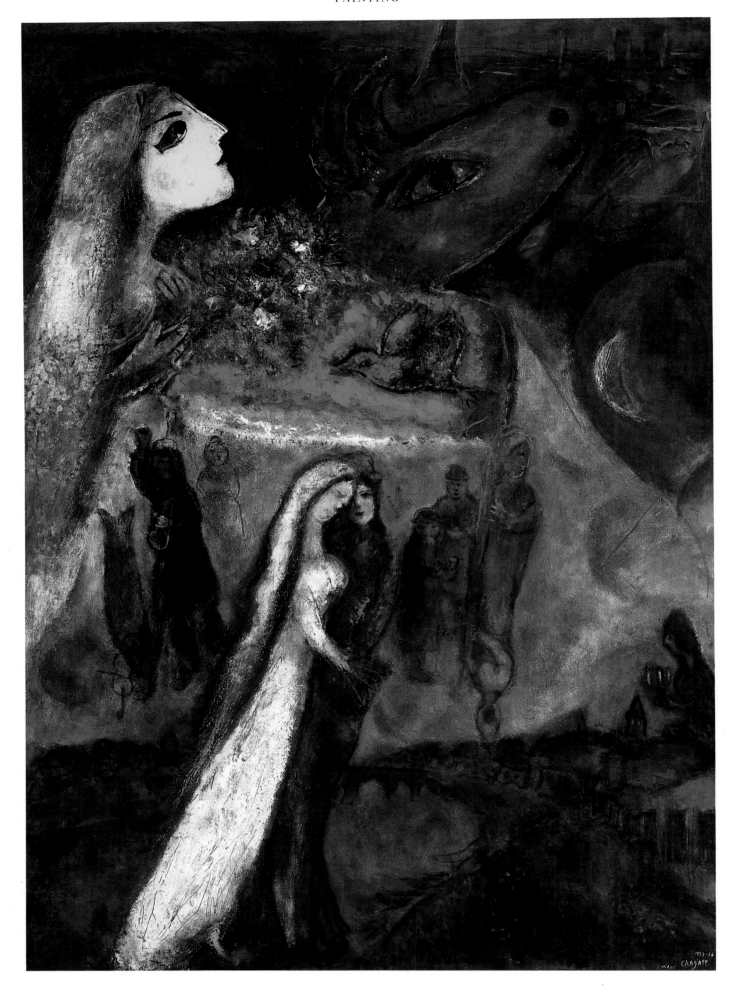

The Two Shores. 1953—56

CAT. NO. 46

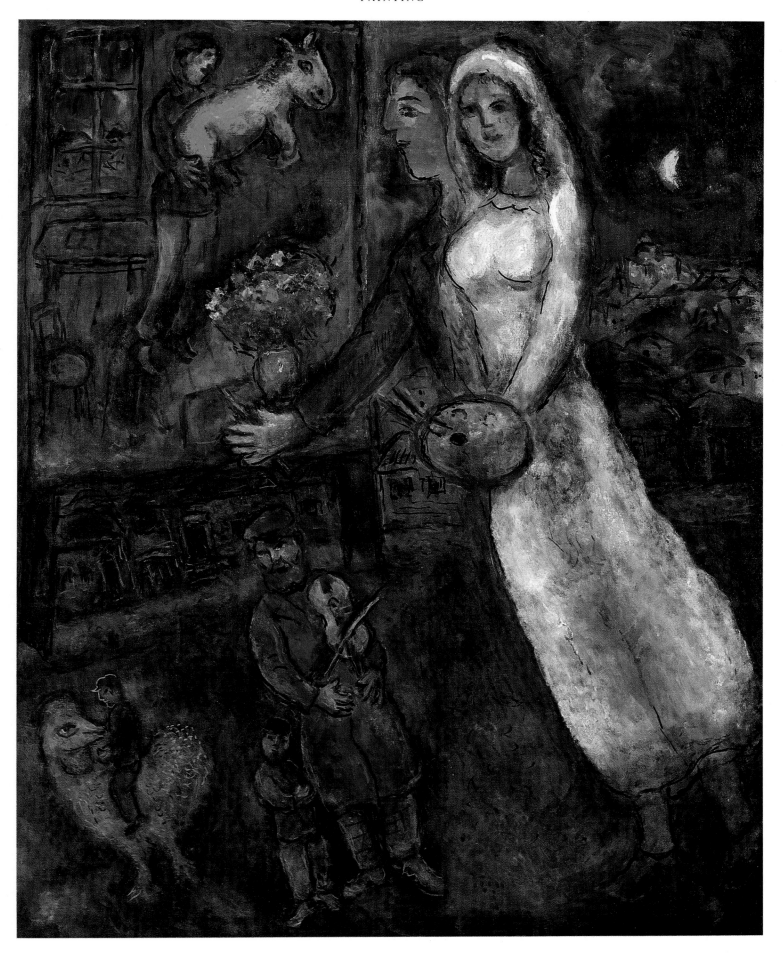

Couple with Fiddler. 1956

CAT. NO. 47

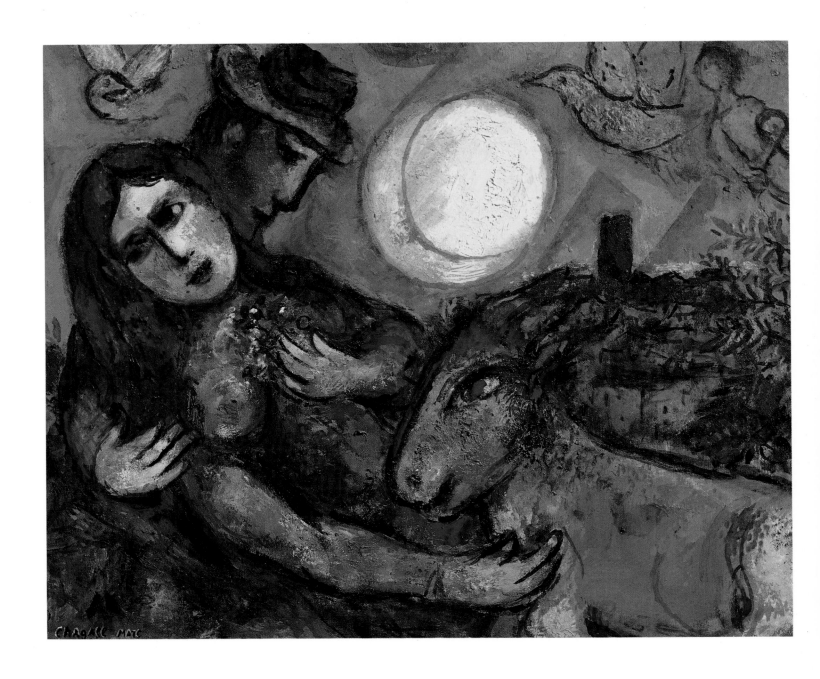

The Midday Sun. 1958

CAT. NO. 48

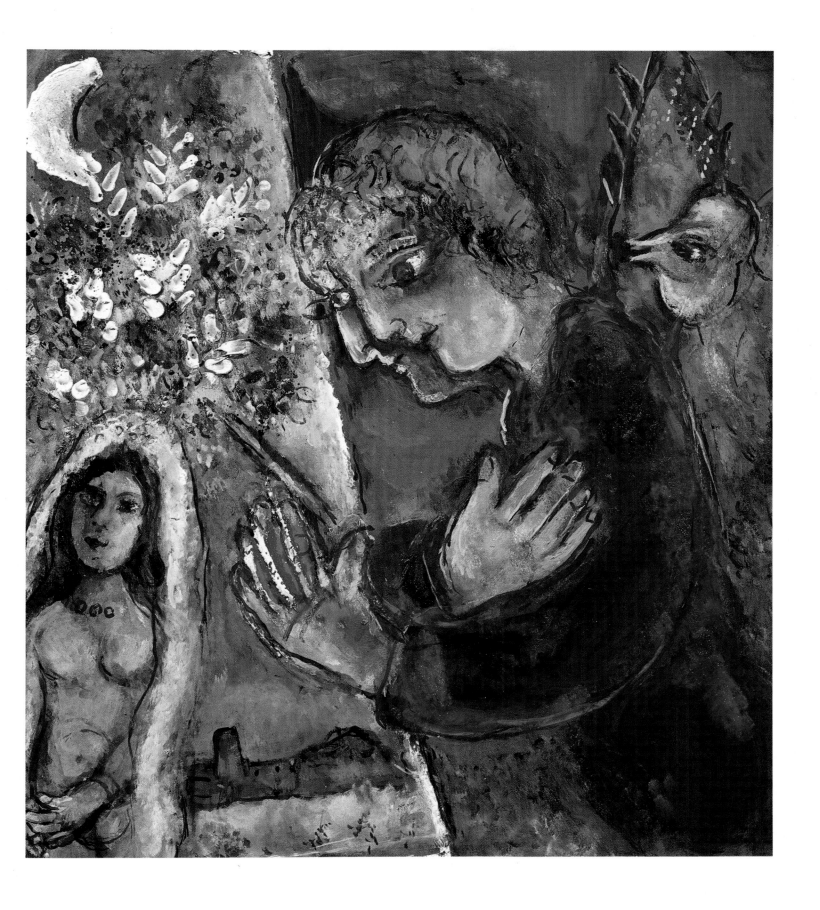

The Painter at the Easel. 1959—68

CAT. NO. 49

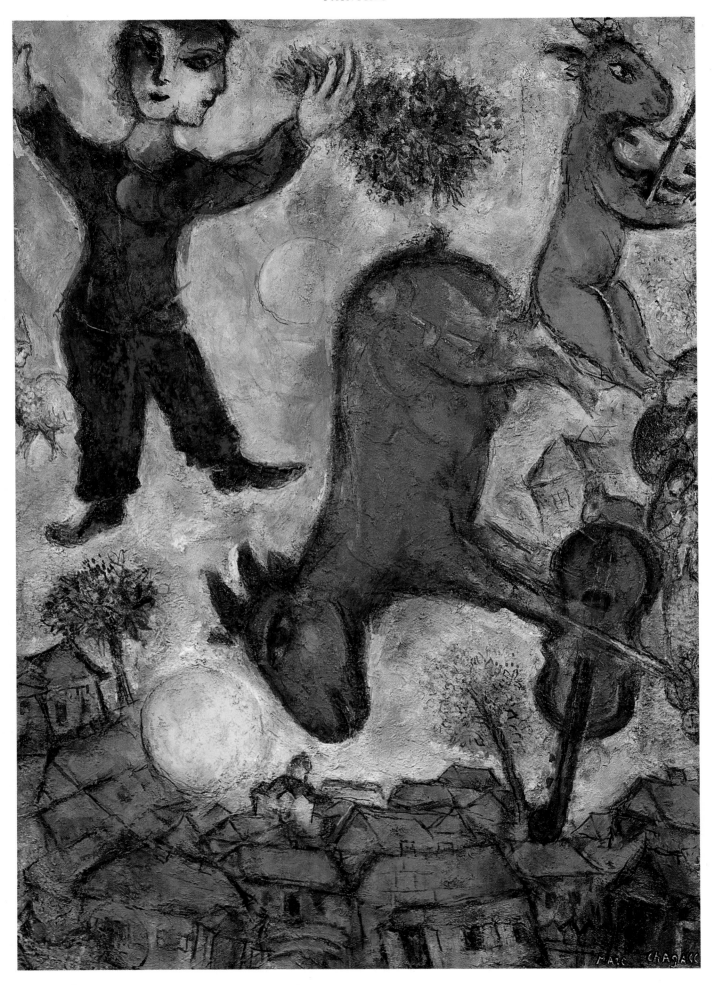

The Flying Cows. 1966
CAT. NO. 50

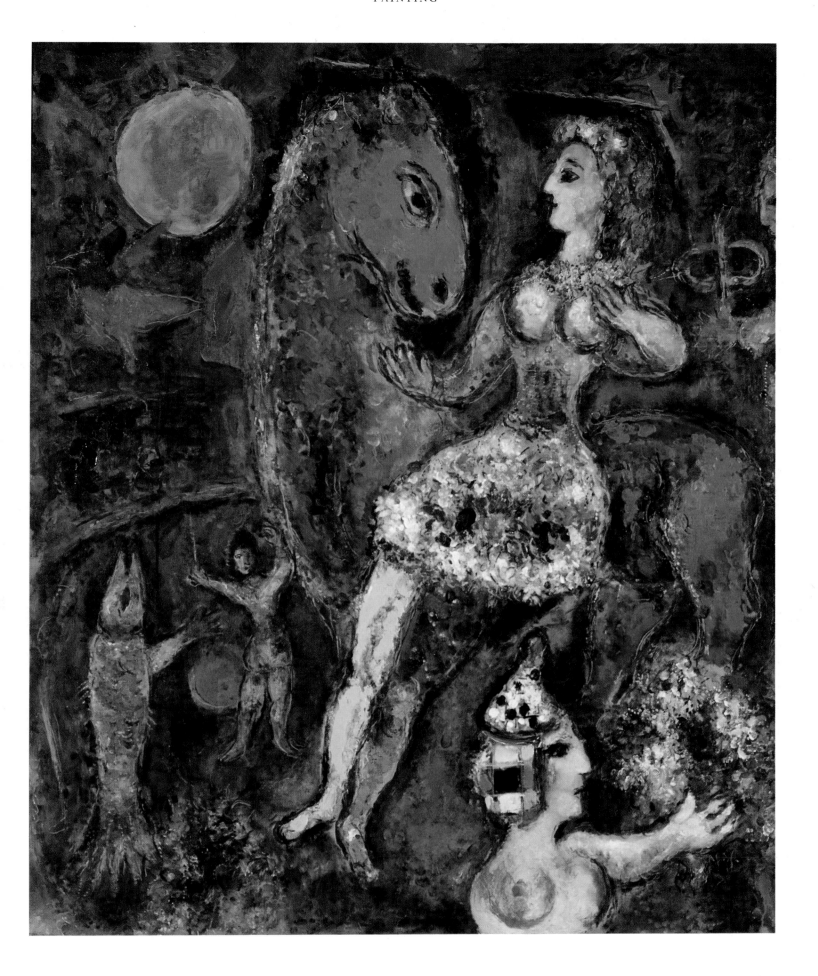

Equestrienne on Red Horse. 1966
CAT. NO. 51

97

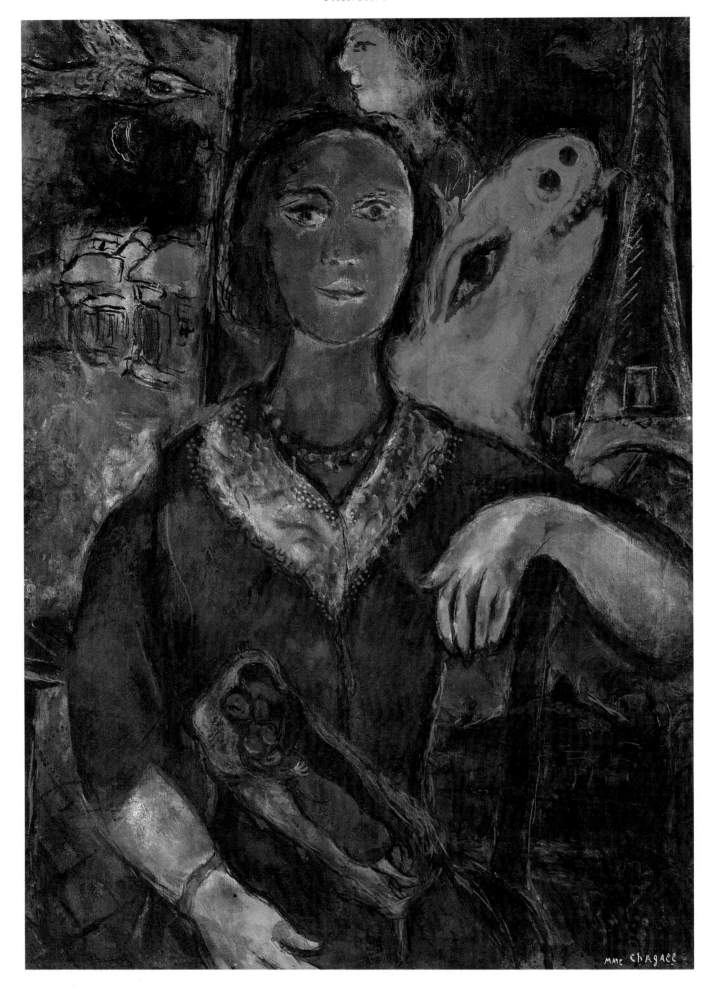

Portrait of Vava. 1966
CAT. NO. 52

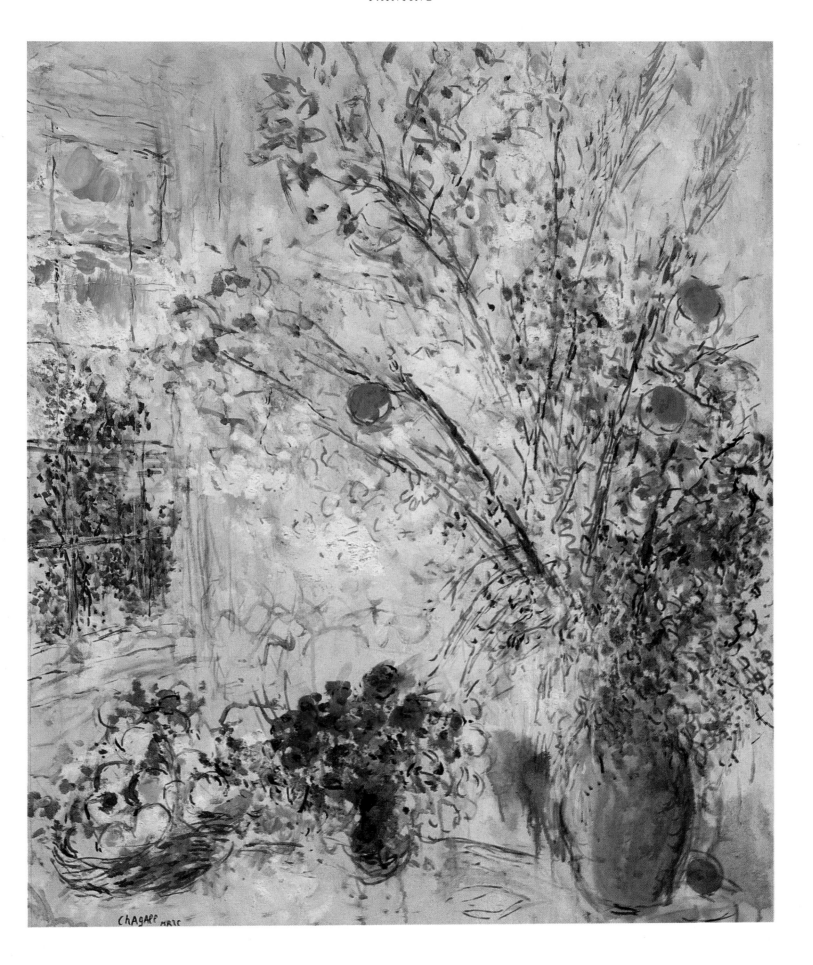

Flowers (La Monnaie du pape). 1967—68

CAT. NO. 53

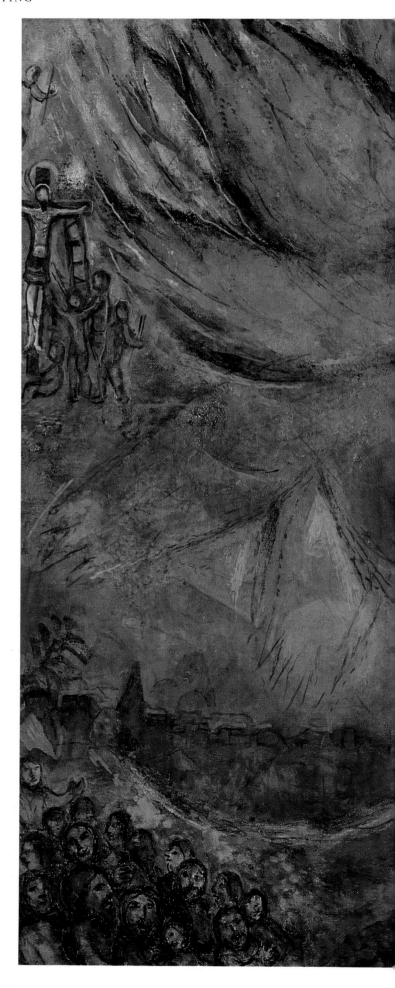

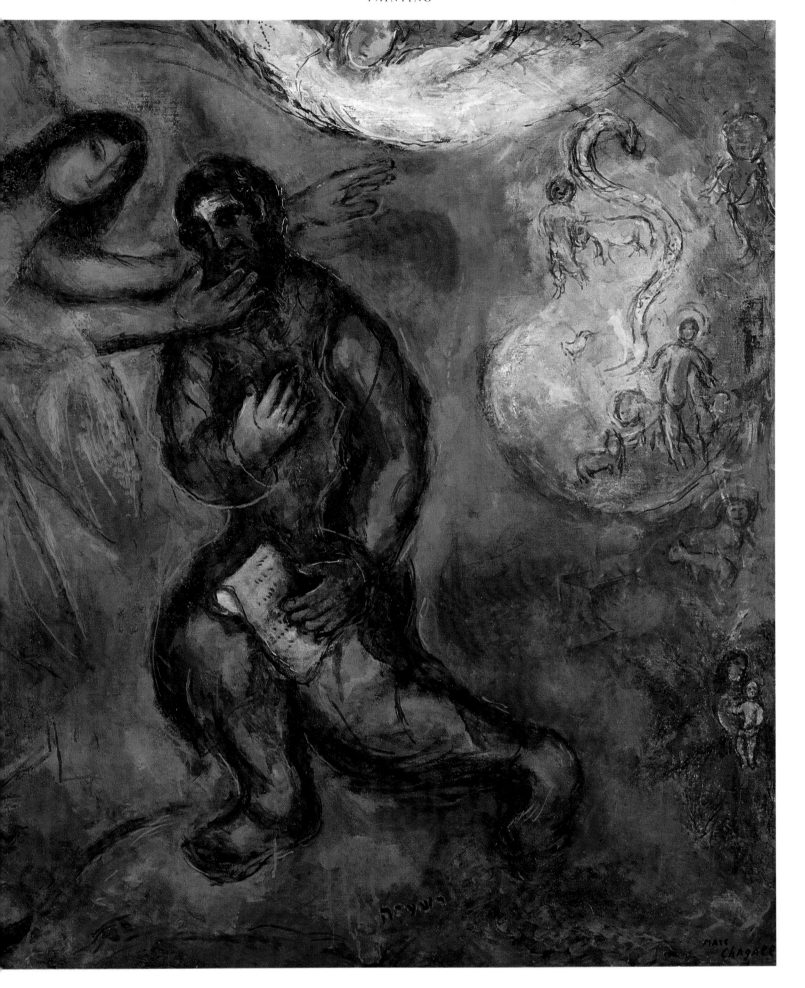

The Prophet Isaiah. 1968
CAT. NO. 56

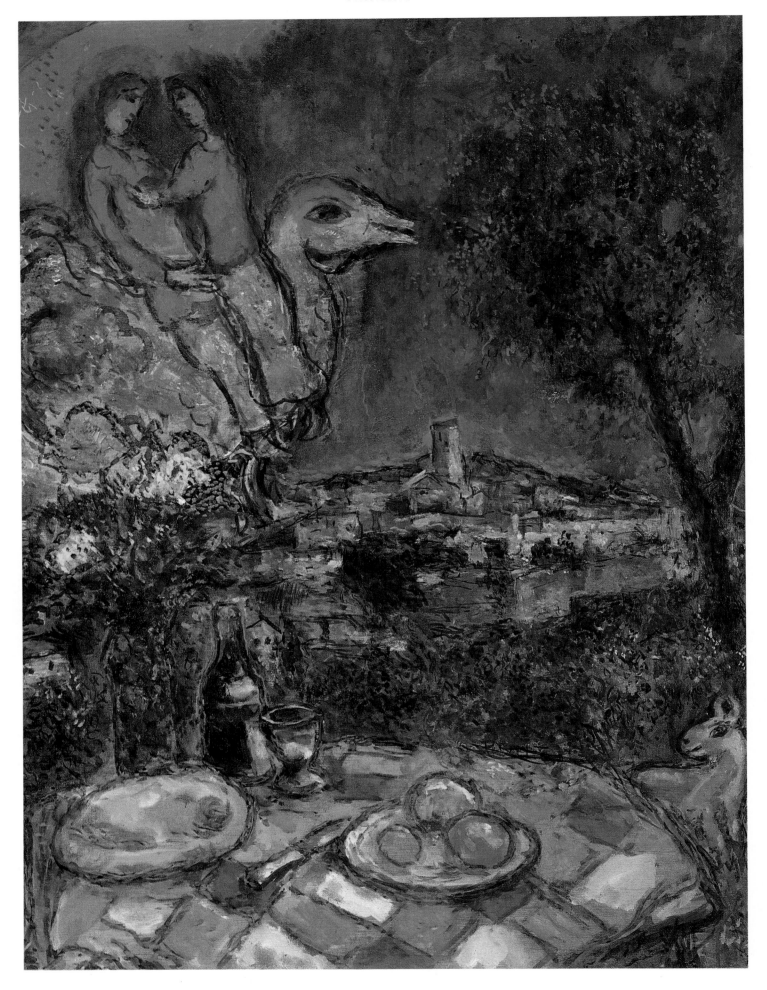

The Table in Front of Saint-Paul. 1968

CAT. NO. 54

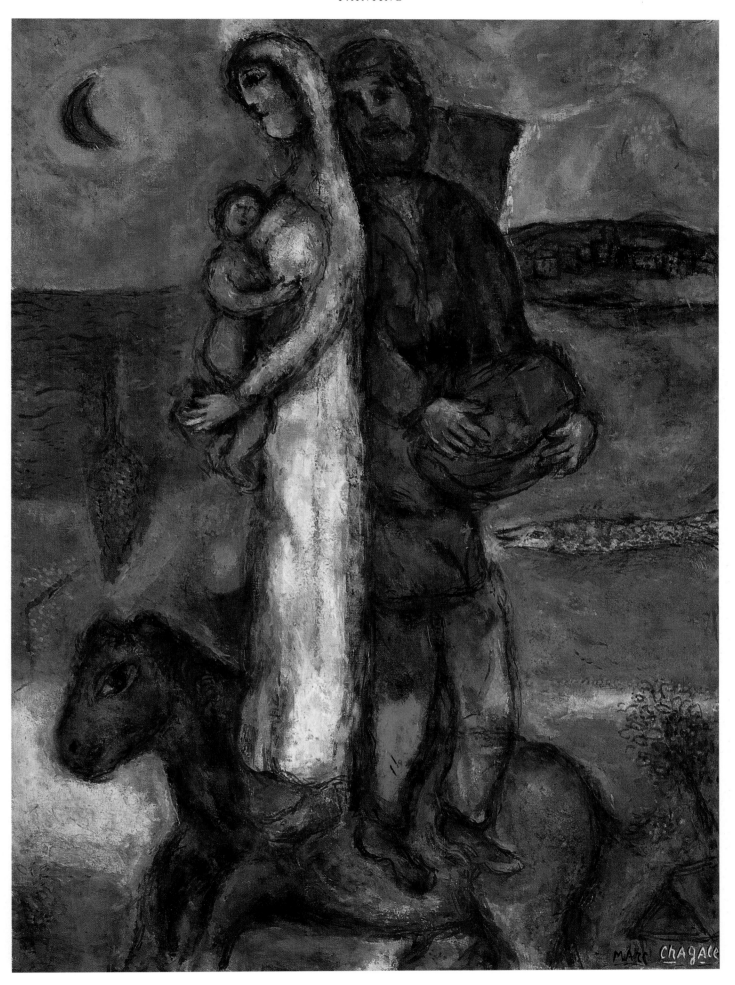

The Fisherman's Family. 1968

CAT. NO. 55

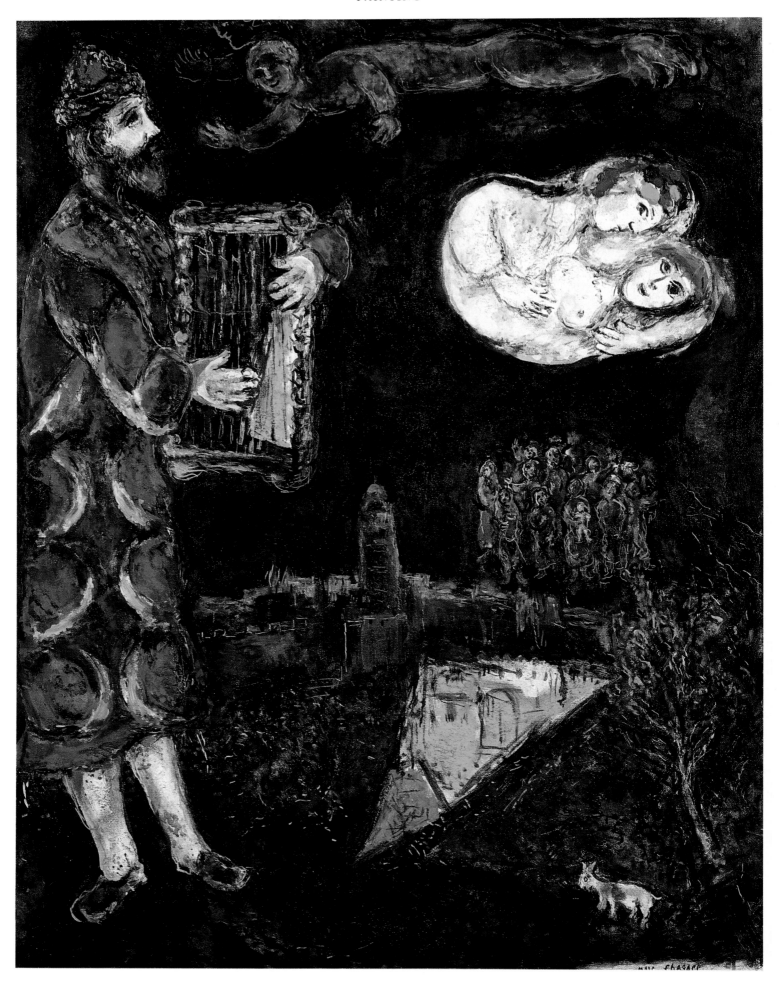

King David. 1968—71

CAT. NO. 57

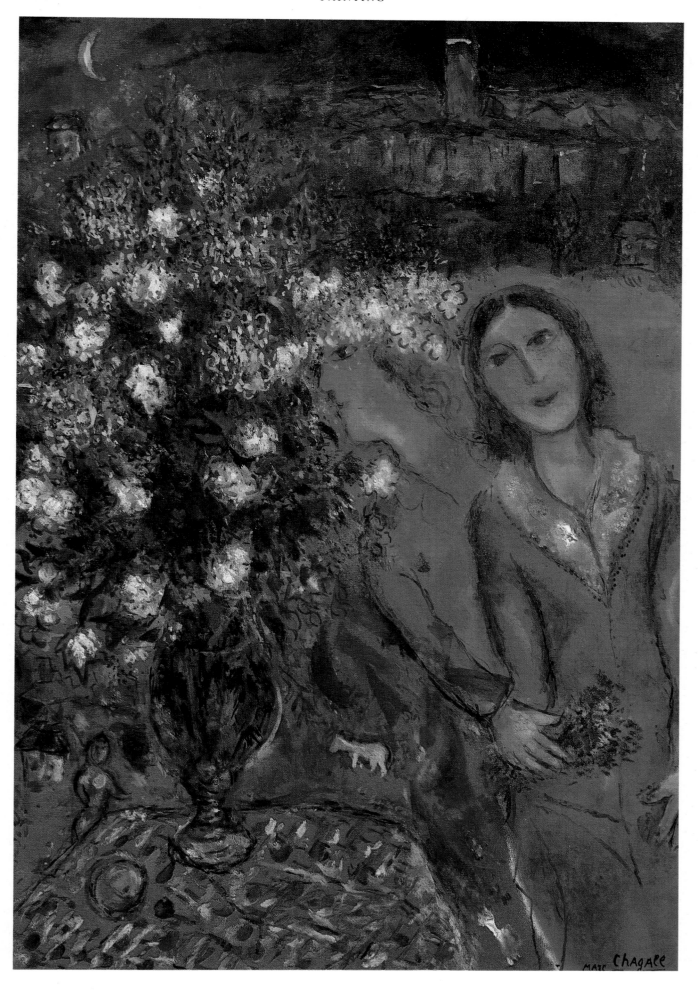

The Artist's Memories. 1981
CAT. NO. 80

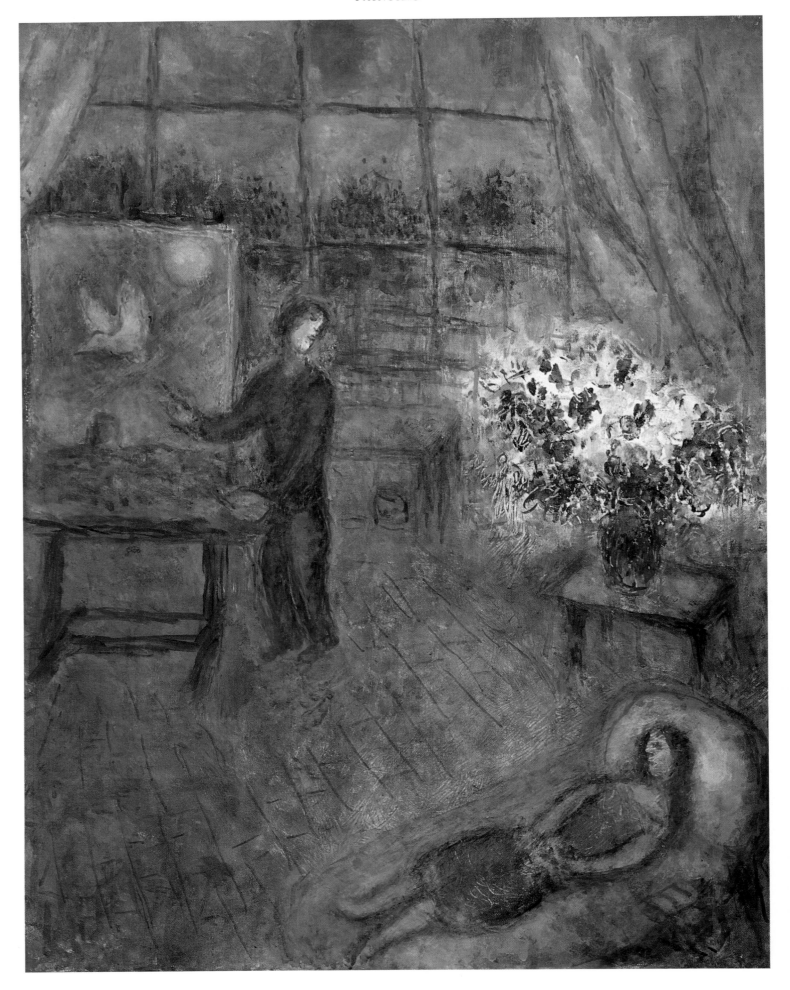

The Artist and His Model. 1970—75
CAT. NO. 60

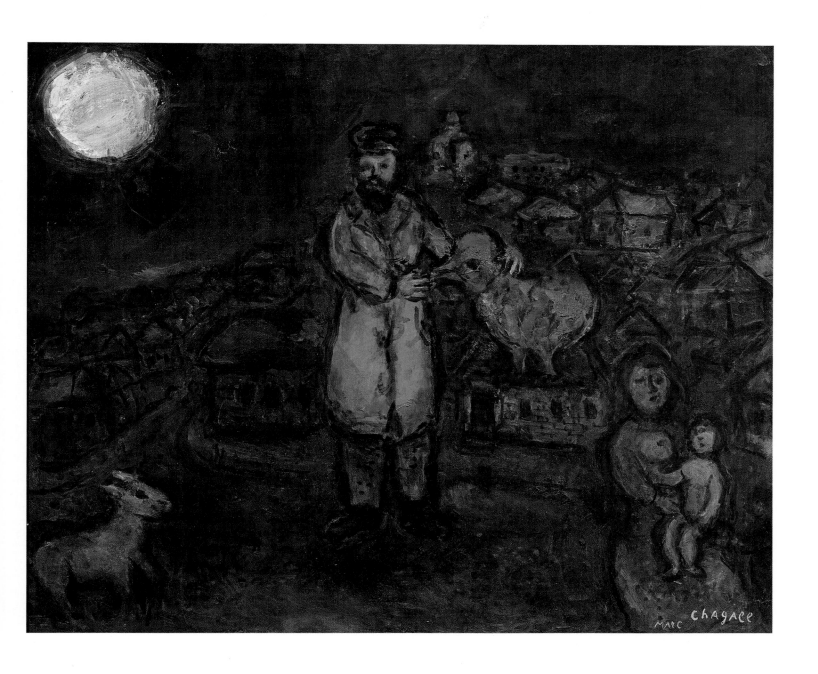

The Village. 1970—75

CAT. NO. 61

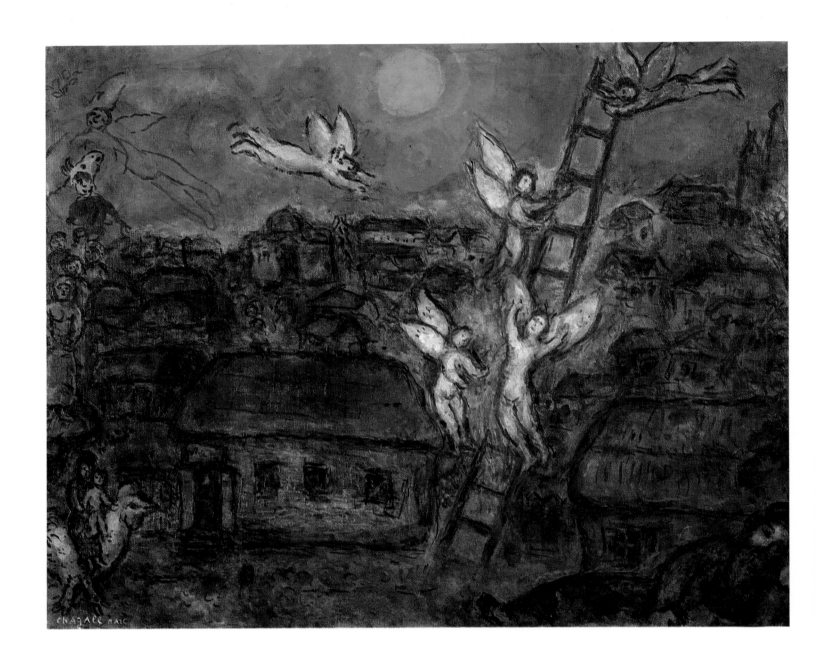

Jacob's Ladder. 1973

CAT. NO. 62

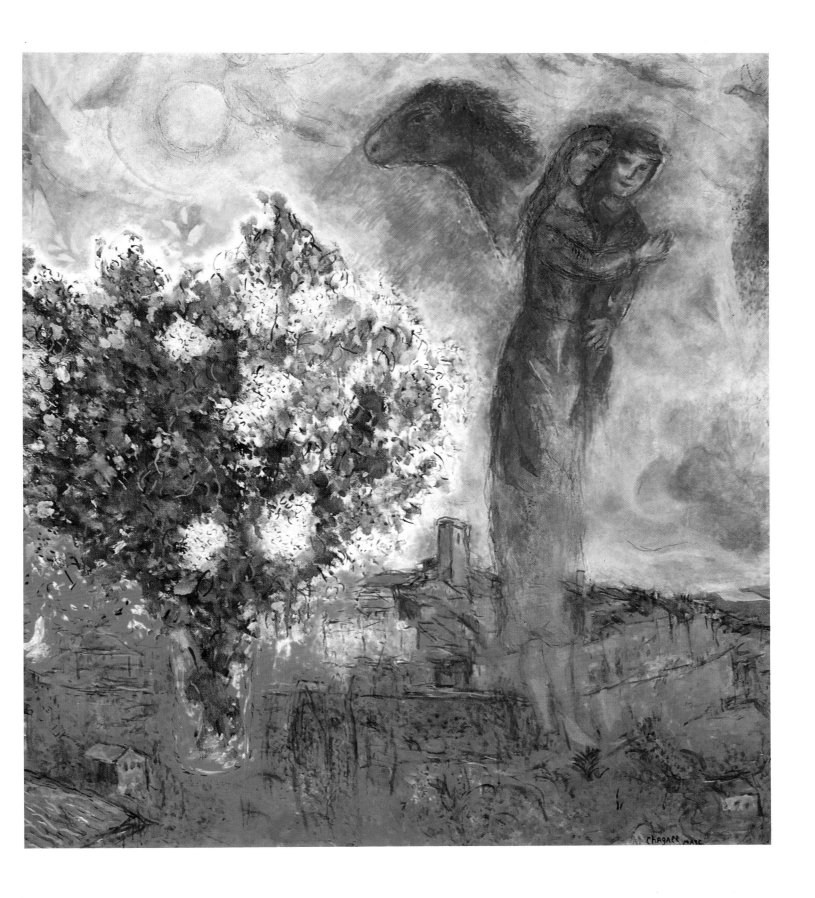

Couple over Saint-Paul. 1970—71

CAT. NO. 59

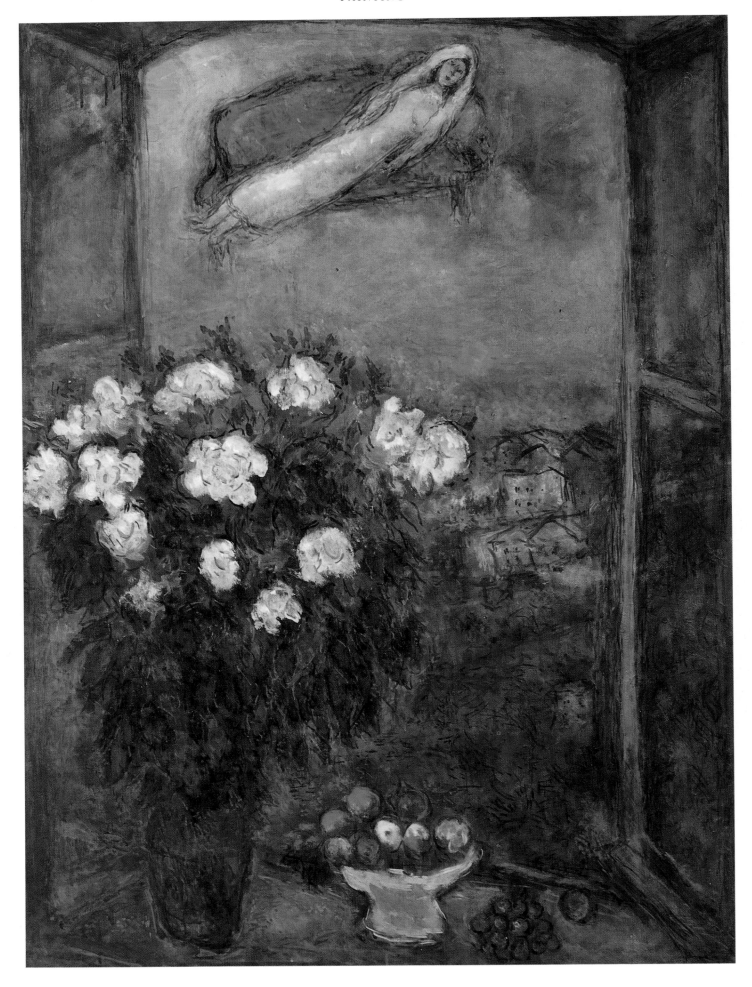

The Reverie. 1973
CAT. NO. 63

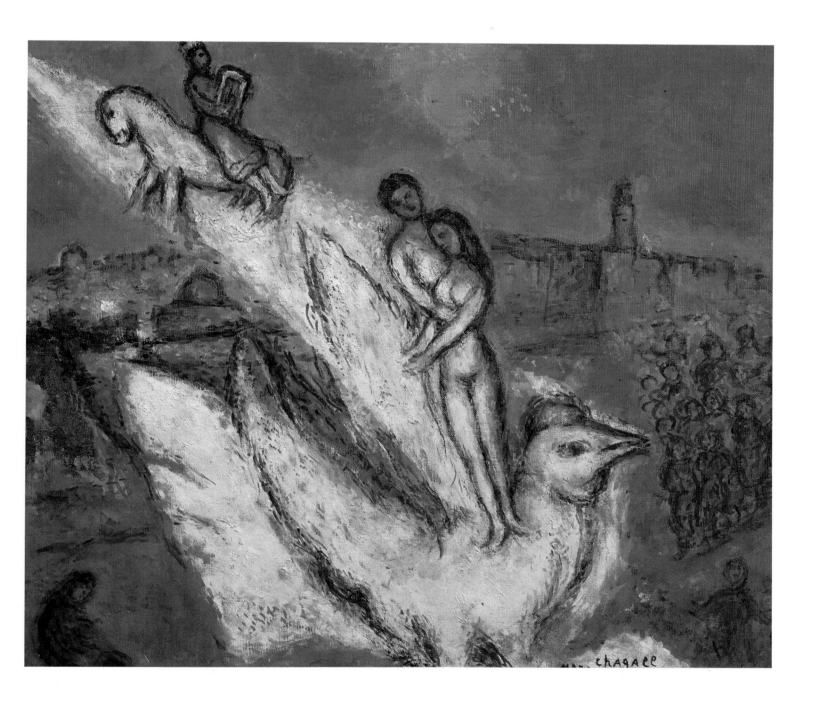

Song of Solomon (The Song of Songs). 1974
CAT. NO. 64

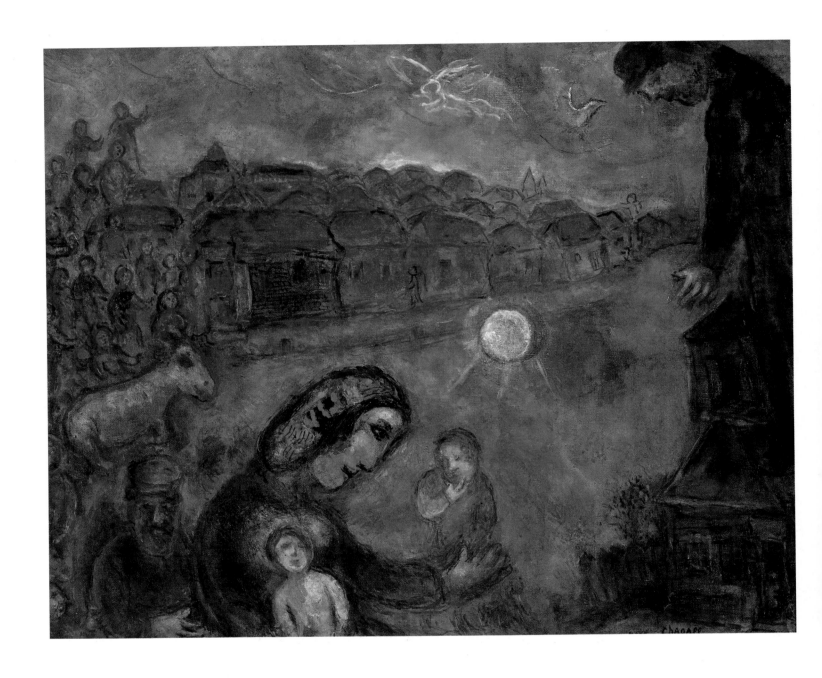

The Blue Village. 1975

CAT. NO. 65

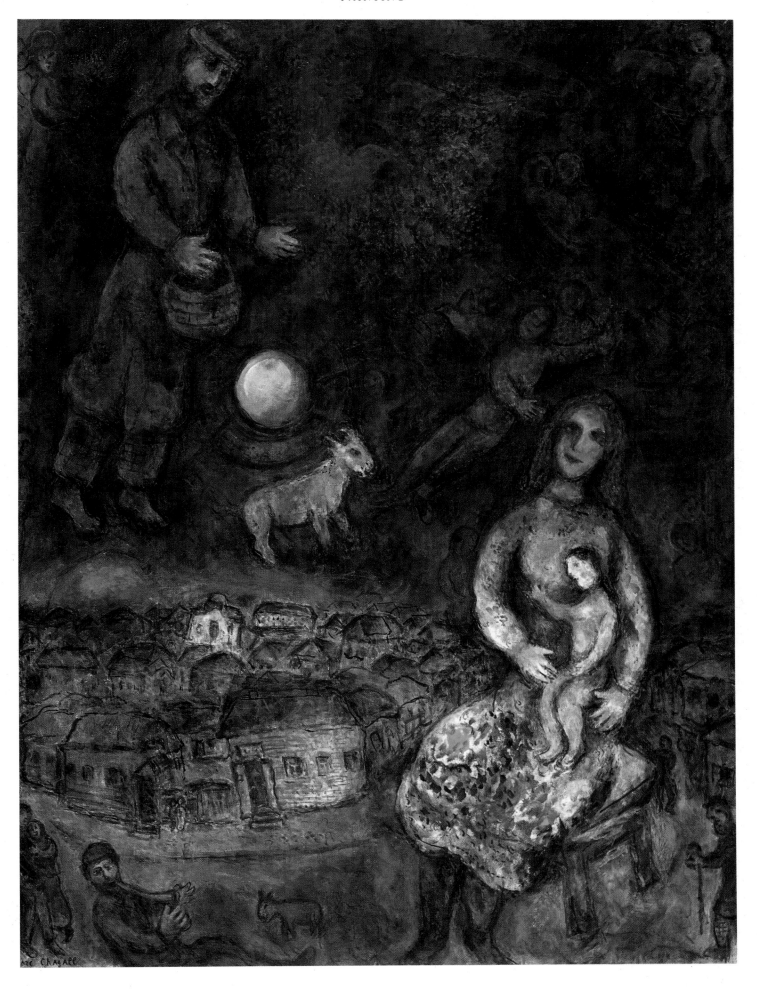

The Family. 1975—76

CAT. NO. 66

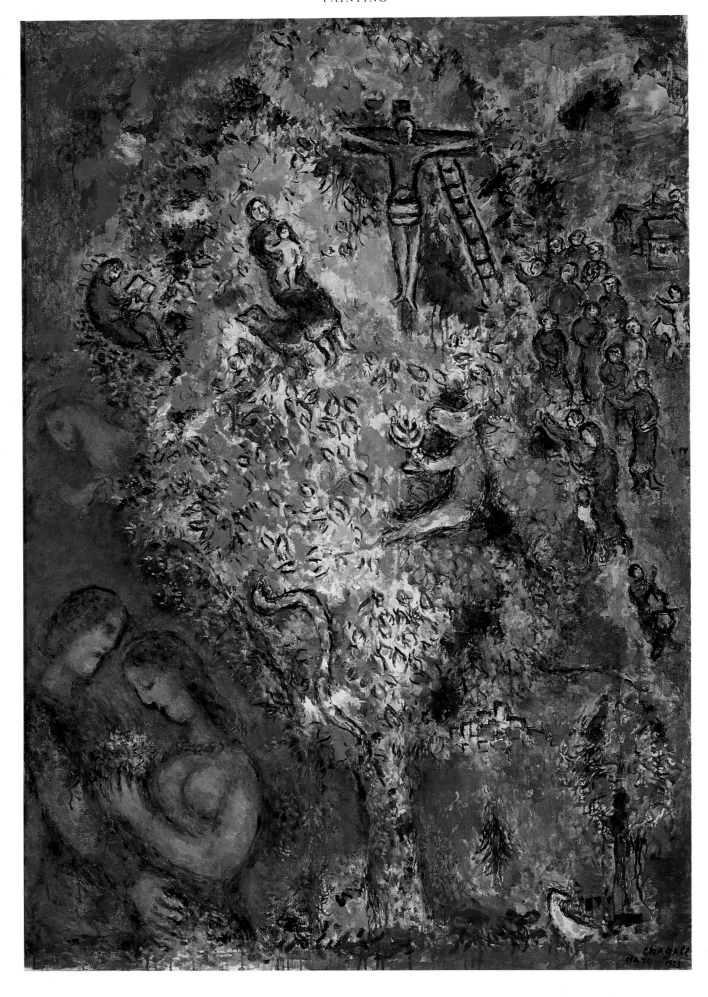

The Tree of Jesse. 1975
CAT. NO. 67

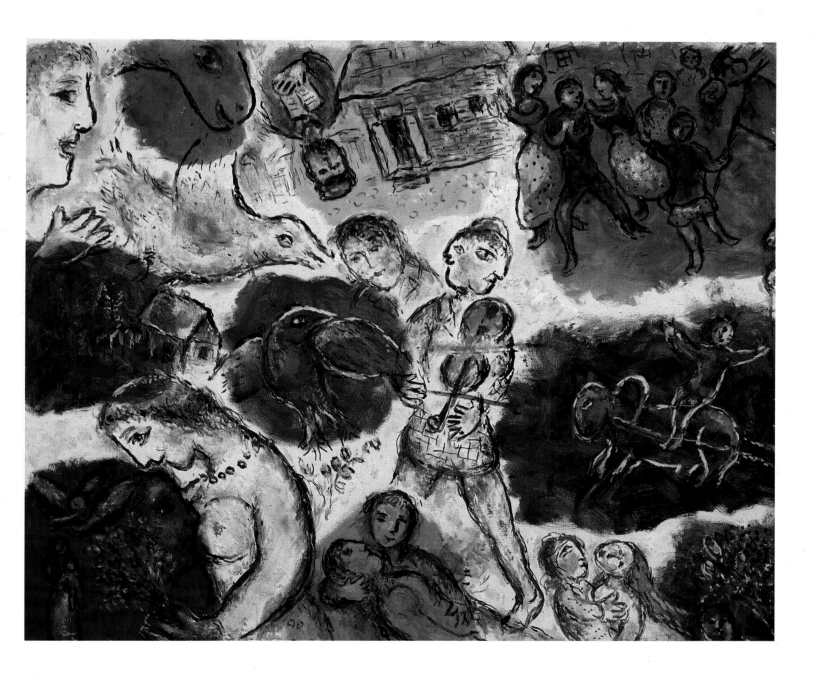

Composition. 1976

CAT. NO. 68

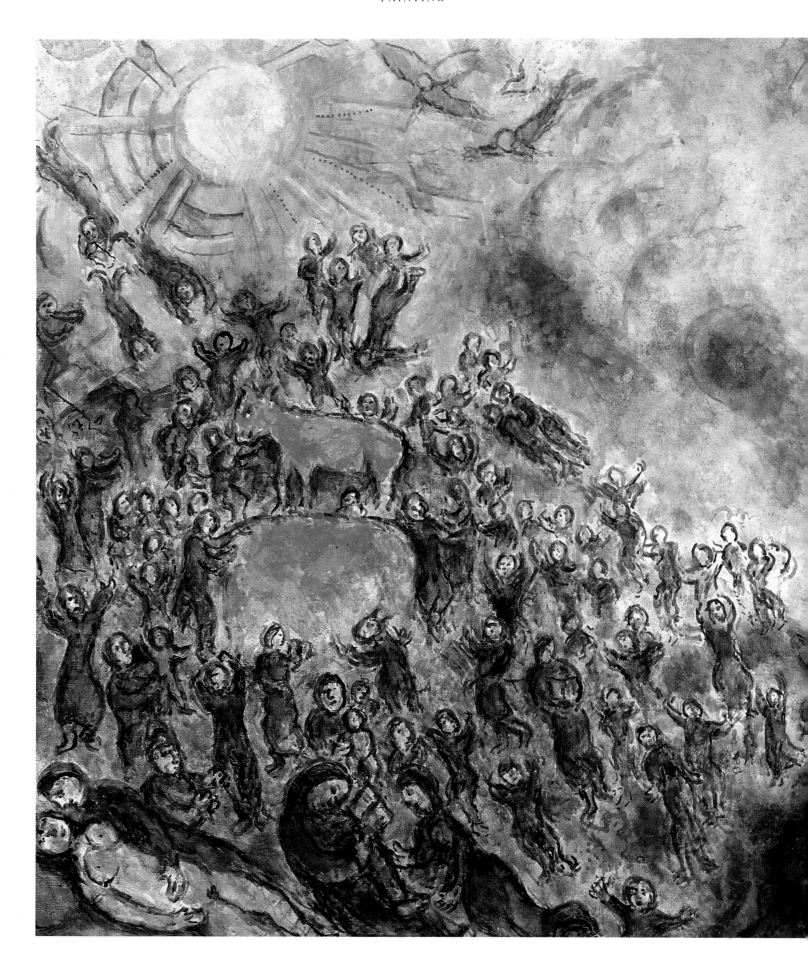

Moses with the Tablets of the Law and the Golden Calf. 1976
CAT. NO. 71

116

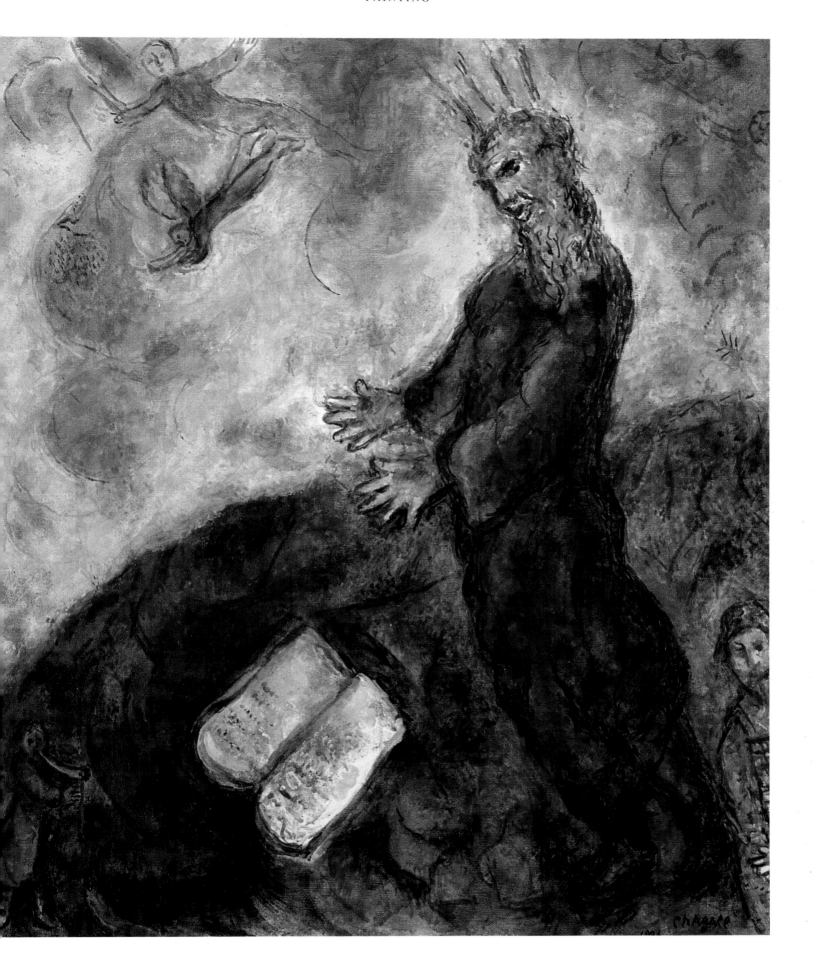

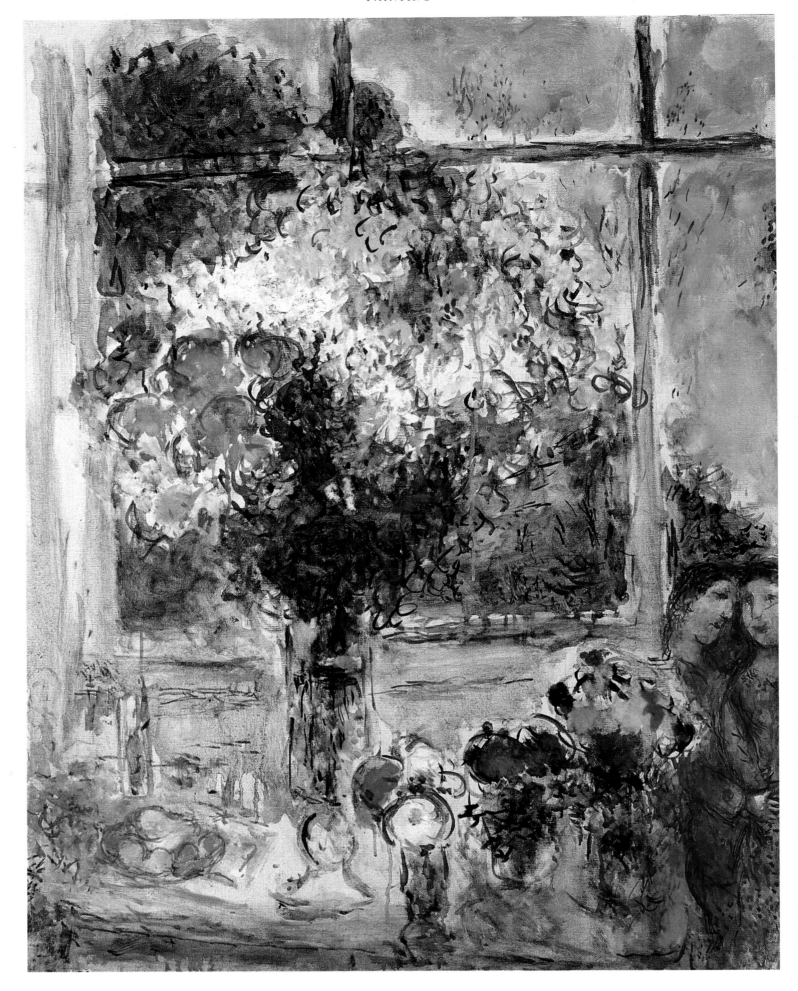

Bouquet Before a Window. 1976
CAT. NO. 70

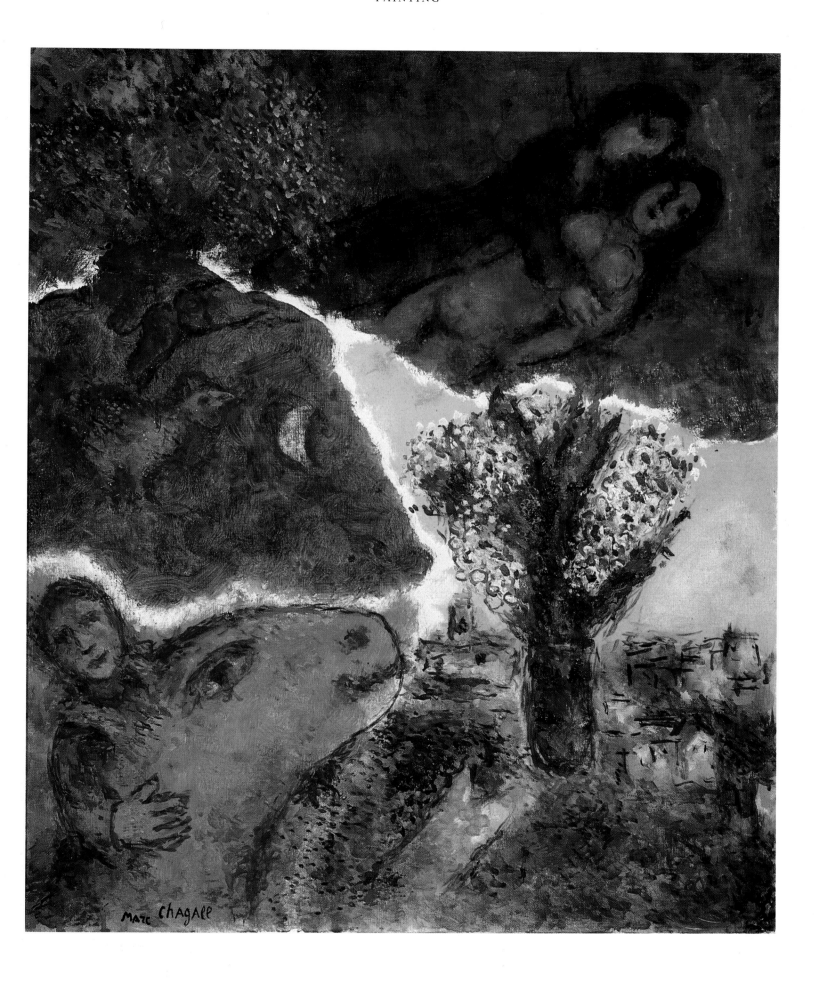

Sunrise. 1976

CAT. NO. 69

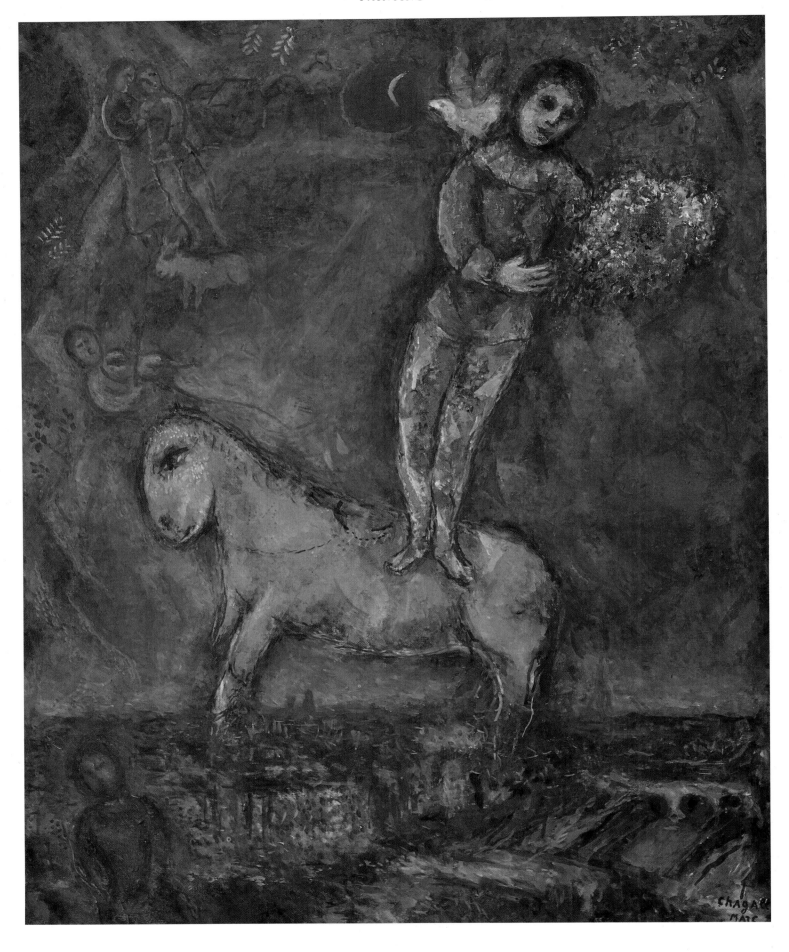

Child with Dove. 1977—79

CAT. NO. 76

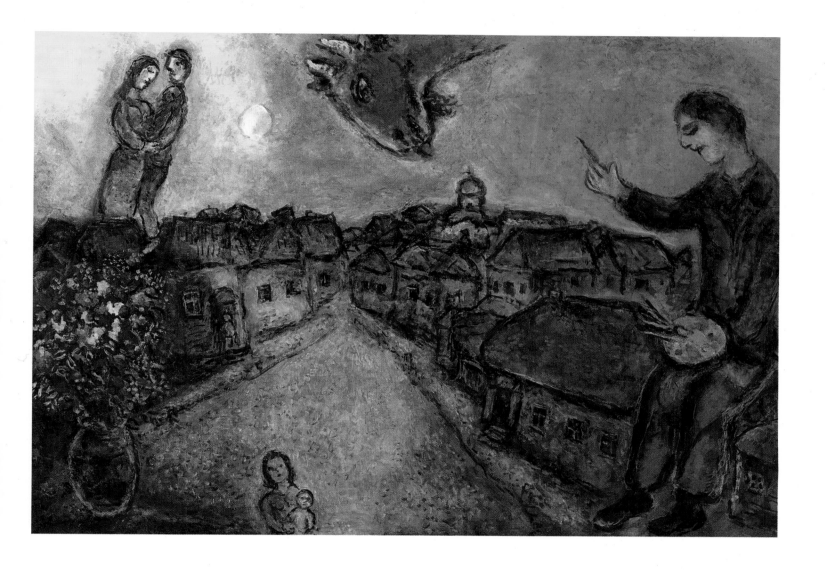

The Painter over Vitebsk. 1977—78
CAT. NO. 75

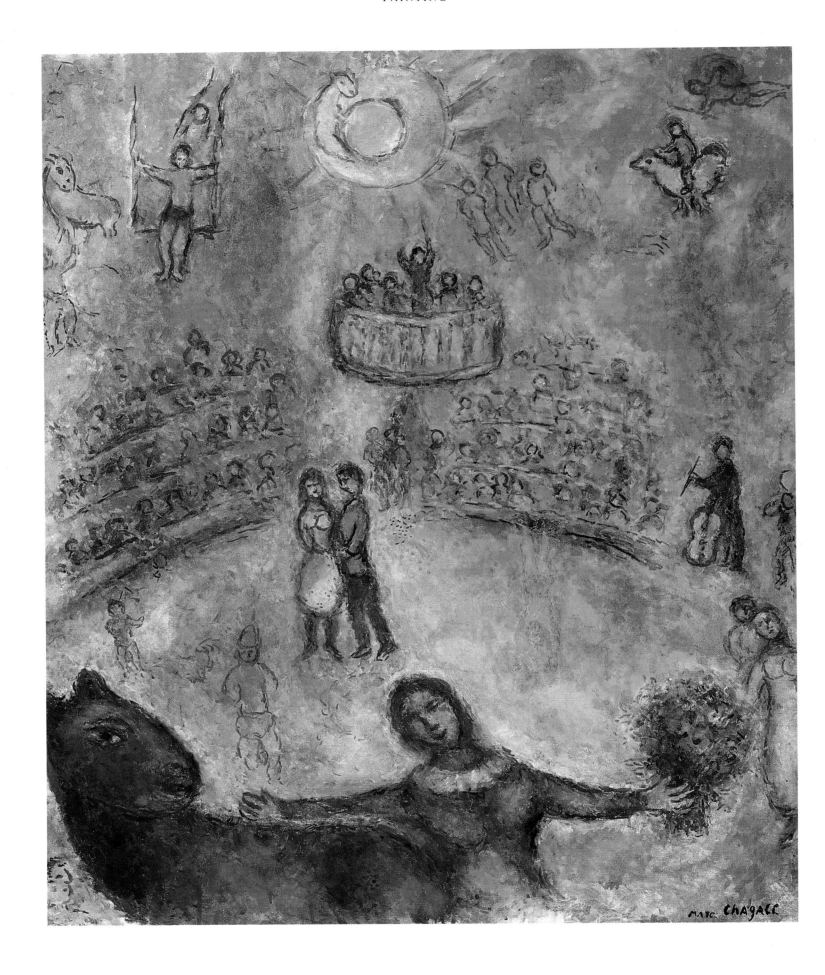

The Circus. 1979—81

CAT. NO. 77

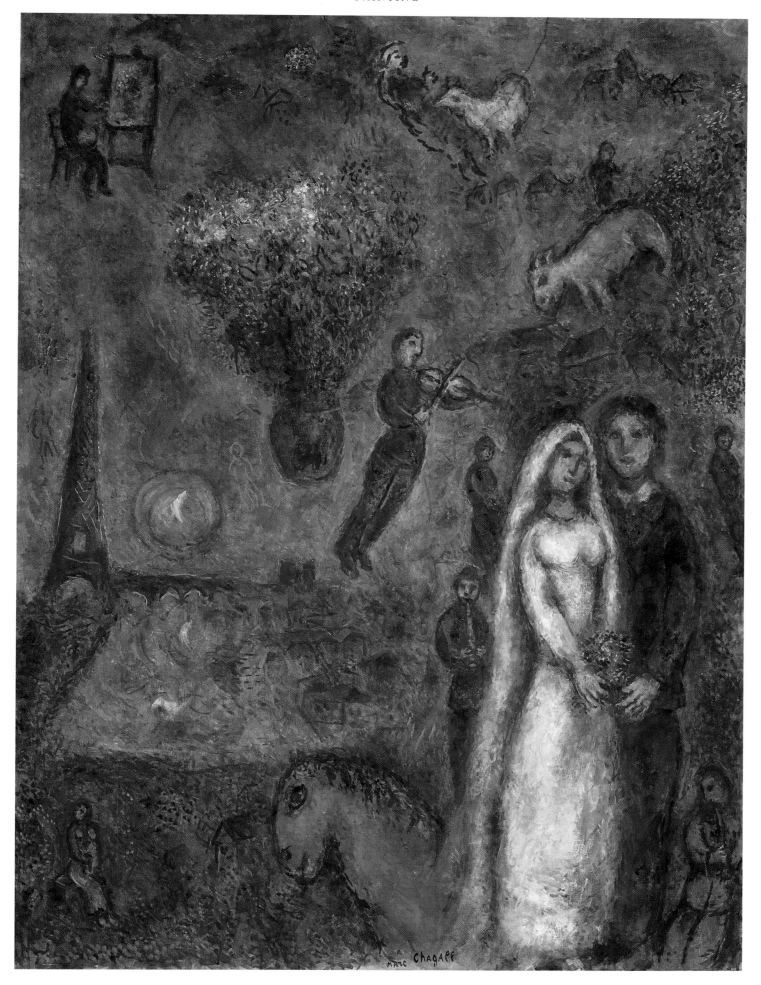

The Painter and His Bride. 1980
CAT. NO. 78

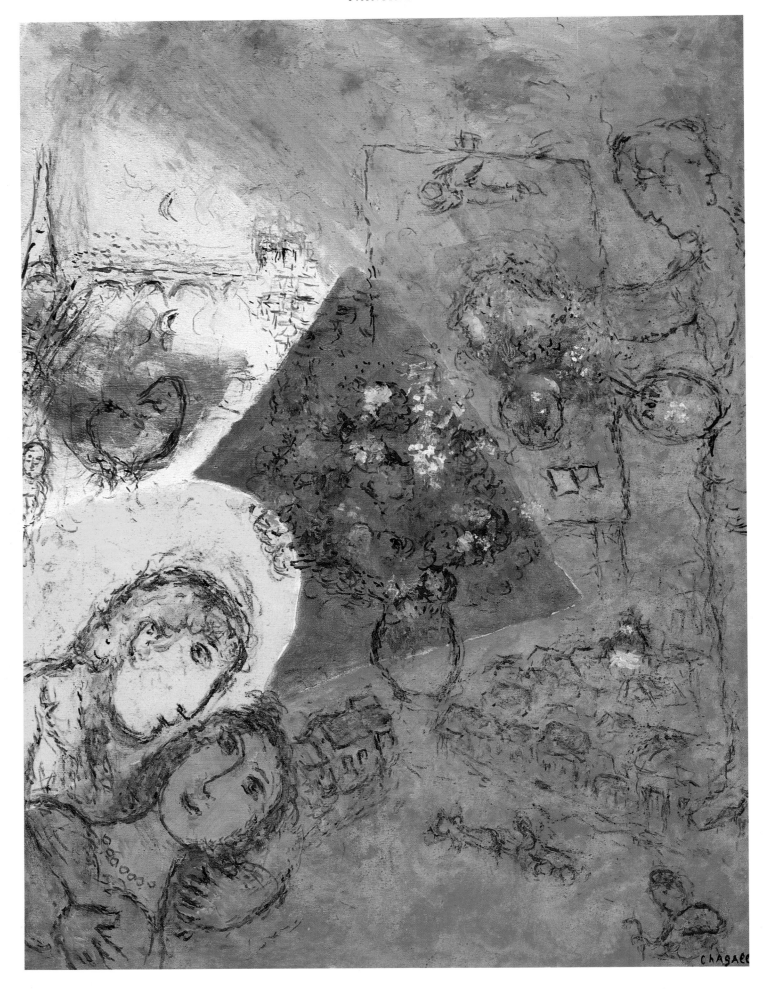

The Painter and His Wife. 1969

CAT. NO. 58

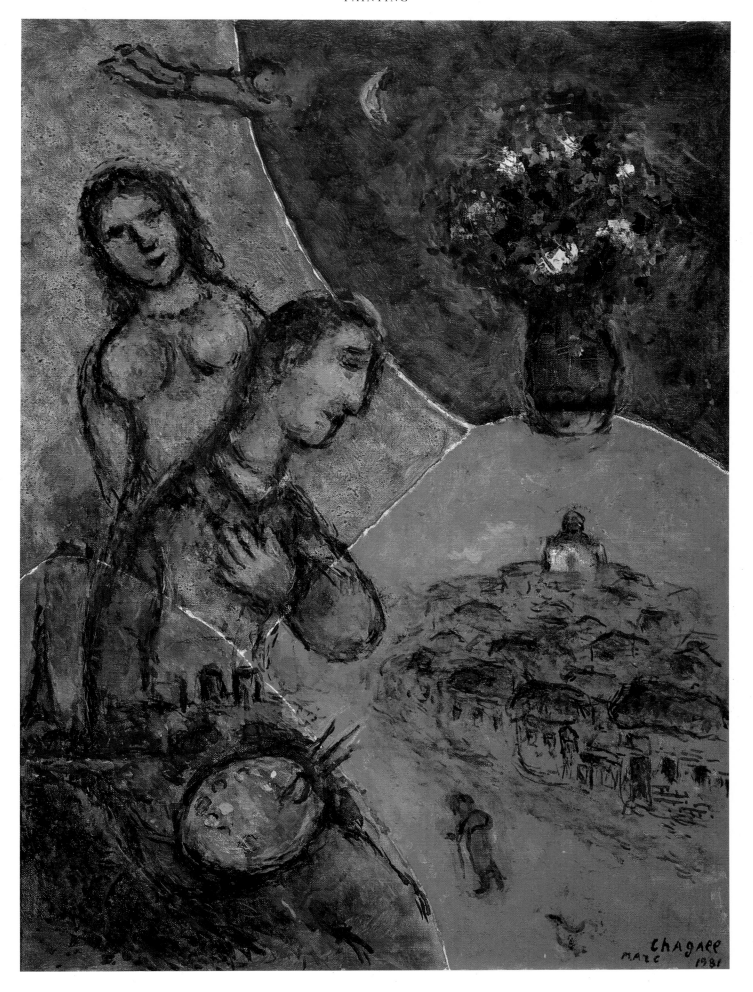

Self-portrait and the Vase of Flowers. 1981
CAT. NO. 81

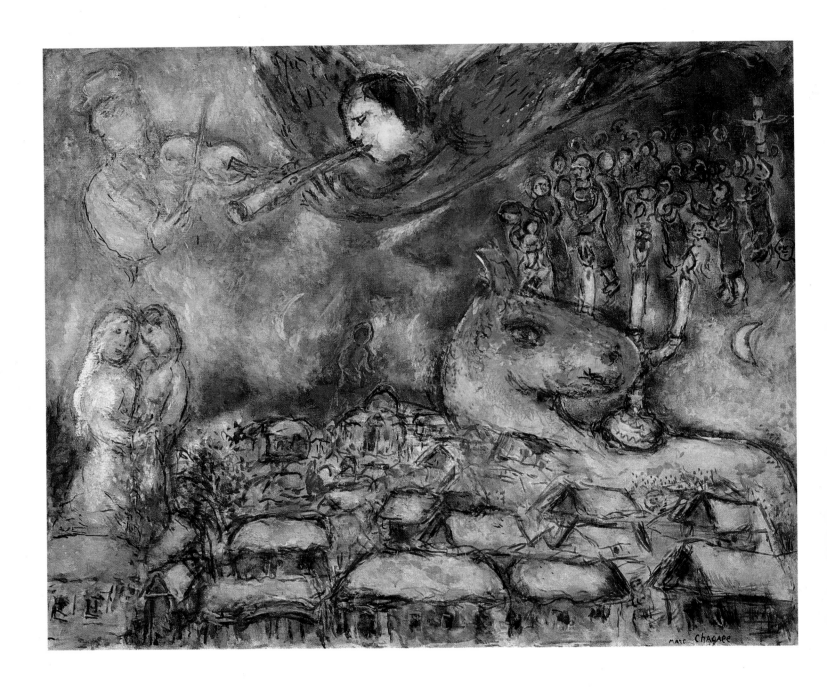

The Angel over Vitebsk. 1977

CAT. NO. 73

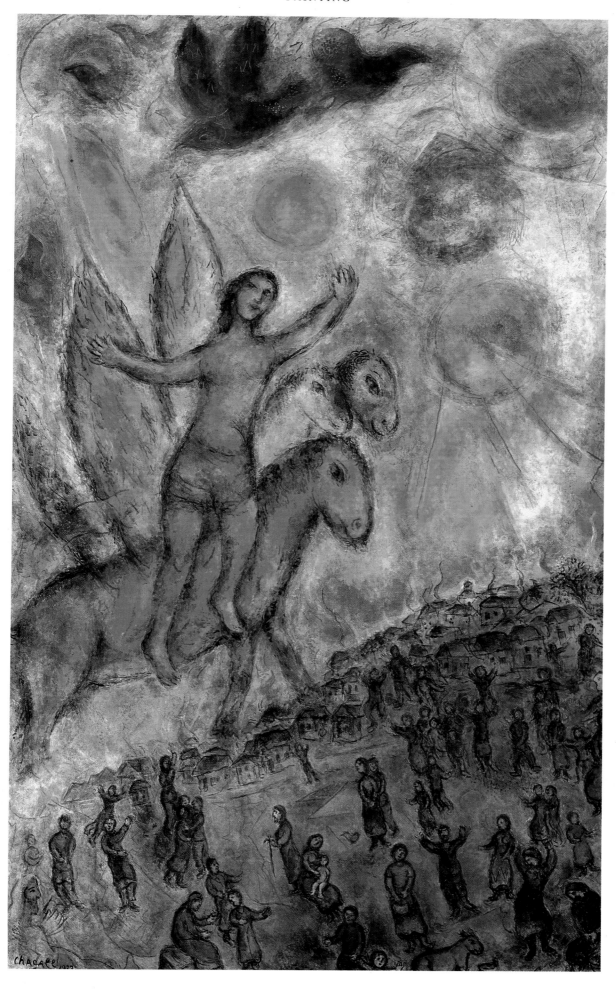

Phaeton. 1977

CAT. NO. 74

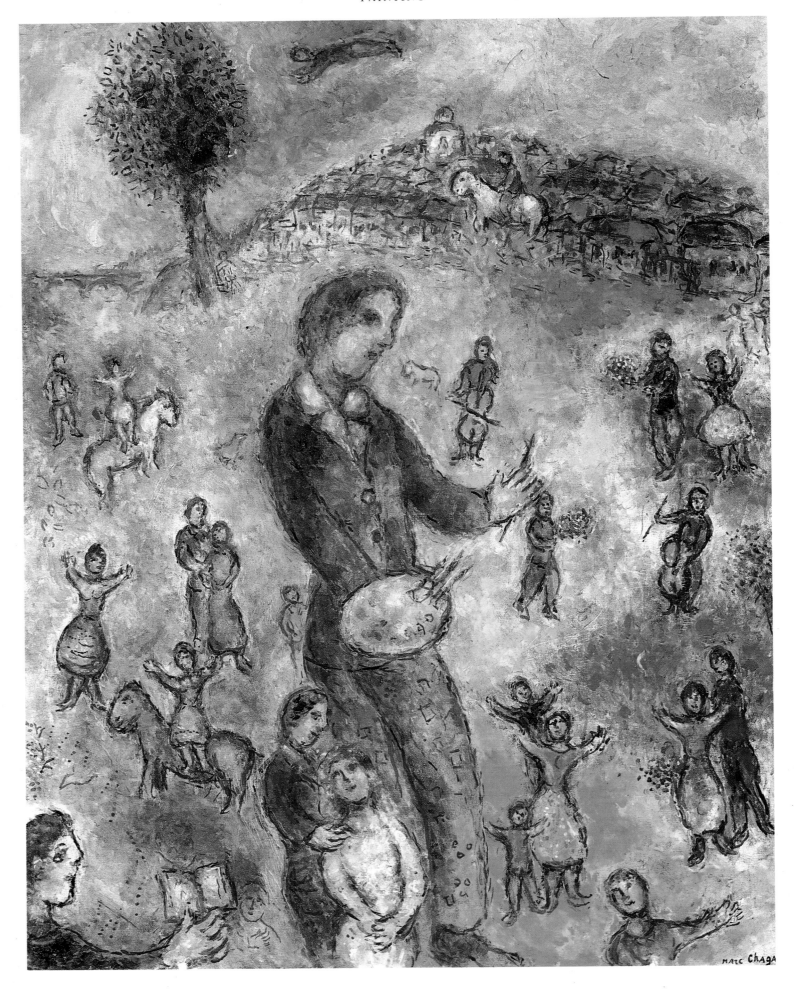

The Painter at the Feast. 1982
CAT. NO. 83

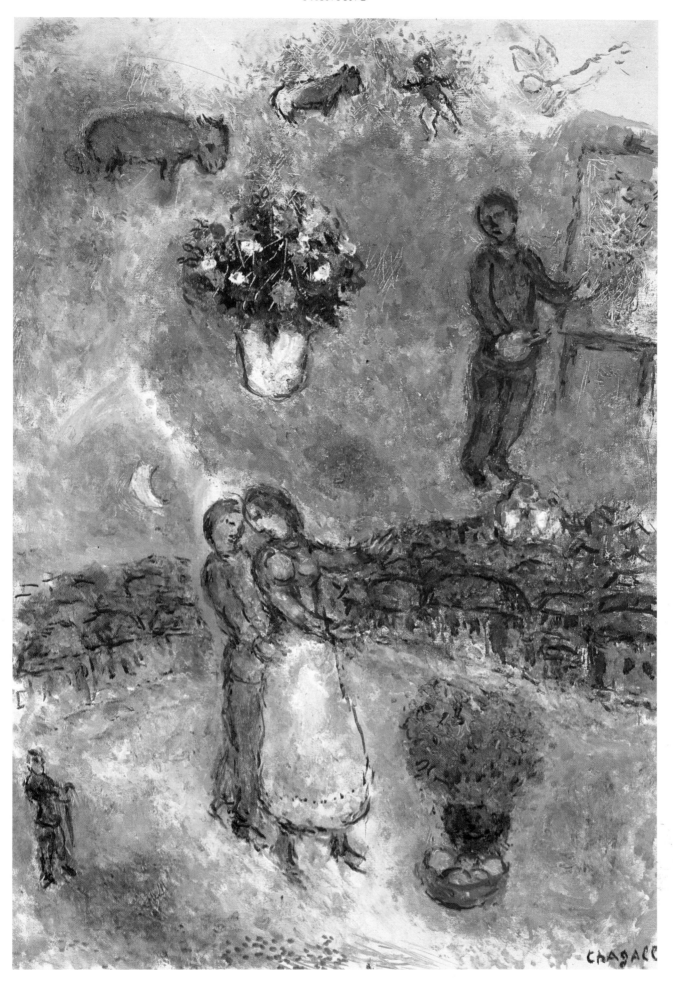

The Painter over Vitebsk. 1982

CAT. NO. 82

129

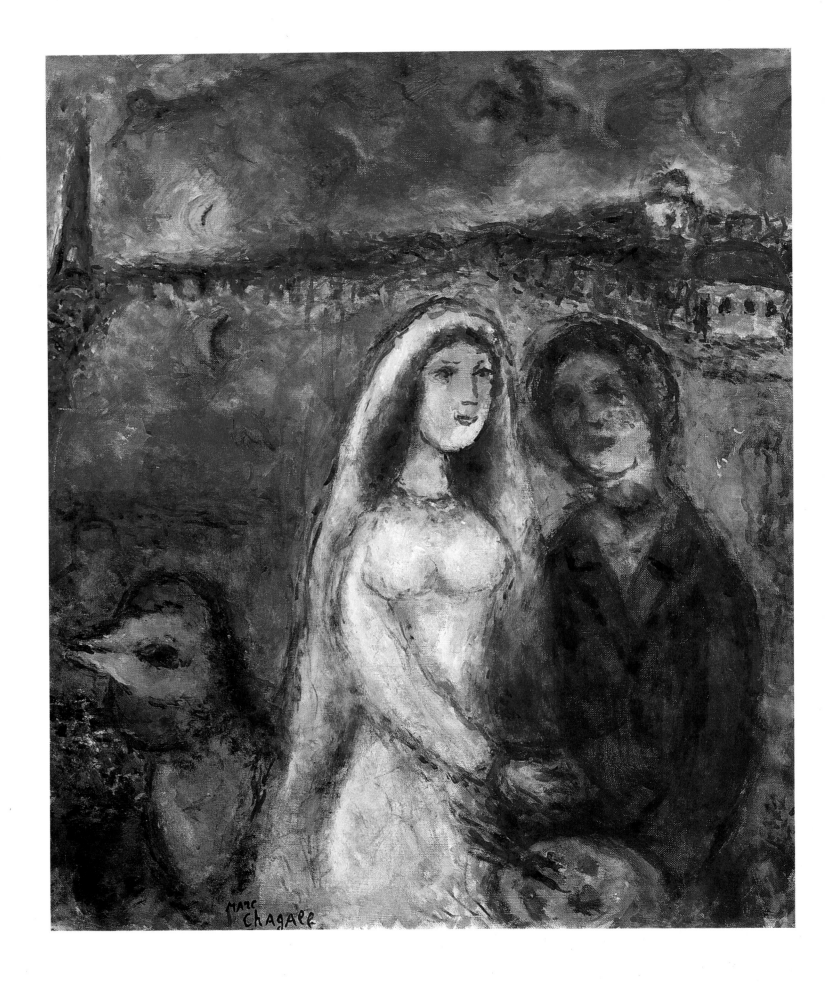

Bride and Groom of the Eiffel Tower. 1982—83

CAT. NO. 85

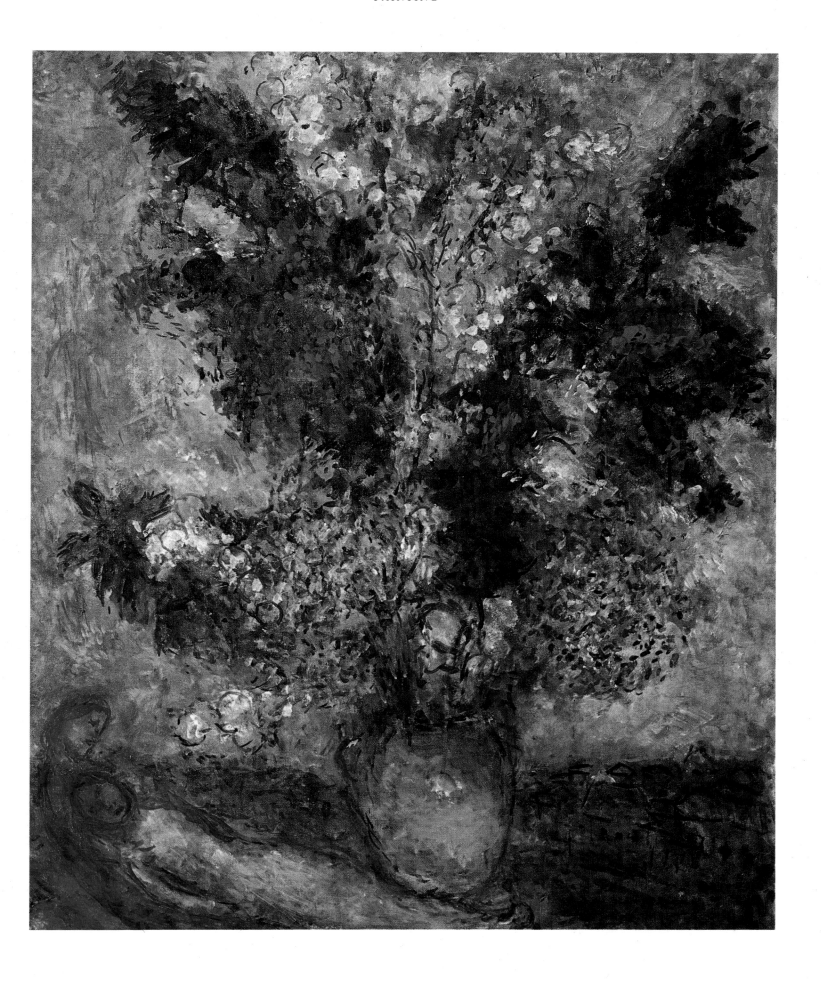

The Bouquet of Flowers. 1982
CAT. NO. 84

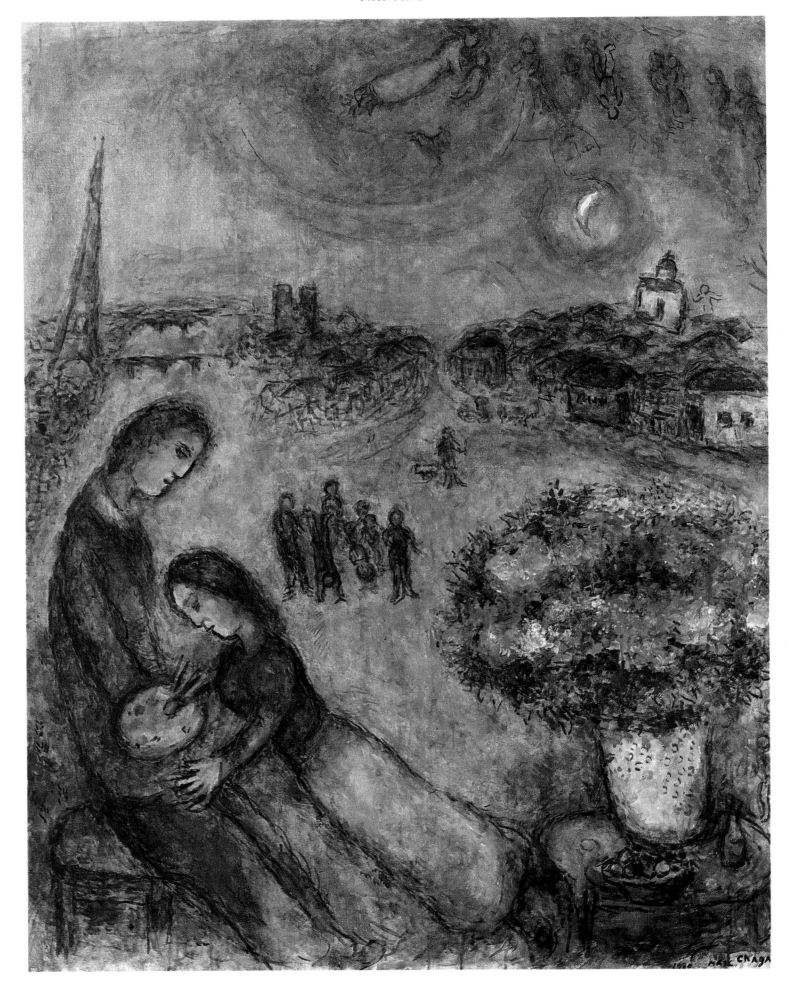

Bride and Groom in Front of Paris. 1980

CAT. NO. 79

132

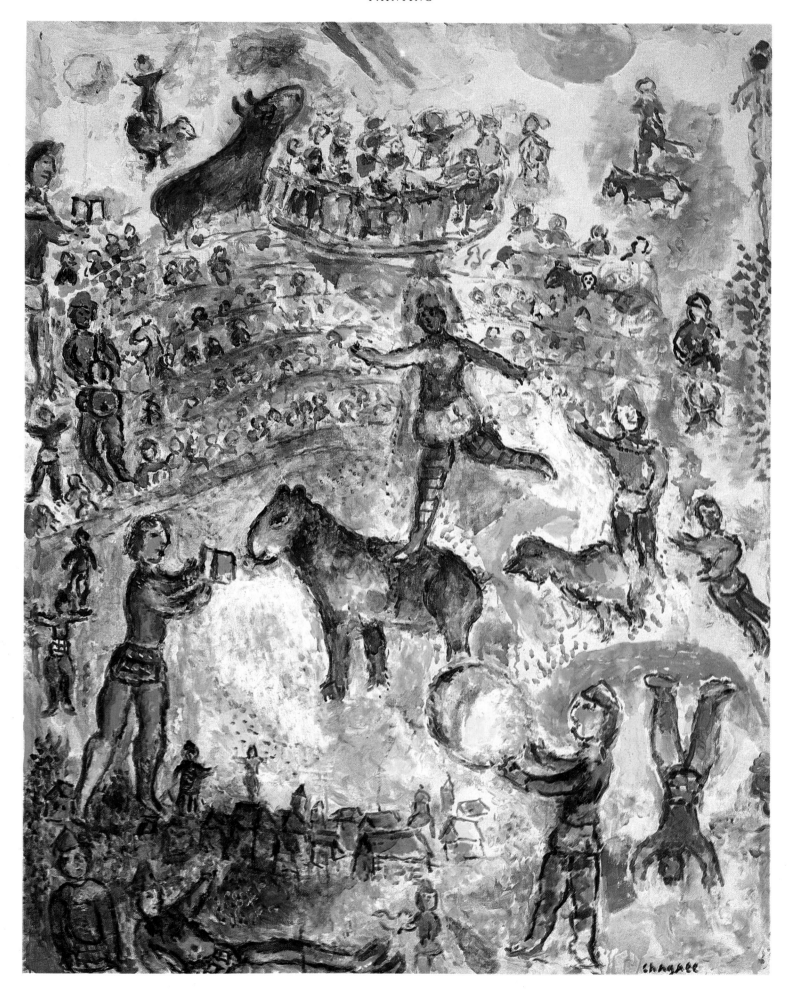

The Large Circus. 1984

CAT. NO. 86

GRAPHIC
WORK

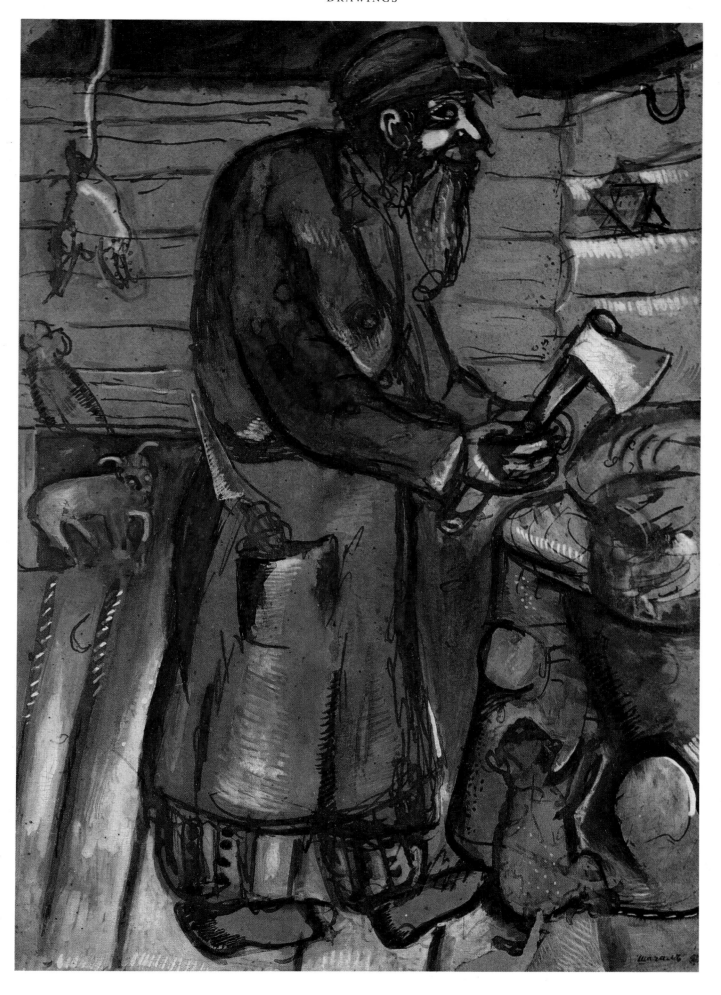

Butcher (Grandfather). 1910
CAT. NO. 87

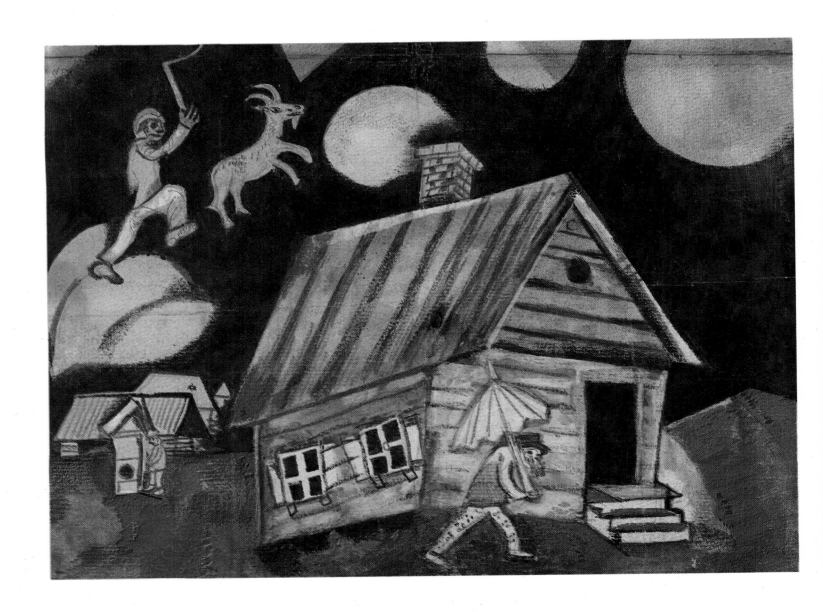

Study for *Rain*. 1911

CAT. NO. 88

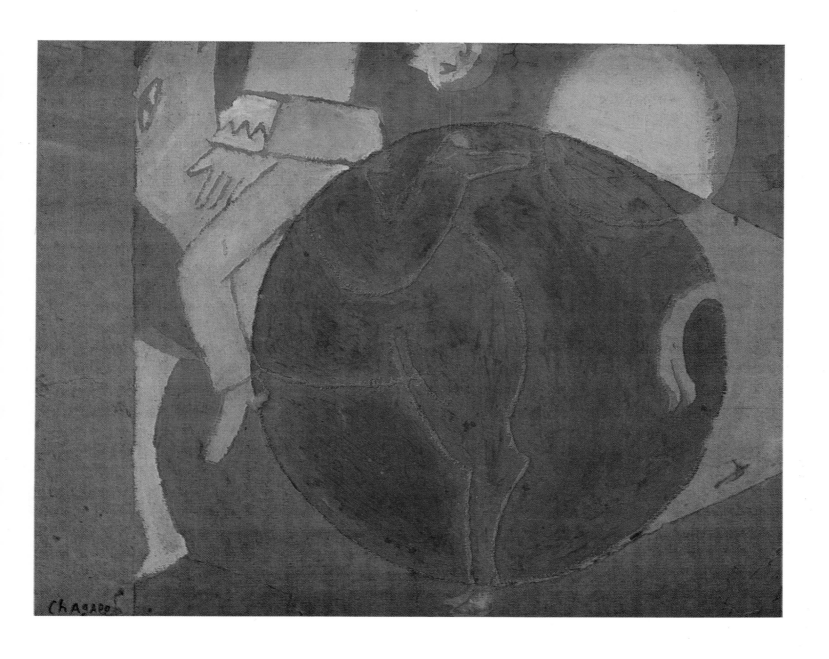

The Circus. 1919

CAT. NO. 33

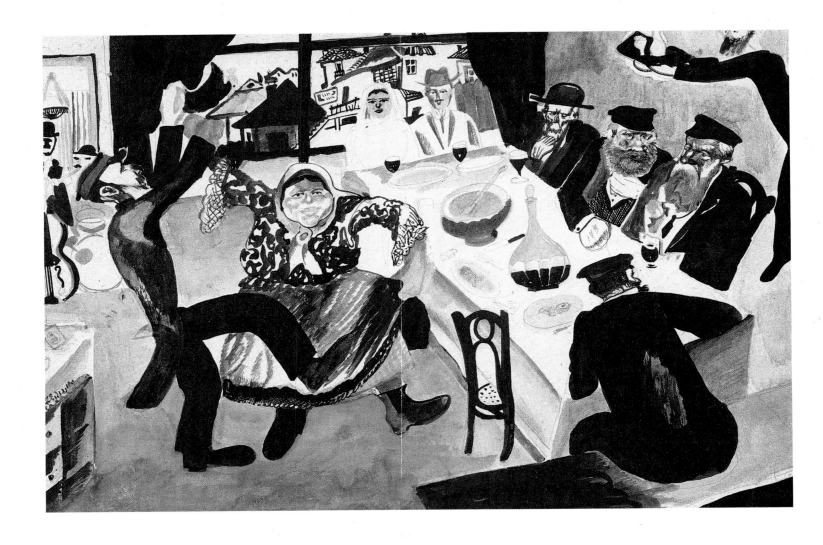

The Jewish Wedding. 1910s

CAT. NO. 89

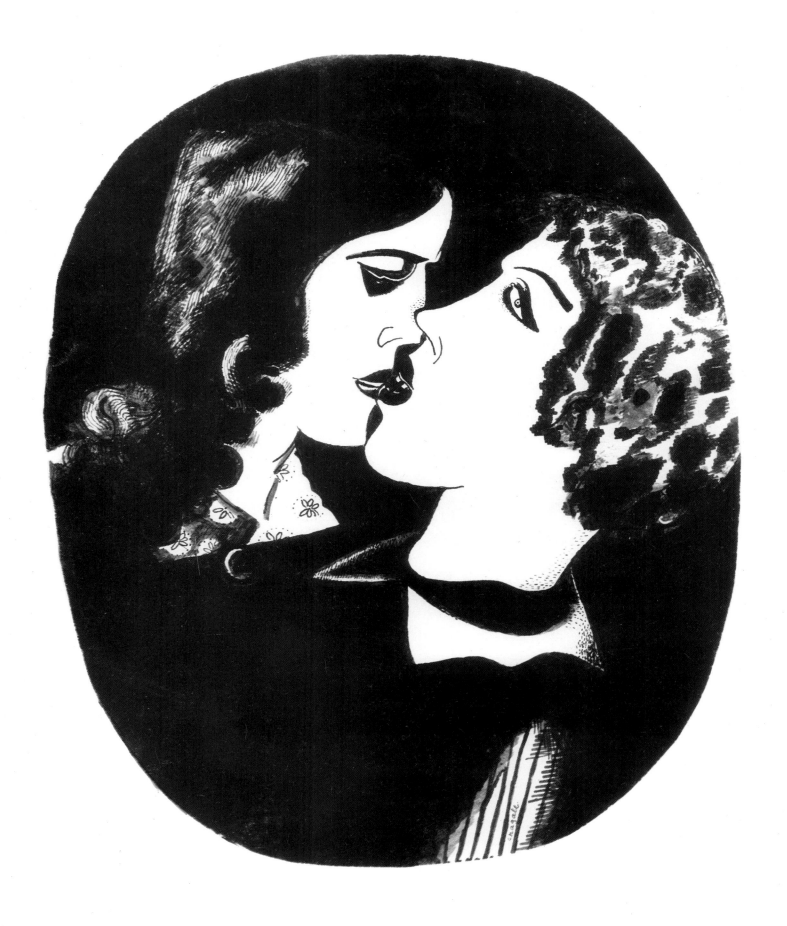

The Lovers
CAT. NO. 90

Street in Vitebsk. 1914

CAT. NO. 91

Railway Station. Vitebsk. 1914

CAT. NO. 92

Strollers. 1914

CAT. NO. 94

The Wounded Soldier. 1914

CAT. NO. 93

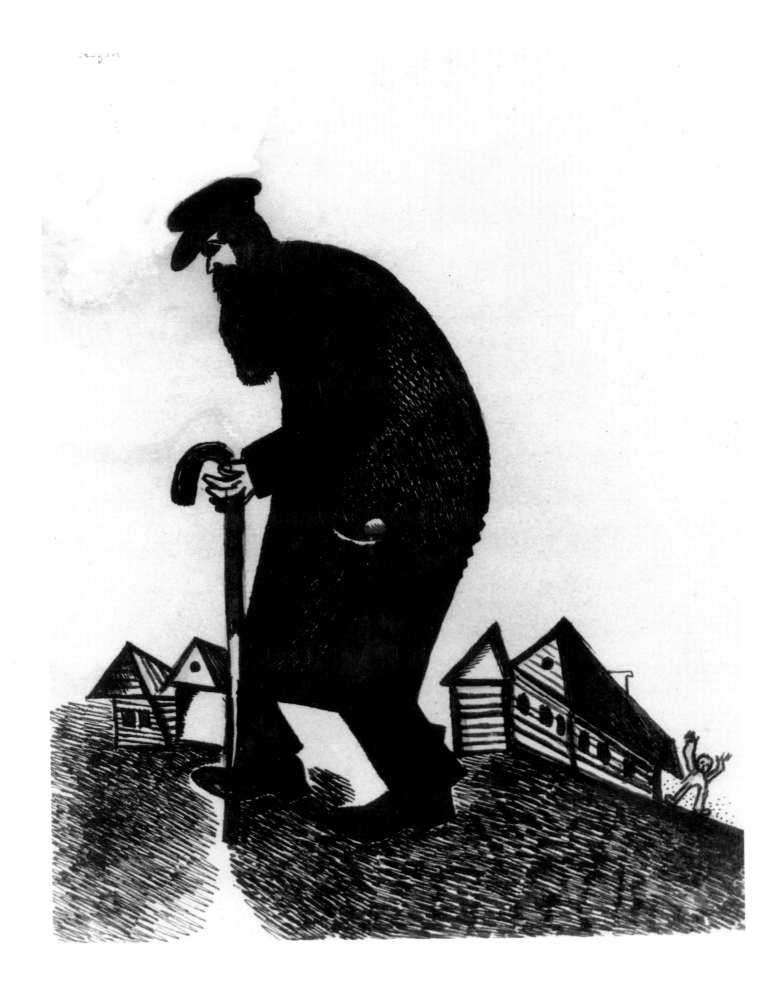

Old Man with Cane. 1914

CAT. NO. 95

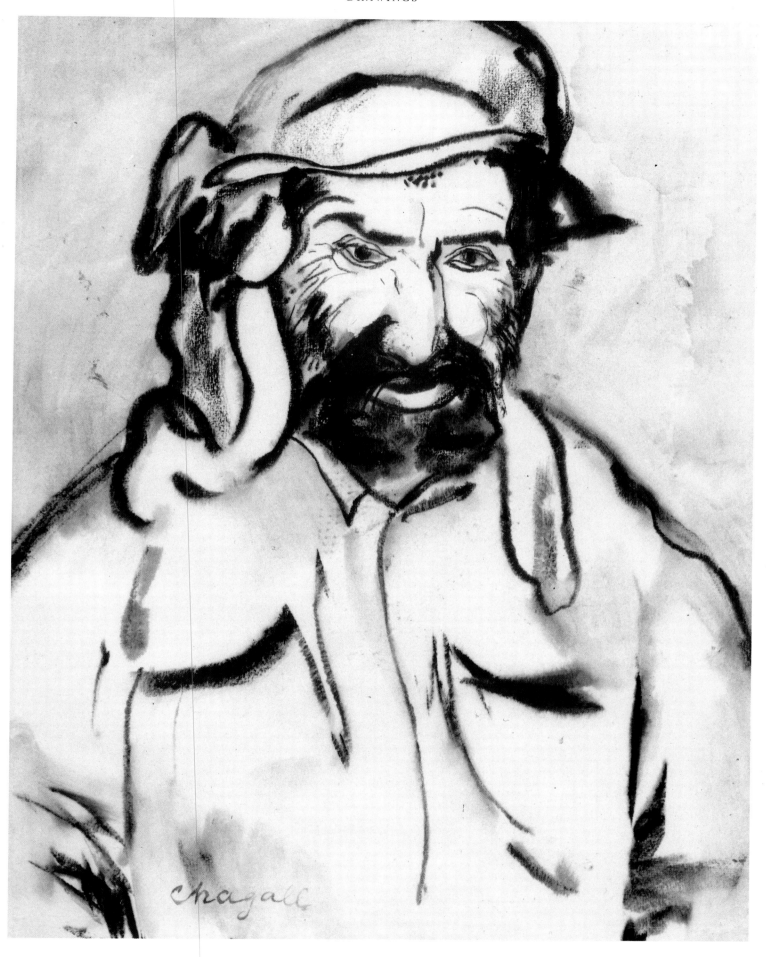

Rabbi of Vitebsk. 1914
CAT. NO. 96

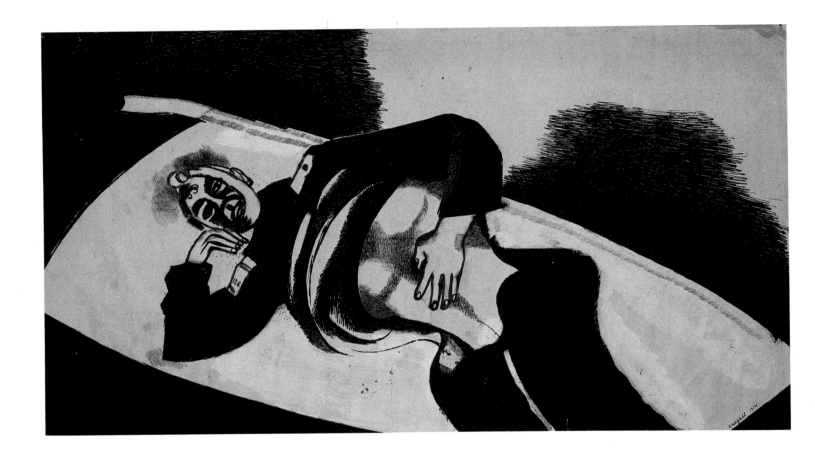

Man on Stretcher. 1914

CAT. NO. 97

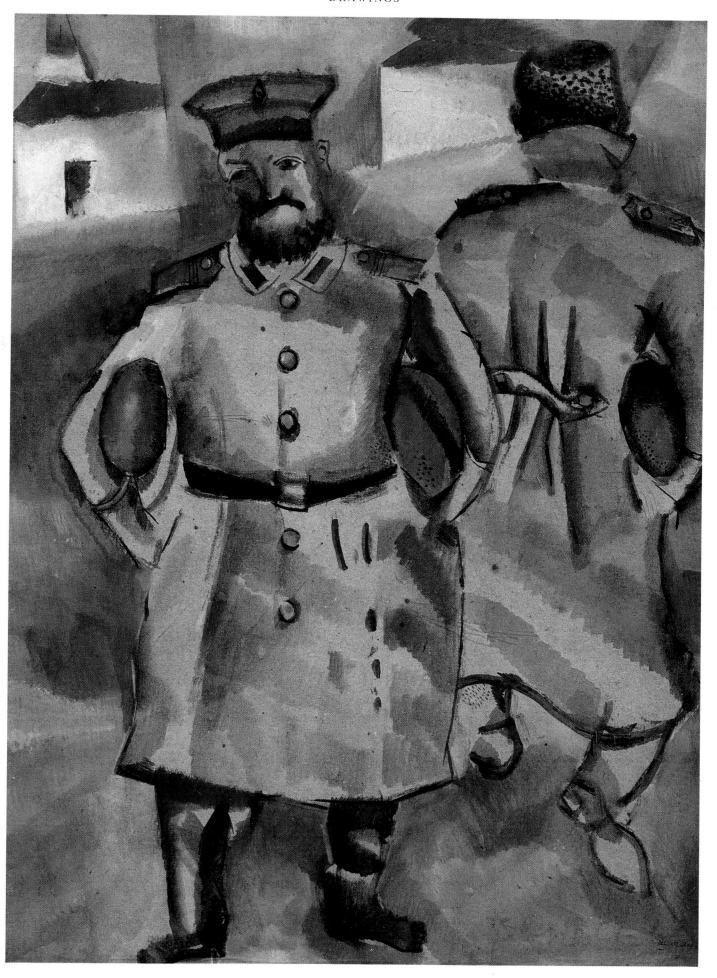

Soldiers with Bread. 1914—15
CAT. NO. 98

Pietà. 1914—15
CAT. NO. 99

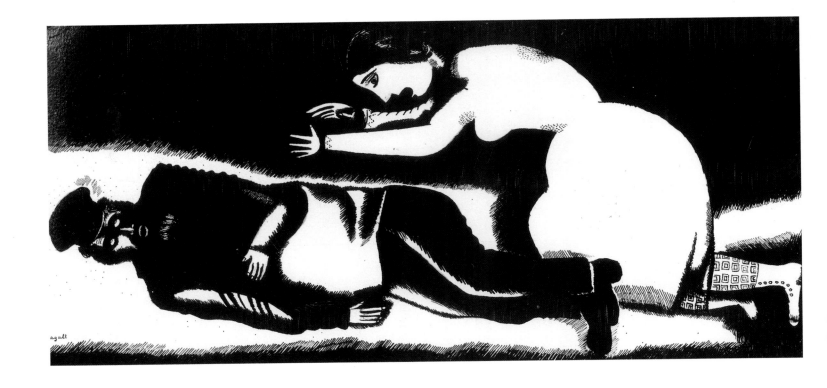

Street. 1914—15

CAT. NO. 100

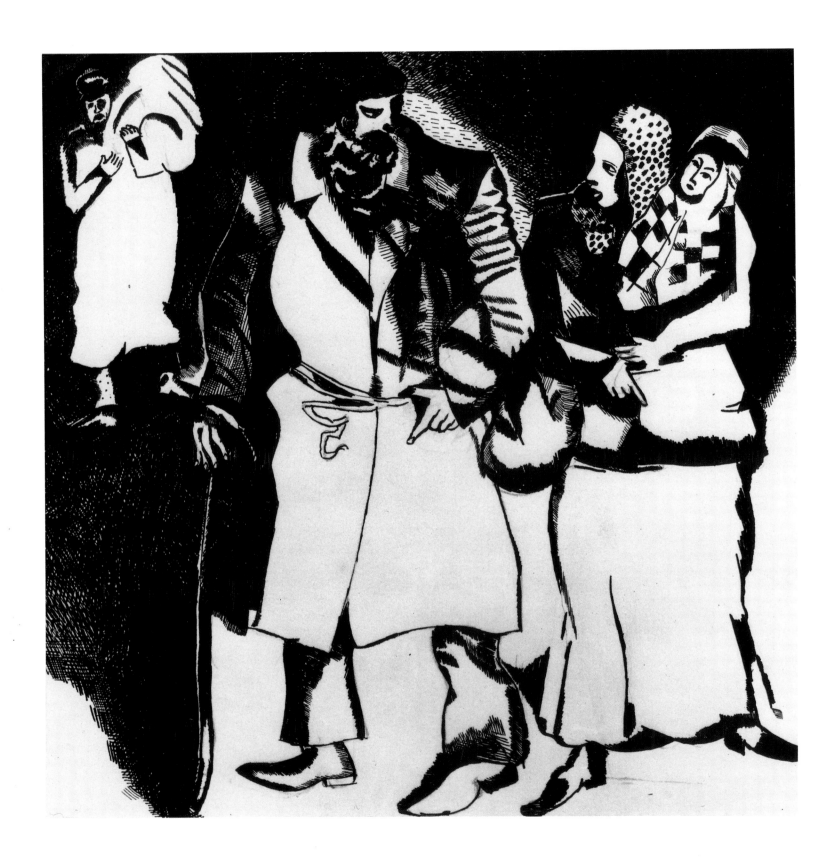

Group. Vitebsk. 1914—15

CAT. NO. 101

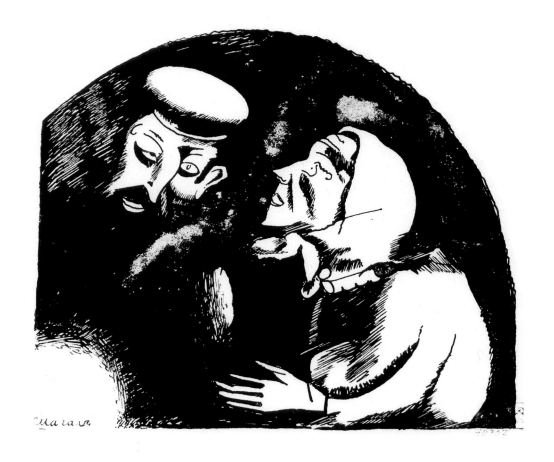

Old Man and Woman. 1914—15

CAT. NO. 102

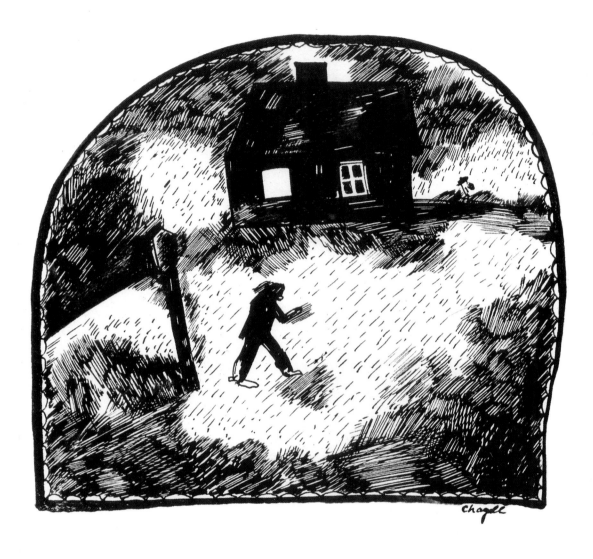

The Street. 1914—15

CAT. NO. 103

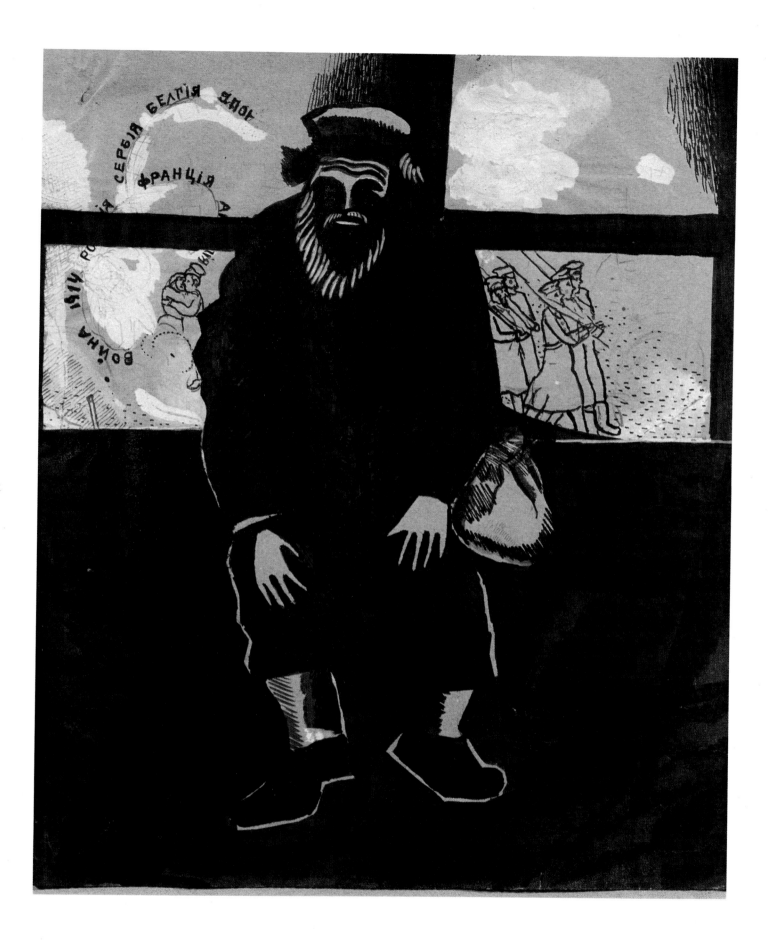

War. 1915

CAT. NO. 104

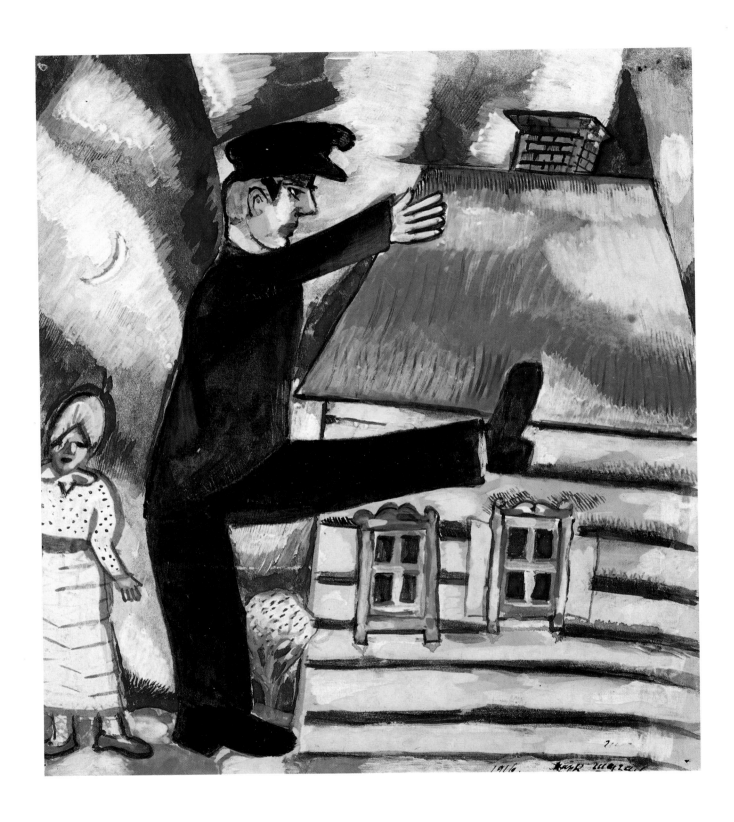

In Step. 1916
CAT. NO. 105

154

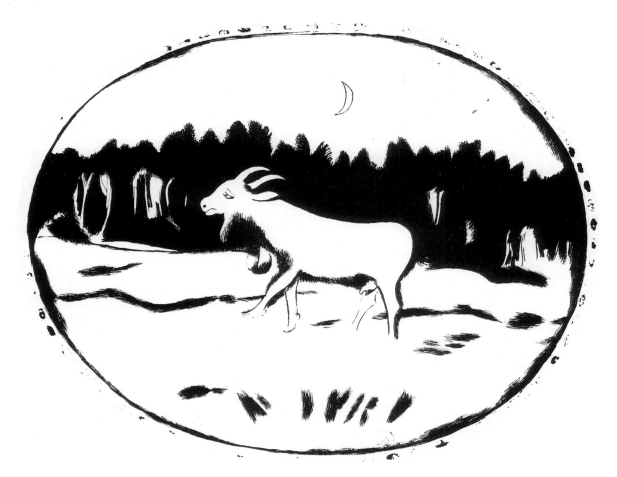

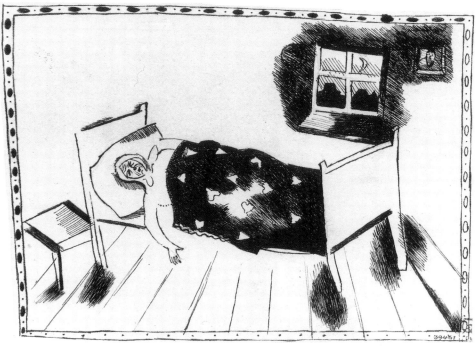

Illustrations to Der Nister's tale
about a little goat and a rooster. 1916
Top: *Goat in the Wood*

CAT. NO. 113

Bottom: *Night*

CAT. NO. 107

155

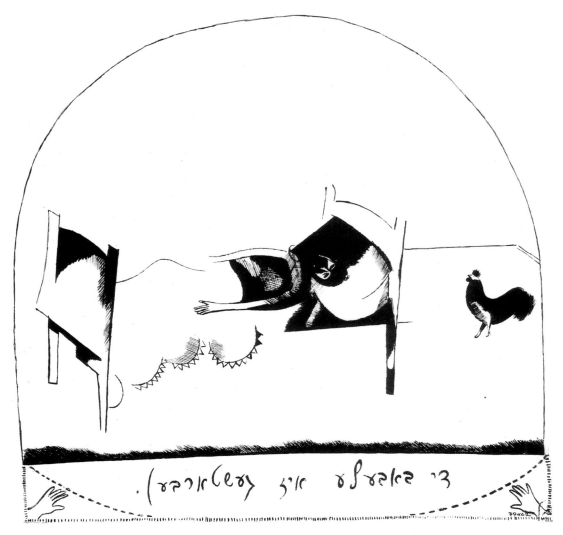

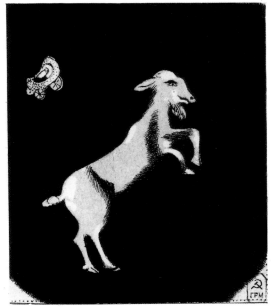

Illustrations to Der Nister's tale
about goat and rooster. 1916
Top: *Man in Bed and Rooster*
CAT. NO. 110
Bottom: *Goat and Perambulator*
CAT. NO. 114

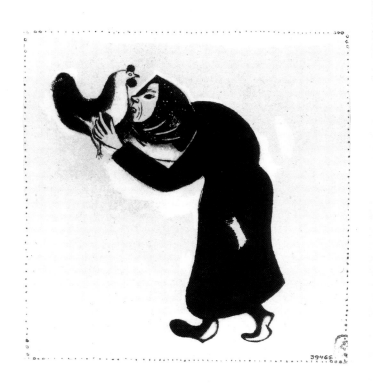

עשתלעמ

Illustrations to Der Nister's tale
about goat and rooster. 1916
Left: *Woman with Rooster*
CAT. NO. 109

Right: *Little Goat and Rooster*. Cover design
CAT. NO. 111

157

Baby in Perambulator and Goat
Illustration to Der Nister's tale about goat and rooster
CAT. NO. 112

Illustrations to Der Nister's tale
about a little goat and a rooster. 1916
Left: *Rooster on Steps*

CAT. NO. 108

Right: *The Little House*

CAT. NO. 106

159

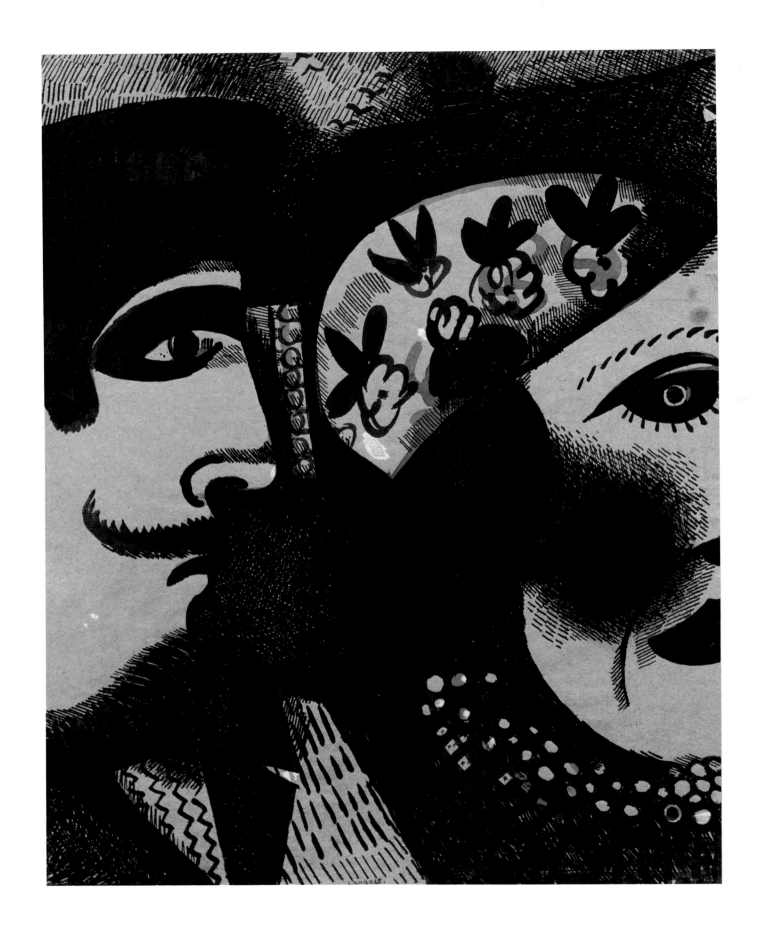

Two Heads. 1918

CAT. NO. 115

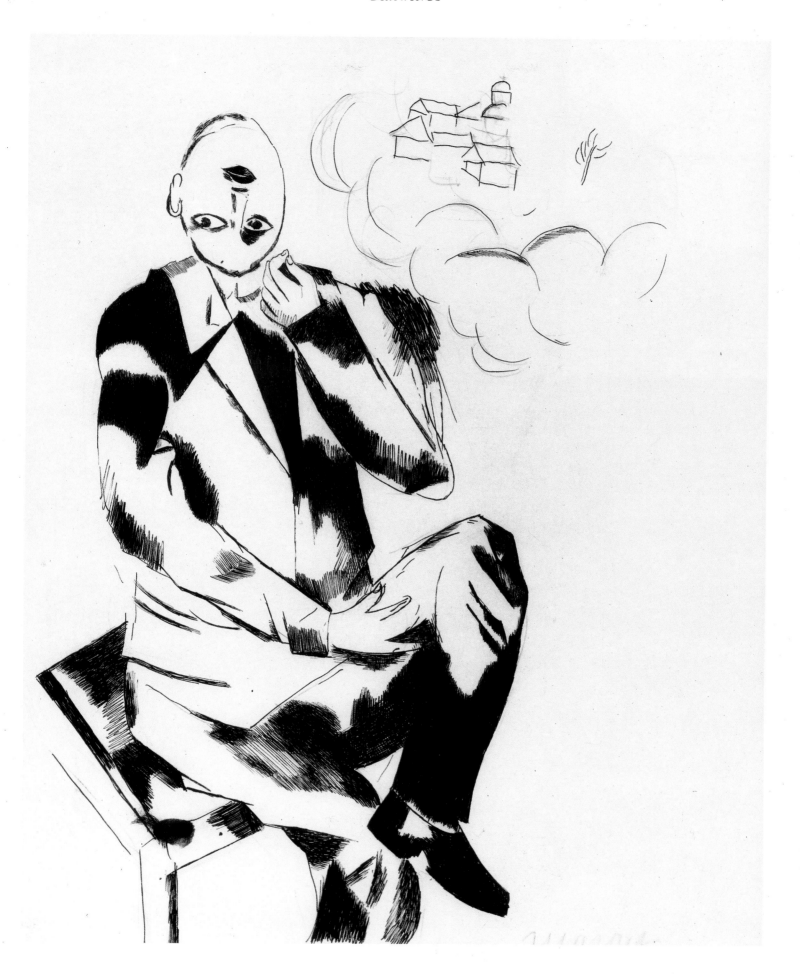

Man with His Head Reversed. Cover design. 1918

CAT. NO. 116

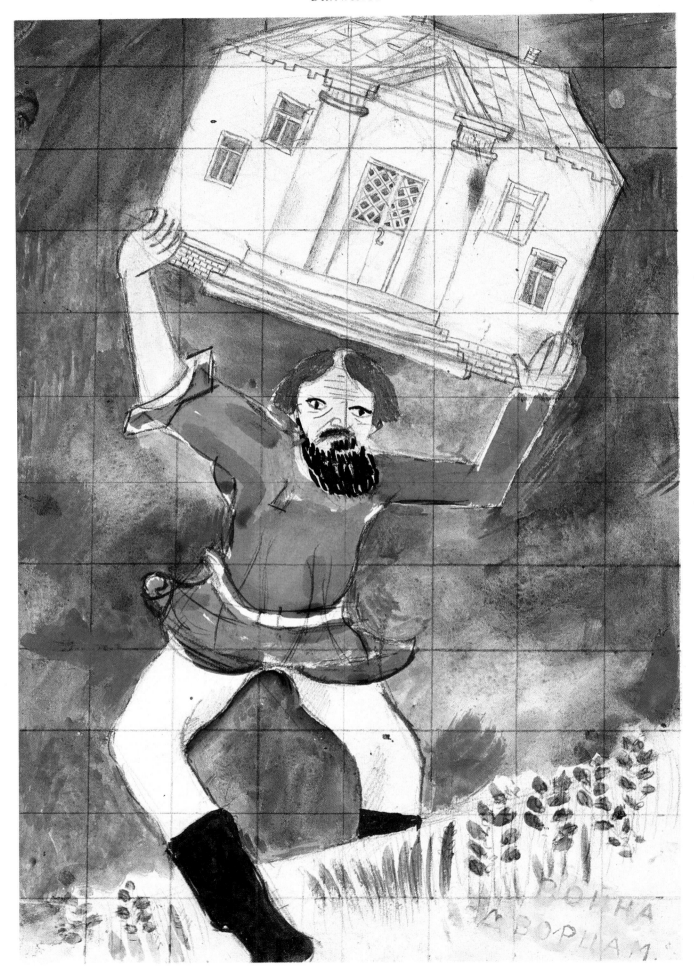

War on the Palaces. 1918—19

CAT. NO. 117

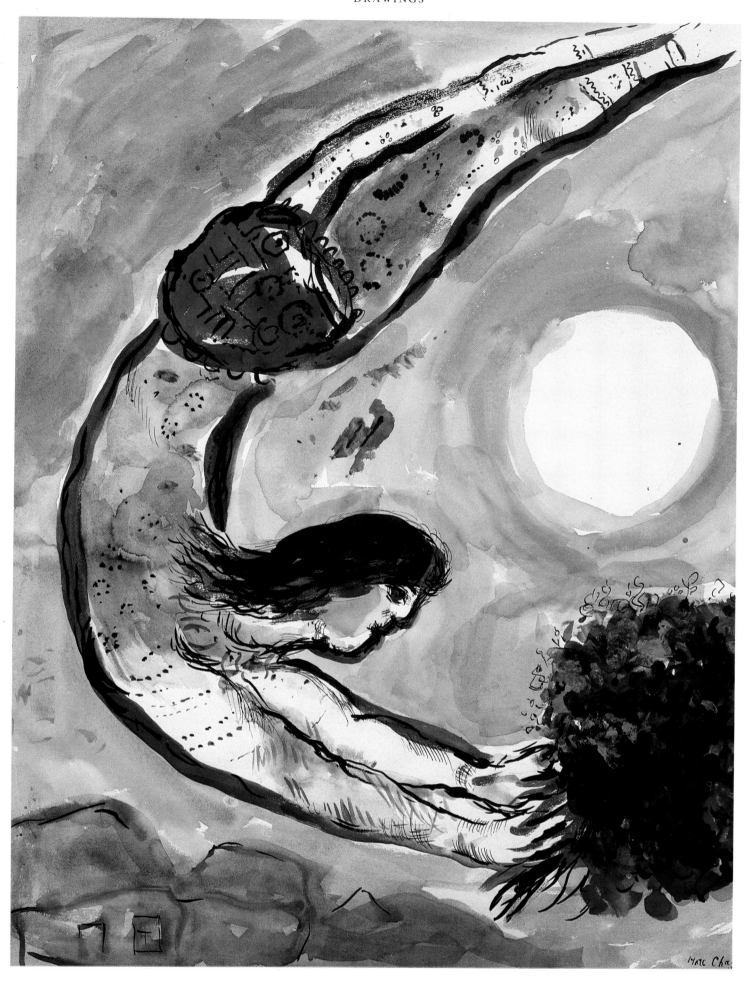

Greetings to My Native Country! 1953

CAT. NO. 118

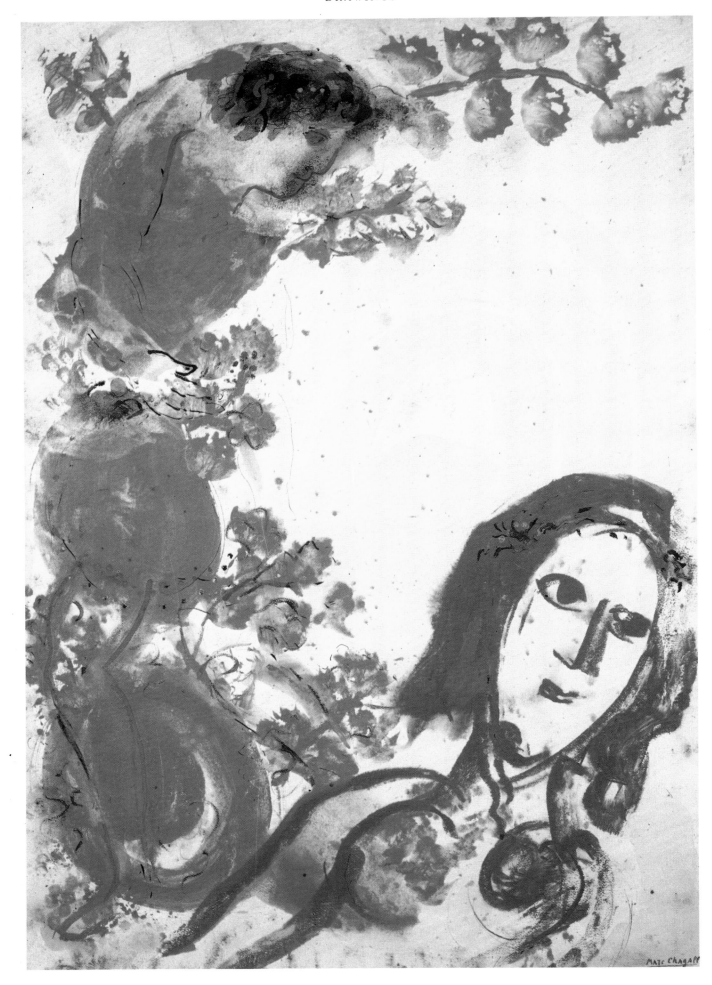

Daphnis and Chloë. 1956
CAT. NO. 119

Self-portrait with Palette. 1966

CAT. NO. 120

165

In Front of the Picture. Drawing on book page. 1959

CAT. NO. 123

Для Лариси.

Дружески

MONOTYPES

Marc Chagall
1968

Self-portrait with Flowering Branch. Drawing on book page. 1968

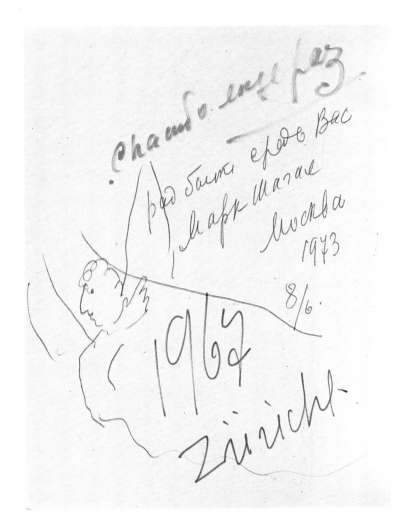

Left: *Self-portrait with Wings.* 1973
CAT. NO. 127

Right: *Figure Beneath a Tree.* Drawing on book page. 1963
CAT. NO. 124

CHAGALL 1972

Cet ouvrage n'aurait pu être réalisé
sans la précieuse collaboration
de Monsieur et Madame Marc Chagall
ainsi que de celle de Madame Ida Chagall
à qui nous adressons
nos plus vifs remerciements.

Marc
Chagall
DE DRAEGER

1979-80

WERNER SCHMALENBACH
CHARLES SORLIER

DRAEGER-VILO PARIS

Top: *The Little Fish*. Drawing on book page. 1972
CAT. NO. 126
Bottom: *Self-portrait with Heart*. Drawing on book page. 1980
CAT. NO. 128

Lyrical Self-portait. 1973
CAT. NO. 121

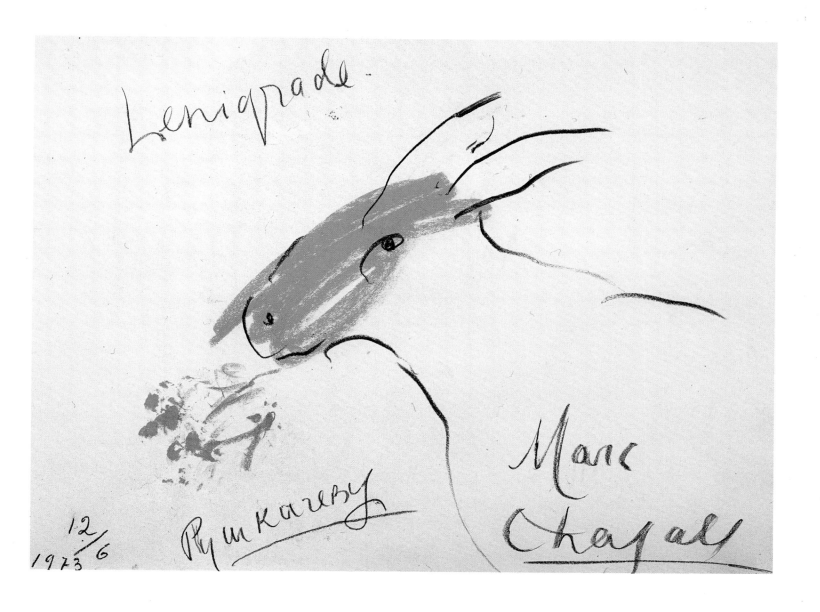

Little Goat. 1973

CAT. NO. 122

The Arrival of Chichikov
CAT. NO. 129

Coachman Selifan

CAT. NO. 130

Petrushka

CAT. NO. 131

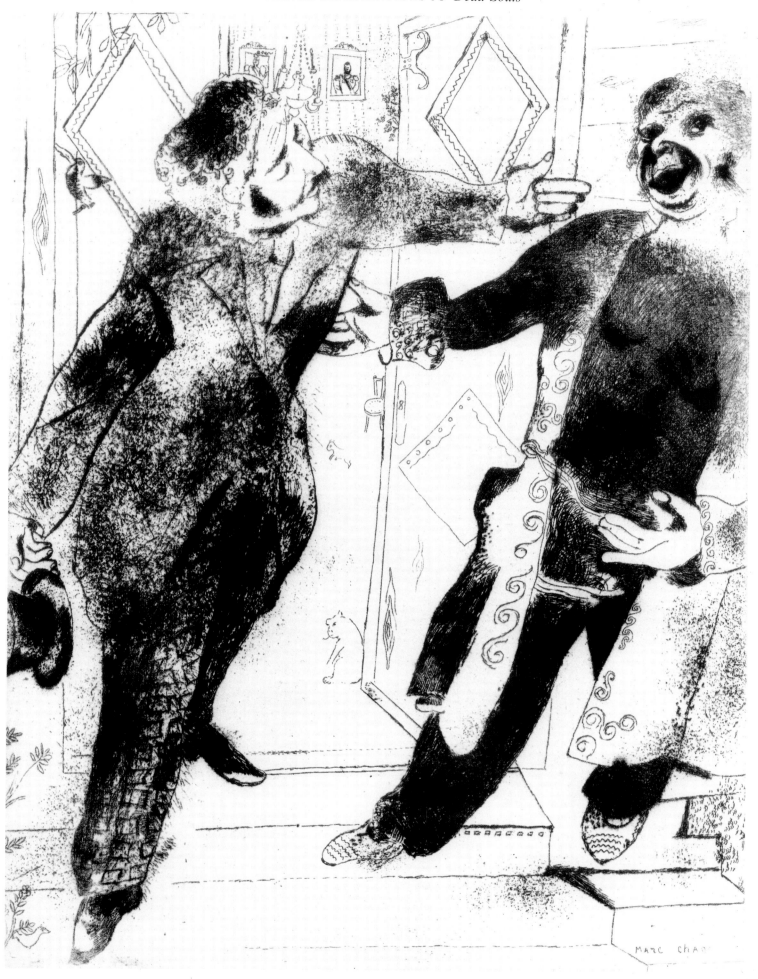

Chichikov and Manilov

CAT. NO. 132

175

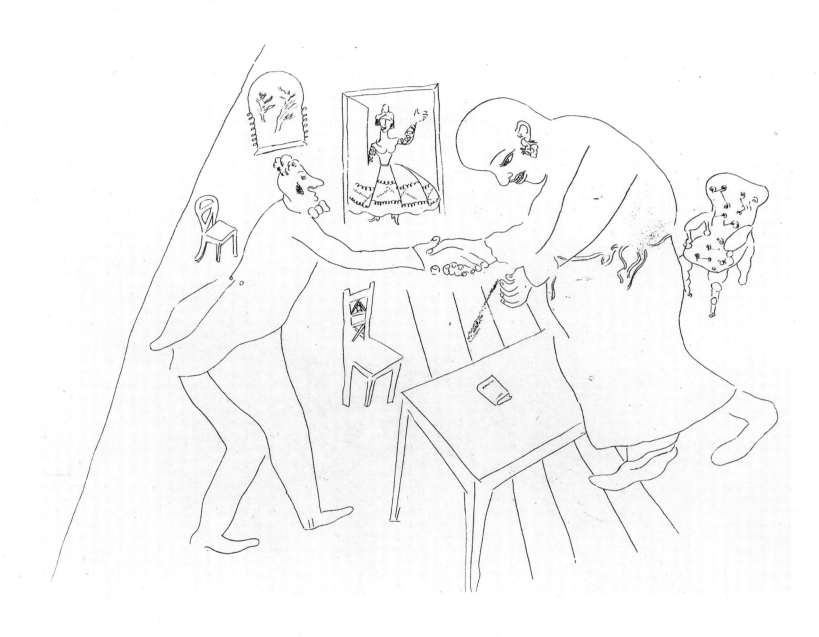

Chichikov at Manilov's

CAT. NO. 133

Courtyard at Korobochka's

CAT. NO. 134

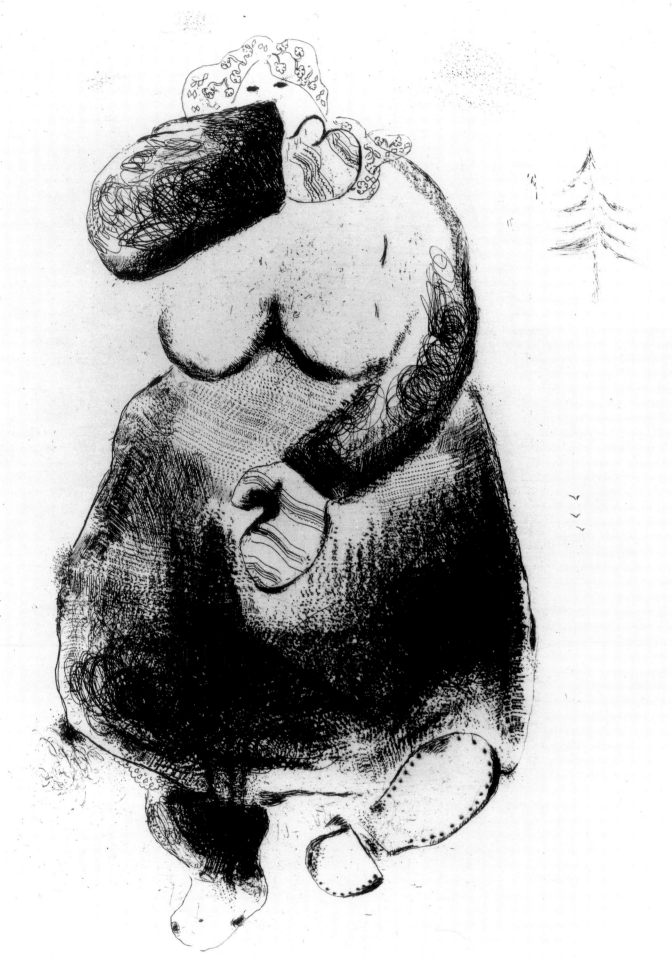

Peasant Woman

CAT. NO. 135

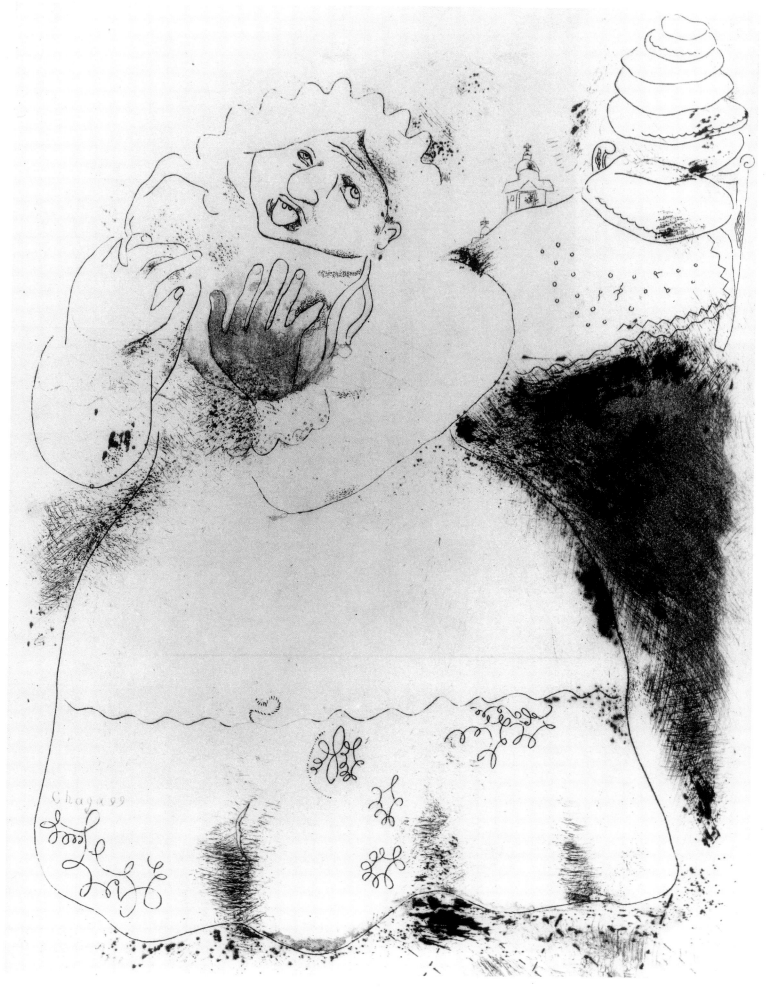

Korobochka

CAT. NO. 136

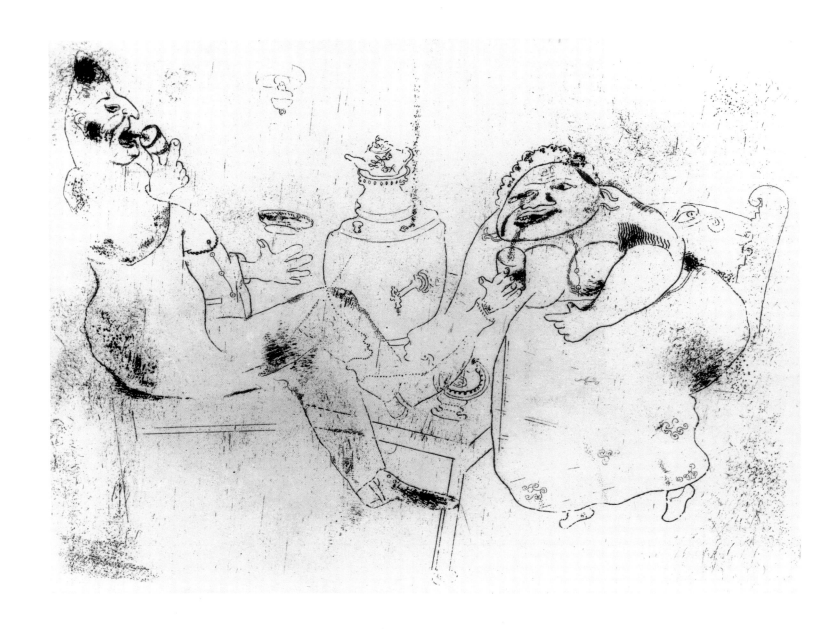

Chichikov at Korobochka's

CAT. NO. 137

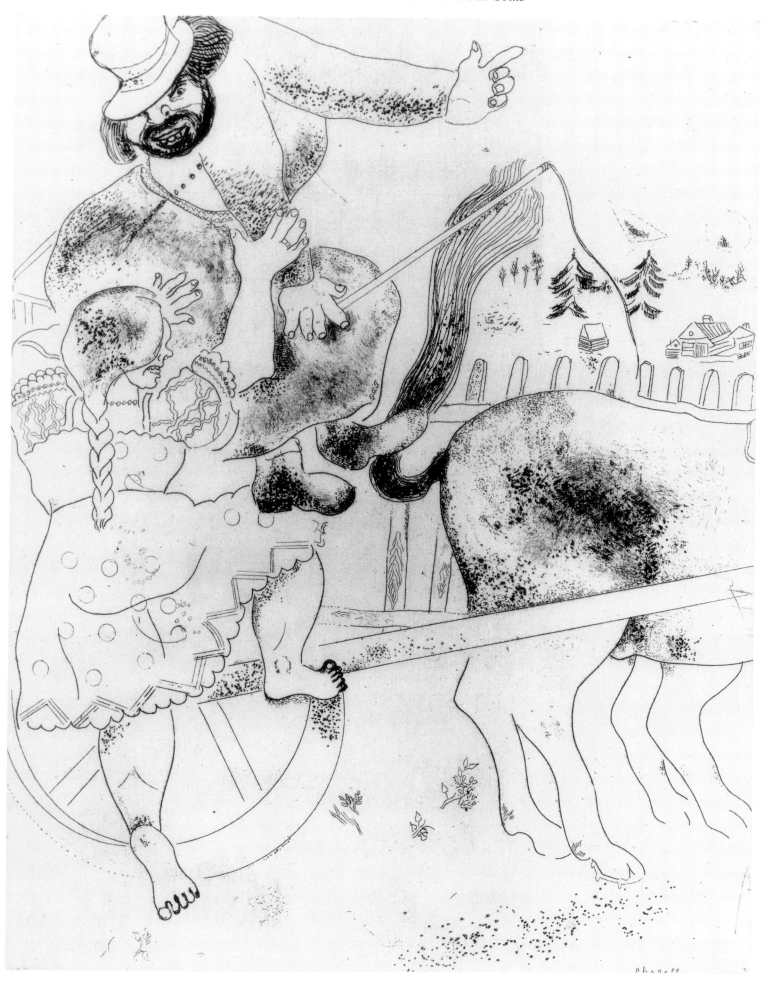

Asking the Way

CAT. NO. 138

181

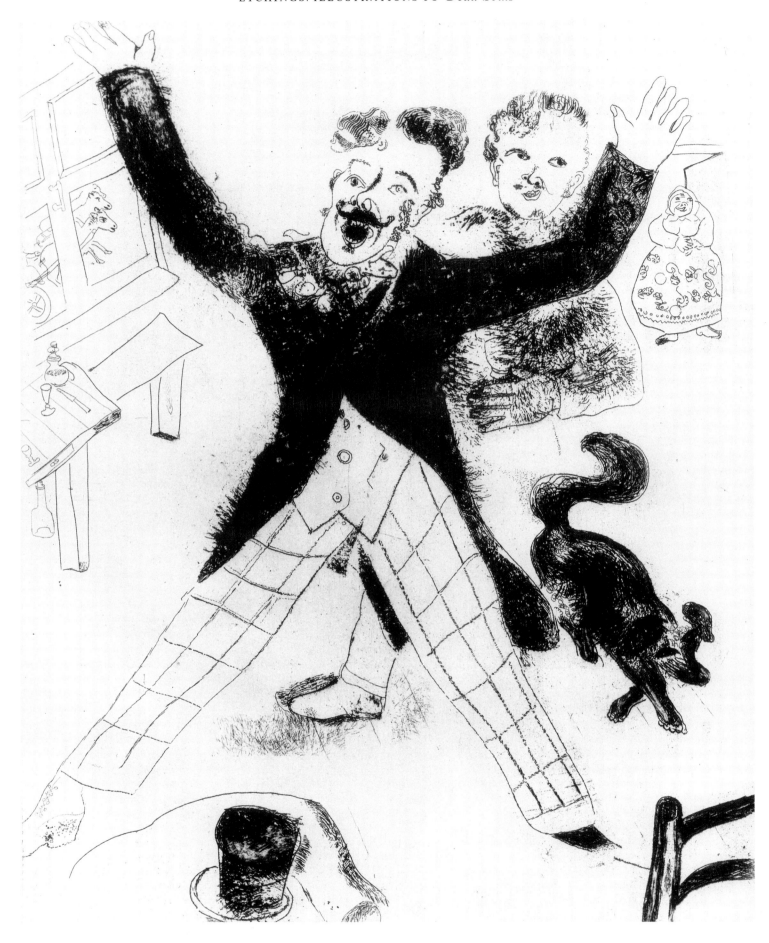

Nozdrev in Tavern
CAT. NO. 139

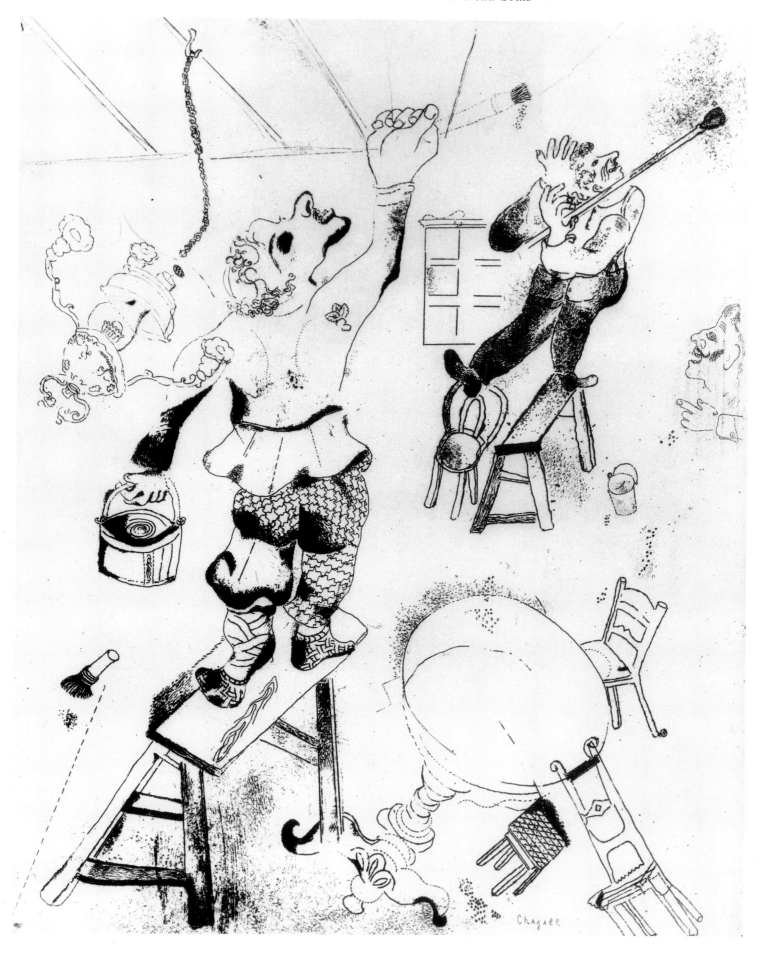

The House Painters

CAT. NO. 140

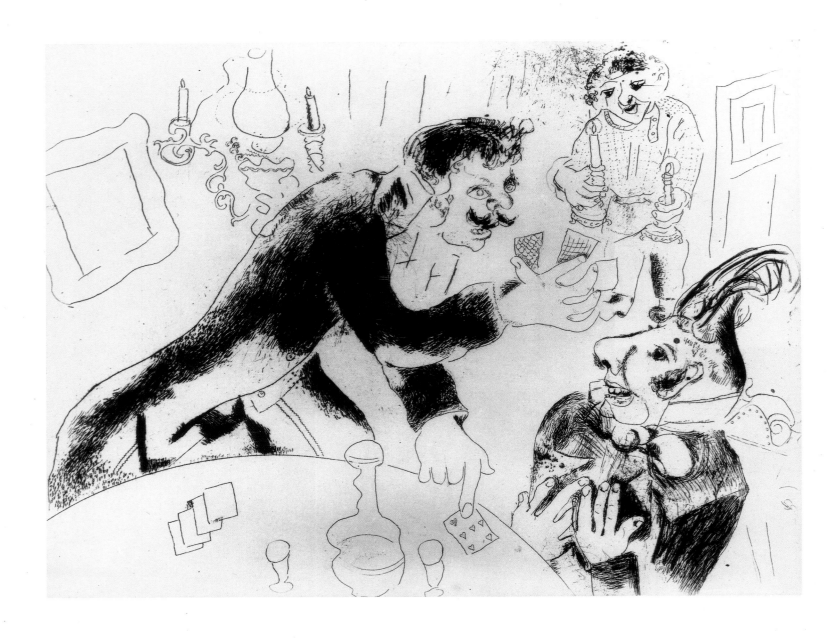

Playing Cards (Nozdrev and Chichikov)
CAT. NO. 141

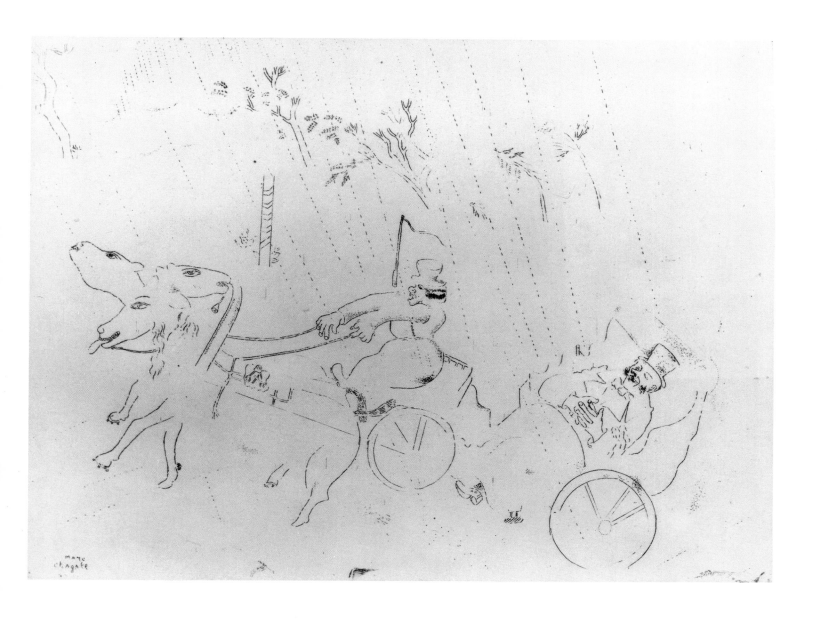

On the Way to Sobakevich's

CAT. NO. 142

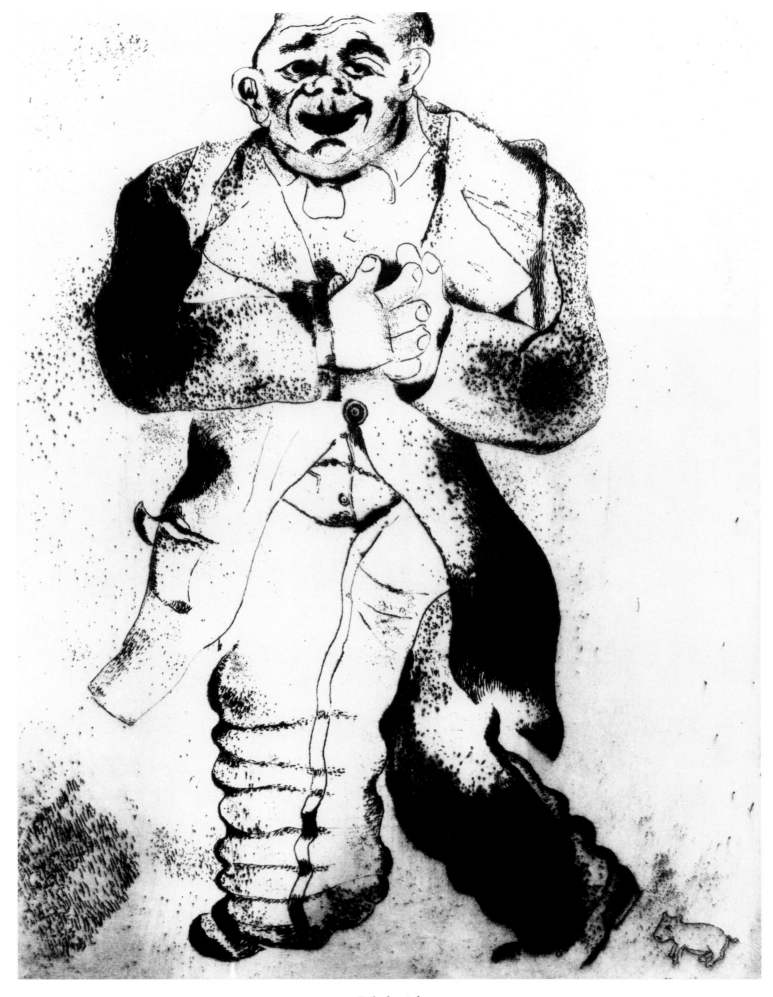

Sobakevich

CAT. NO. 143

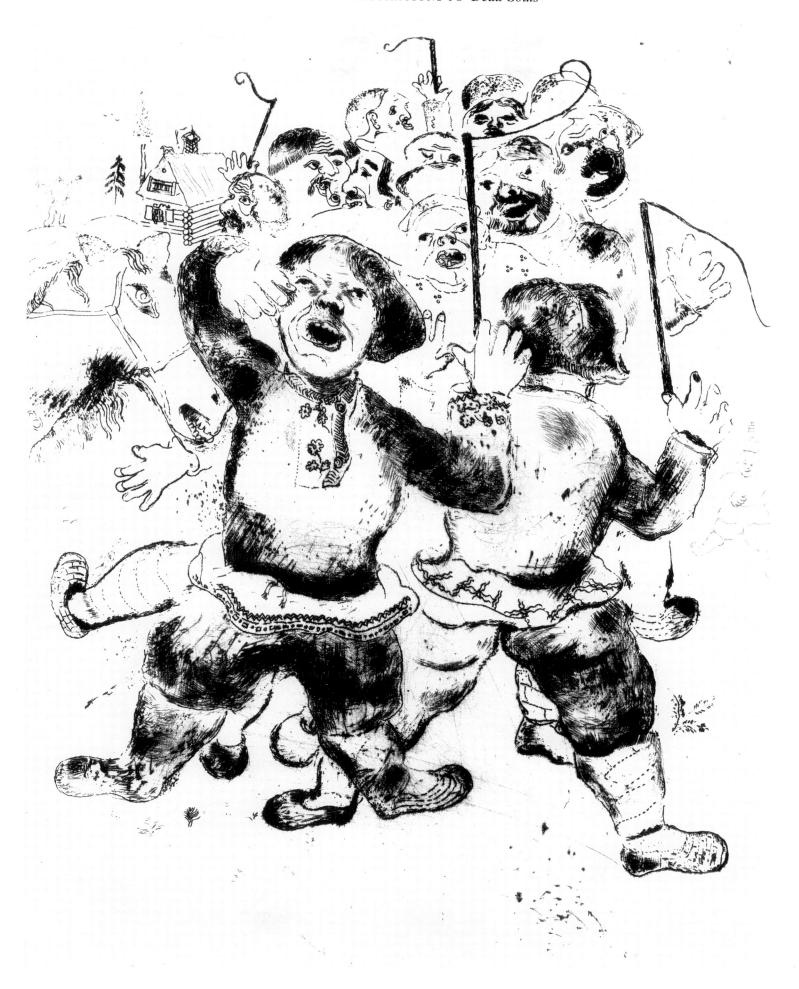

The Coachmen on the Main Road

CAT. NO. 144

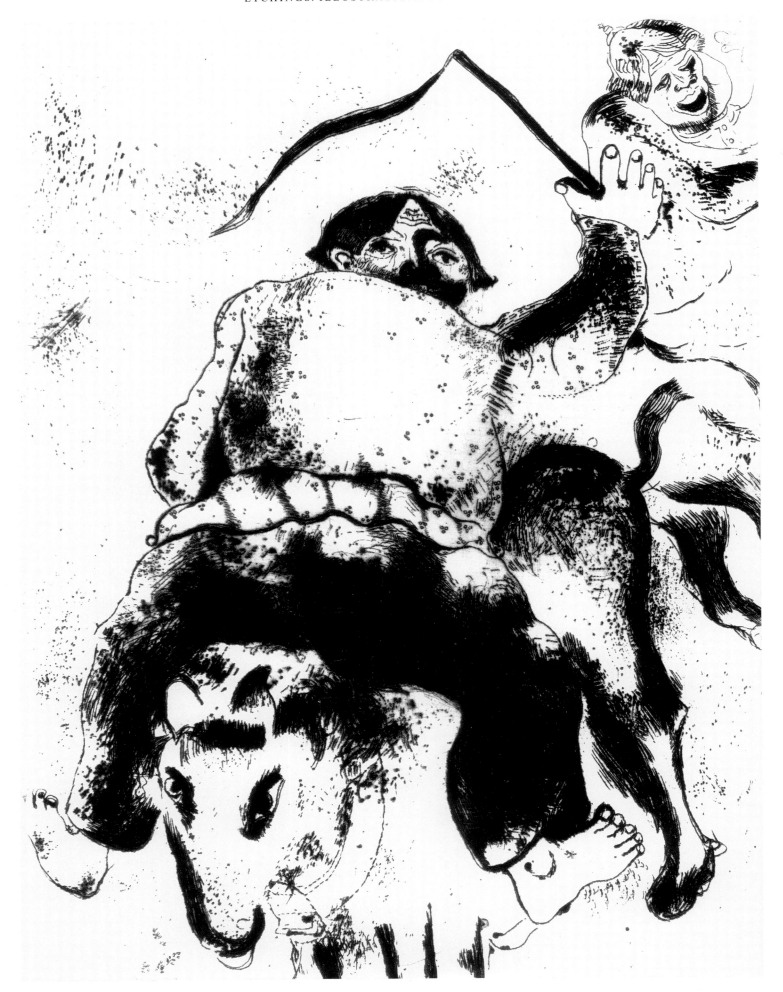

Uncle Mityai and Uncle Minyai

CAT. NO. 145

Chichikov Dreaming of the Governor's Daughter
CAT. NO. 146

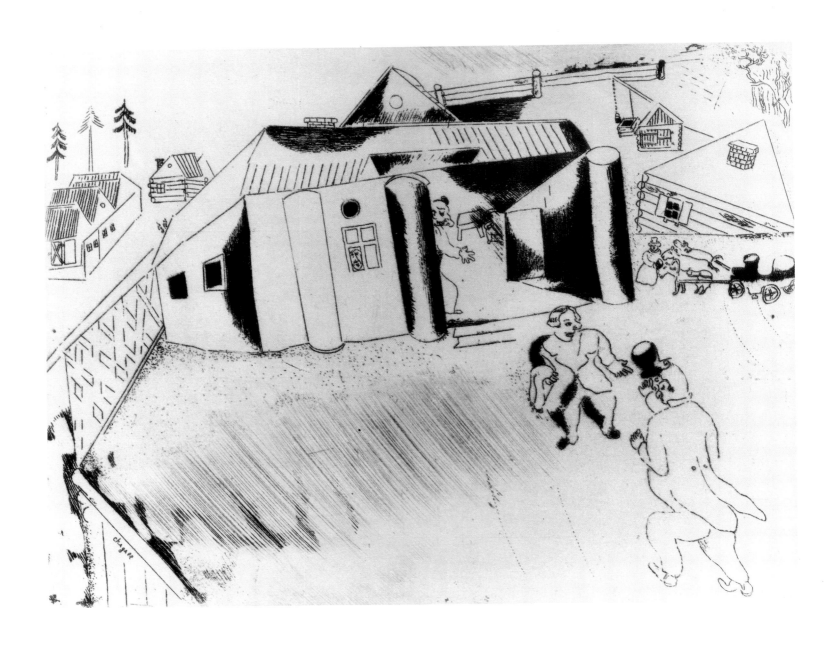

The Arrival of Chichikov at Sobakevich's

CAT. NO. 147

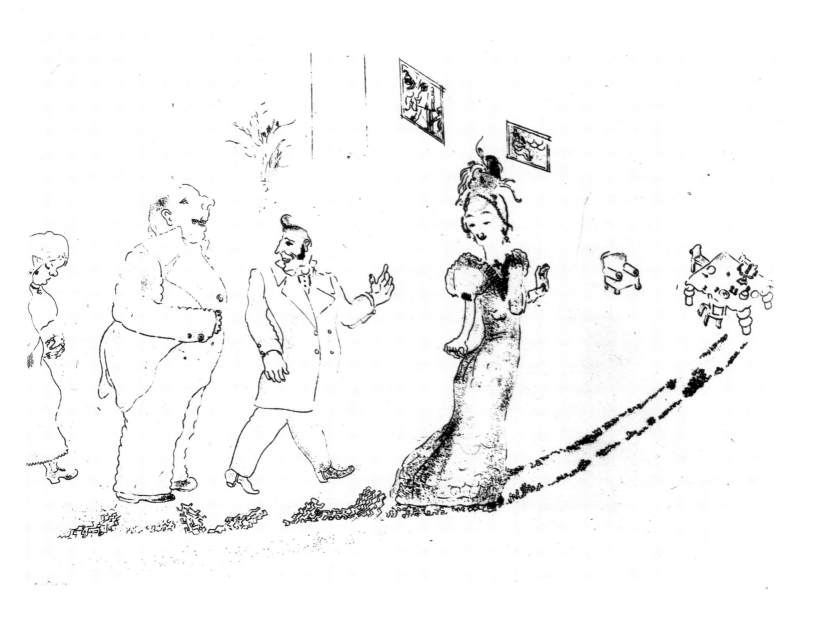

At Sobakevich's: On the Way to the Table
CAT. NO. 148

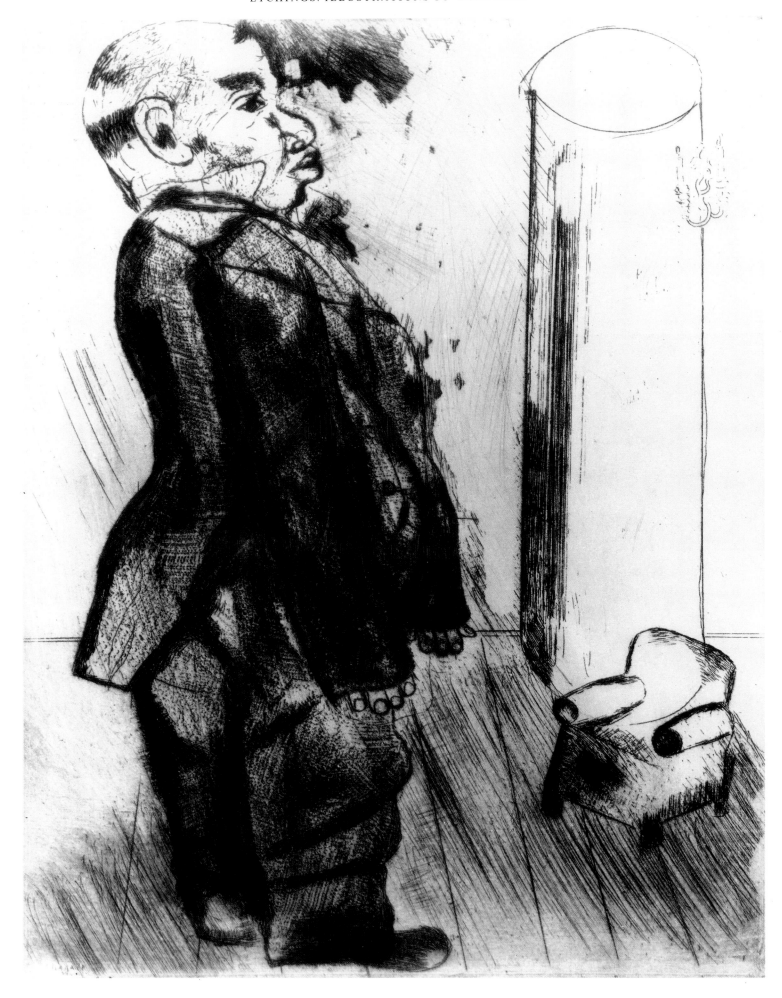

Sobakevich (with Armchair)
CAT. NO. 149

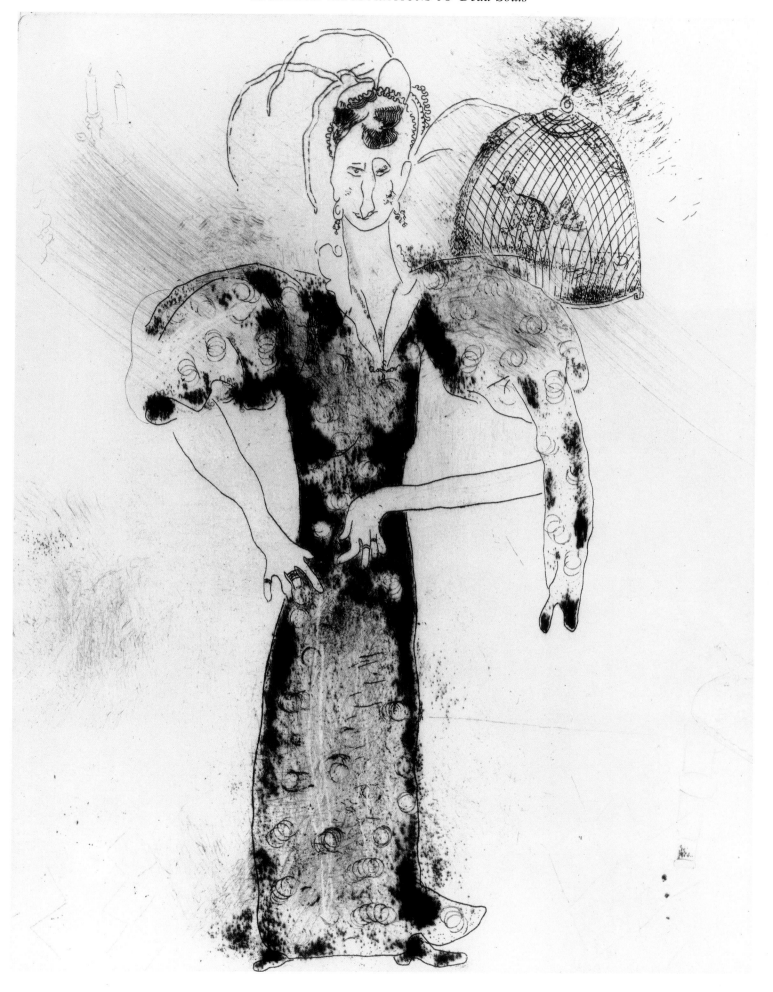

Feodulia Ivanovna, Sobakevich's Spouse

CAT. NO. 150

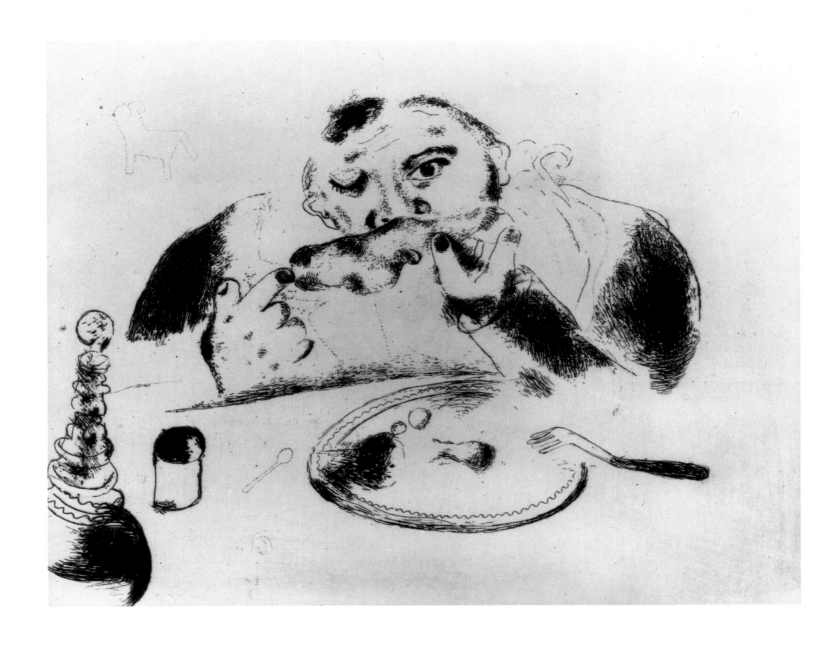

Sobakevich's Feast

CAT. NO. 151

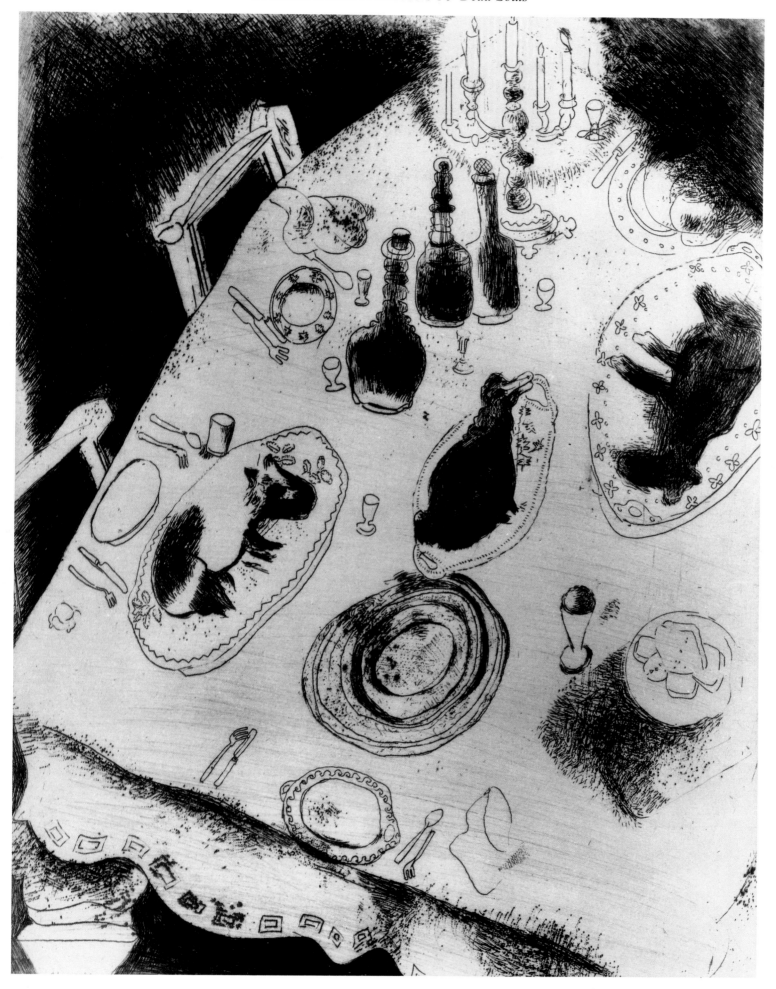

The Table at Sobakevich's

CAT. NO. 152

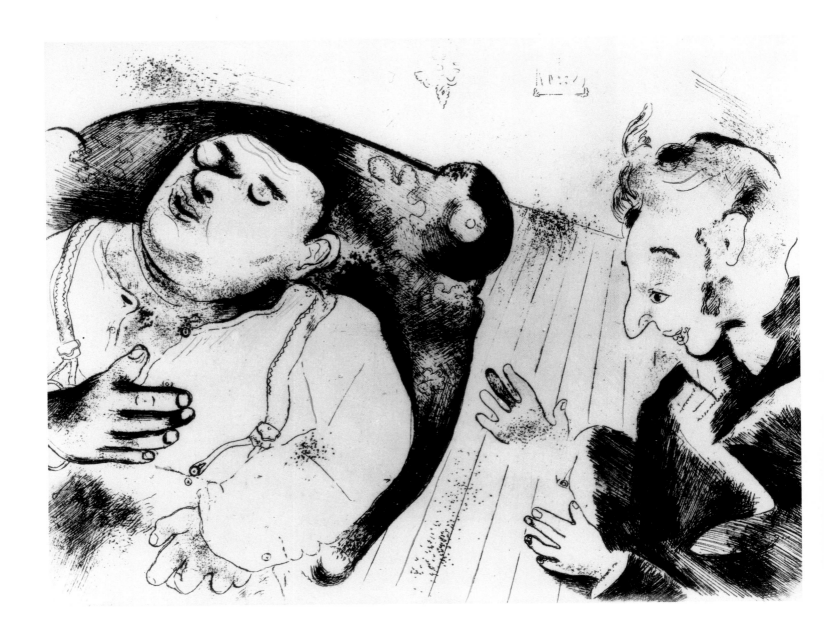

Chichikov and Sobakevich, Nodding Off

CAT. NO. 153

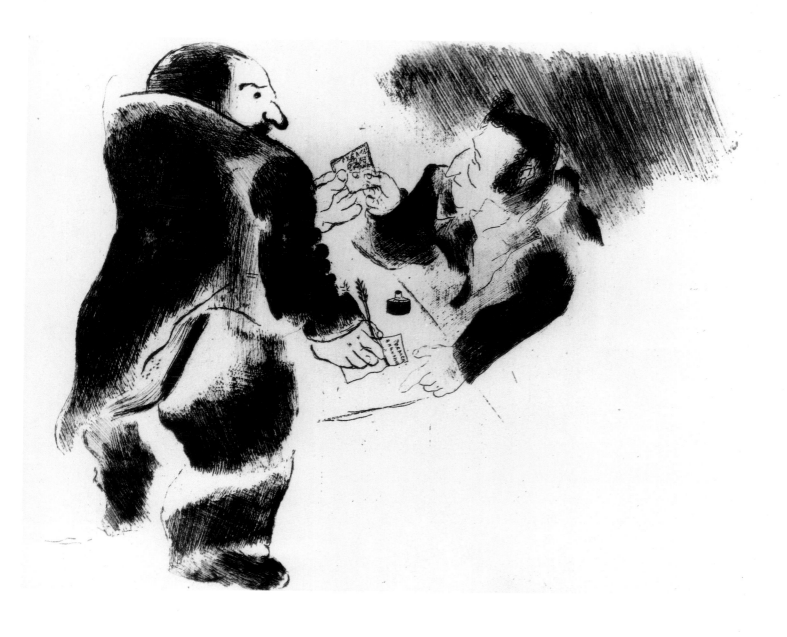

Chichikov and Sobakevich Discussing Business
CAT. NO. 154

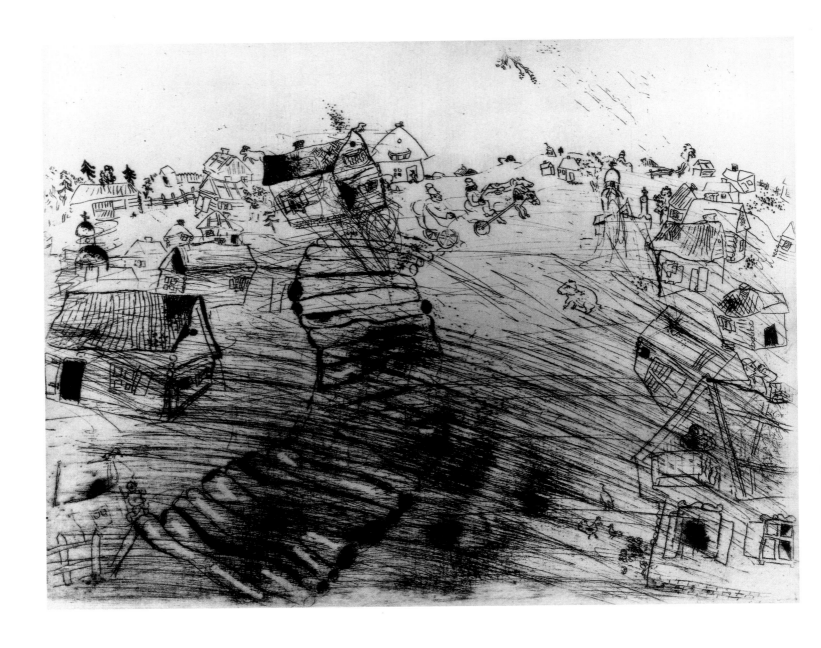

The Arrival at Plyushkin's Village
CAT. NO. 155

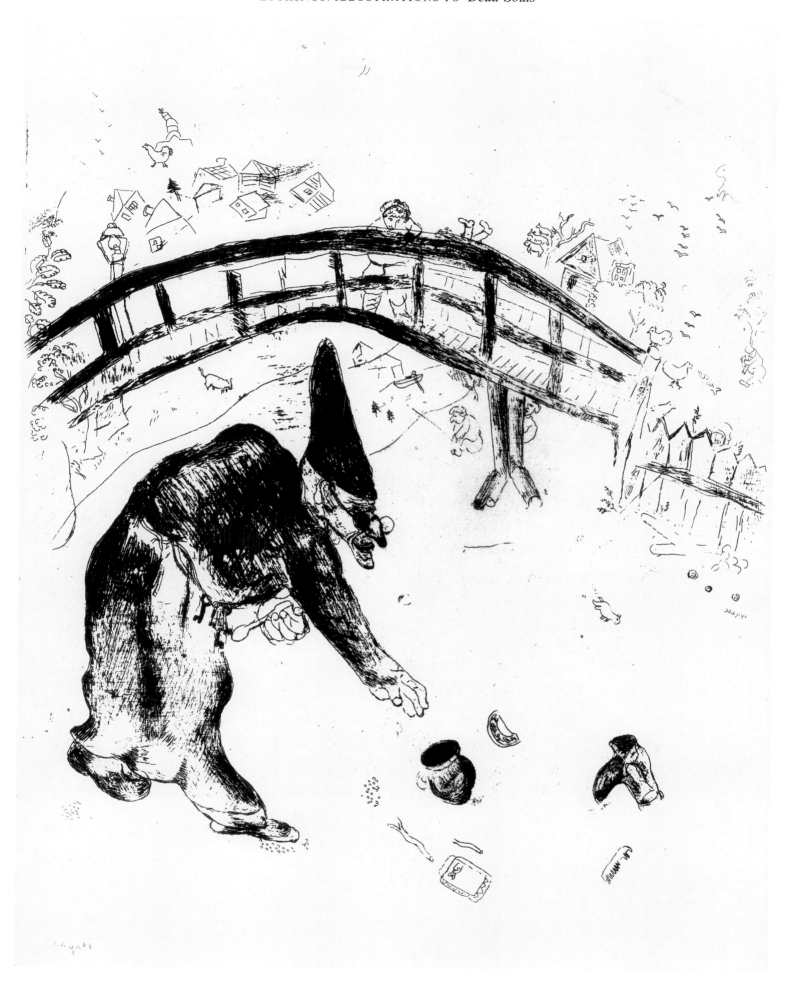

Plyushkin Sweeping Up

CAT. NO. 156

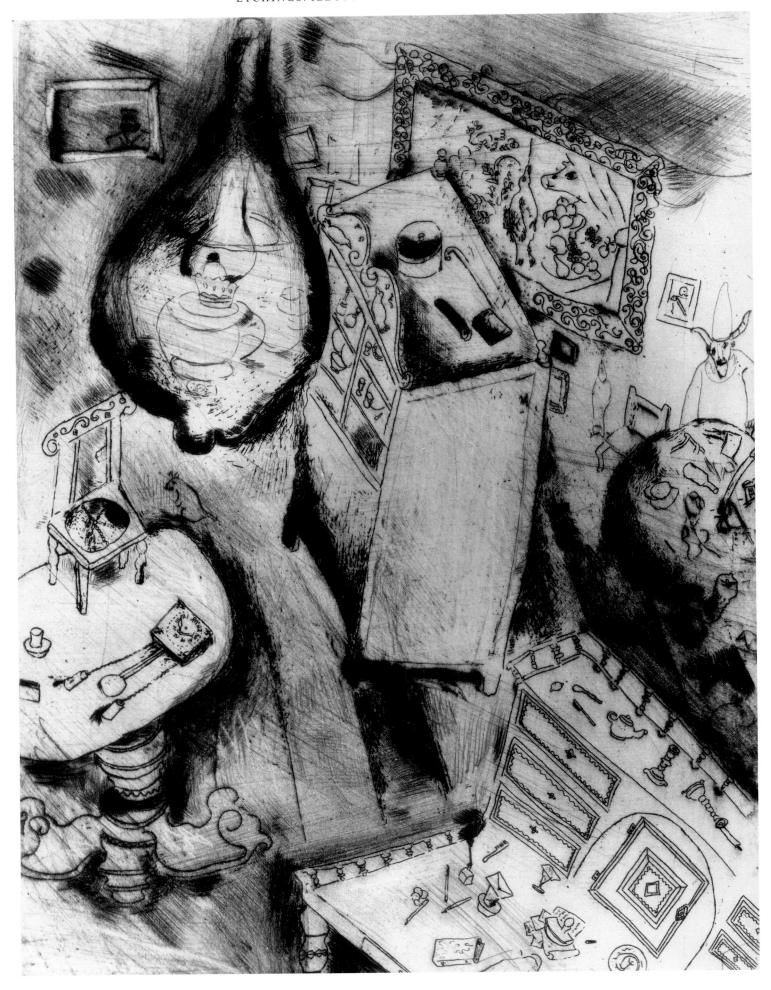

Plyushkin's Study

CAT. NO. 157

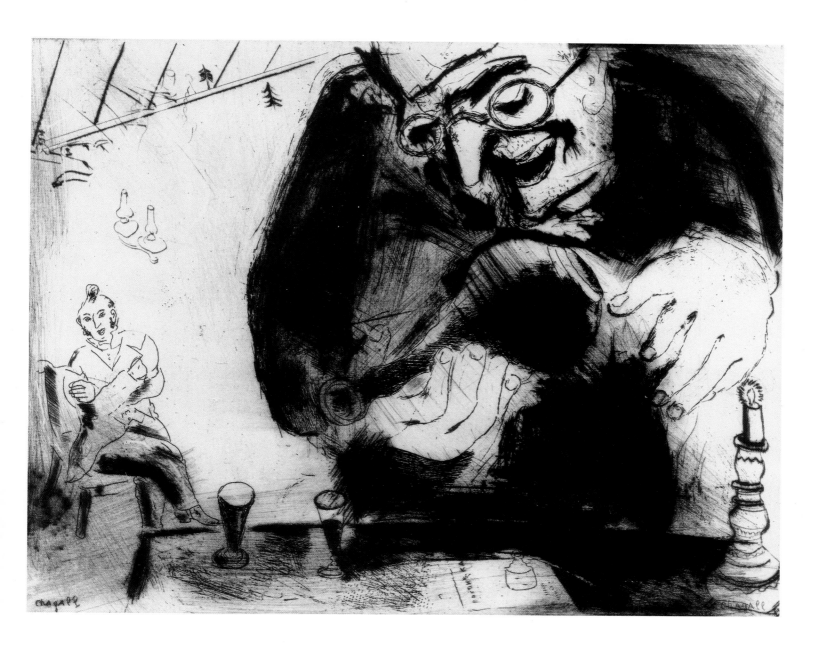

Chichikov at Plyushkin's

CAT. NO. 158

201

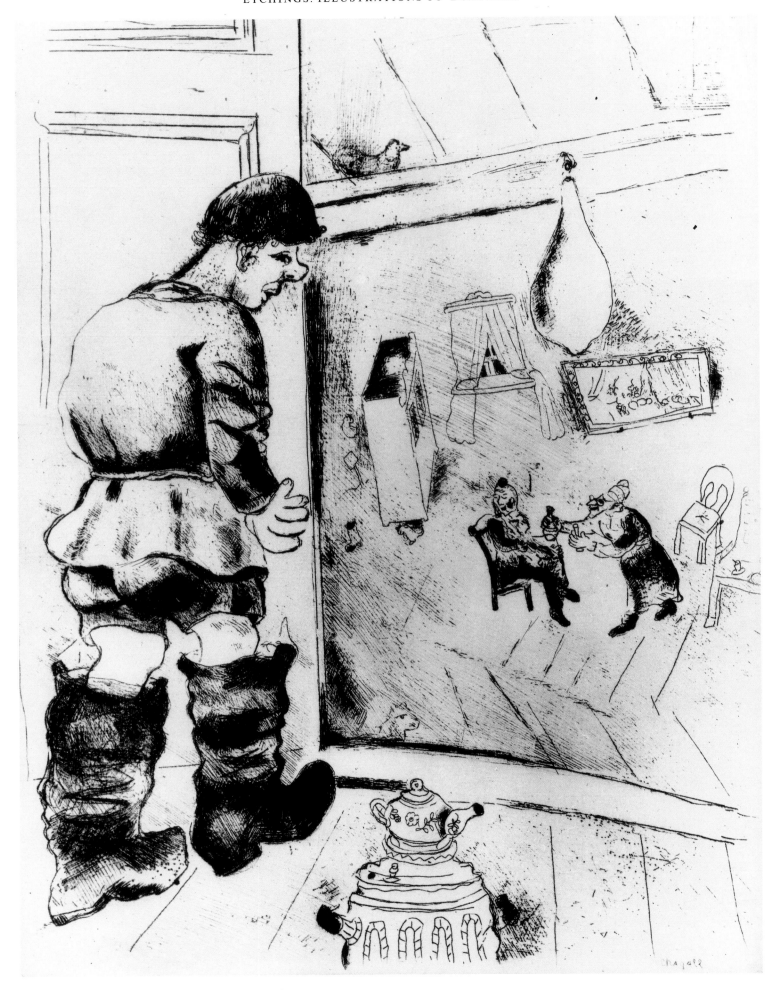

Proshka Peeping

CAT. NO. 159

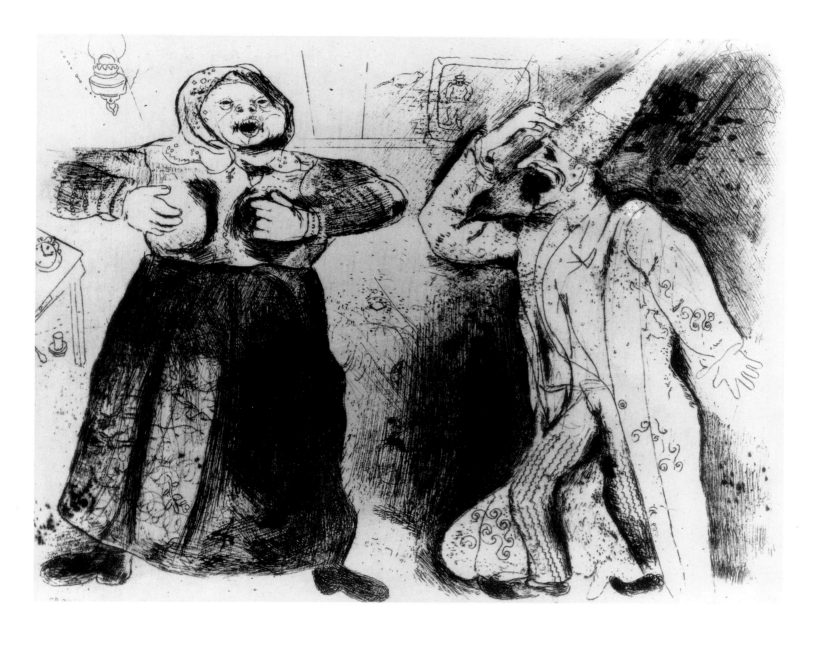

Plyushkin and His Cook Mavra

CAT. NO. 160

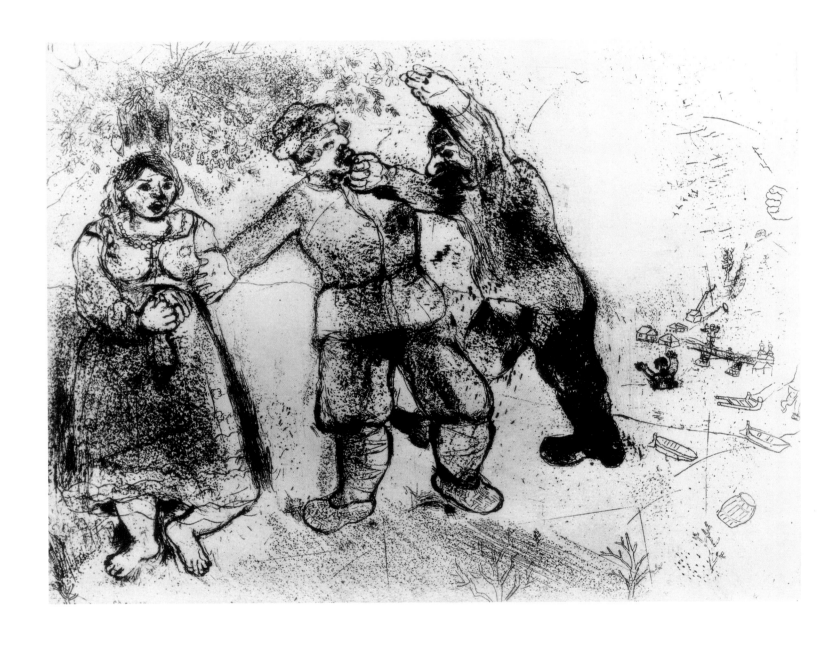

The Fate of Grigory

CAT. NO. 161

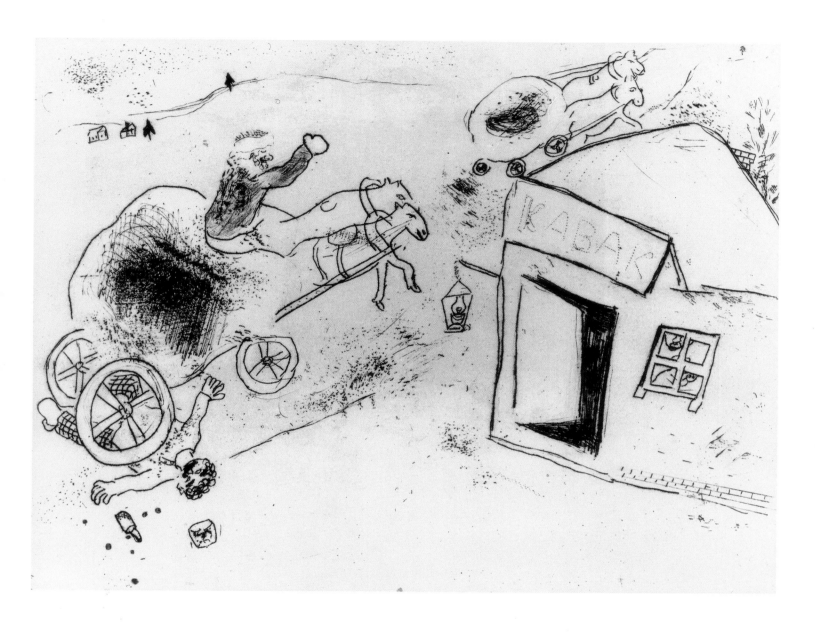

Death of Pyotr Neuvazhai-Koryto

CAT. NO. 162

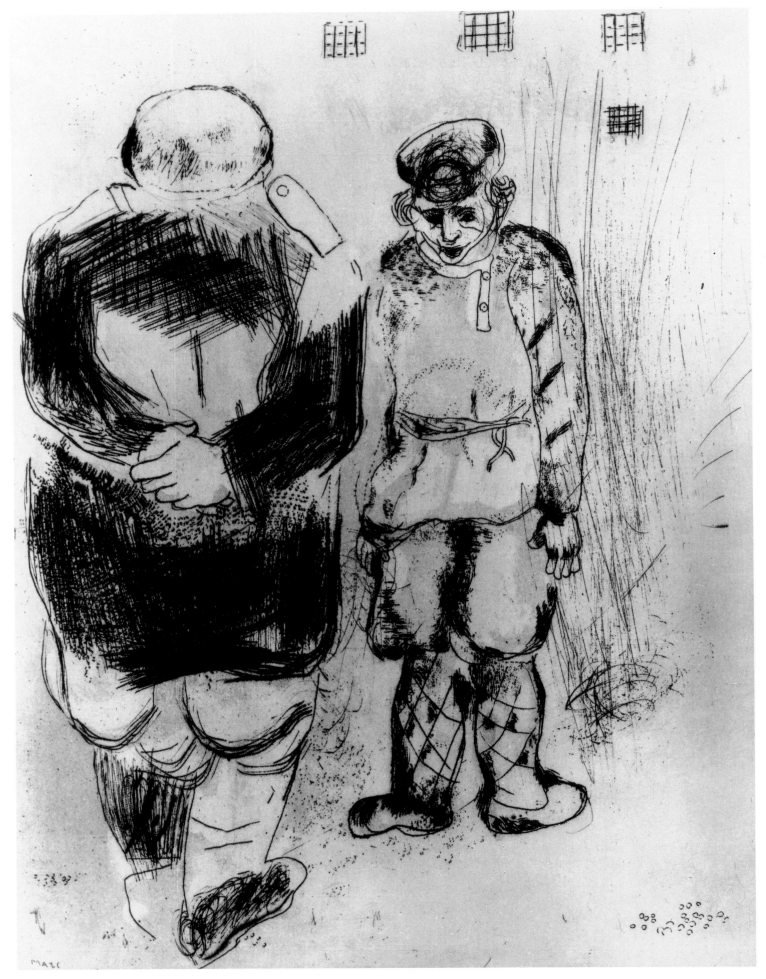

*Peasant Without Passport Before
the Chief of Police District*

CAT. NO. 163

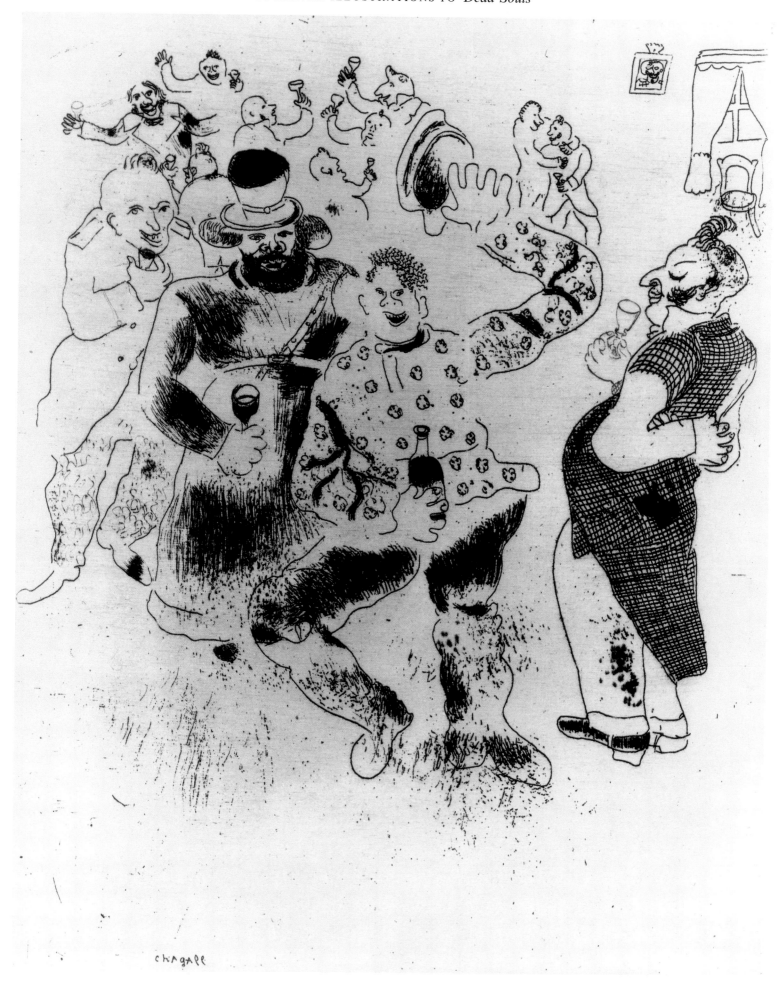

Chichikov, Petrushka and Selifan

CAT. NO. 164

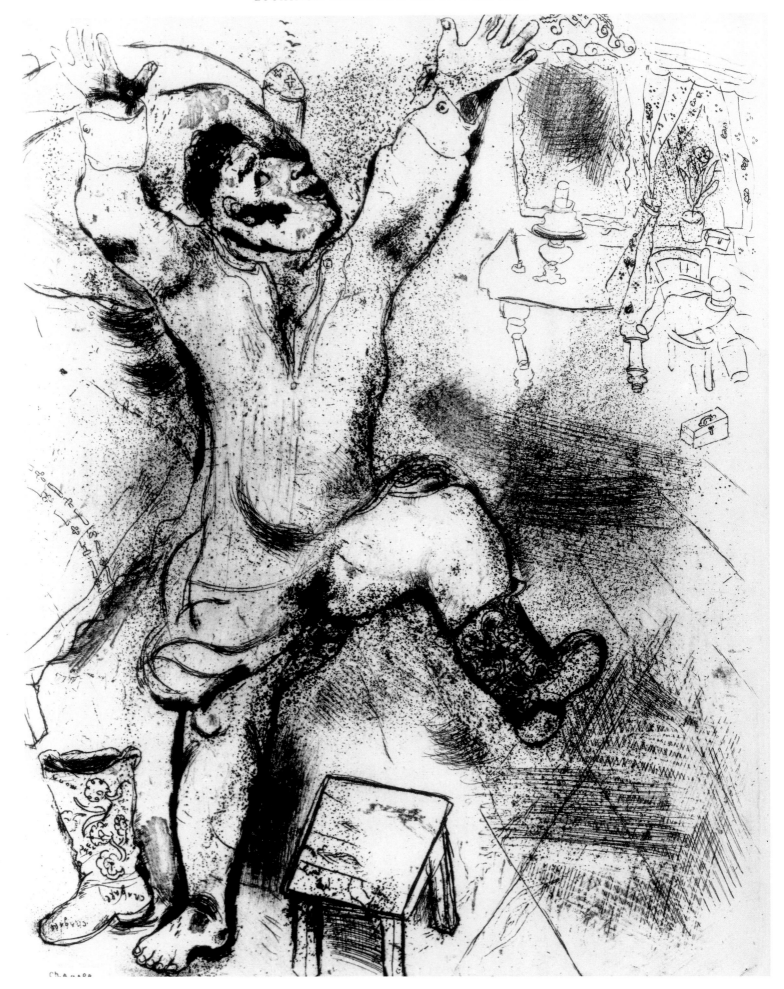

Chichikov's Triumph

CAT. NO. 165

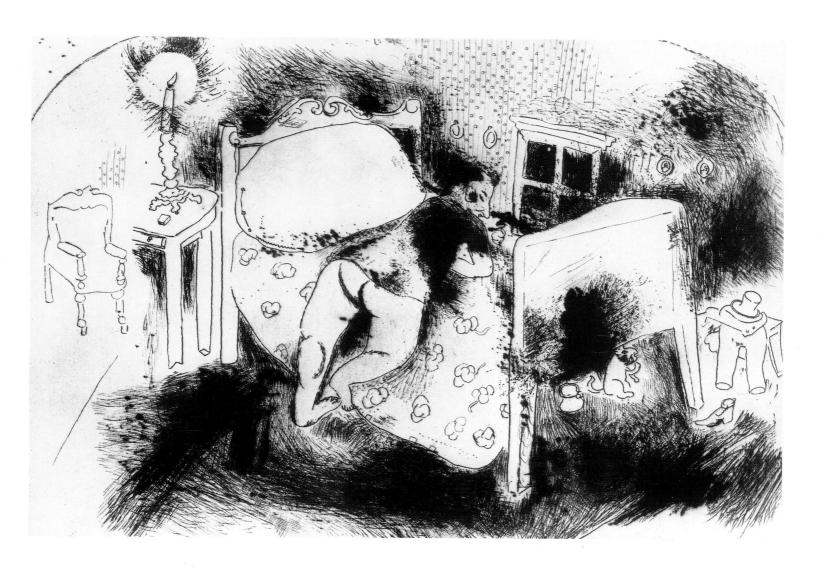

Chichikov in Bed

CAT. NO. 166

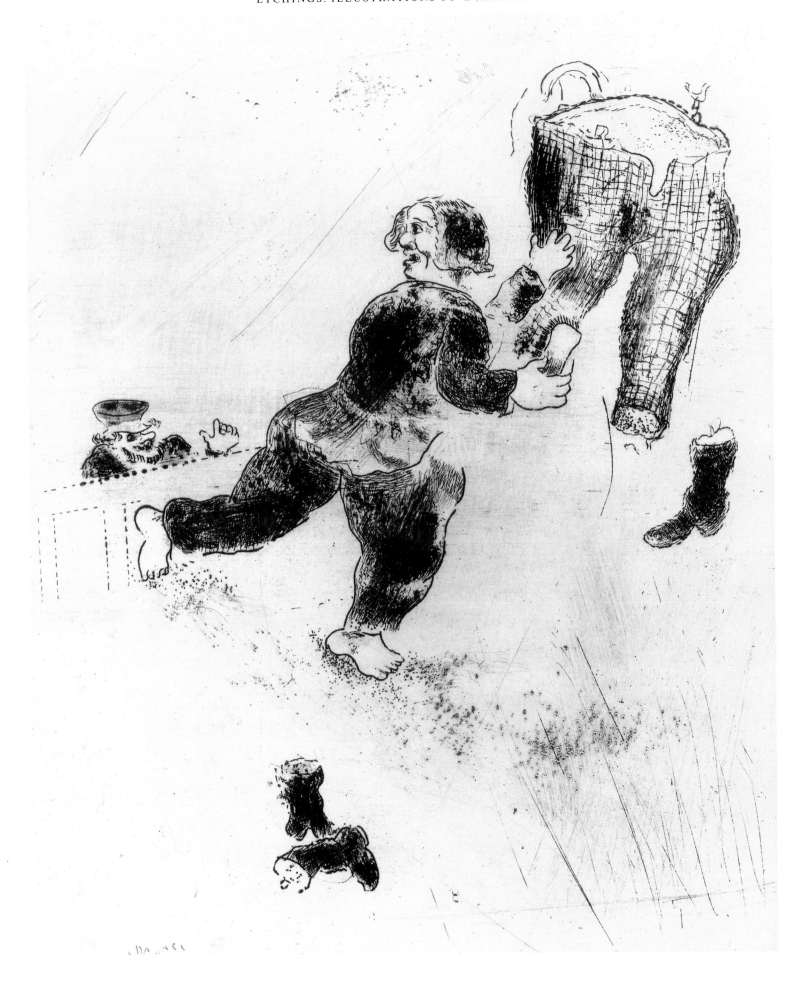

Petrushka Holding Chichikov's Pantaloons, and Selifan

CAT. NO. 167

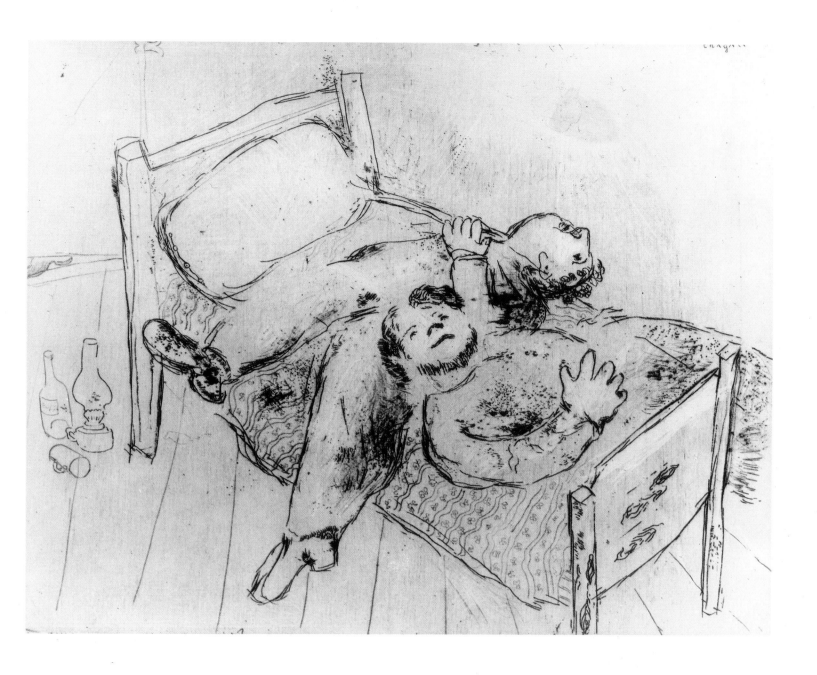

Drunken Petrushka and Selifan

CAT. NO. 168

211

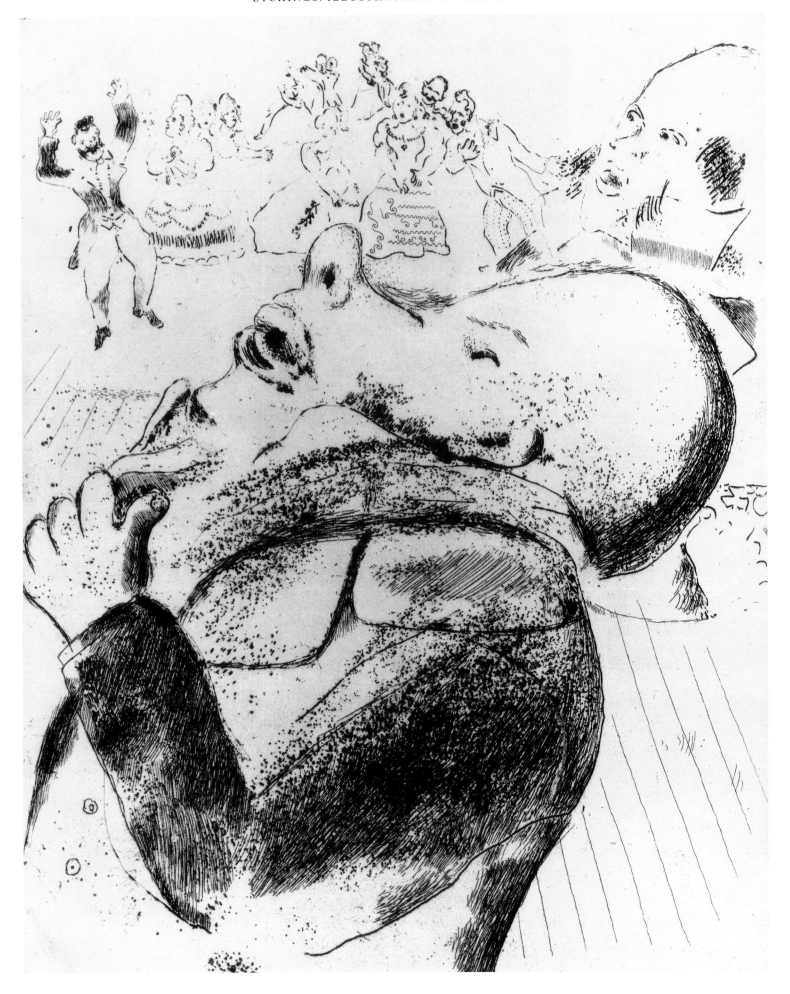

Chichikov at the Governor's. Nozdrev Unmasks Chichikov

CAT. NO. 169

212

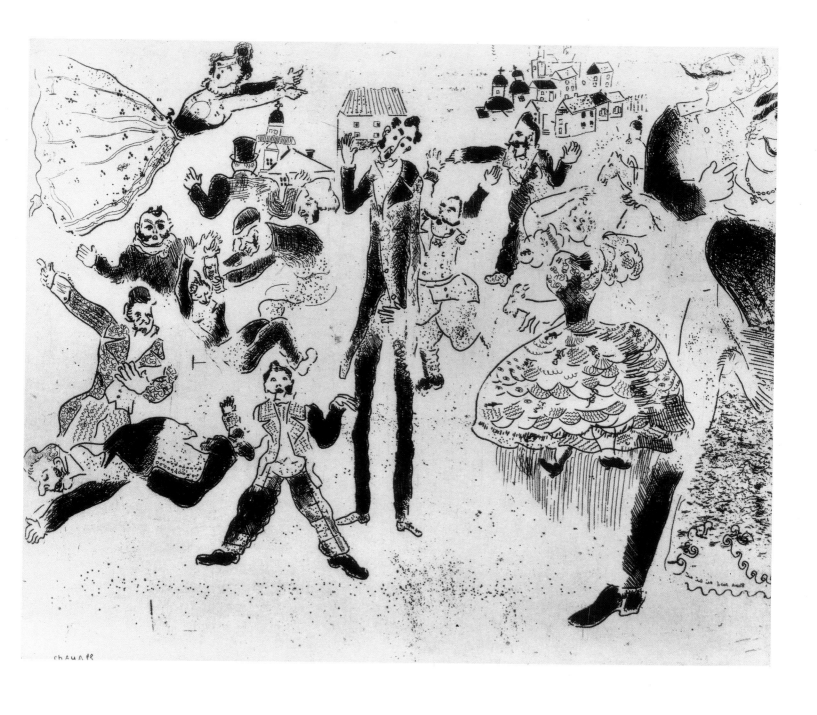

Inhabitants of the Town of N: Rumours and Gossips

CAT. NO. 170

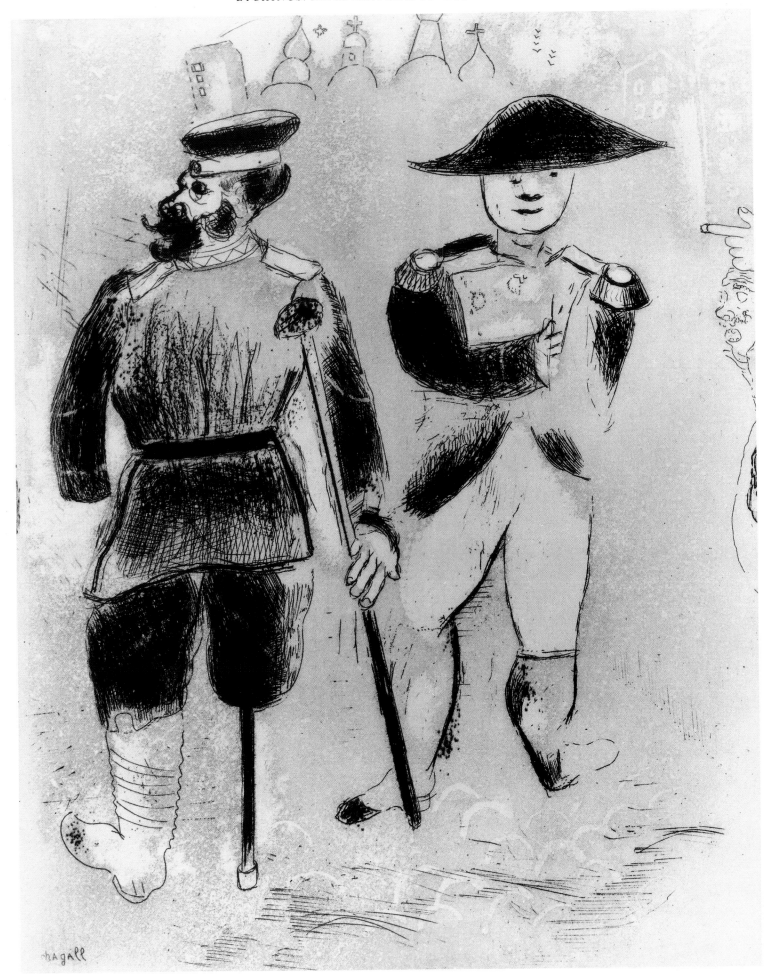

Captain Kopeikin and Napoleon
CAT. NO. 171

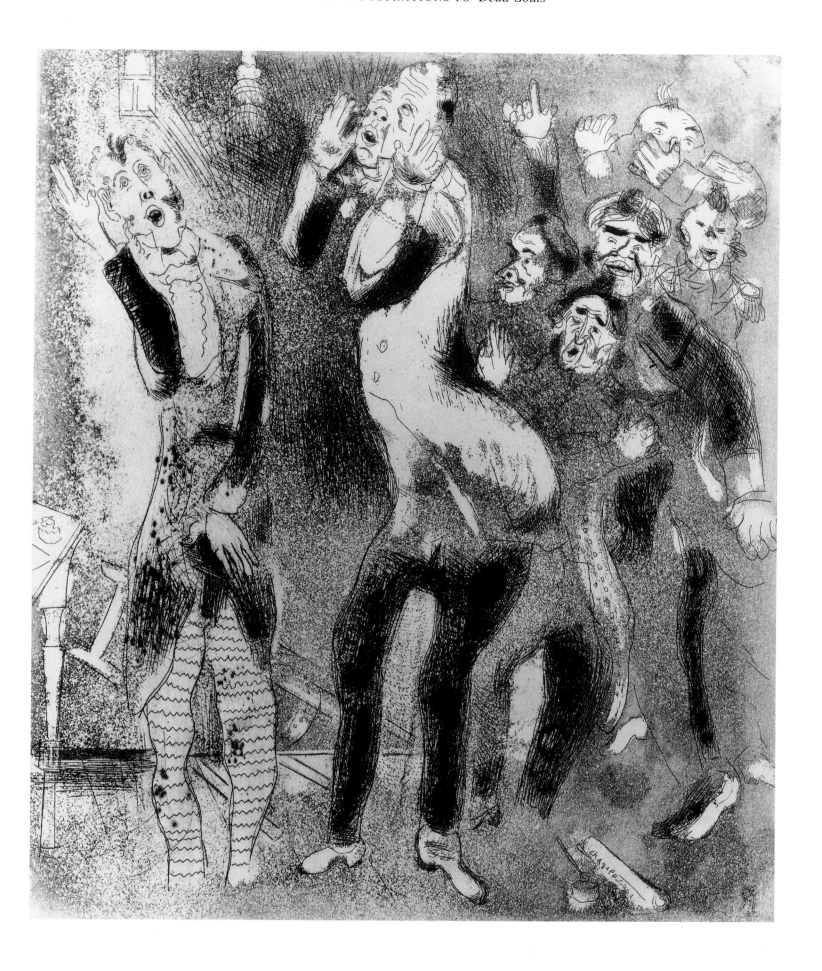

Confusion in the Office

CAT. NO. 172

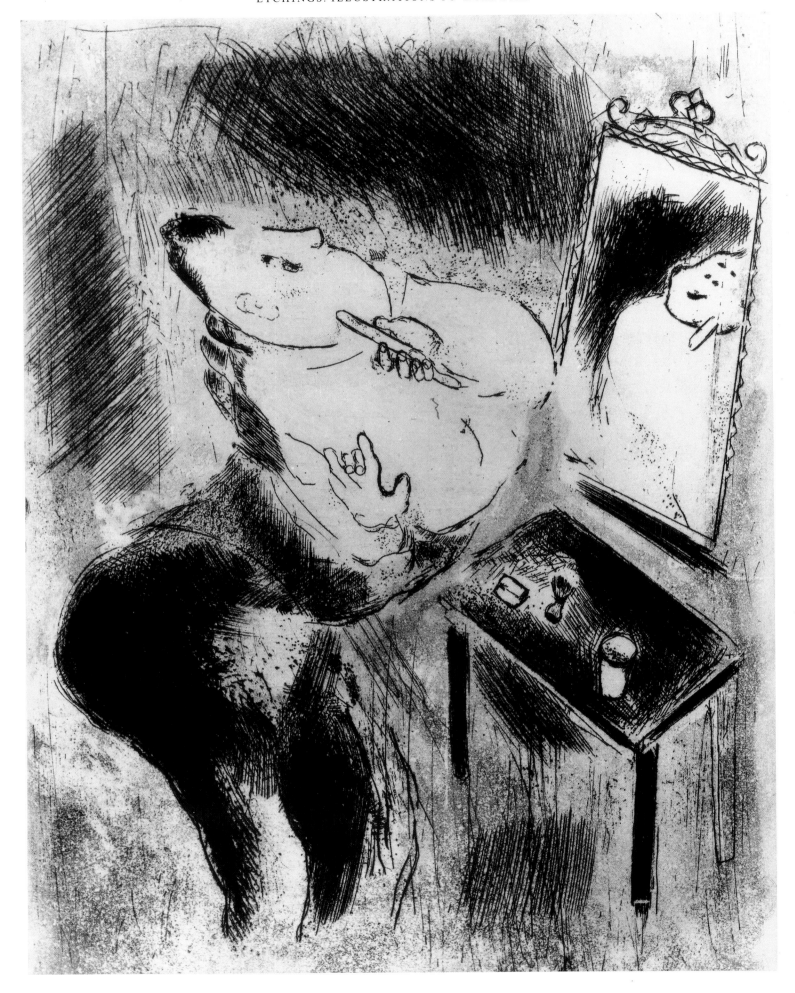

Chichikov Before Looking-glass
CAT. NO. 173

216

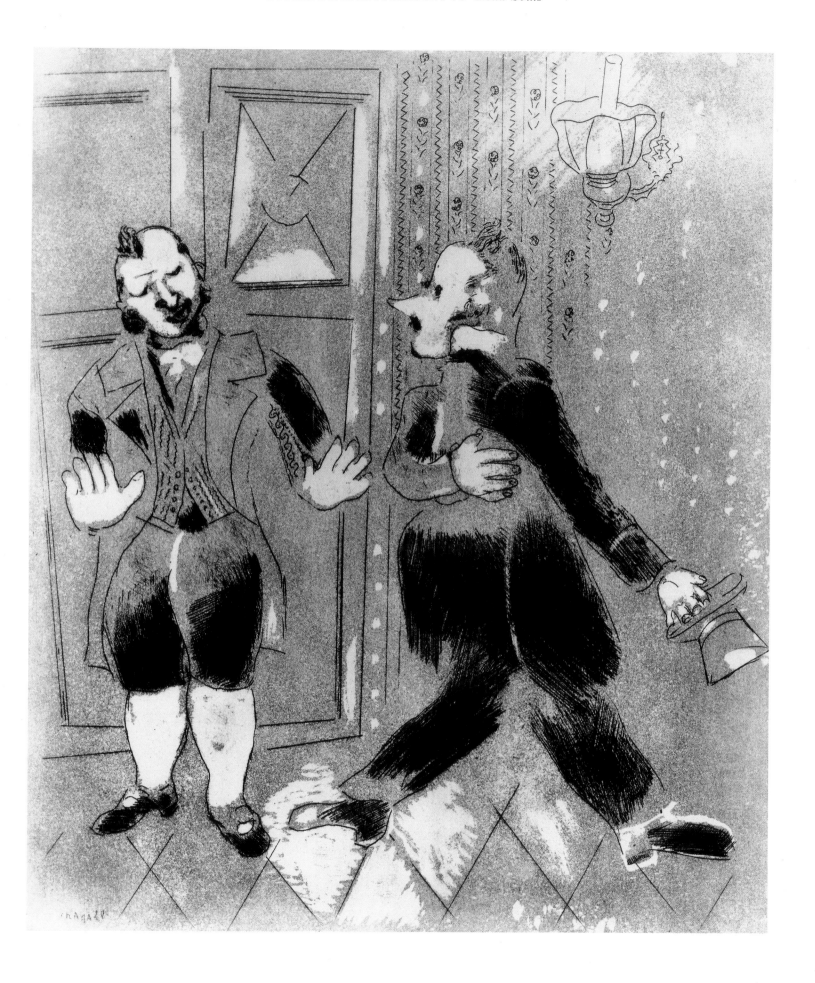

Chichikov and the Governor's Hall-porter

CAT. NO. 174

217

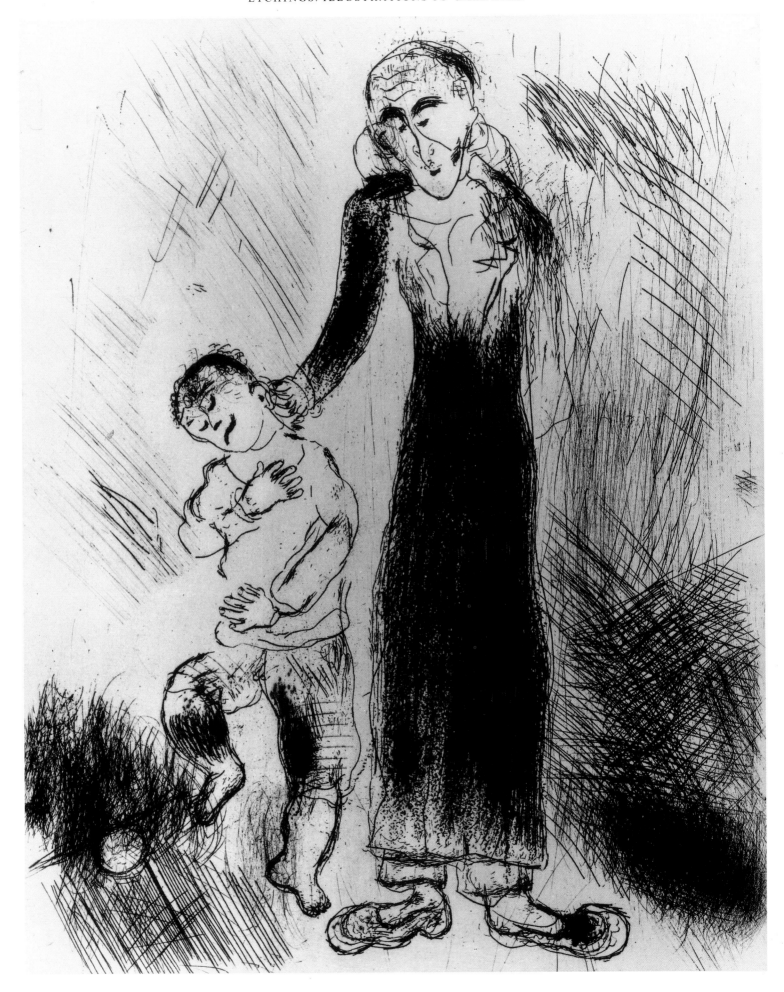

Chichikov's Upbringing

CAT. NO. 178

Coachman Selifan Watering the Horses

CAT. NO. 175

Funeral Procession

CAT. NO. 176

220

Death of the Procurator
CAT. NO. 177

Chichikov as Customs Official

CAT. NO. 179

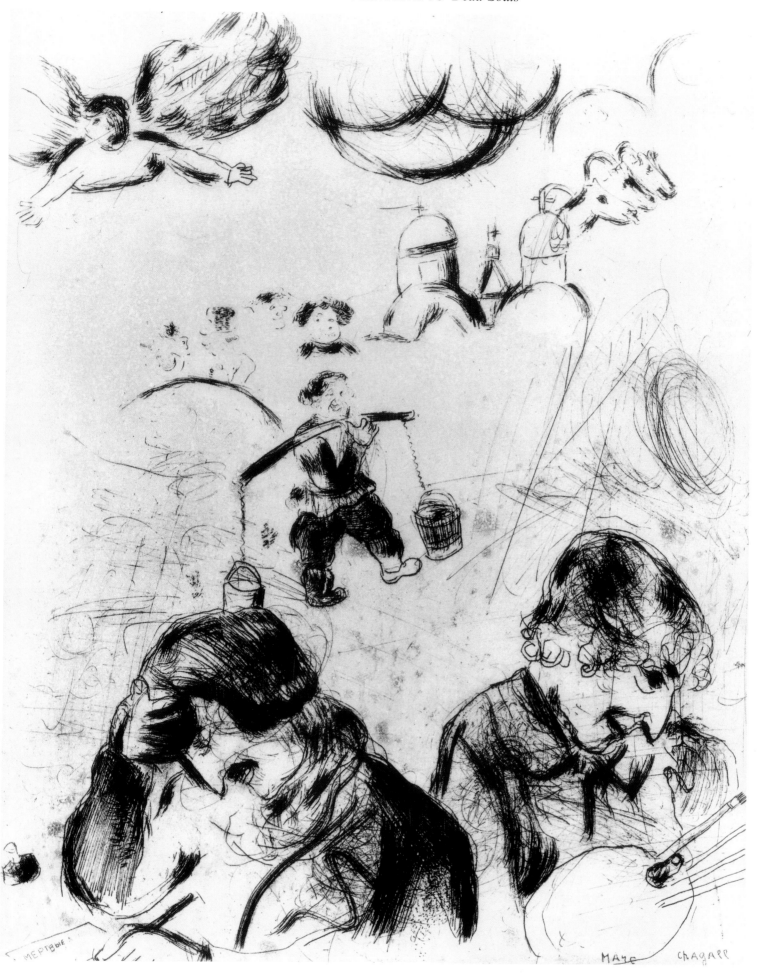

Gogol and Chagall

CAT. NO. 180

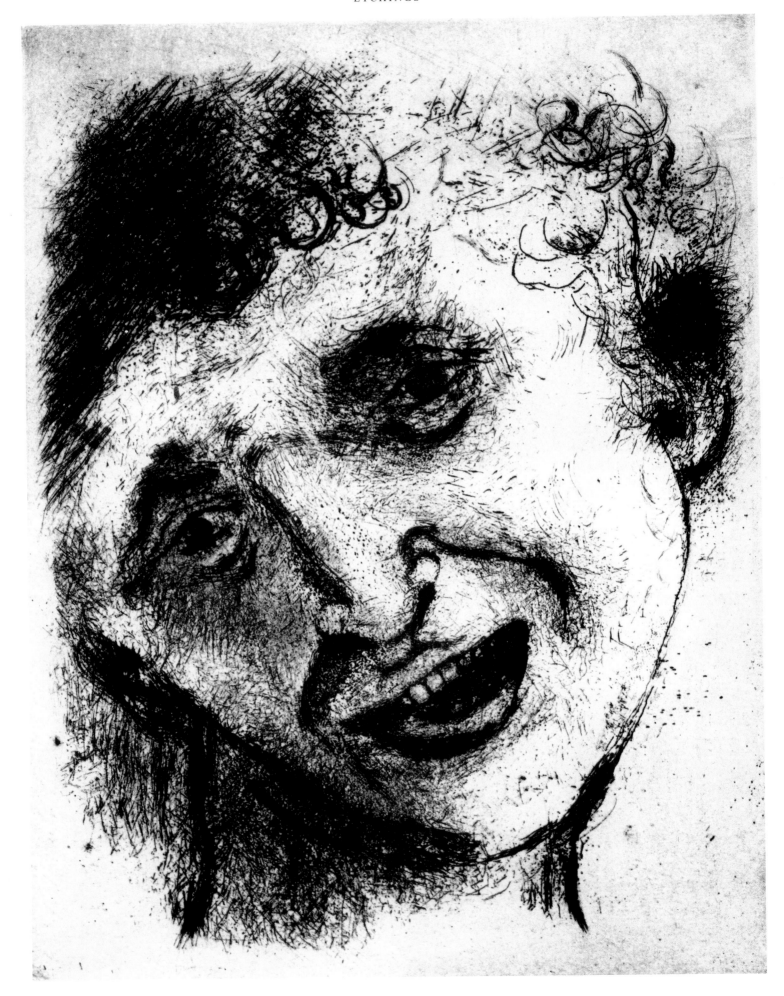

Self-portrait, Smiling. 1927

CAT. NO. 181

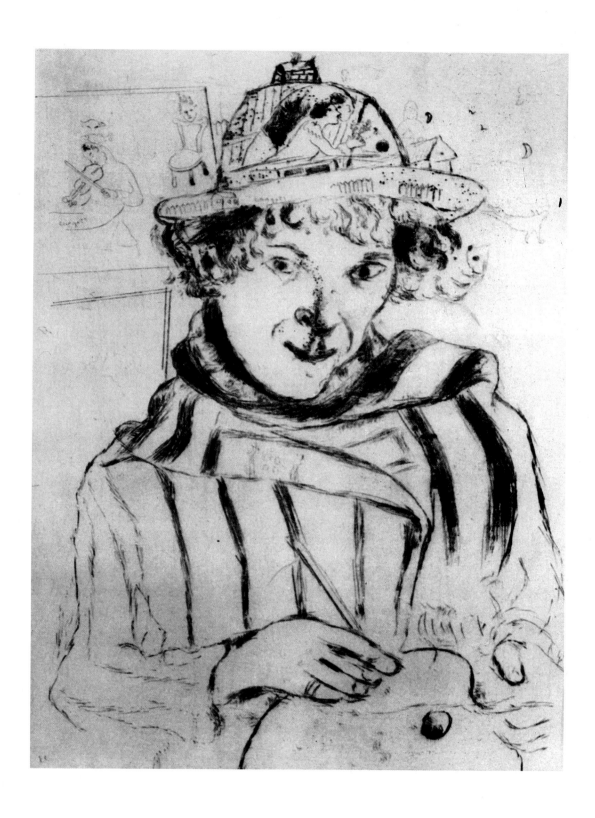

Self-portrait in Hat. Late 1920s

CAT. NO. 182

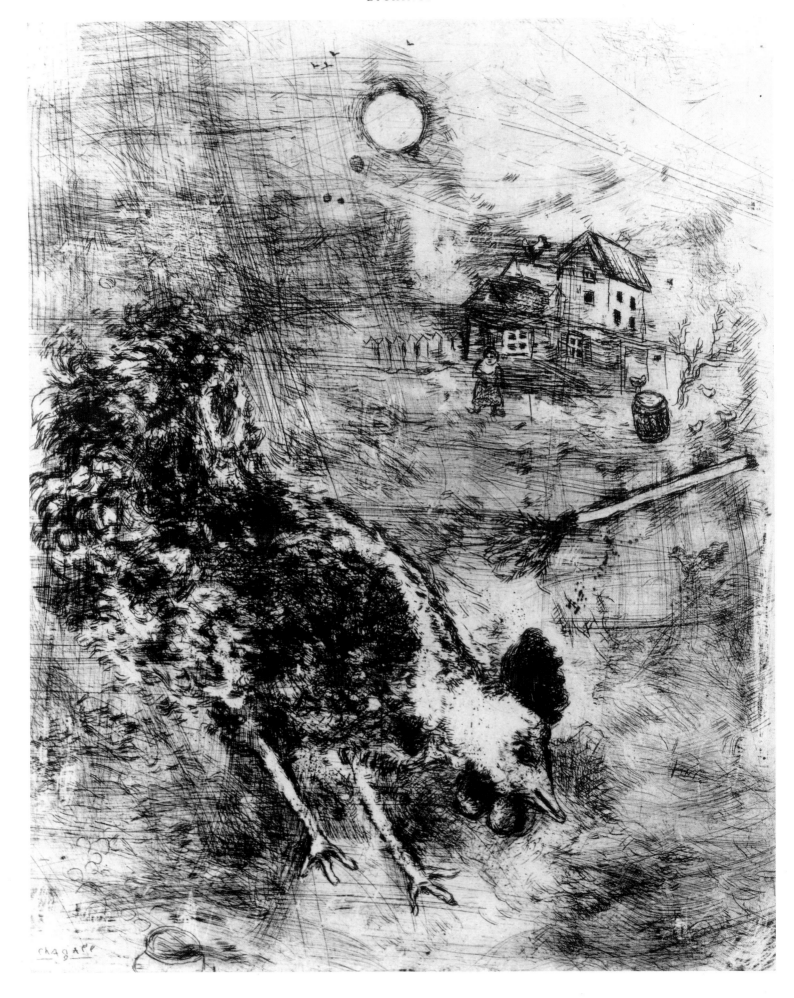

The Cock and the Pearl. Illustration to La Fontaine's *Fables.* 1930
CAT. NO. 183

226

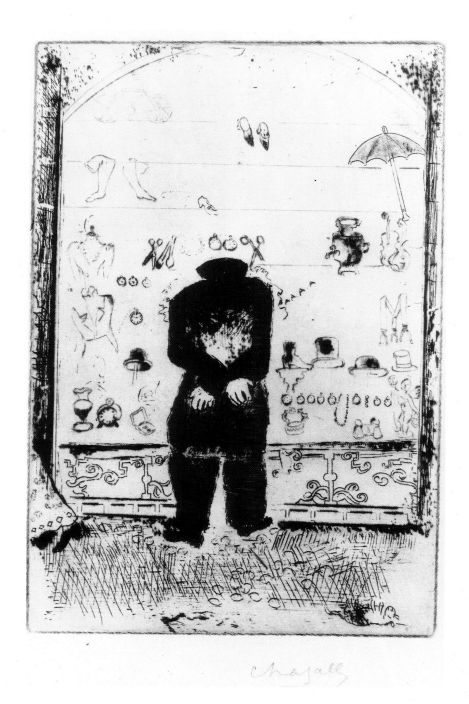

Before a Shopwindow. Late 1930s

CAT. NO. 186

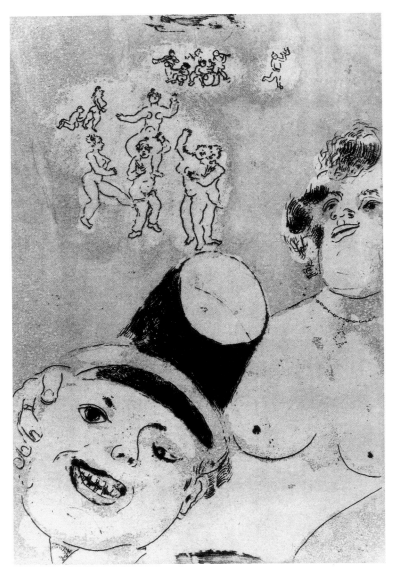 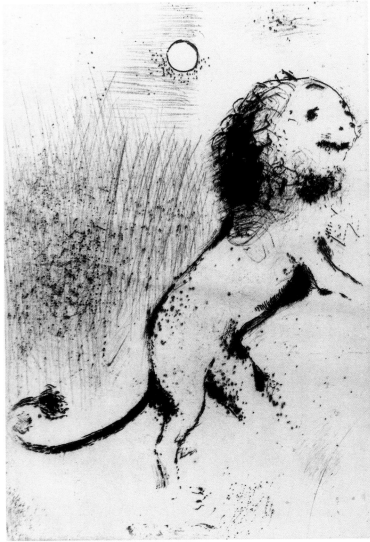

Woman Acrobat and Clown. Sheet from the *Circus* series. Late 1930s

CAT. NO. 184

The Lion. Sheet from the *Circus* series. Late 1930s

CAT. NO. 185

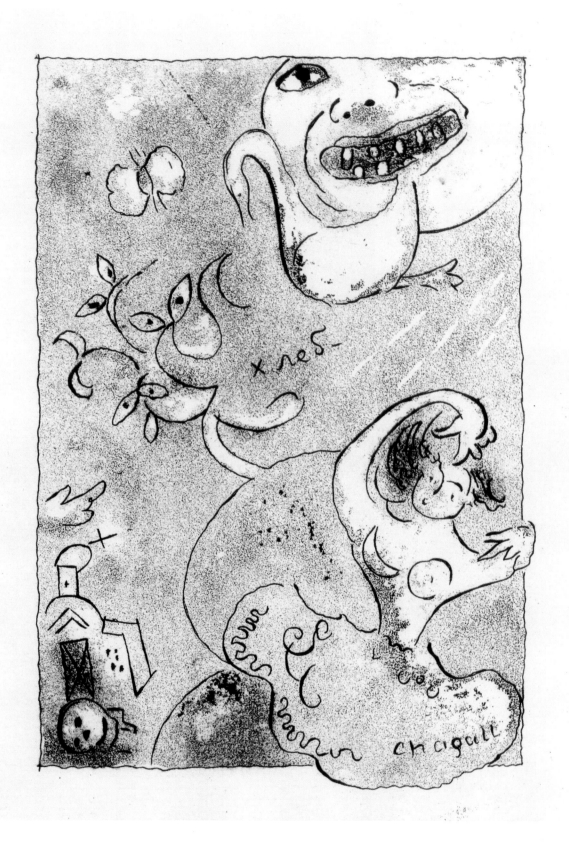

Composition based on early Khlebnikov. *C.* 1949

CAT. NO. 187

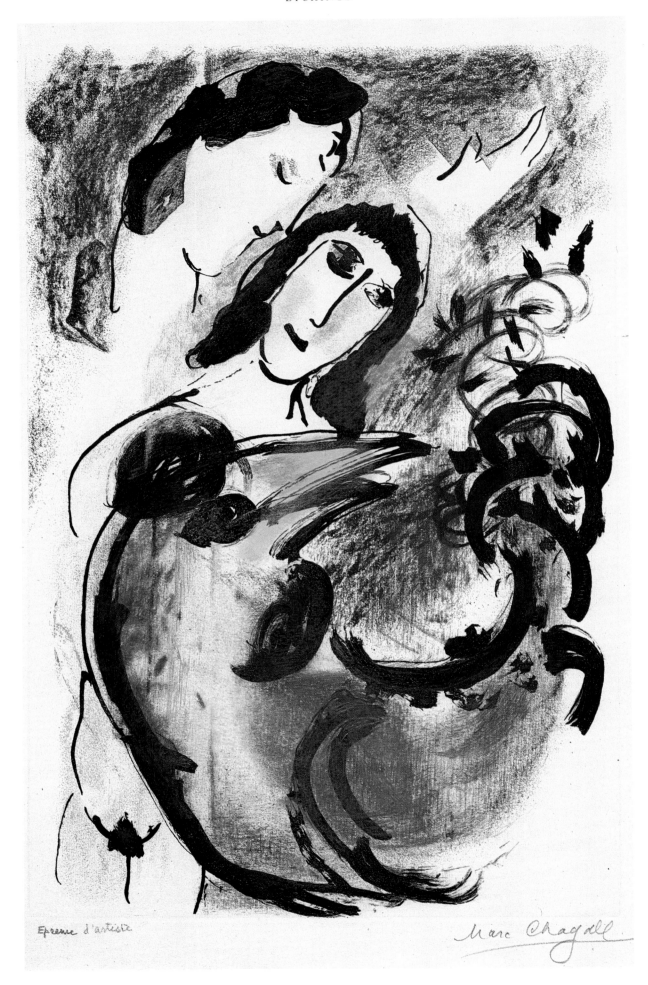

Epreuve d'artiste

Marc Chagall

The Yellow Cock. Late 1980s

CAT. NO. 188

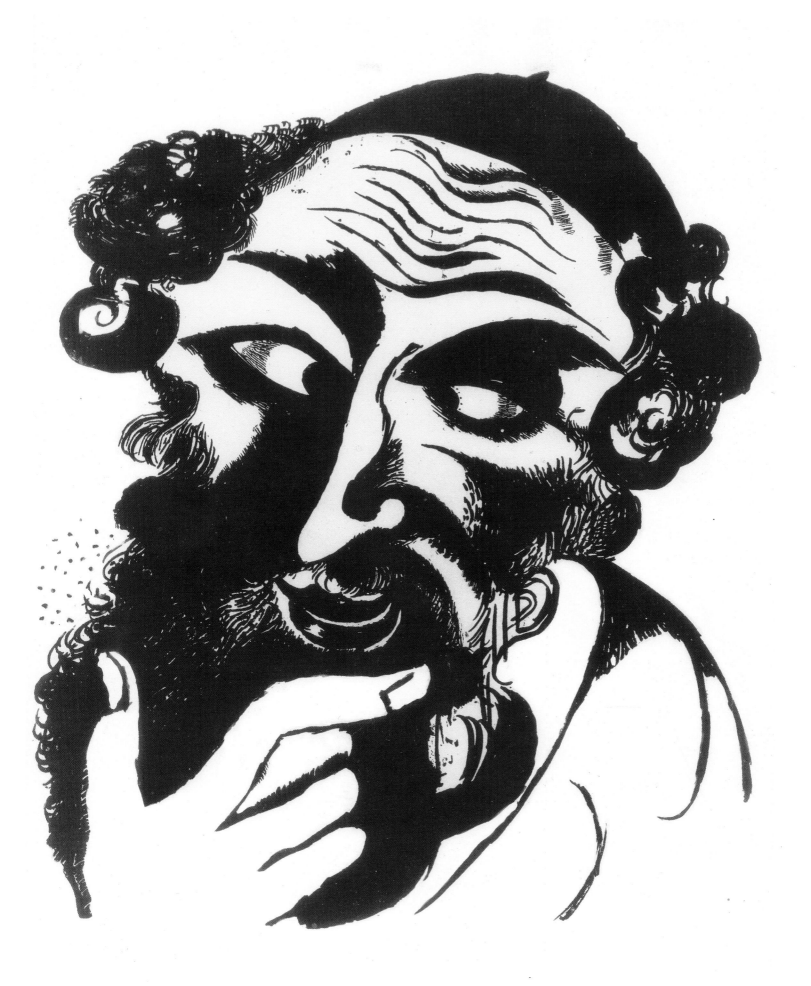

Old Jew. 1914

CAT. NO. 189

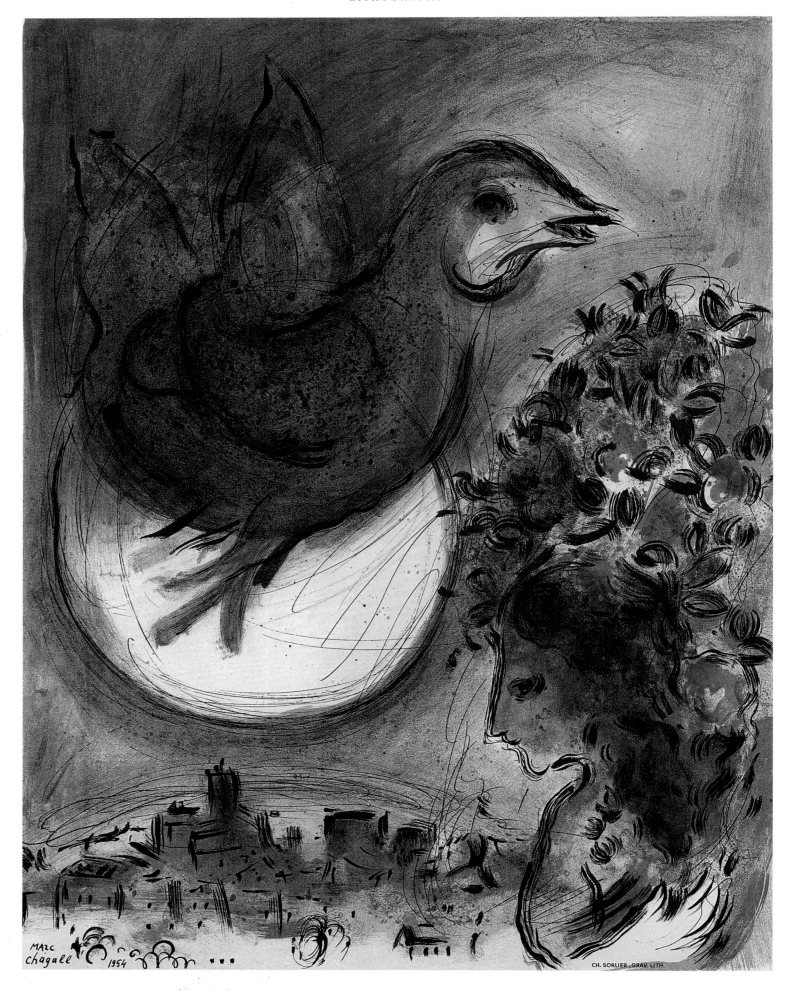

Bird on Moon. 1954

CAT. NO. 190

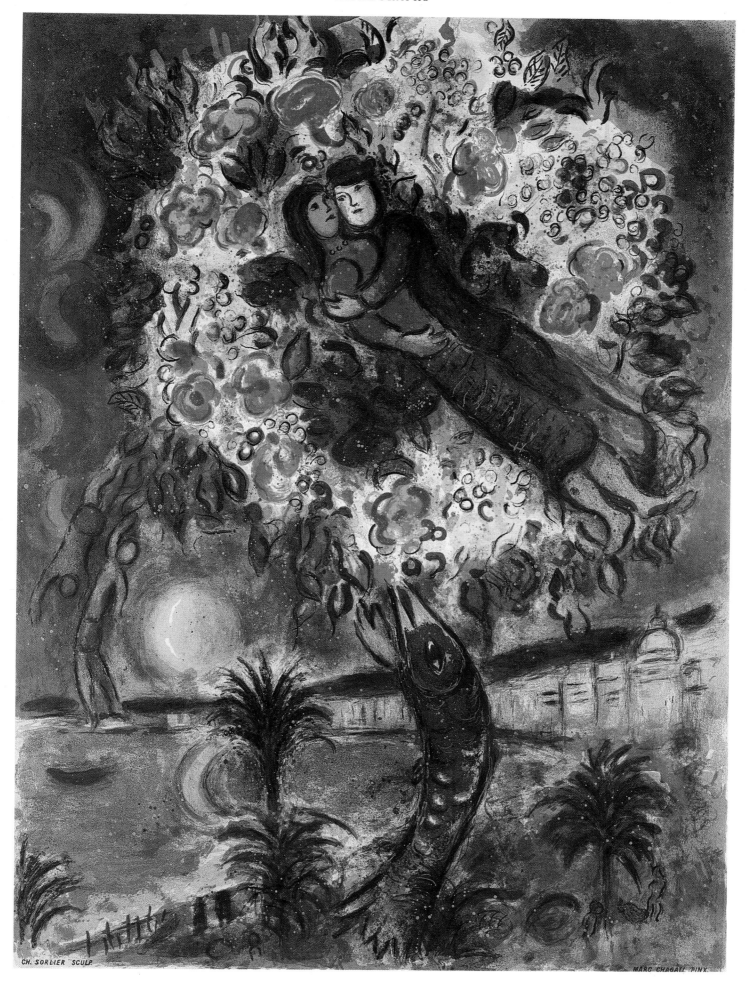

CH. SORLIER SCULP.

MARC CHAGALL PINX.

The Lovers and Fish

CAT. NO. 191

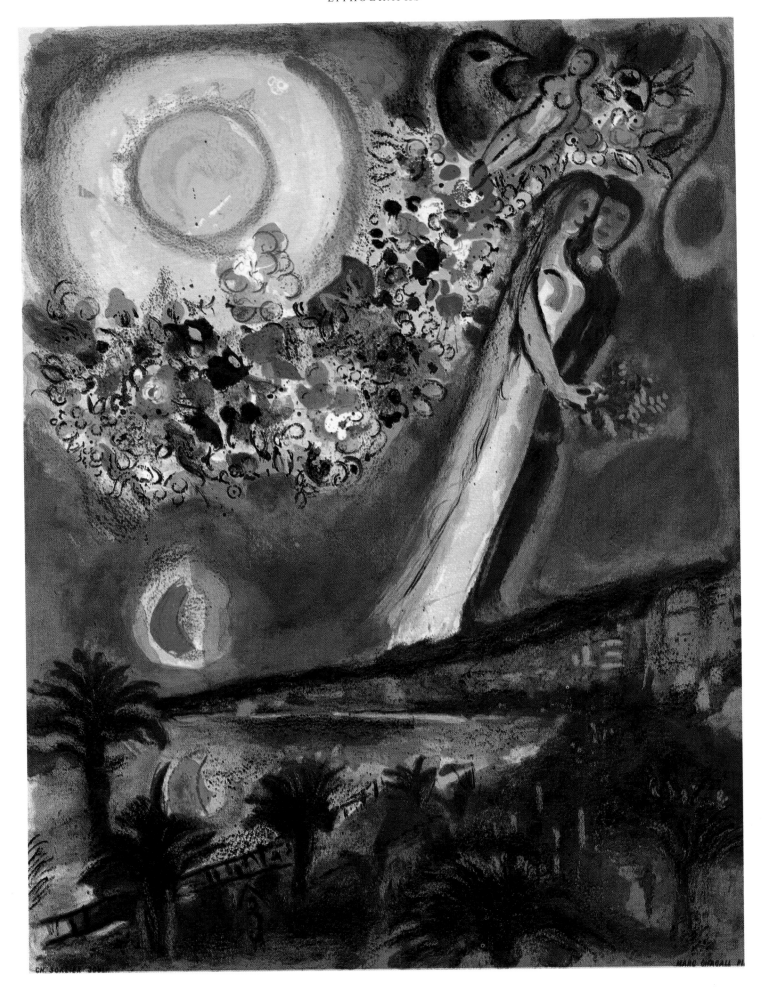

Honeymoon

CAT. NO. 192

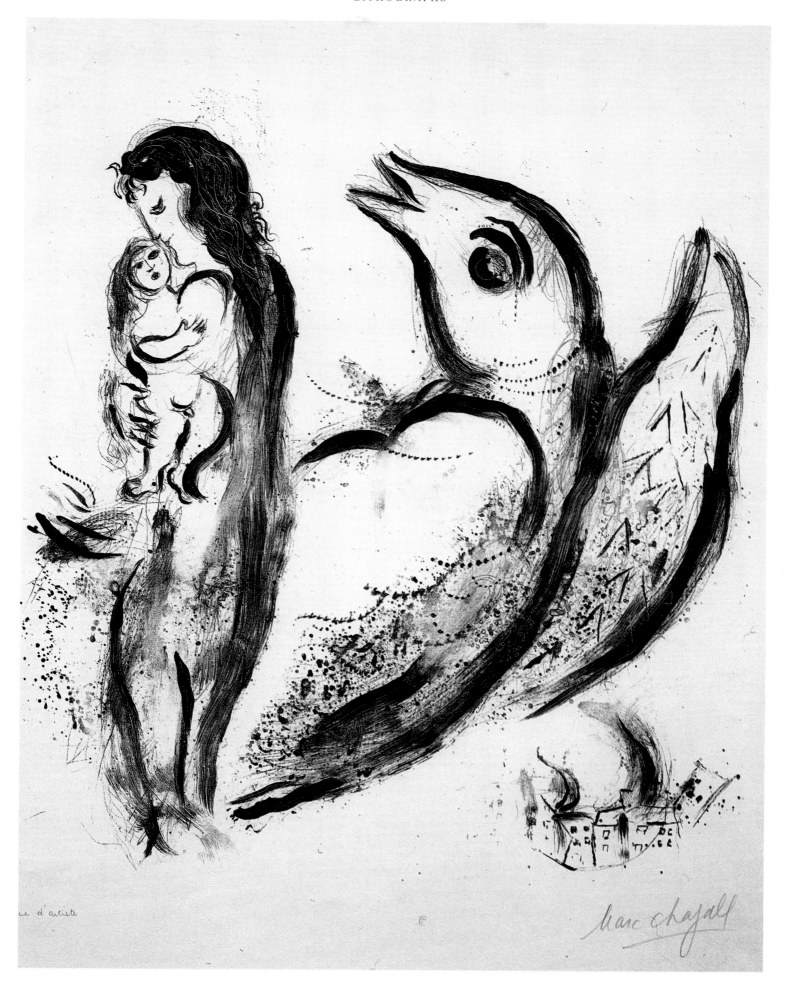

Mother and Child. 1956
CAT. NO. 193

Self-portrait: Ma Vie. 1956

CAT. NO. 194

Profile and Red Boy. 1956
CAT. NO. 195

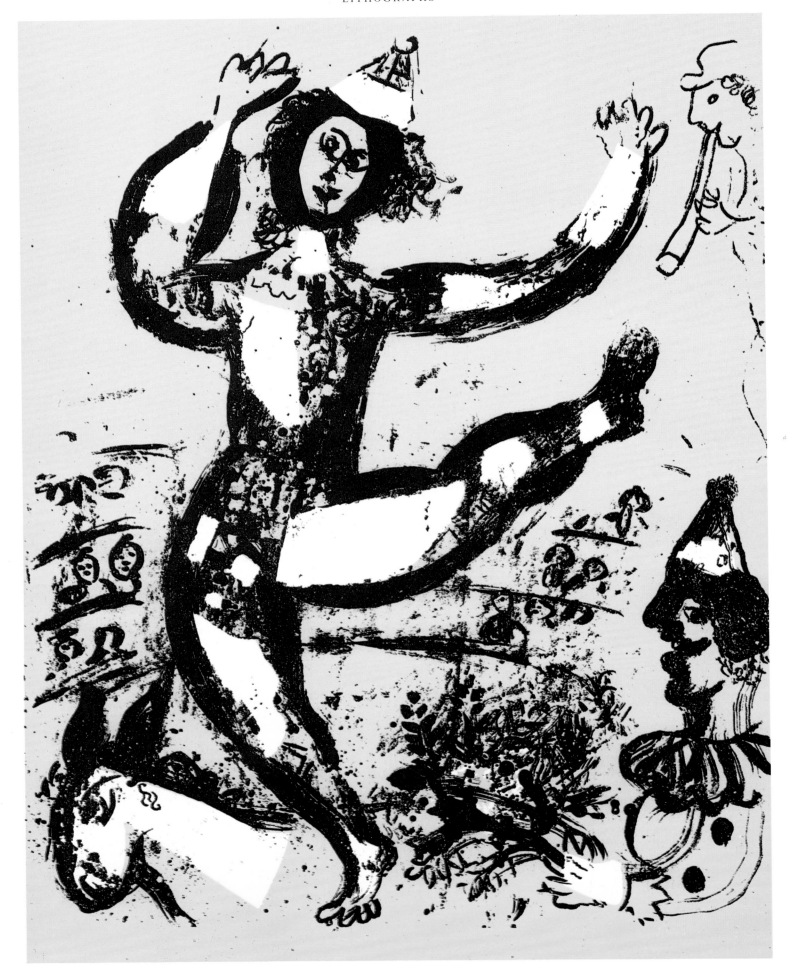

The Circus. Sheet from the *Circus* series. 1956—62

CAT. NO. 196

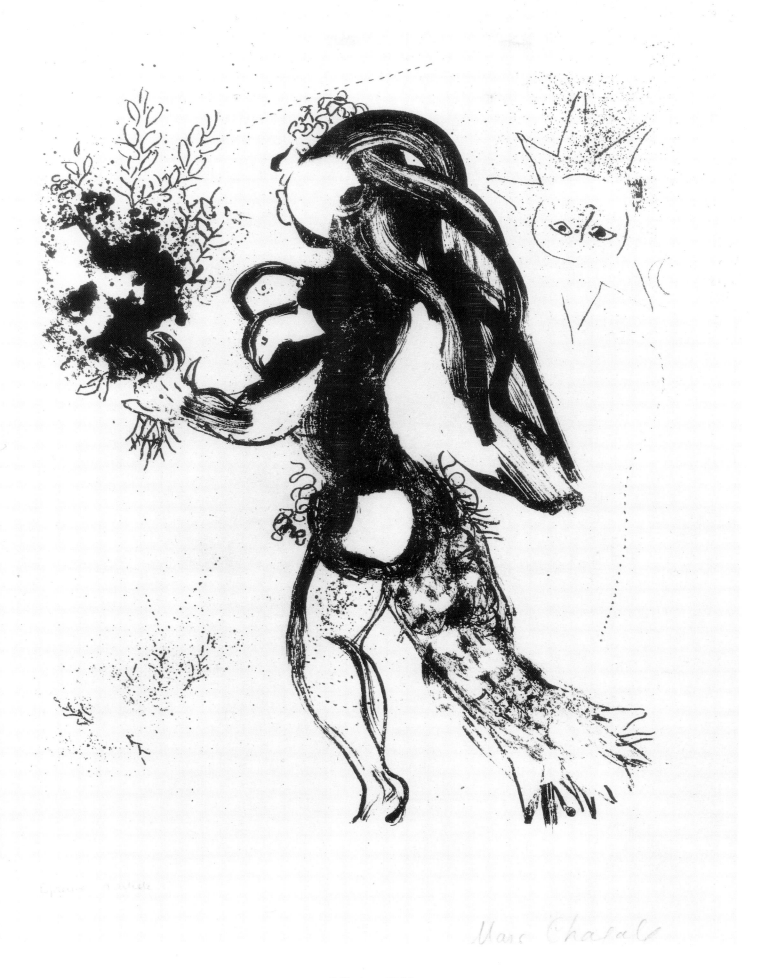

Offering. 1956

CAT. NO. 208

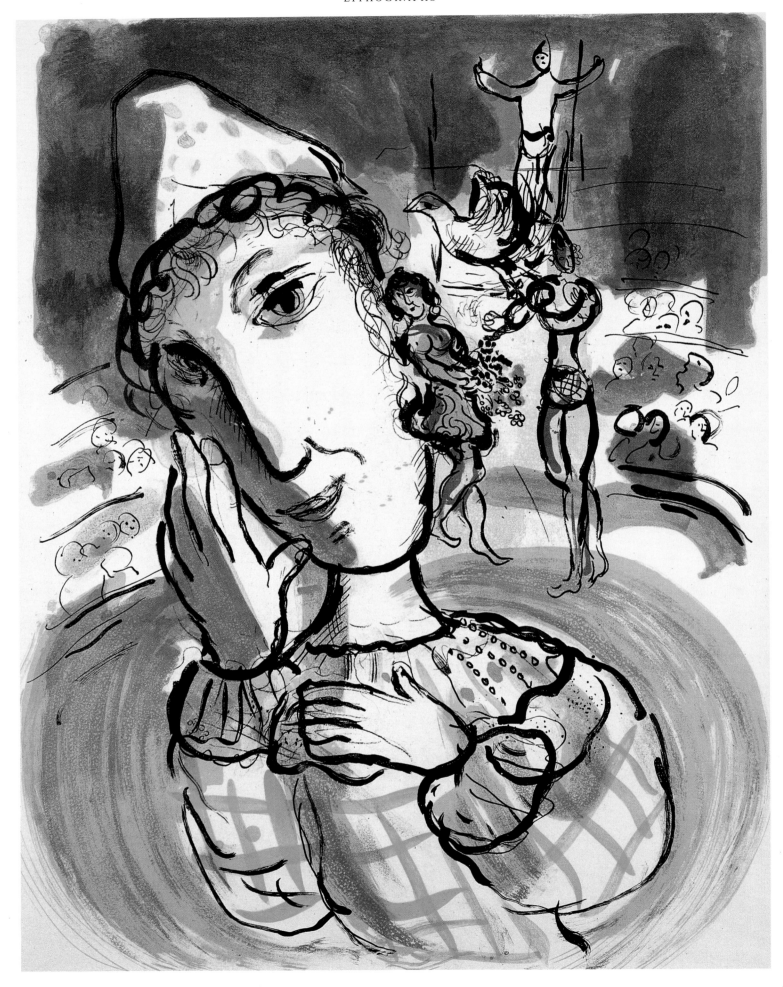

Clown and Acrobats. Sheet from the *Circus* series. 1956—62
CAT. NO. 197

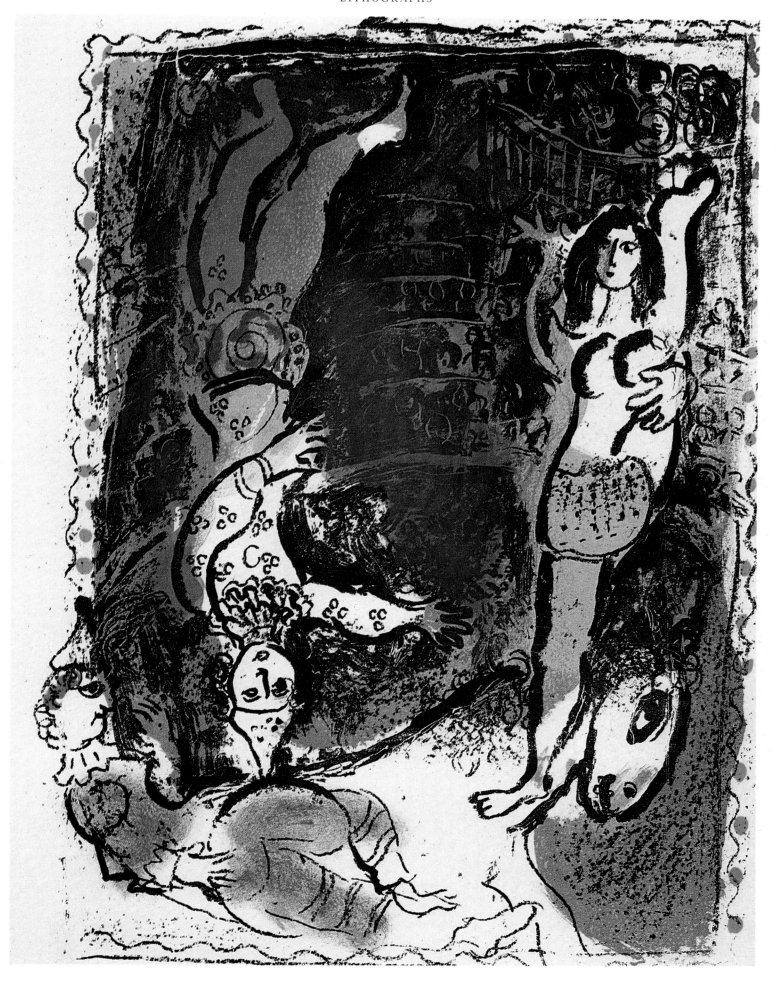

Equestrienne and Clowns. Sheet from the *Circus* series. 1956—62

CAT. NO. 198

·241

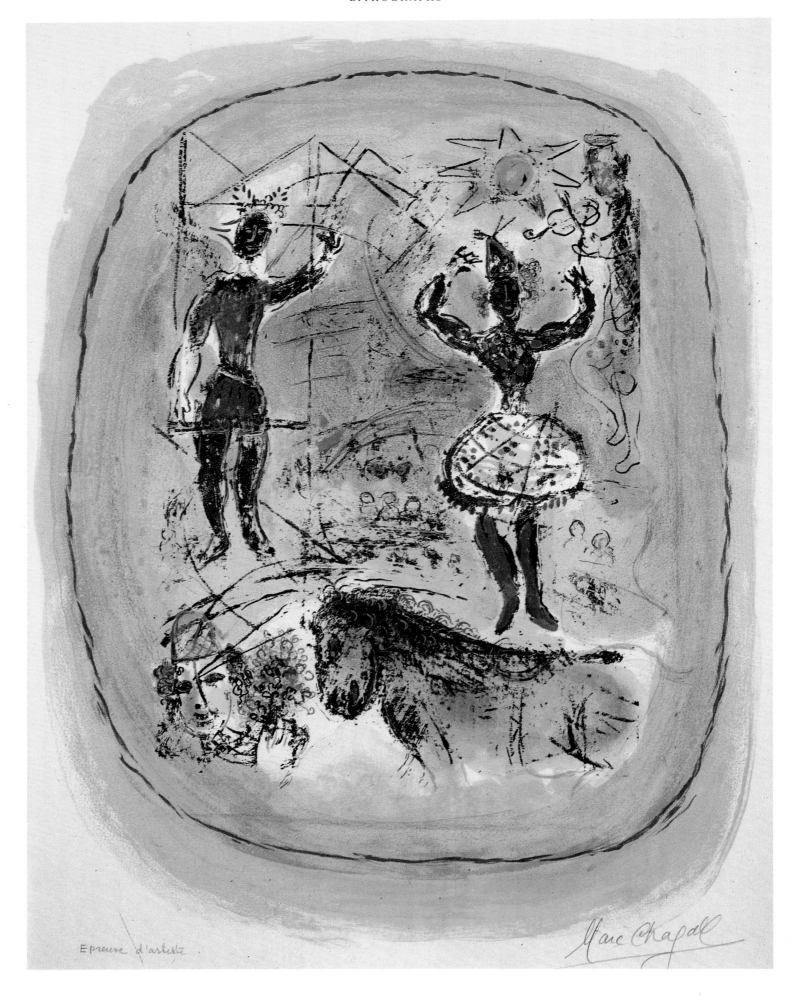

Epreuve d'artiste

Marc Chagall

Circus Finale. Sheet from the *Circus* series. 1956—62

CAT. NO. 199

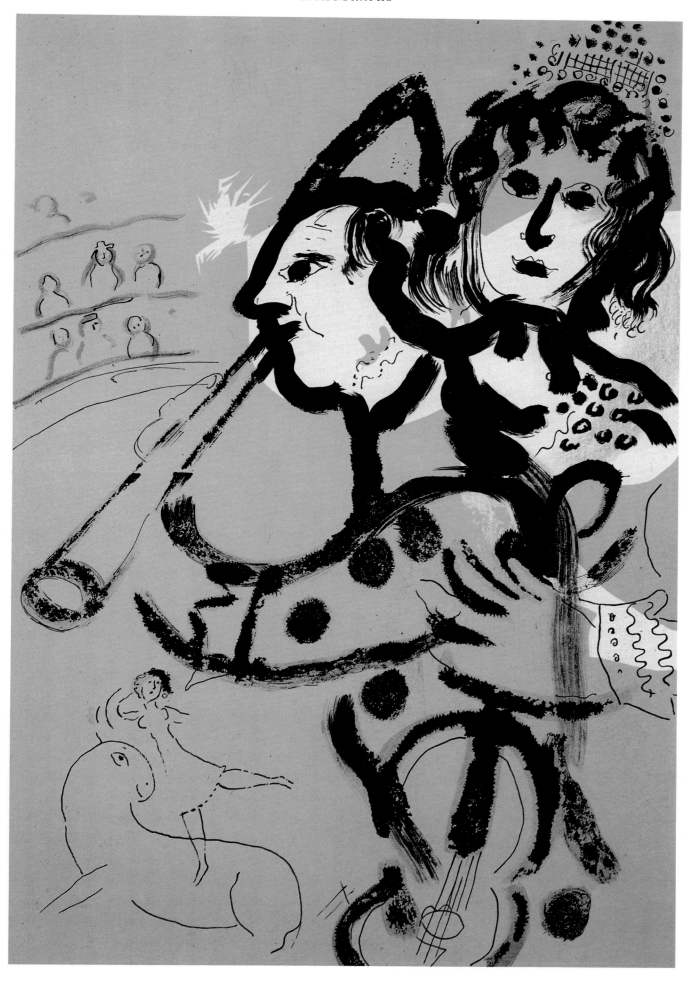

Clown with Trumpet. Poster announcing Chagall exhibition. 1957

CAT. NO. 209

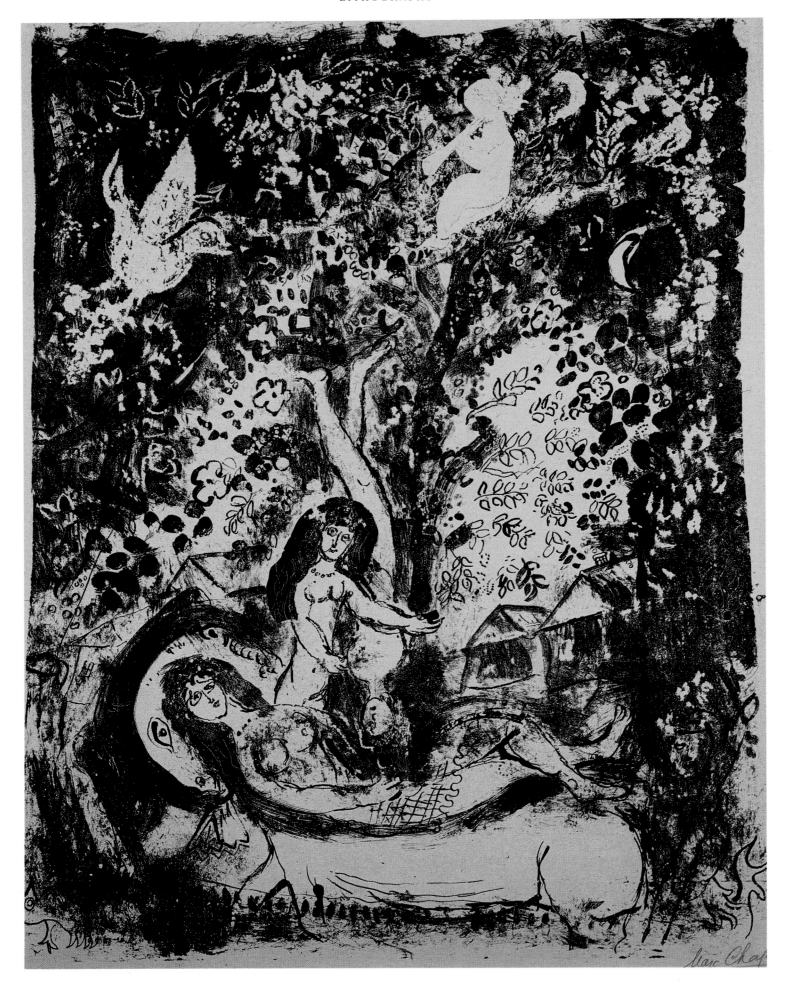

The Flute Player. 1957

CAT. NO. 210

Epreuve d'artiste

With Flowers in Hand
CAT. NO. 211

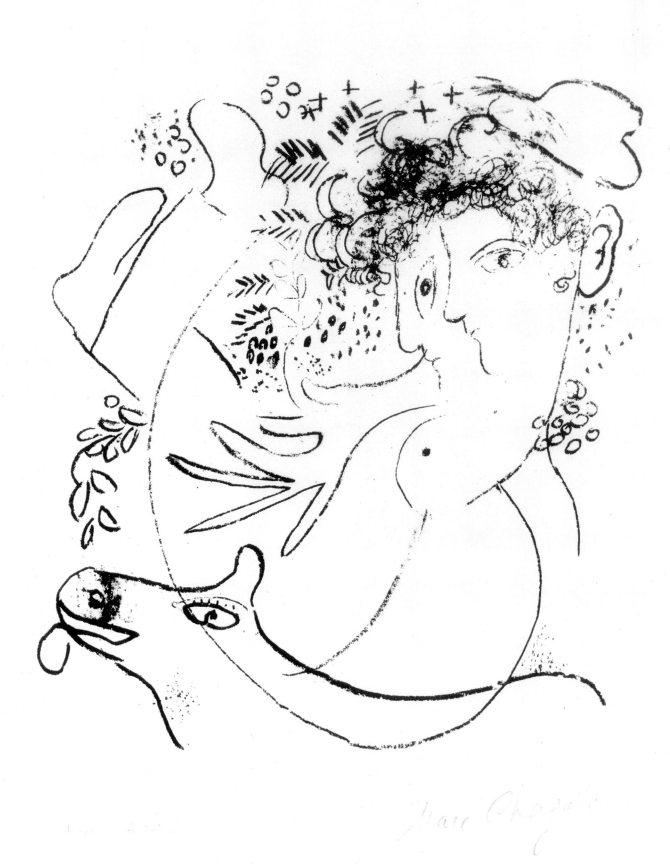

Two Profiles. 1957

CAT. NO. 212

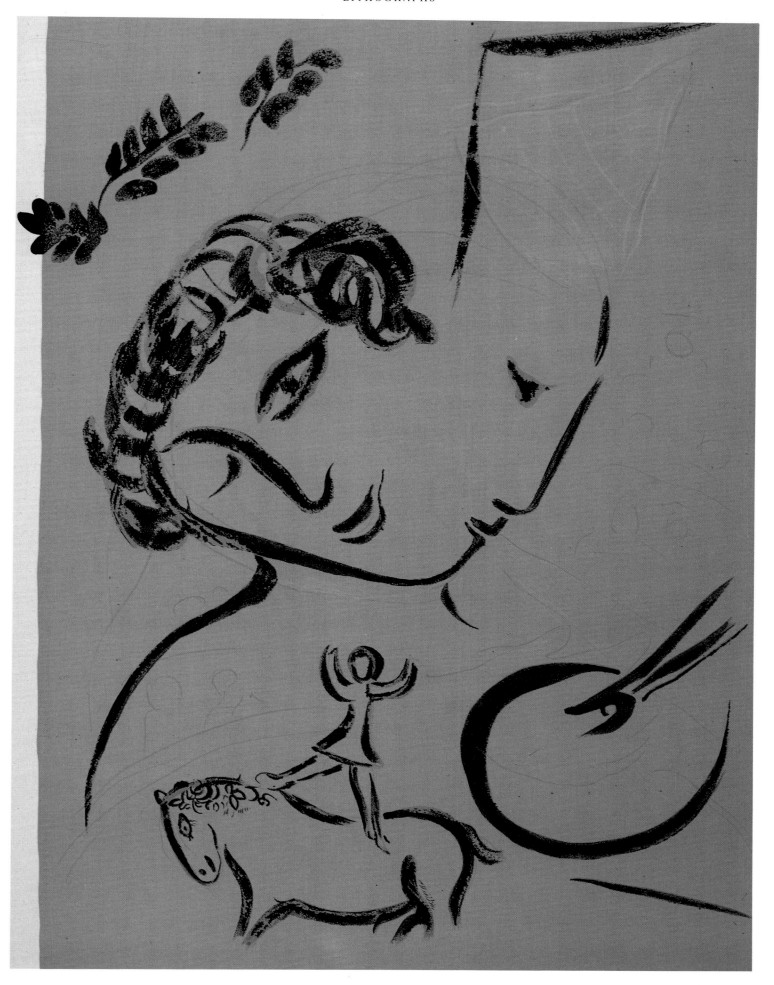

The Artist. Poster announcing Chagall exhibition. 1959
CAT. NO. 214

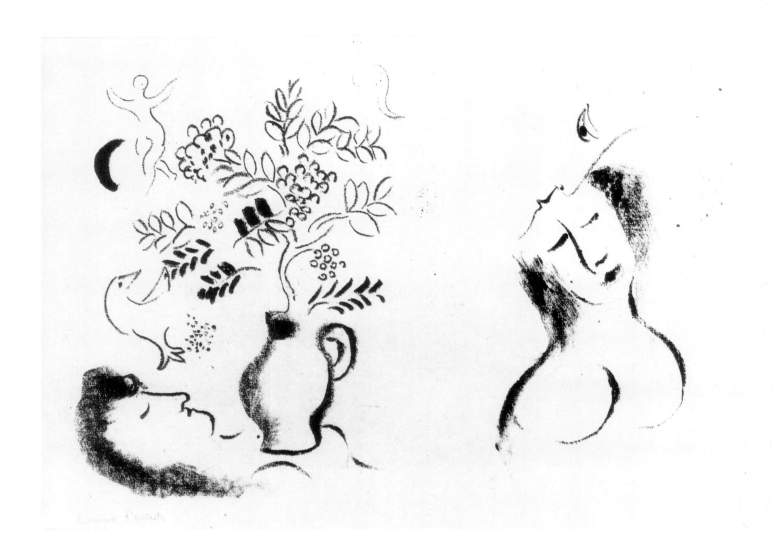

Lithograph for catalogue of Chagall exhibition (1959)

CAT. NO. 213

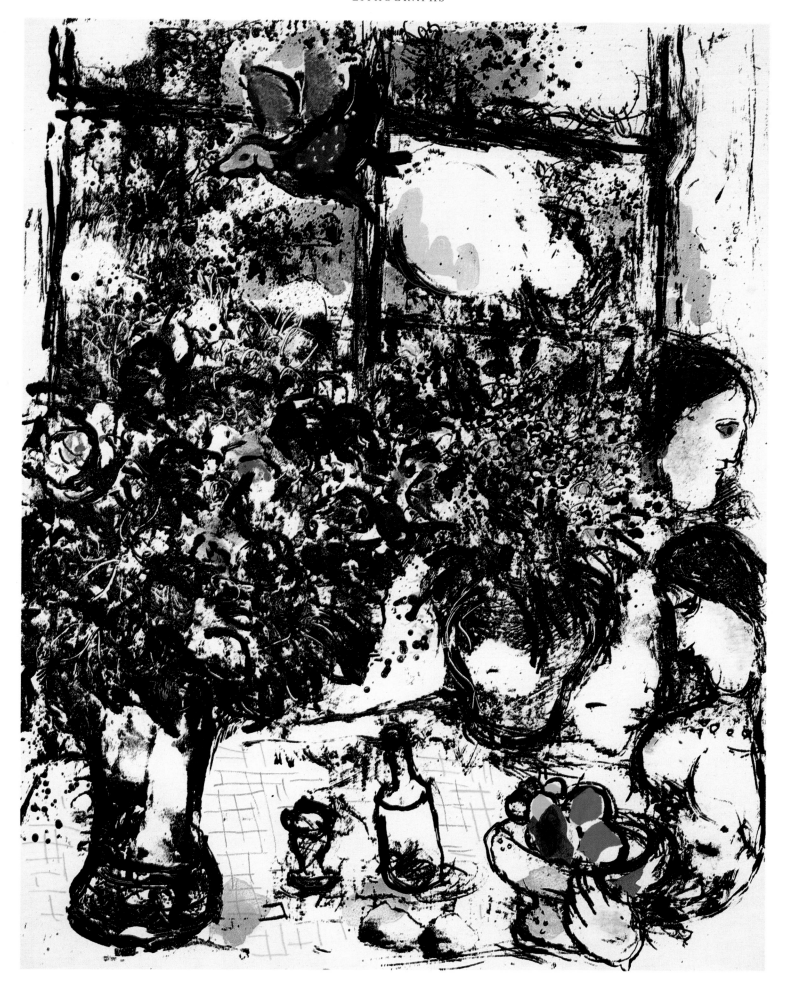

Still Life with Flowers. 1960

CAT. NO. 215

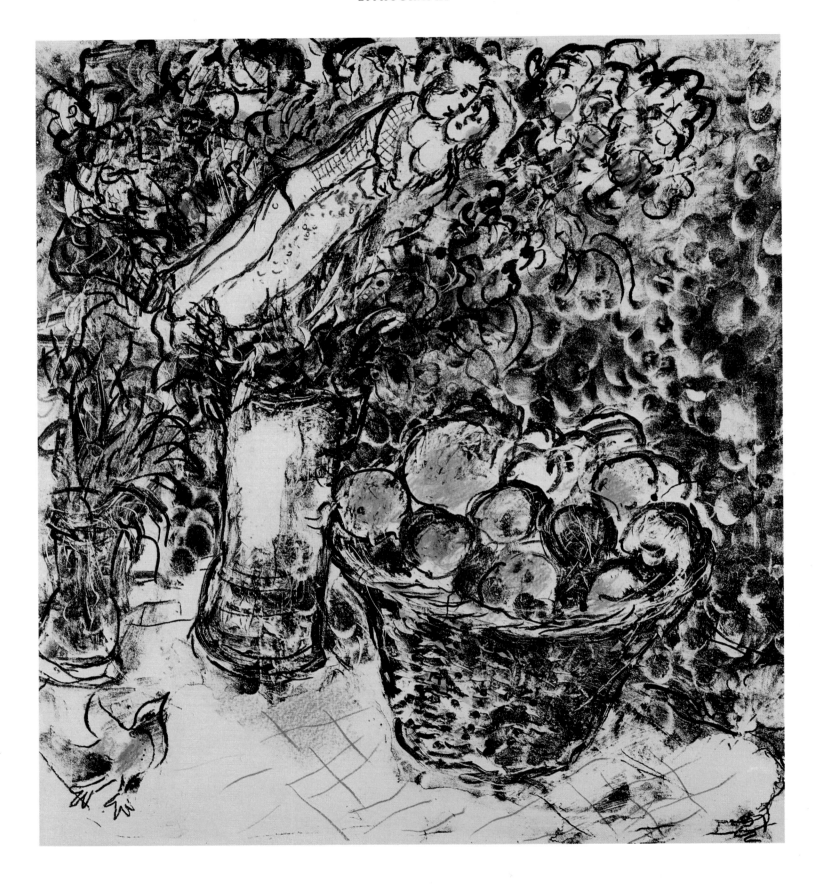

Flying Couple with the Vase of Flowers
CAT. NO. 216

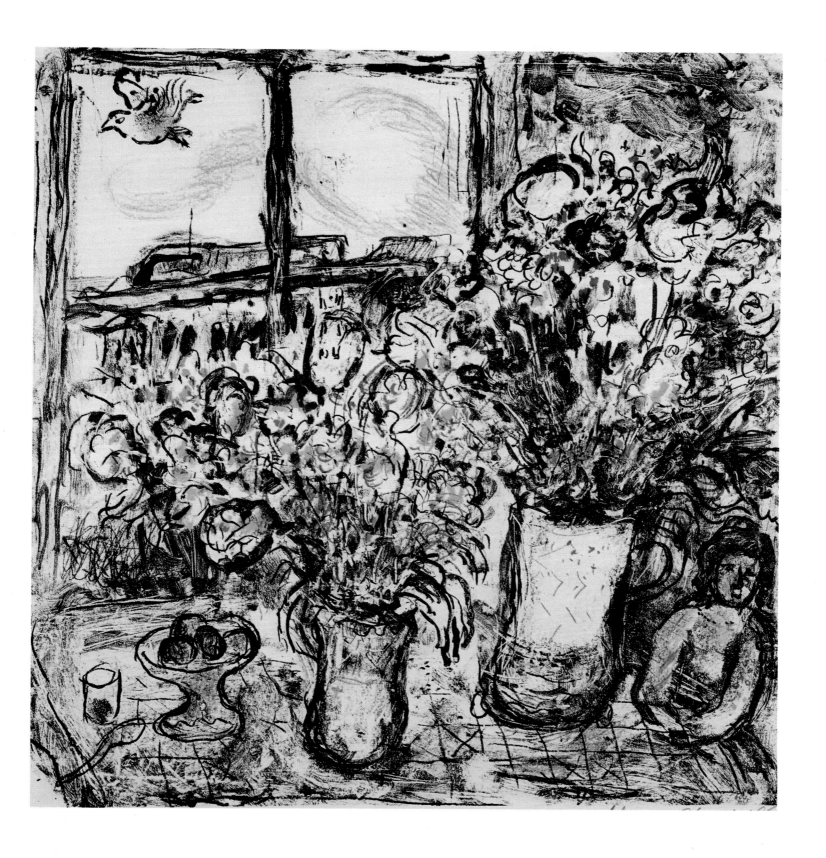

Window of the Studio (Still Life with Flowers and Two Figures)
Not later than 1973

CAT. NO. 251

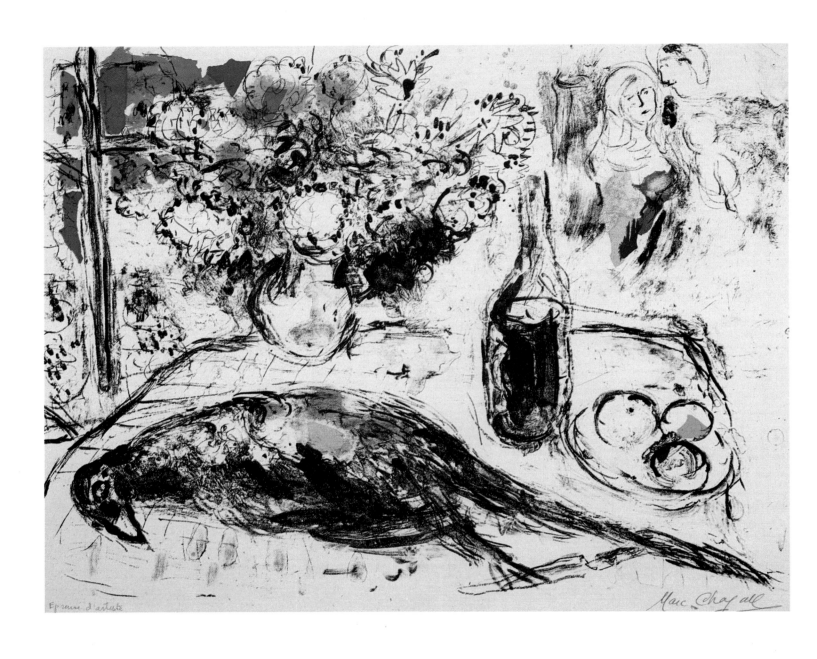

The Pheasant

CAT. NO. 217

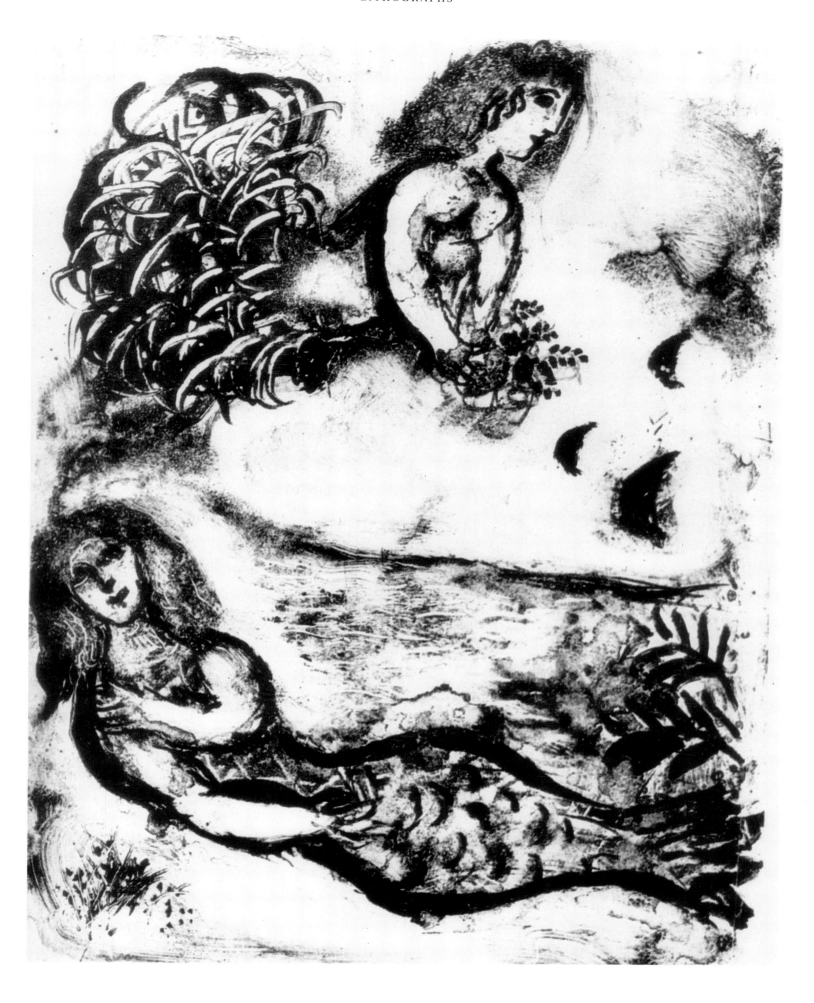

Two Sirens. Not later than 1963

CAT. NO. 219

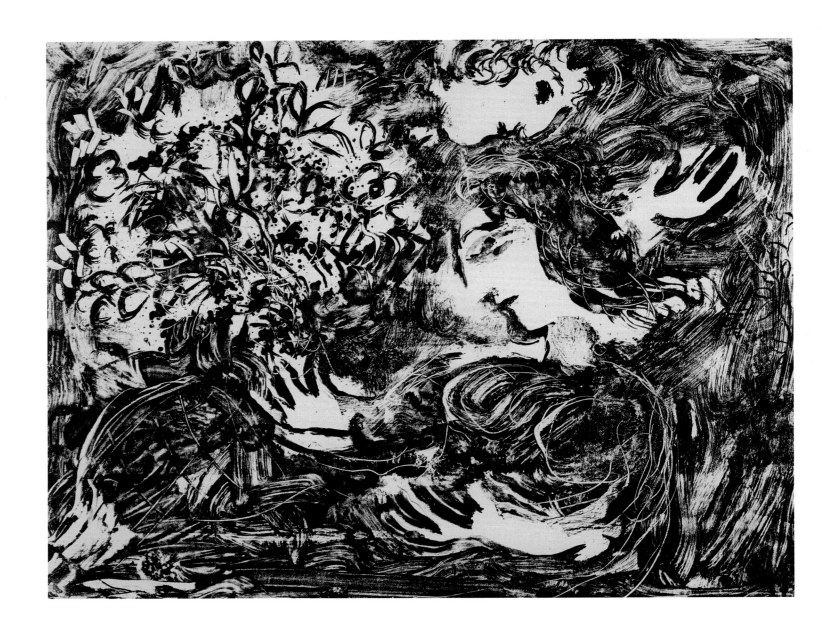

Passion. Not later than 1963

CAT. NO. 220

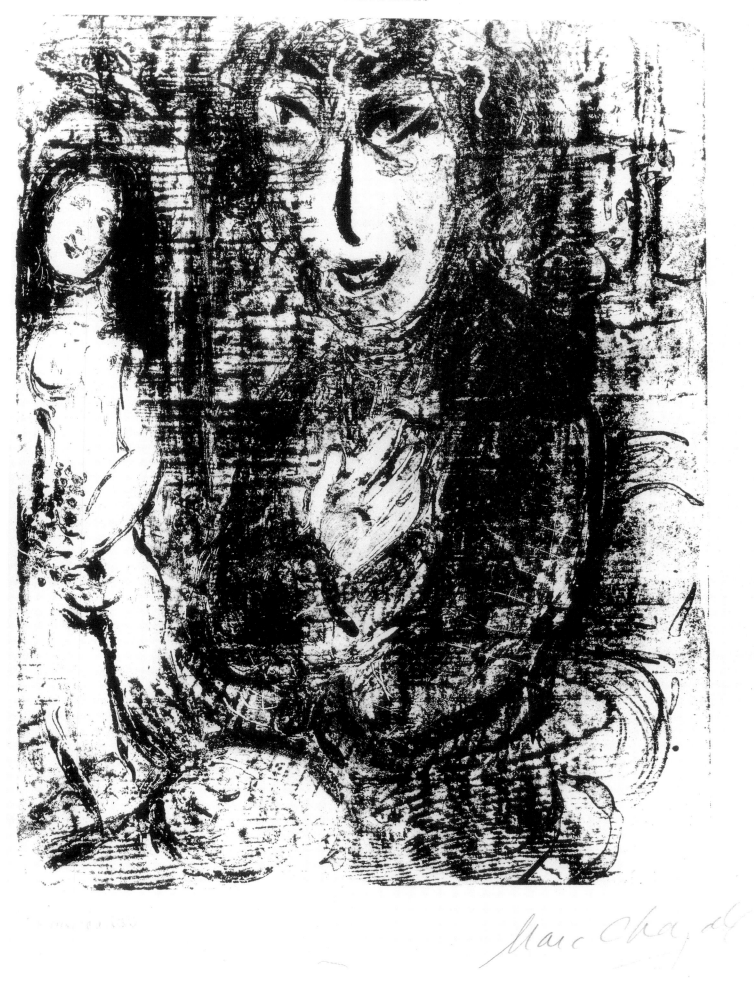

The Reverie. Not later than 1963

CAT. NO. 221

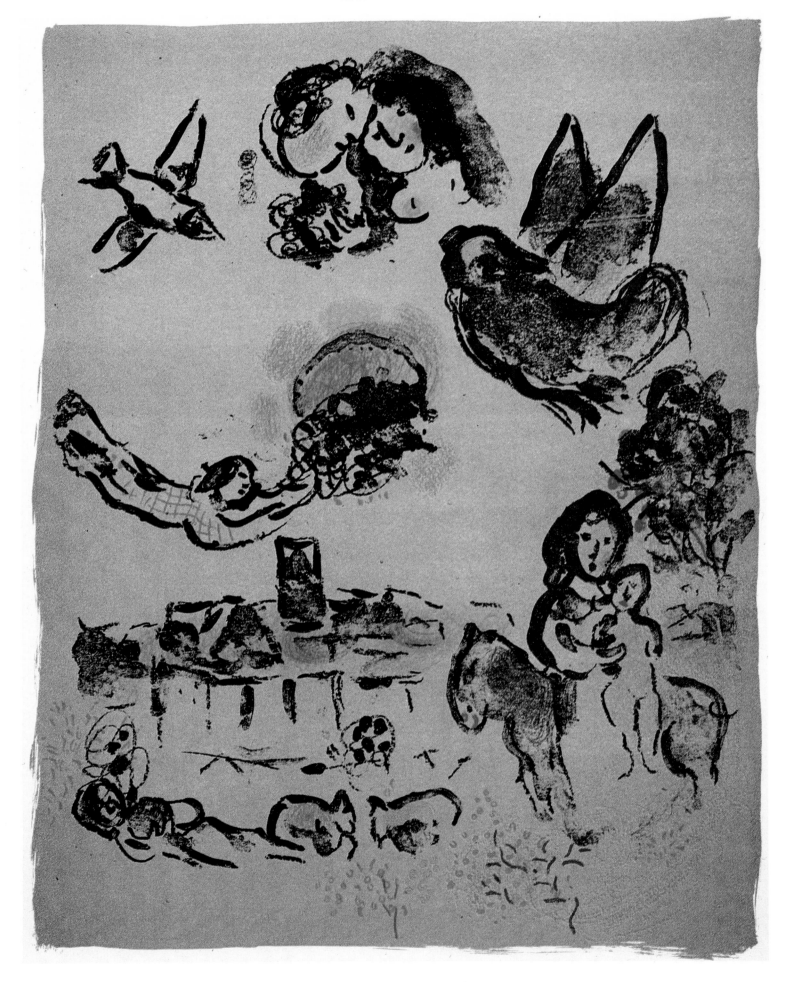

Saint-Paul by Night. Sheet from
the *Saint-Paul-de-Vence* series. 1957—62

CAT. NO. 233

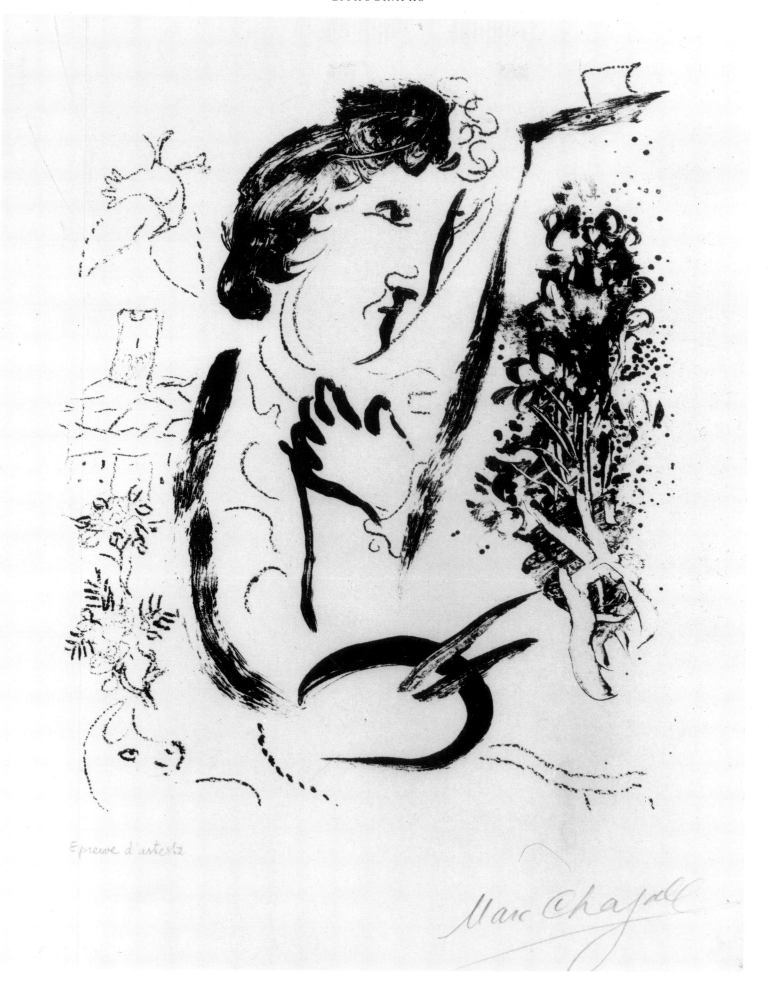

In Front of the Picture. Not later than 1963

CAT. NO. 222

257

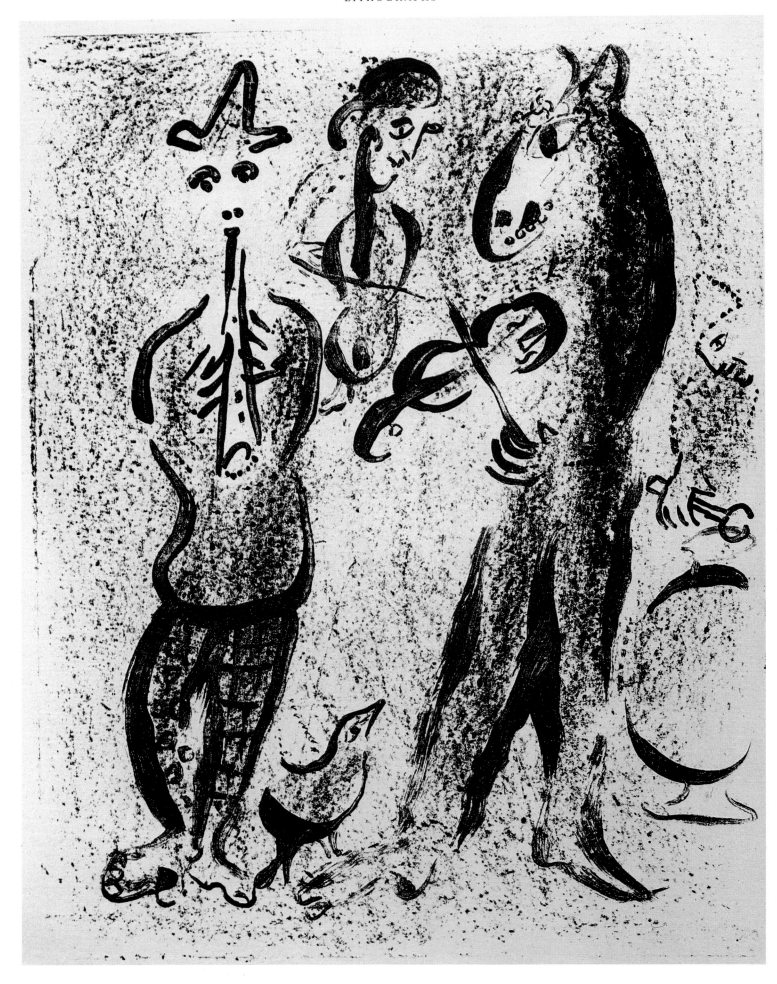

Circus Players. Sheet from the *Circus* series. 1956—62

CAT. NO. 206

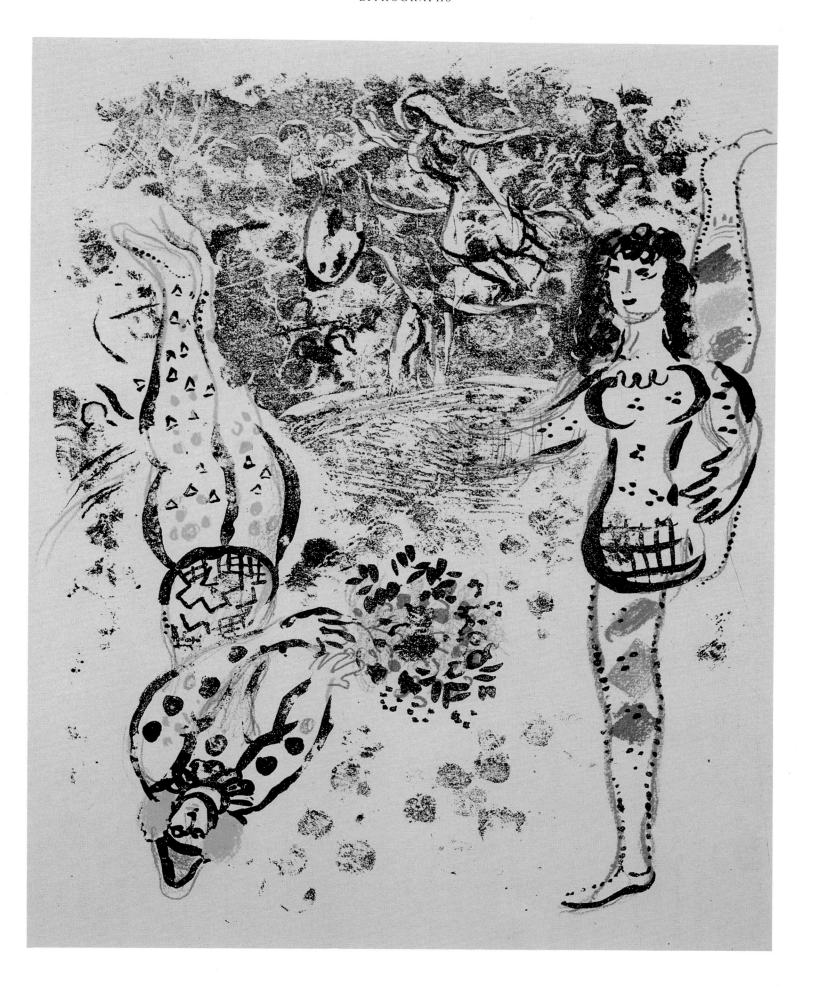

Play of Acrobats. Sheet from the *Circus* series. 1956—62
CAT. NO. 200

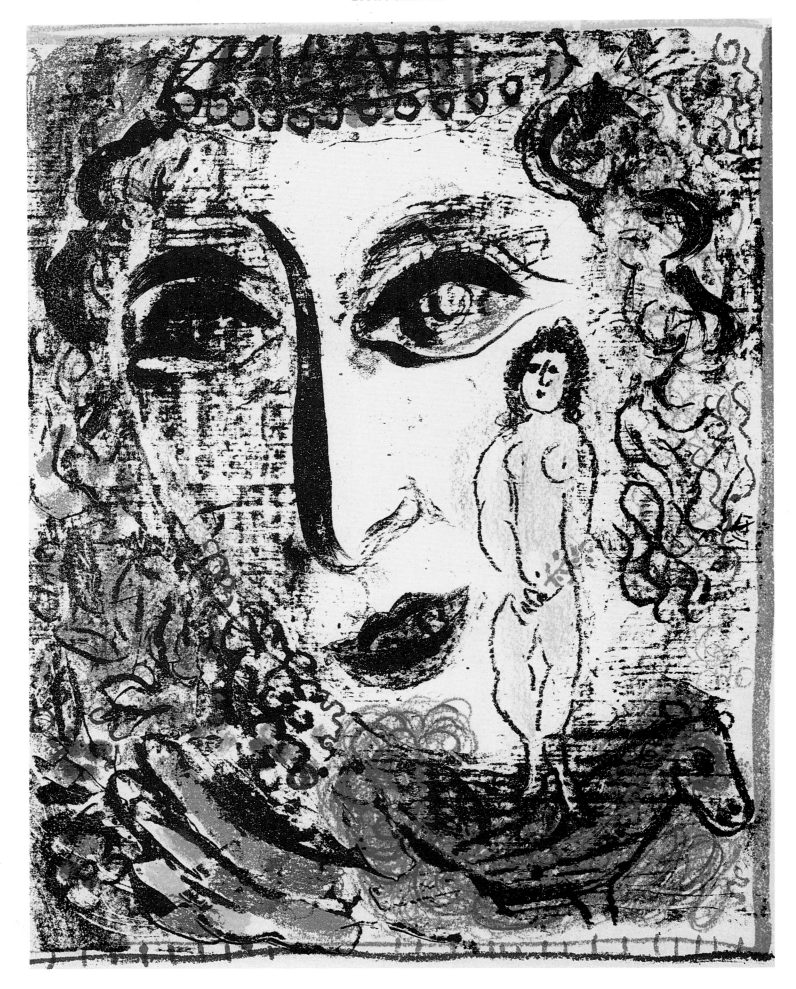

Circus Appearance. Sheet from the *Circus* series. 1956—62

CAT. NO. 201

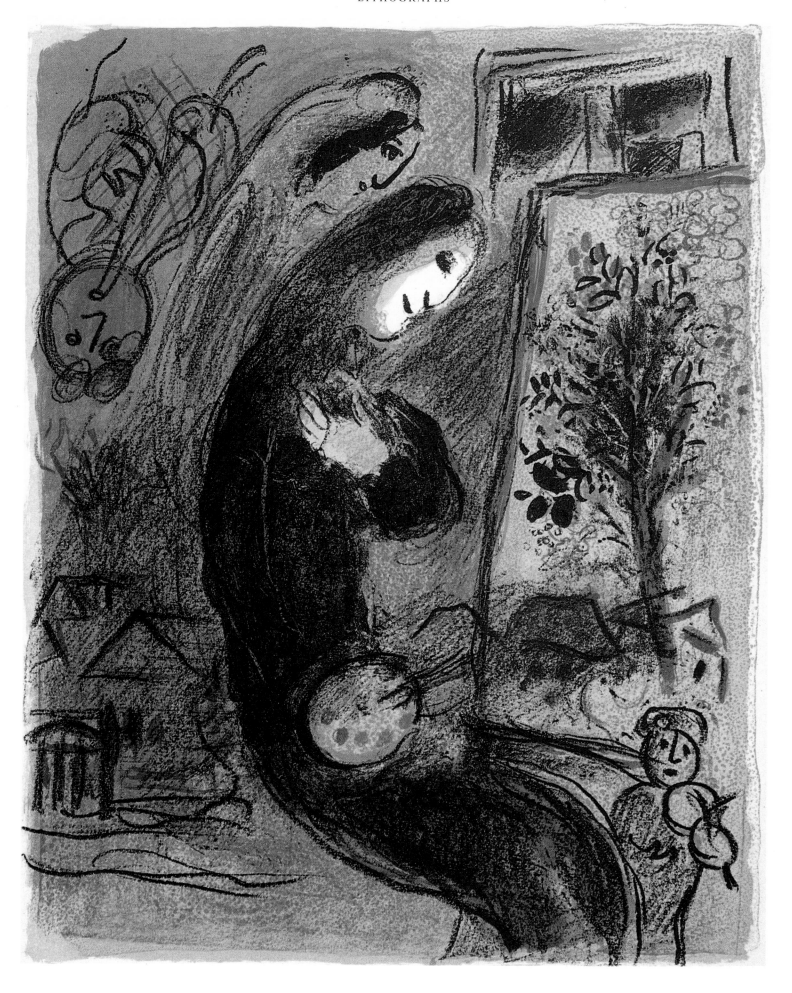

Inspiration. Not later than 1963

CAT. NO. 223

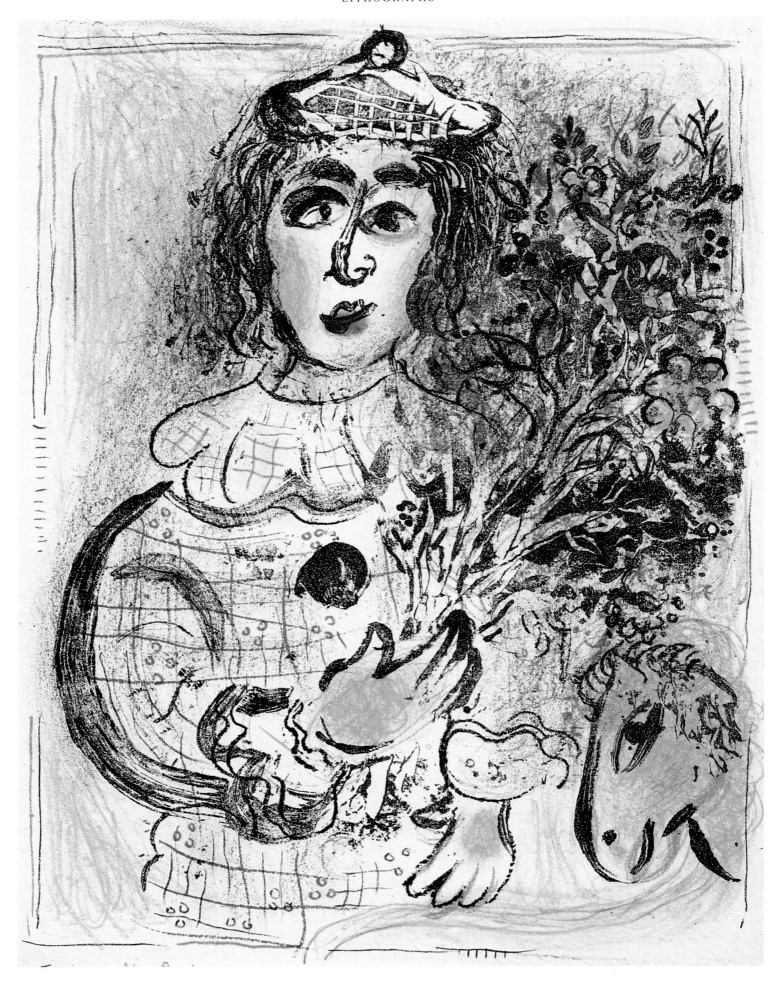

Clown with Bouquet. Sheet from the *Circus* series. 1956—62

CAT. NO. 202

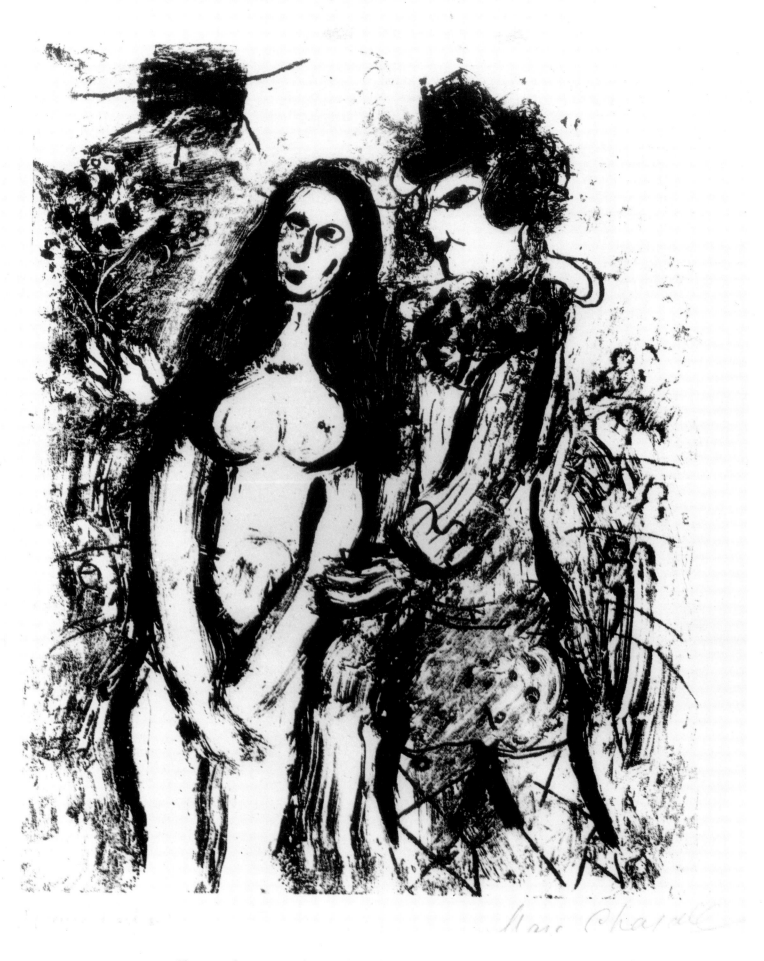

Clown and His Sweetheart. Sheet from the *Circus* series. 1956—62

CAT. NO. 207

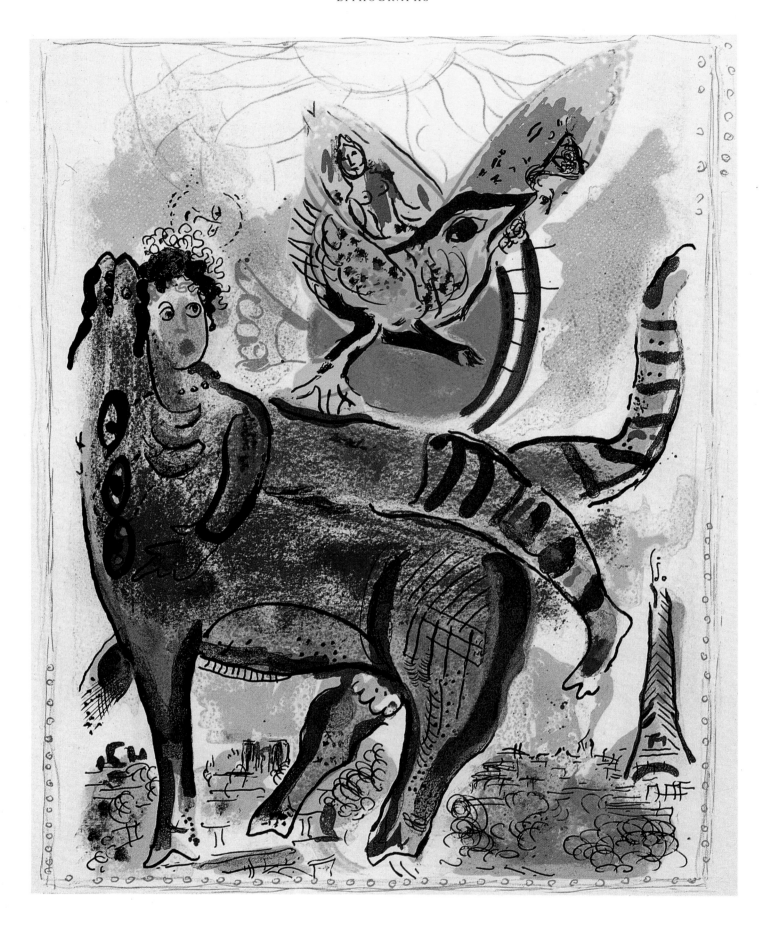

Equestrienne. Sheet from the *Circus* series. 1956—62

CAT. NO. 203

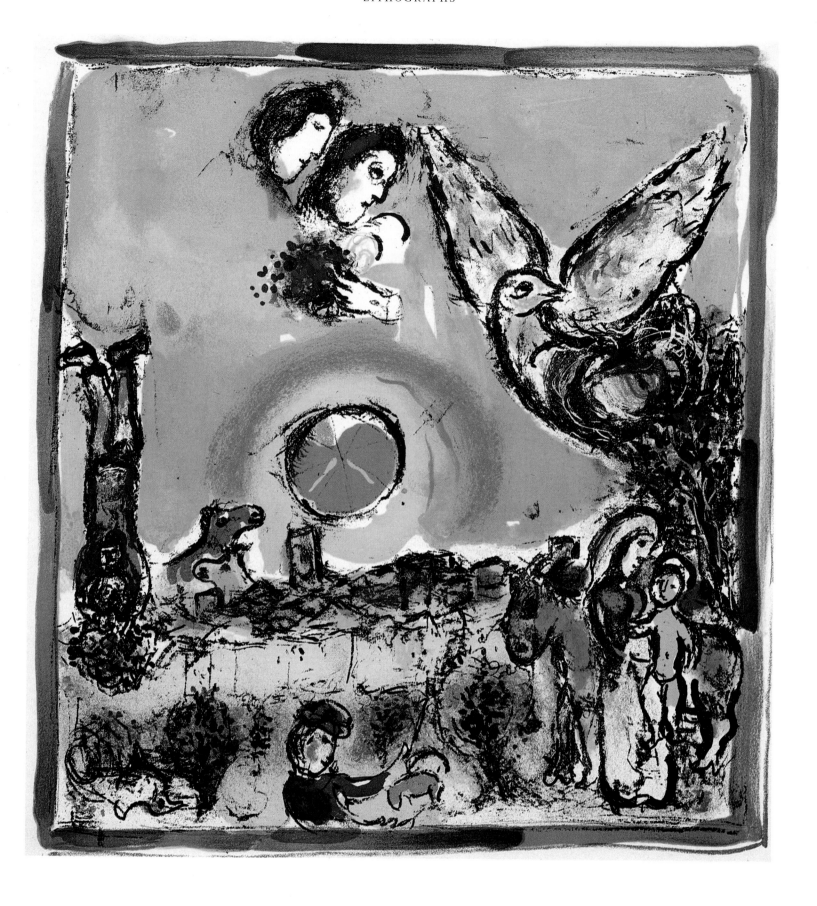

Sun in Saint-Paul. Sheet from the *Saint-Paul-de-Vence* series. 1957—62
CAT. NO. 234

Wandering Musicians. Sheet from the *Circus* series. 1956—62

CAT. NO. 205

The Bay. Sheet from the *Saint-Paul Bay* series. Not later than 1973

CAT. NO. 254

Play of Harlequins. Not later than 1973

CAT. NO. 257

Rest. Sheet from the *Saint-Paul Bay* series. Not later than 1973

CAT. NO. 256

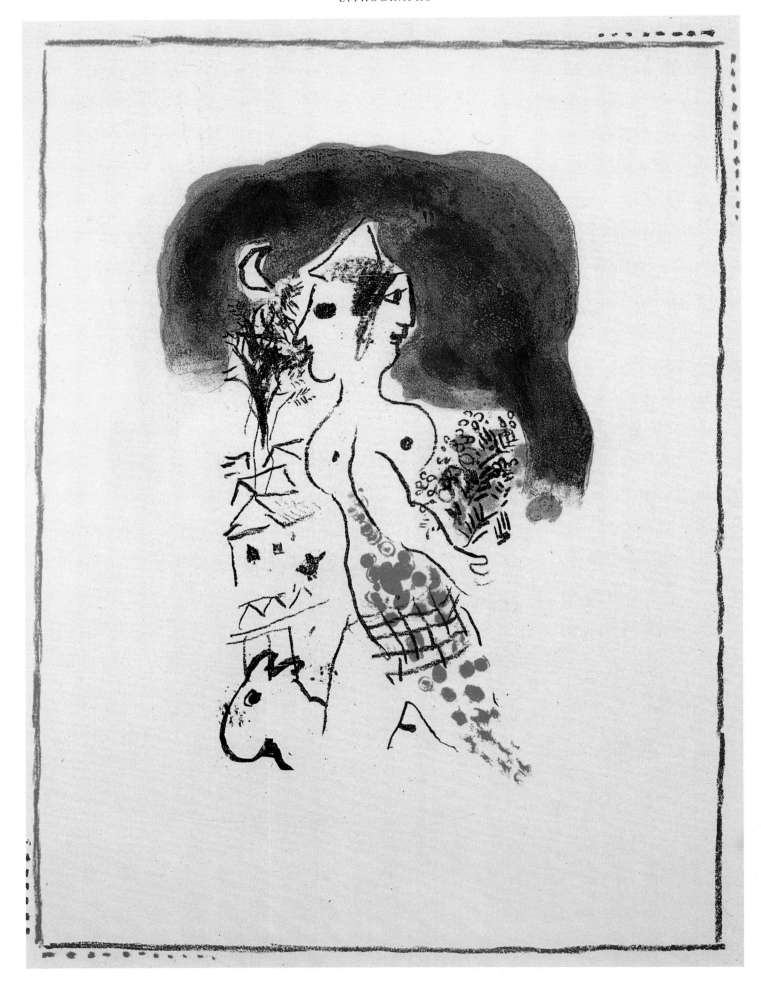

The Walk
CAT. NO. 243

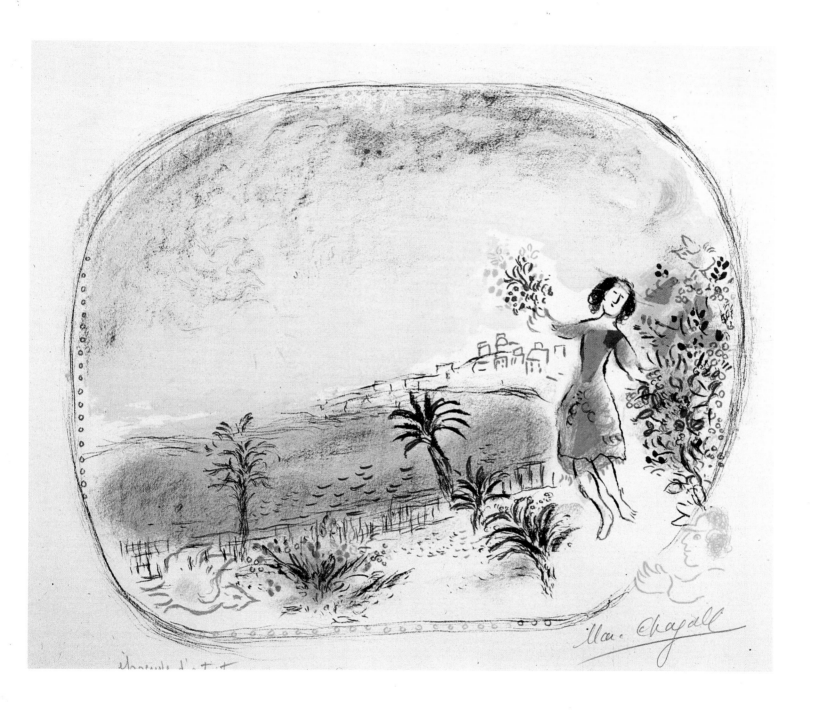

Woman with Bouquet on the Shore. Sheet from
the *Saint-Paul Bay* series. Not later than 1973
CAT. NO. 255

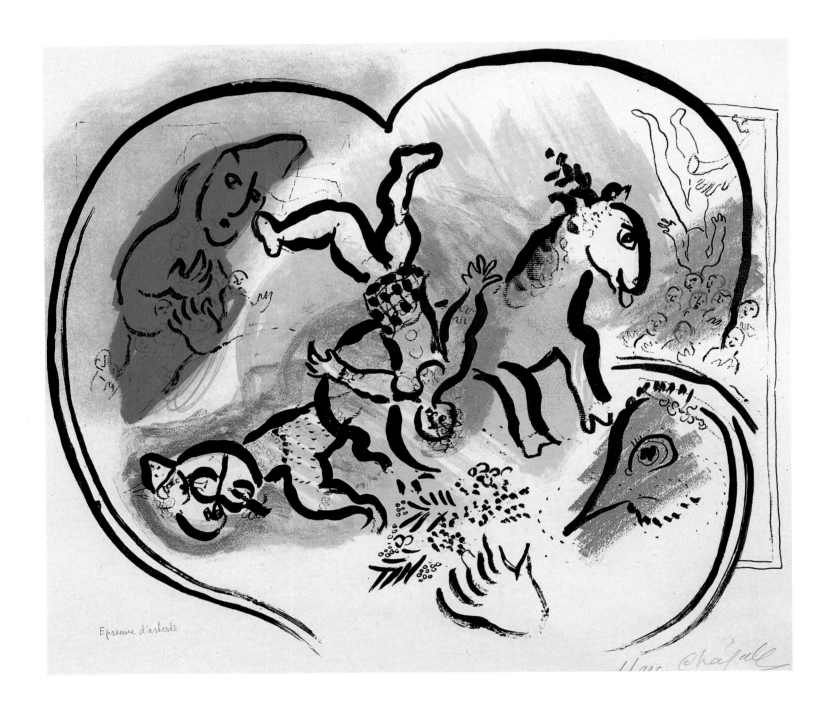

Heart of the Circus. Sheet from the *Circus* series. 1956—62

CAT. NO. 204

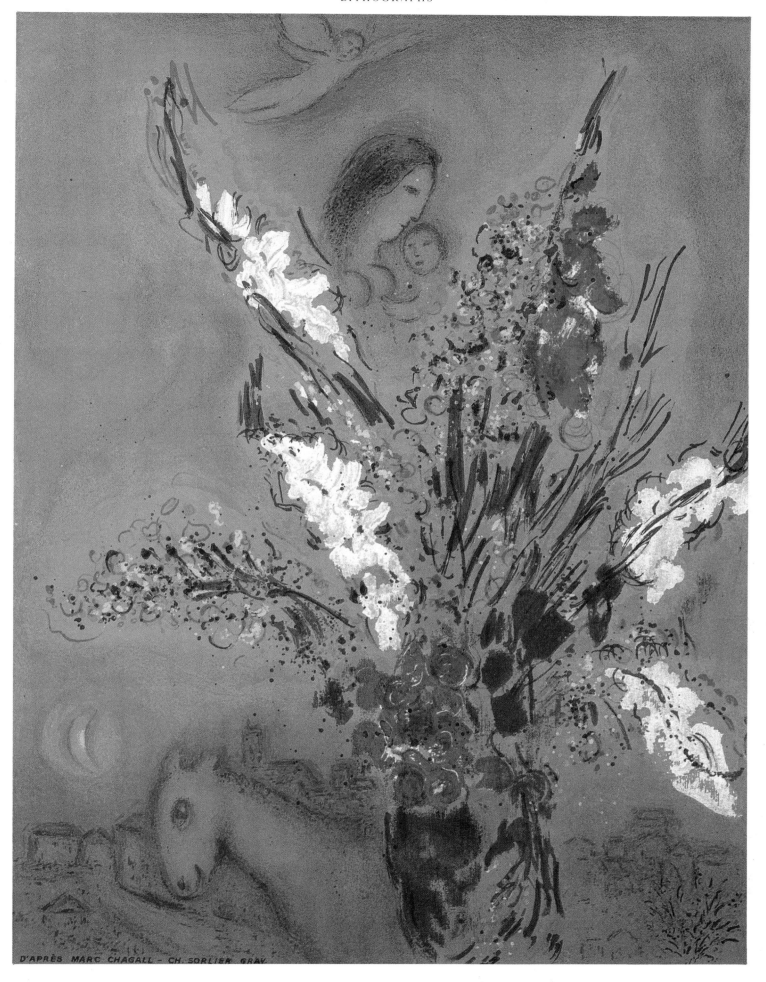

D'APRÈS MARC CHAGALL – CH. SORLIER GRAV.

Gladioli

CAT. NO. 246

273

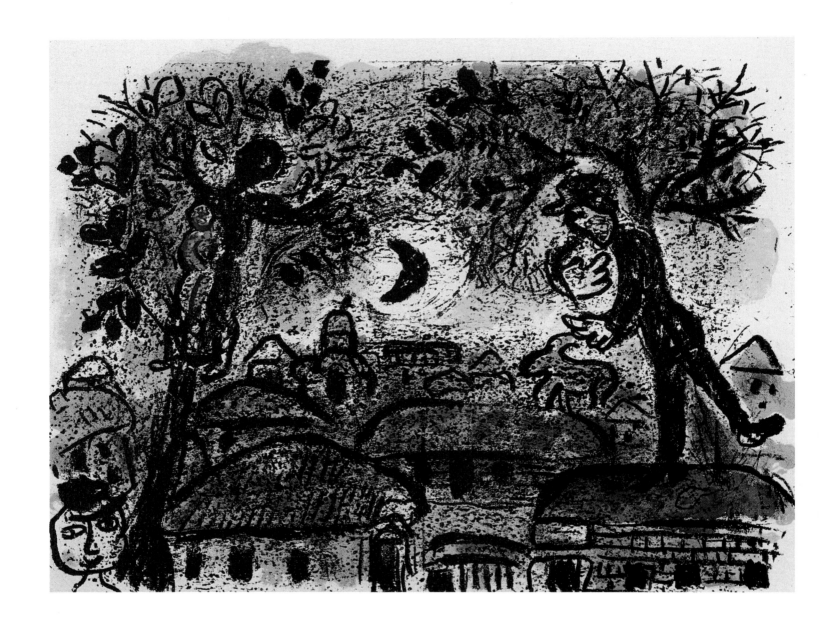

Children in Trees. Sheet on the theme *Memories of Vitebsk*

CAT. NO. 227

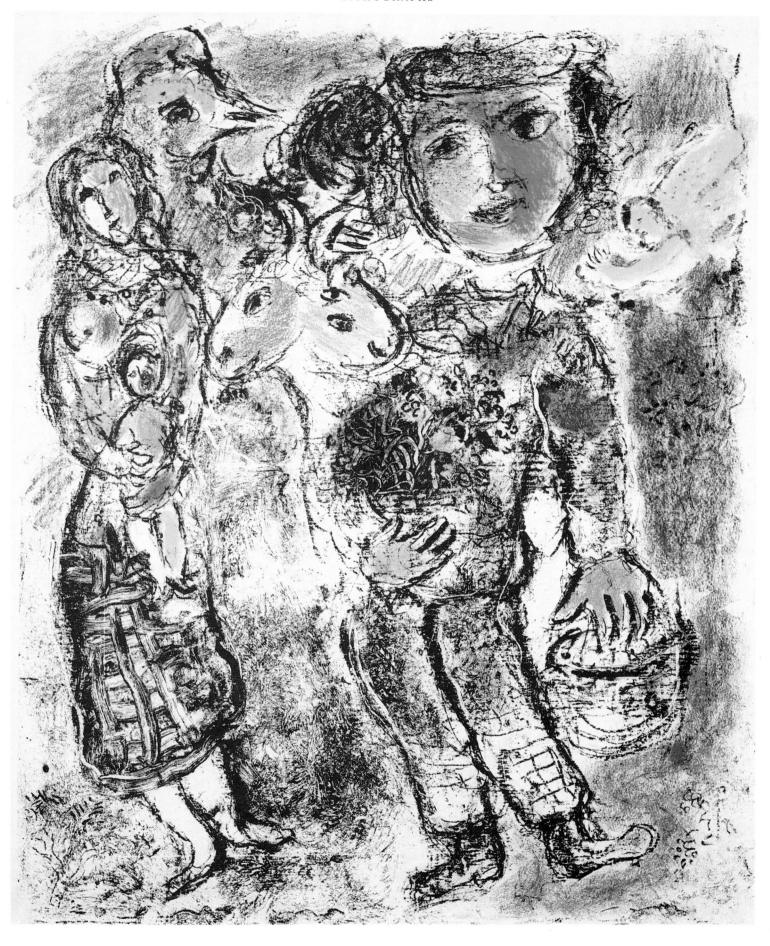

Peasants

CAT. NO. 232

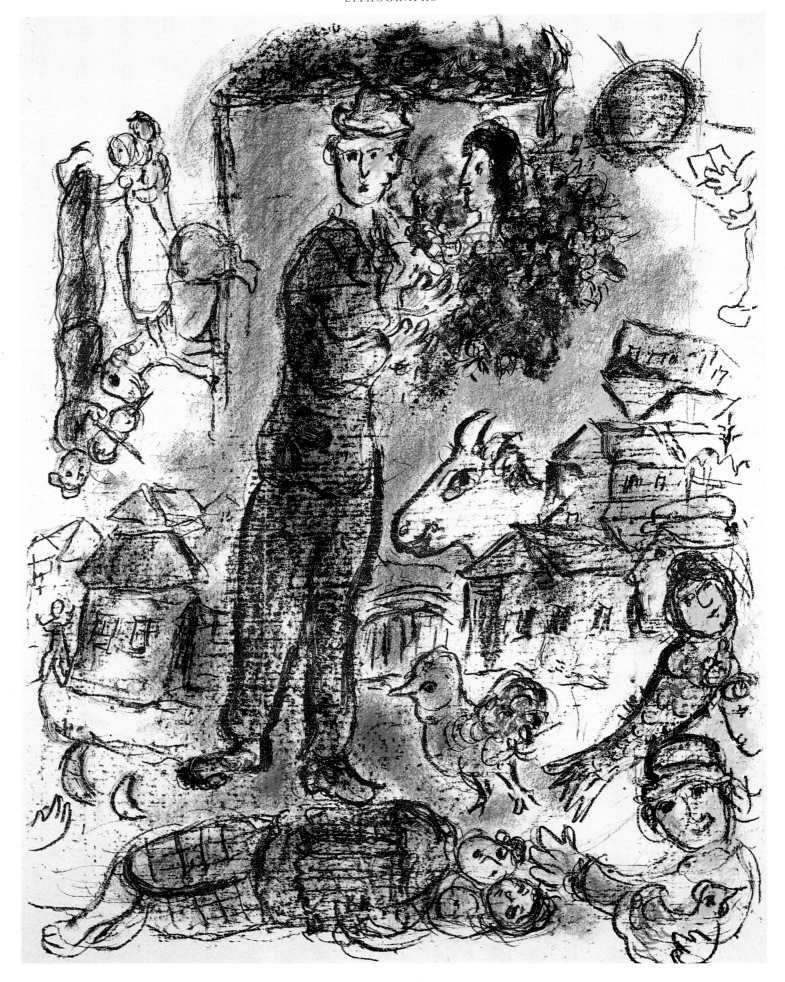

Man with Double Profile and His Bride. Sheet on
the theme *Memories of Vitebsk*

CAT. NO. 228

276

Epreuve d'artiste

Marc Chagall

The Flying Fish

CAT. NO. 258

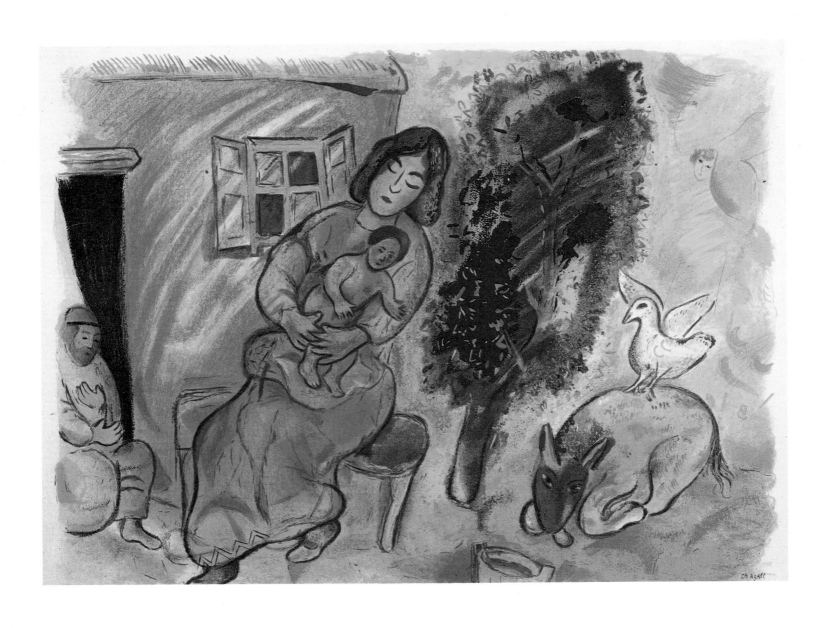

Maternity
CAT. NO. 241

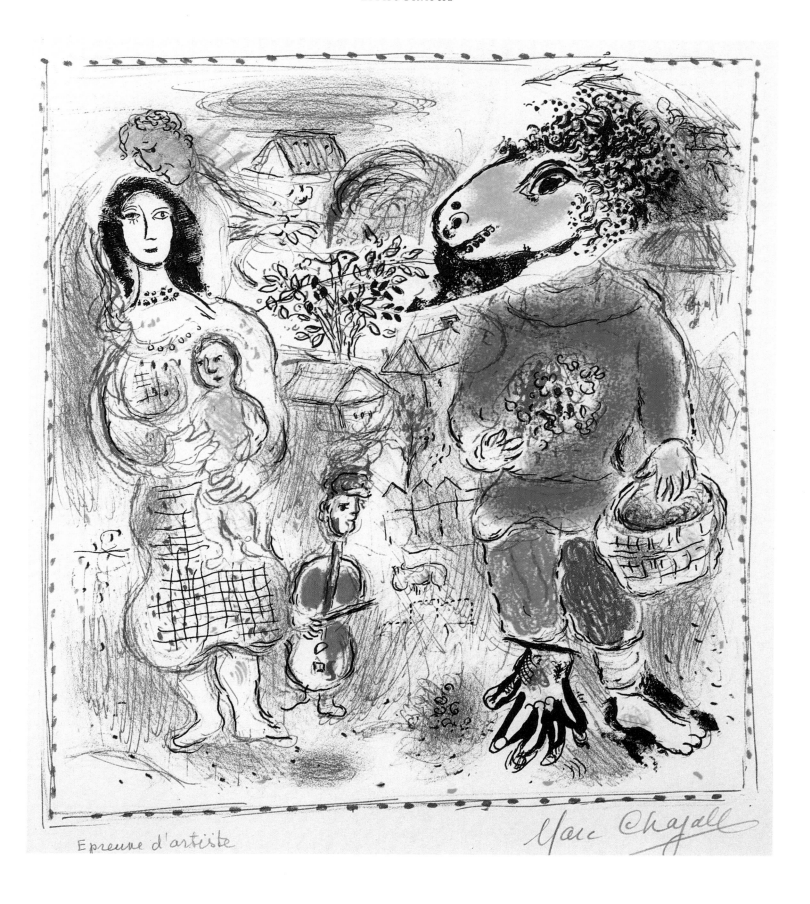

Green Violin. Sheet on the theme *Memories of Vitebsk*

CAT. NO. 231

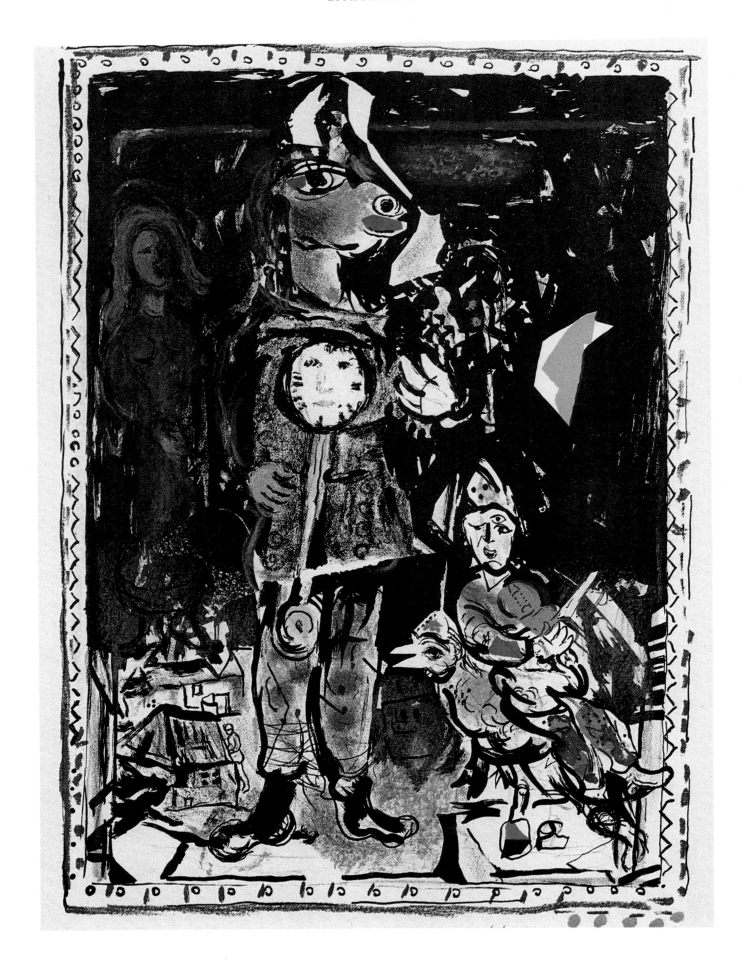

Time

CAT. NO. 242

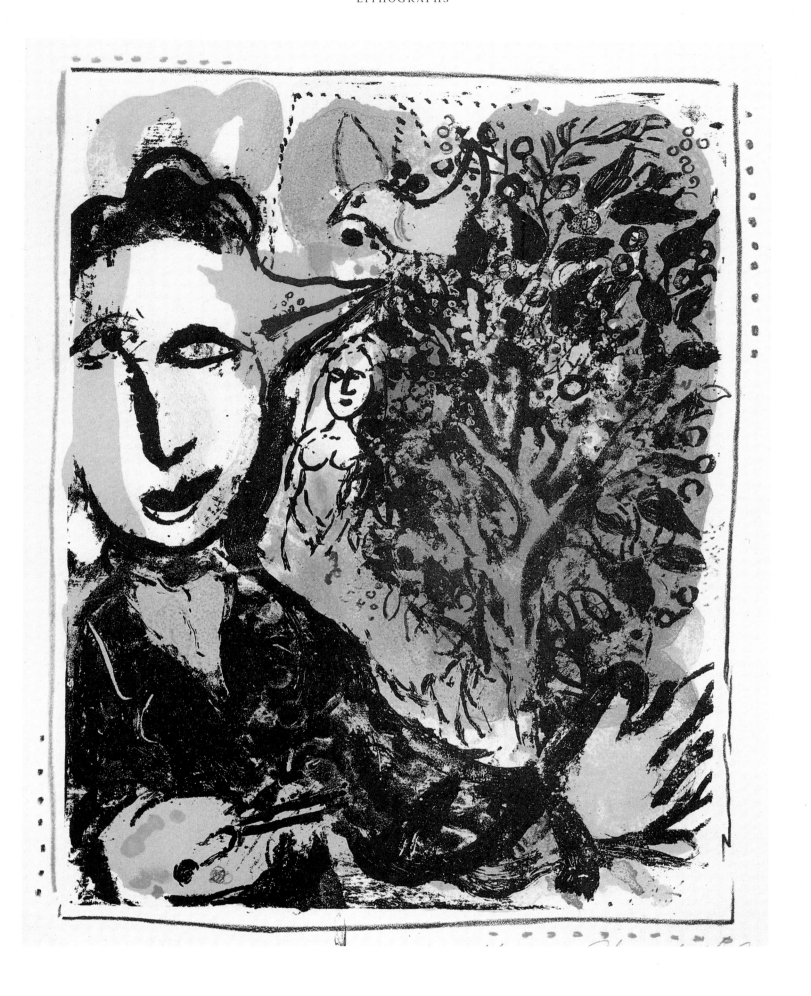

The Artist

CAT. NO. 240

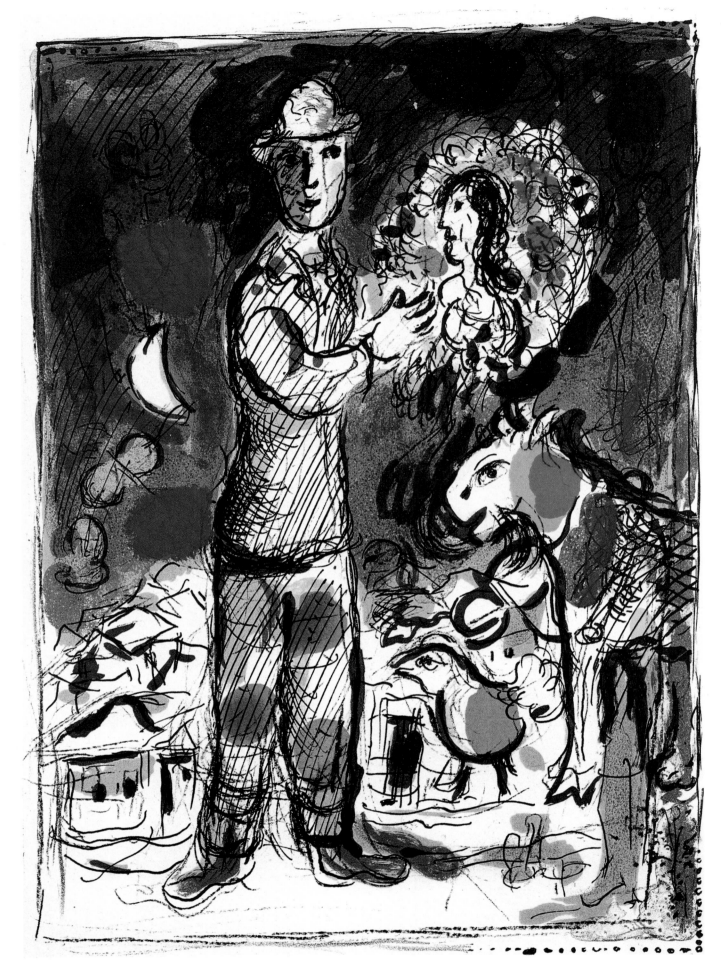

Composition with Figure. Sheet on
the theme *Memories of Vitebsk*
CAT. NO. 229

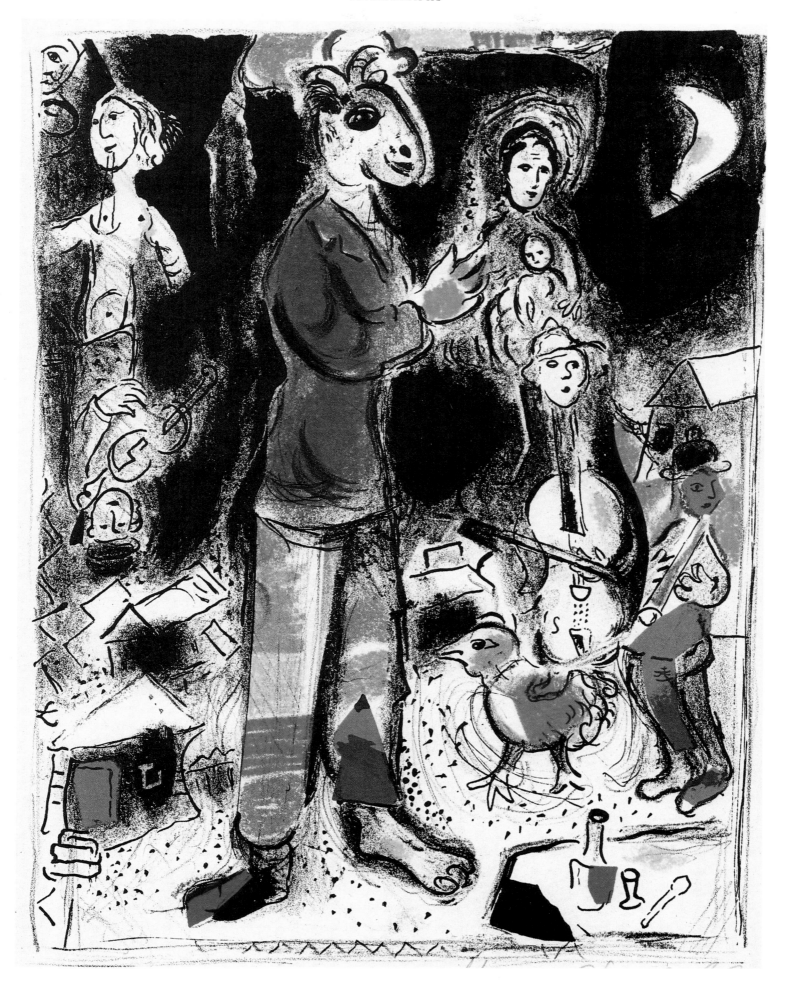

Composition
CAT. NO. 249

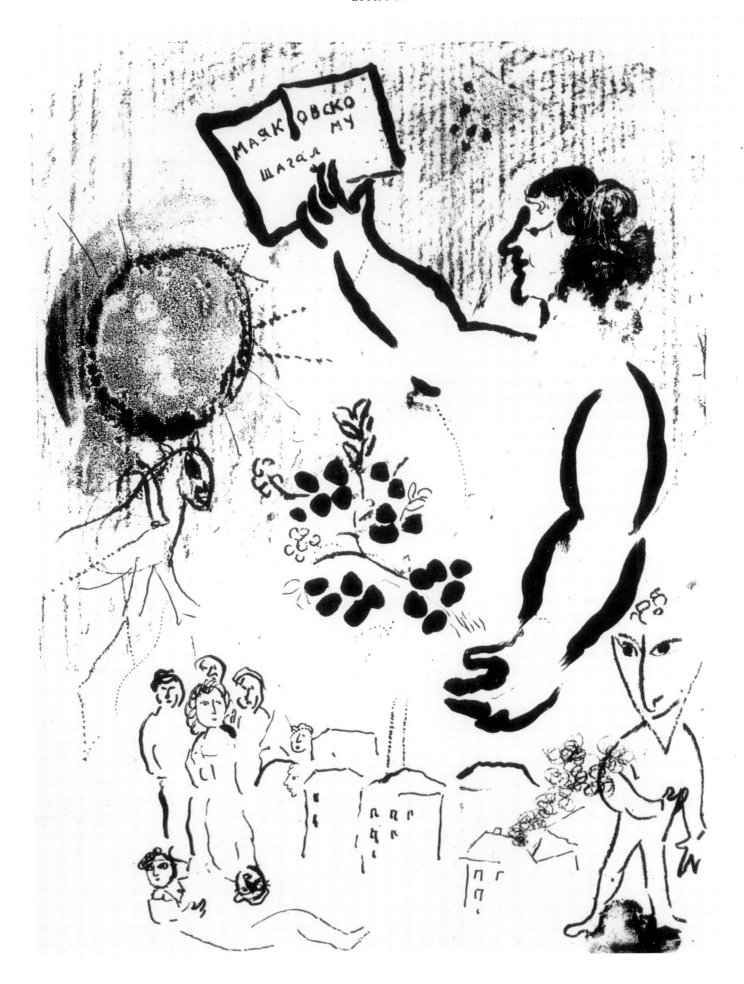

To Mayakovsky from Chagall. Sheet from
the *Vladimir Mayakovsky* series. 1963

CAT. NO. 236

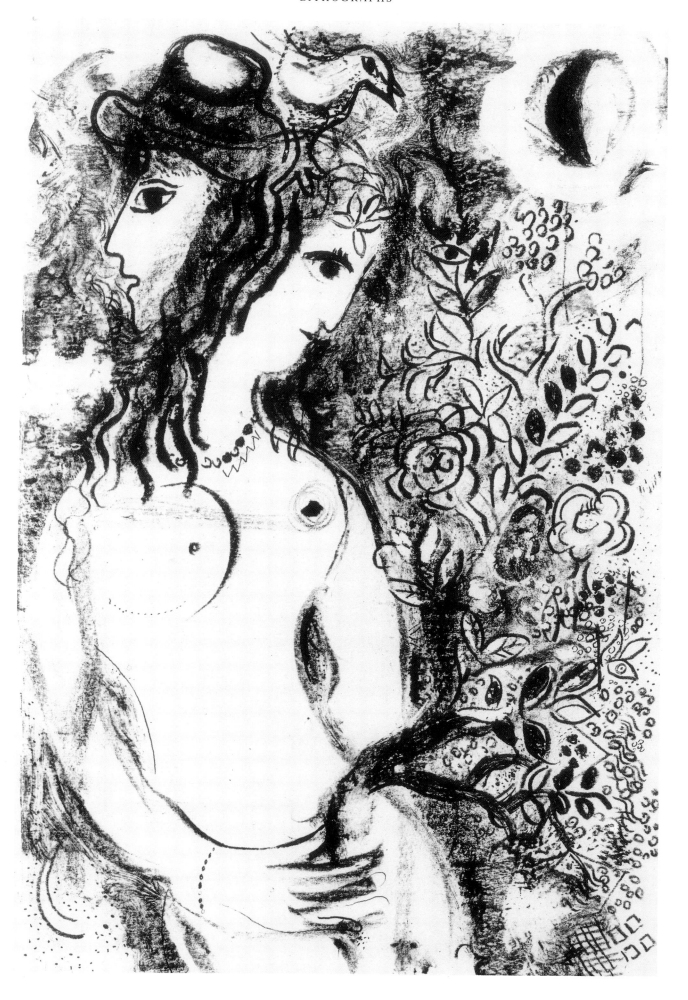

Sheet from the *Vladimir Mayakovsky* series. 1963

CAT. NO. 237

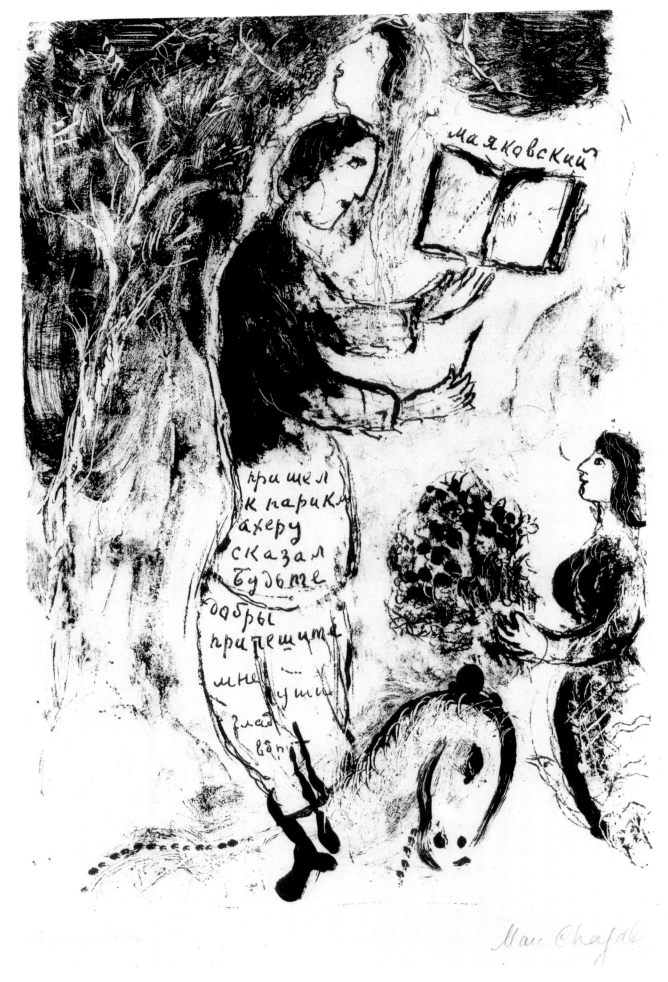

"I came to the Barber and said: Scratch my ears."
Sheet from the *Vladimir Mayakovsky* series. 1963

CAT. NO. 238

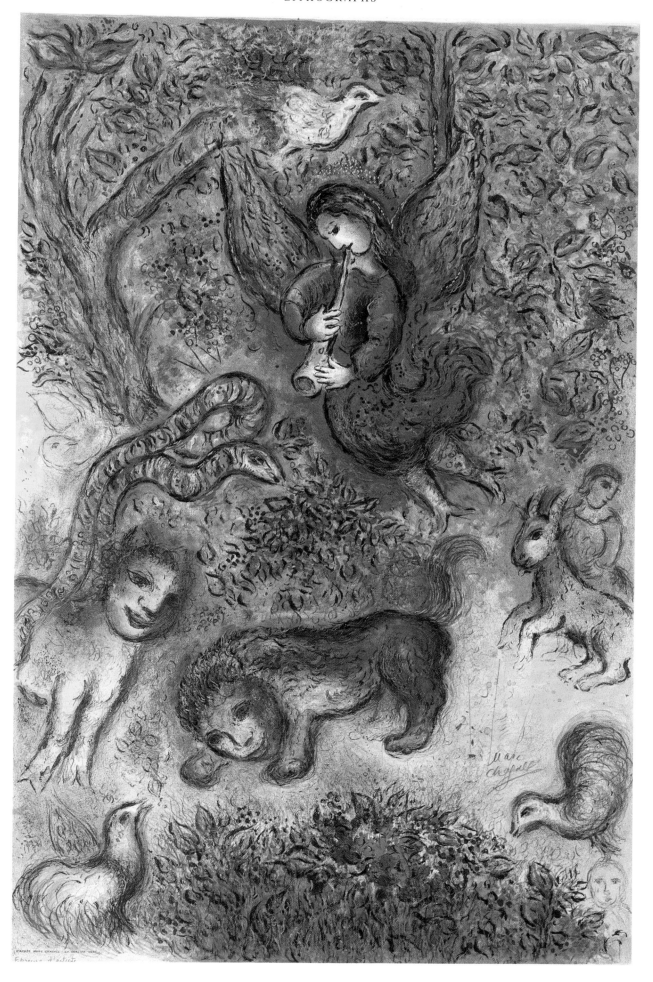

The Magic Flute. 1967
CAT. NO. 247

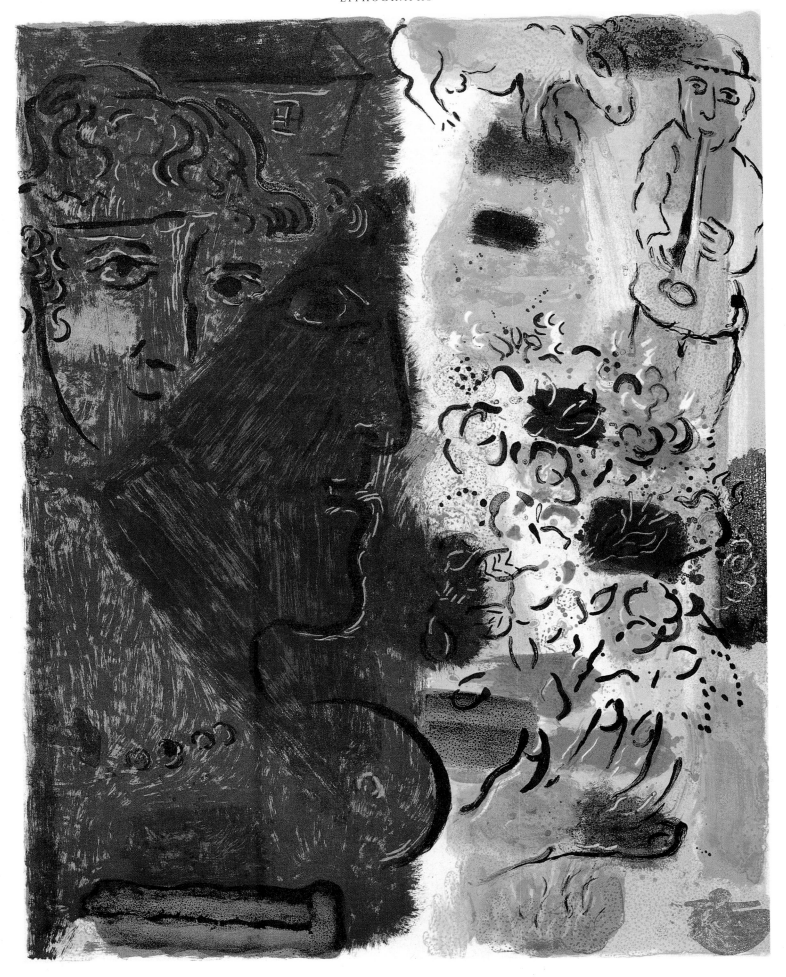

Profile and Trumpet Player. Not later than 1973

CAT. NO. 253

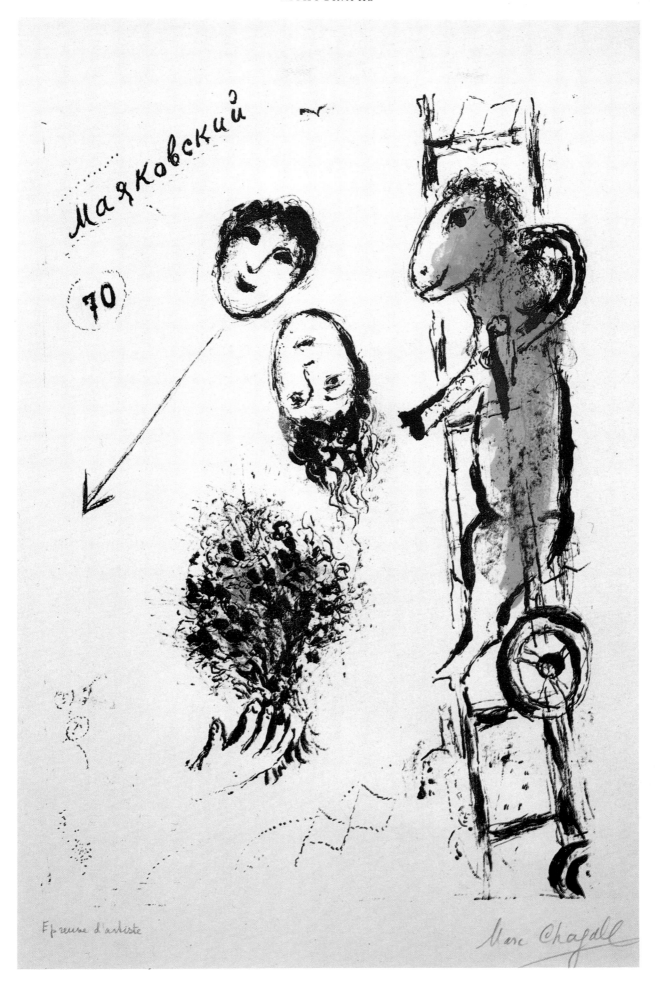

Mayakovsky—70. Sheet from the *Vladimir Mayakovsky* series. 1963

CAT. NO. 239

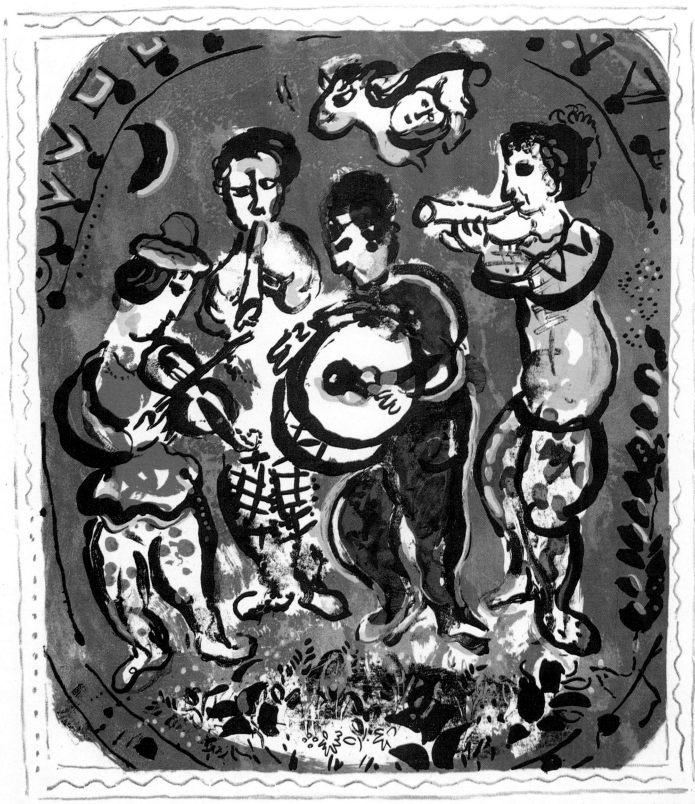

Epreuve d'artiste

Marc Chagall

Musicians on Green
CAT. NO. 248

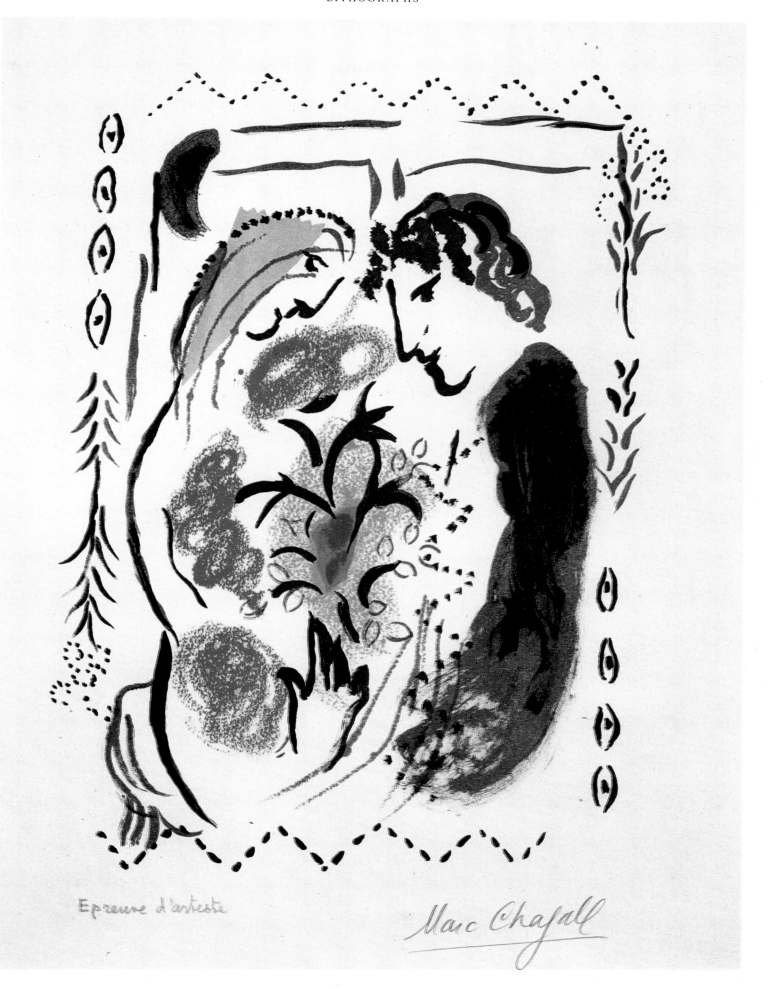

Epreuve d'artiste

Marc Chagall

Bridal Couple
CAT. NO. 244

291

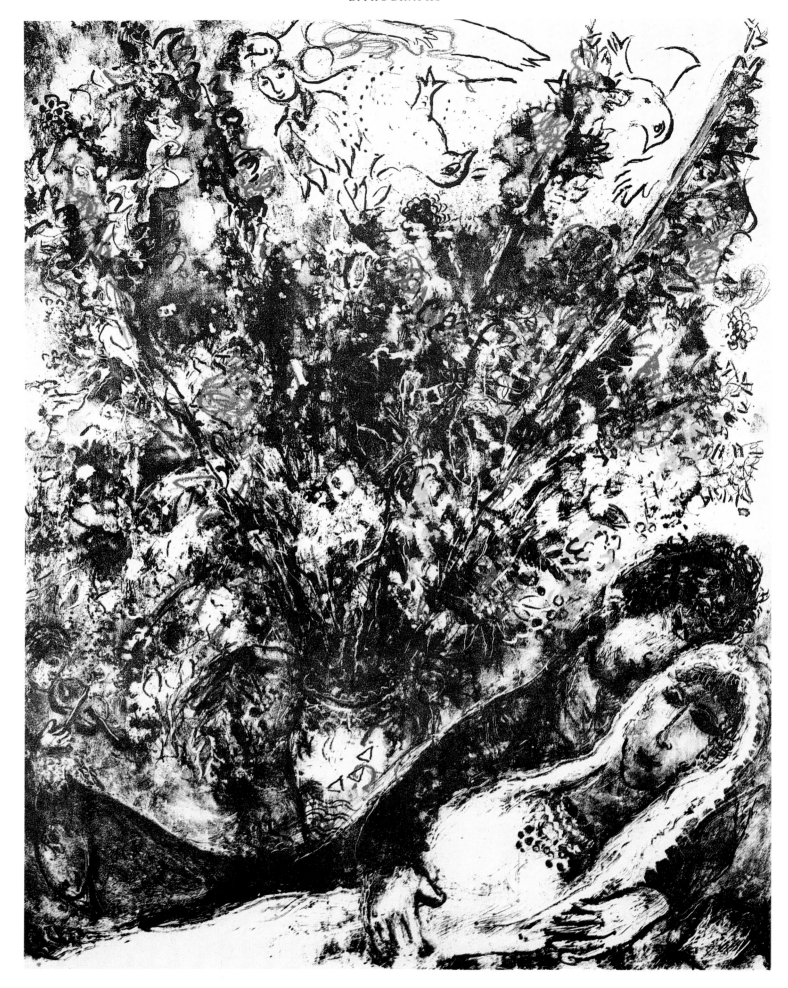

Couple with Flowers
CAT. NO. 252

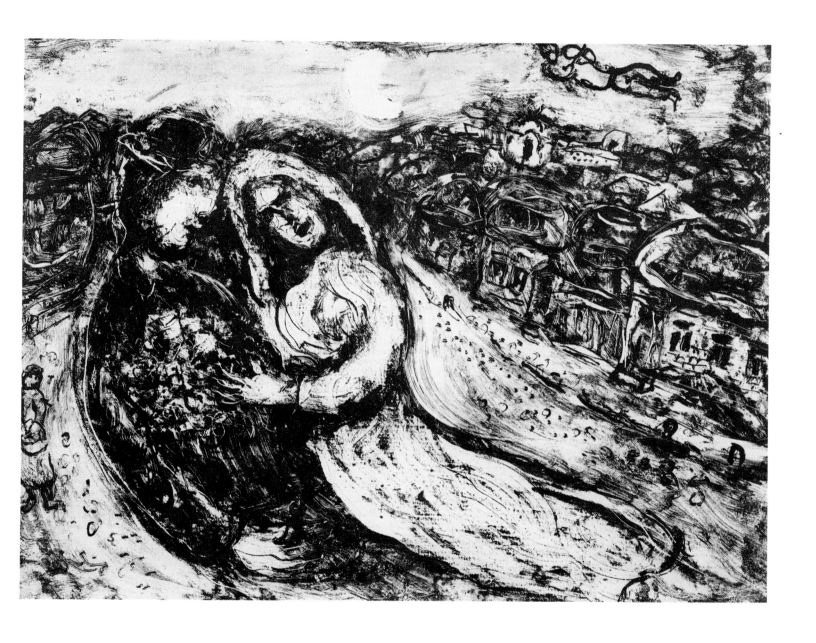

Lovers' Sky. Sheet on the theme *Memories of Vitebsk*
Not later than 1963

CAT. NO. 224

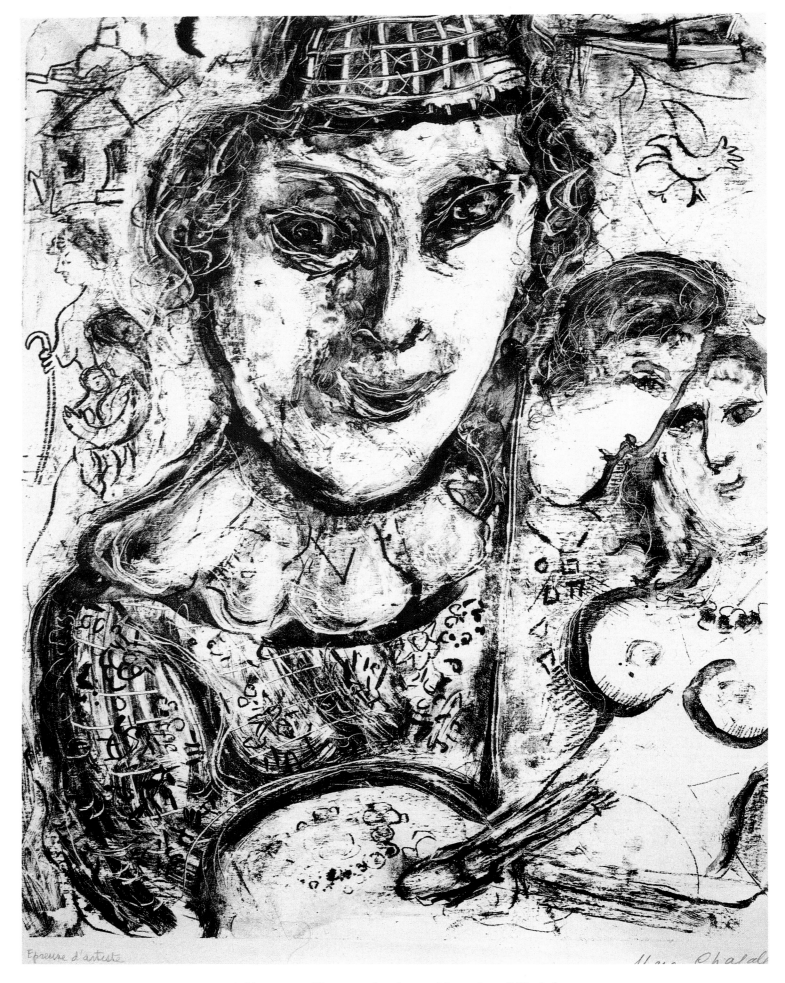

Epreuve d'artiste

Self-portrait. Sheet on the theme *Memories of Vitebsk*
Not later than 1963
CAT. NO. 225

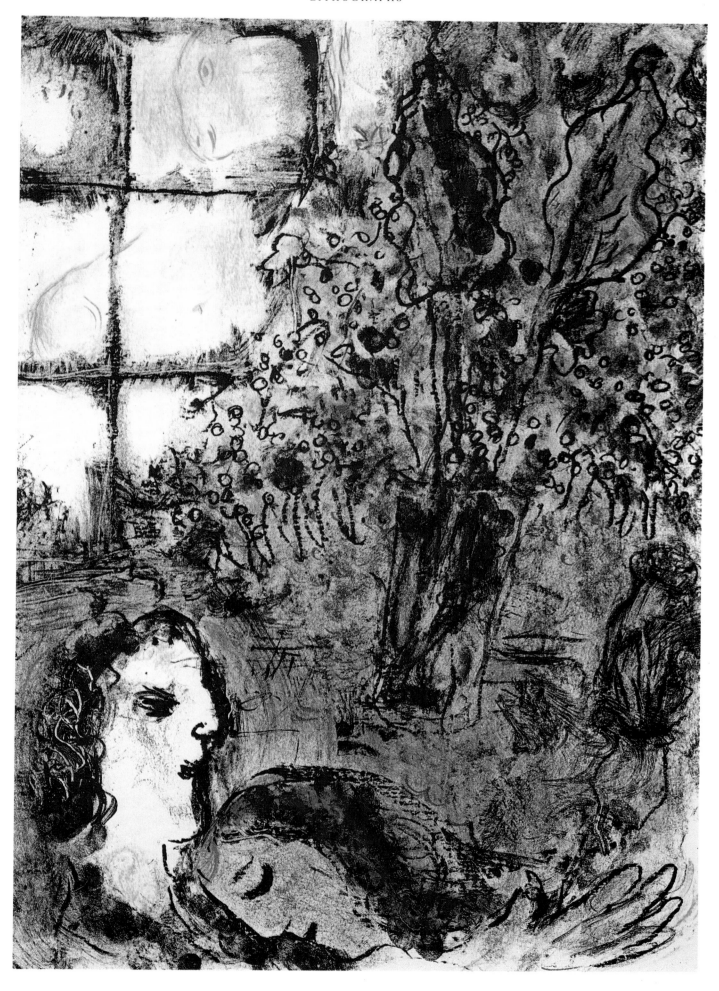

Summer Evening. C. 1960

CAT. NO. 218

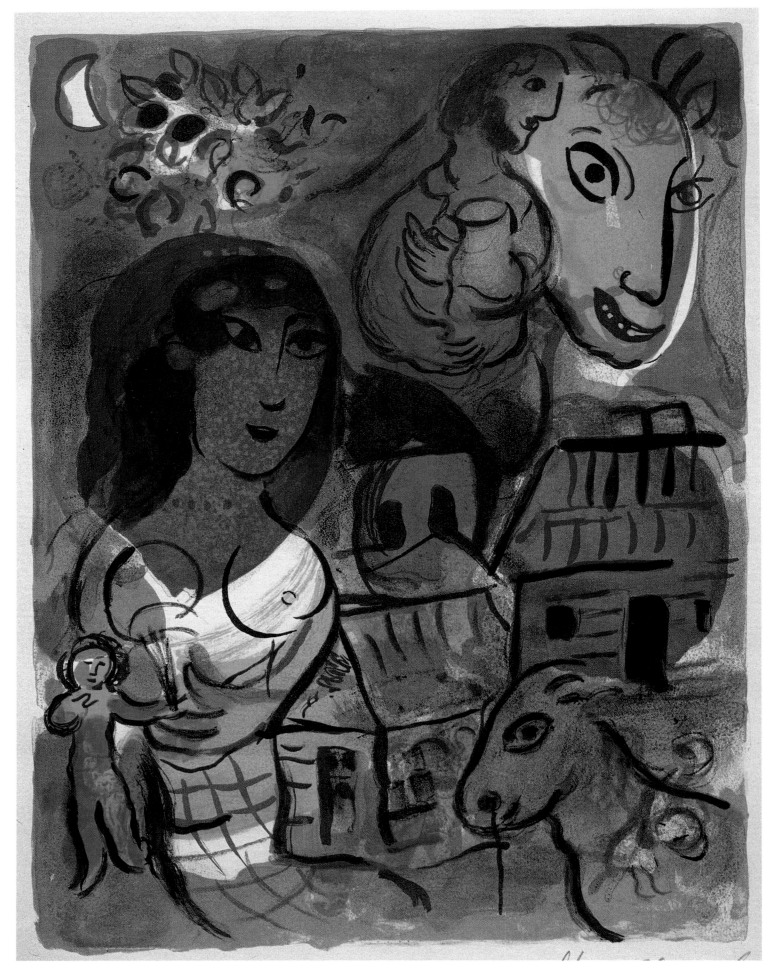

Composition based on *The Little Golden Calf*,
novel by Ilf and Petrov

CAT. NO. 250

296

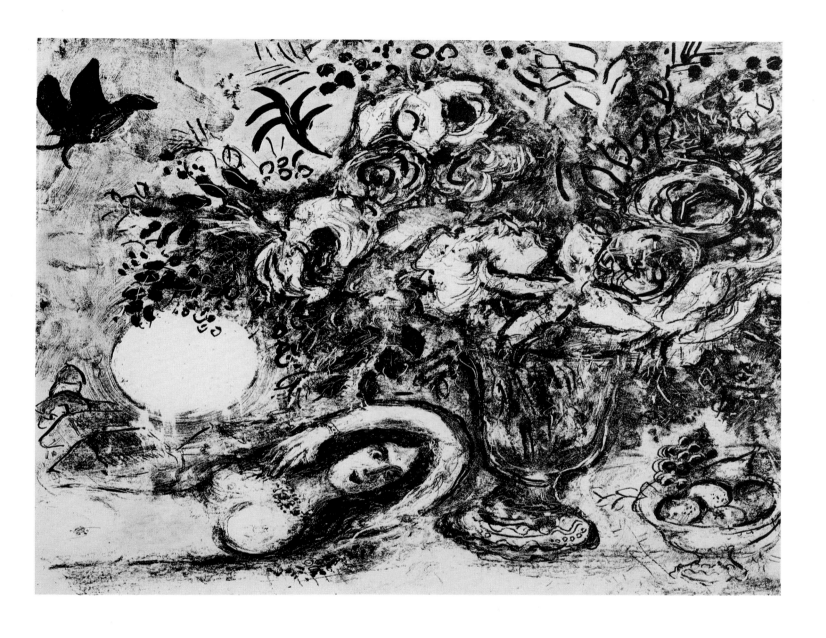

Nude and Flowers. Sheet on the theme *Memories of Vitebsk*

CAT. NO. 226

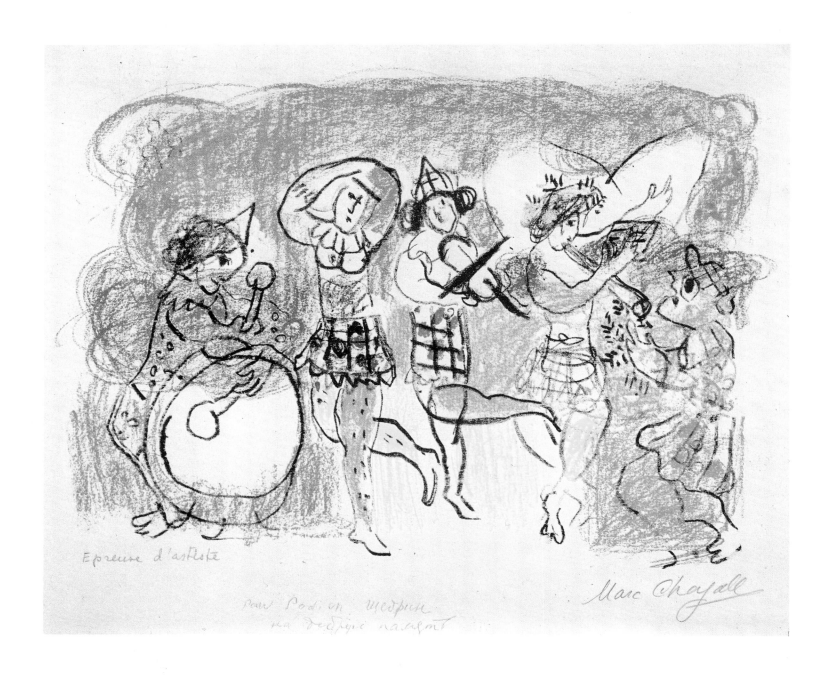

Circus Musicians

CAT. NO. 245

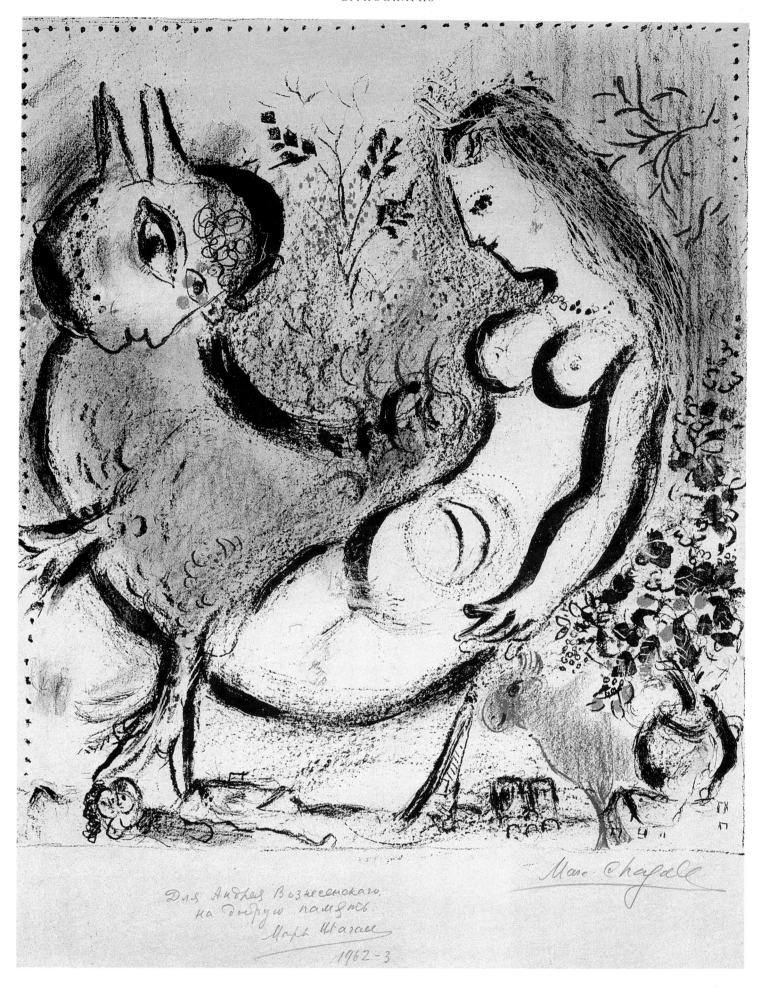

Composition in Blue

CAT. NO. 235

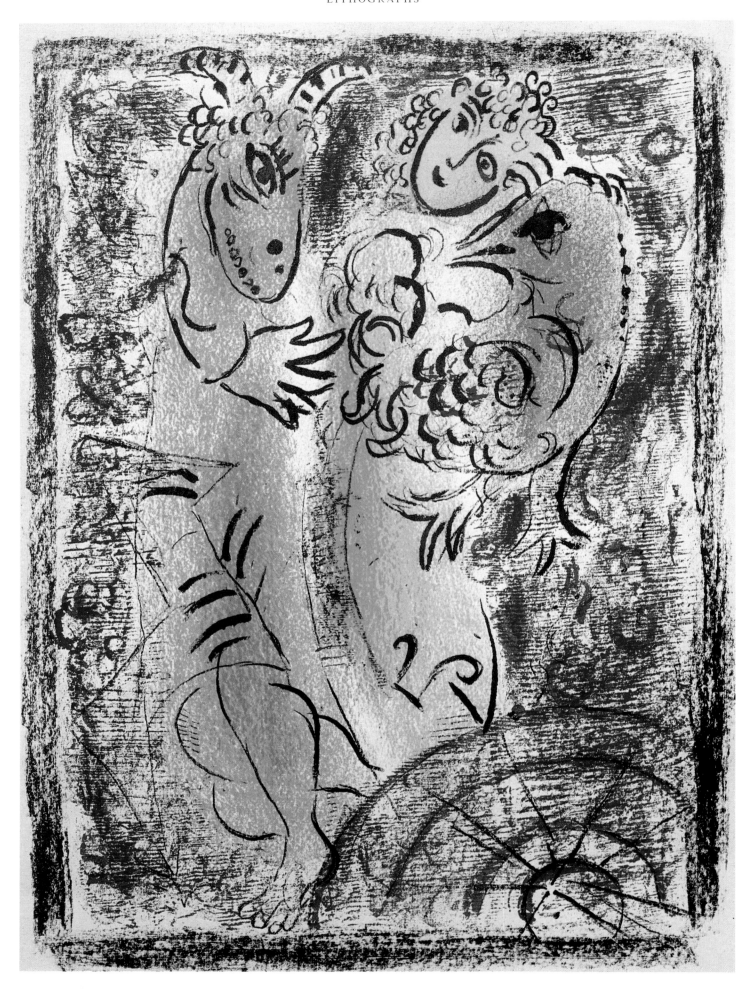

Composition

CAT. NO. 230

The Lovers and Bull. Ceramic platter

CAT. NO. 259

CATALOGUE

NOTES TO THE CATALOGUE

The Catalogue includes sections of painting, graphic work (drawings, etchings and lithographs) and archive materials. In each section the material is arranged chronologically.

Titles of works follow those established by Meyer (Franz Meyer, *Marc Chagall. Life and Work*, trans. R. Allen, New York, Abrams, [1964], monograph), where possible.

Dimensions are given in centimetres, with height preceding width.

The place names, dates, signatures, slogans, etc. found in the signature areas are given in Russian with English translation put in square brackets.

In the section of archive materials references to exhibitions and books, and the editor's explanatory text are put in square brackets. The acronyms TsGALI and GMII refer, respectively, to the Central State Archive for Art and Literature and the Pushkin Museum of Fine Arts, both located in Moscow. The abbreviations for each archival citation are: holding (*fond, f*), file (*opis*), item (*edinitsa khraneniya*), and page number. The end of each page in the original texts (held at TsGALI) is marked by the sign //.

PAINTING

1
Woman with Basket (Peasant Woman).
C. 1906
Gouache, oil and charcoal on cardboard. 67.5 × 50 cm
Signed lower left: *Marc Chagall*
The Tretyakov Gallery, Moscow; gift of George Costakis
Inv.no. П—46707

2
Little Parlour. 1908
Oil on paper fixed on canvas. 22.5 × 29 cm
Signed and dated lower right in pencil: *Chagall 1908*
Collection of Valentine Chagall, Saint-Paul-de-Vence

3
The Window. Vitebsk. 1908
Oil on canvas fixed on cardboard. 67 × 58 cm
Signed and dated lower right: *М. Шагал* [Marc Chagall] *1908*
Collection of Zinaida Gordeeva, Leningrad

4
The Birth. 1911
Oil on canvas. 46 × 36 cm
Signed and dated lower right: *Chagall 1911*
Collection of Ida Chagall, Paris

5
The Poet Mazin. 1911—12
Oil on canvas. 73 × 54 cm
Inscribed lower left: *Paris*
Collection of Ida Chagall, Paris

6
Newspaper Vendor. 1914
Oil on cardboard. 98 × 78.5 cm

Signed and dated lower right: *1914 Marc Chagall*
Collection of Ida Chagall, Paris

7
Self-portrait at the Easel. 1914
Oil on canvas. 72 × 47 cm
Signed and dated lower right: *Marc 1914 Chagall*
Collection of Vera Kozintseva, Leningrad; formerly collection of Ilya Ehrenburg

8
Clock. 1914
Oil and gouache on paper. 49 × 37 cm
Signed lower right: *Шагалъ* [Chagall]
Inscription in picture reads: *Le roi de Paris*; the initials *K.A.* are painted on the pendulum
The Tretyakov Gallery, Moscow
Inv.no 9190 rp.

9
Lovers in Green
Gouache and oil on paper fixed on cardboard.
48 × 45.5 cm
Signed by right edge: *M. Chagall*
Private collection, Moscow

10
Lovers in Blue. 1914
Oil on cardboard. 49 × 44 cm
Private collection, Leningrad

11
Uncle Zussy (The Barbershop). 1914
Oil and gouache on paper. 49.3 × 37.2 cm
Signed lower right: *Chagall*

Inscription in picture reads: *Абонеты платять вперед*
[Clients pay in advance]
The Tretyakov Gallery, Moscow
Inv.no. 17334 гр.

12
Study for *Over Vitebsk*. 1914
Oil on cardboard. 19.5 × 25 cm
Signed and dated in picture, lower right: *Шагал*
[Chagall]. *1914*
Private collection, Leningrad

13
Uncle's Store in Lyozno
Oil on paper fixed on cardboard. 37 × 49 cm
Inscriptions in picture read: *Мучная и бакалейня*
Хаинсон and *Парикмахер З. Шагалъ* [Cornchandler
and grocer Khainson and Barber Z. Chagall]
The Tretyakov Gallery, Moscow
Inv.no. 22893 гр.

14
Vitebsk Chemist's
Gouache, tempera, watercolour and oil on paper fixed
on cardboard. 40 × 52.4 cm
Signed lower right: *Шагалъ* [Chagall]
Collection of Valery Dudakov, Moscow

15
David with a Mandolin. 1914
Gouache on cardboard. 49.5 × 37 cm
Maritime Picture Gallery, Vladivostok
Inv.no. Г—7

16
Mariaska. 1914
Oil on cardboard. 51 × 36 cm
Private collection, Leningrad

17
Jew in Bright Red. 1915
Oil on cardboard. 100 × 80.5 cm
Signed lower right: *Chagall*
The Russian Museum, Leningrad
Inv.no. 1708

18
View from Window. Vitebsk
Gouache on cardboard. 49 × 36.3 cm
Signed bottom centre: *Chagall*
The Tretyakov Gallery, Moscow
Inv.no. 22894 гр.

19
Window in the Country. 1915
Oil and gouache on cardboard. 100 × 80 cm
Signed lower left: *Chagall*
The Tretyakov Gallery, Moscow
Inv.no. 9196

20
Bella and Ida at the Window. 1916
Oil on cardboard fixed on canvas. 56 × 45 cm
Dated and signed lower right: *1916 Chagall*
Collection of Ida Chagall, Paris

21
Lilies of the Valley. 1916
Oil on cardboard. 42 × 33.5 cm
Signed and dated by left edge: *M. Шагал*
[M. Chagall] *1916*
The Tretyakov Gallery, Moscow; gift of George
Costakis
Inv.no. П—46678

22
Strawberries. 1916
Oil on canvas fixed on cardboard. 45 × 59 cm
Signed and dated lower right: *Marc Chagall 1916;* half-
erased signature in the same place: *Шагалъ* [Chagall]
Collection of Ida Chagall, Paris

23
Baby's Bath
Tempera on paper fixed on cardboard. 53 × 44 cm
Signed lower right: *Шагалъ* [Chagall]
Art and History Museum, Pskov

24
Over the Town. 1914—18
Oil on canvas. 141 × 198 cm
Signed and dated lower right: *Marc Chagall 1914—918*
The Tretyakov Gallery, Moscow
Inv.no. 11887

25
View on the Garden. *C*.1917
Tempera on paper fixed on cardboard. 46.5 × 61 cm
Brodsky Memorial Flat, Leningrad
Inv.no. М Бр.Ж—153

26
Cemetery Gates. 1917
Oil on canvas. 87 × 68.5 cm
Signed and dated lower right: *Chagall 1917*
Collection of Ida Chagall, Paris

27
Lovers in Grey. 1917
Oil on canvas. 69 × 49 cm
Signed and dated upper right: *Chagall 1917;* lower right:
Шагалъ женъ [Chagall. For my wife]
Collection of Ida Chagall, Paris

28
The Promenade (The Walk). 1917—18
Oil on canvas. 170 × 163.5 cm
Signed and dated lower right in green paint: *Шагал*
[Chagall] *1917*
The Russian Museum, Leningrad
Inv.no. 1726

29
The Apparition. 1917—18
Oil on canvas. 157 × 140 cm
Collection of Zinaida Gordeeva, Leningrad

30
The Wedding. 1918
Oil on canvas. 100 × 119 cm
Signed lower right: *Marc Chagall 1918*
The Tretyakov Gallery, Moscow
Inv.no. 11888

31
Behind the House. 1918
Oil on cardboard. 60.5 × 46 cm
Armenian Picture Gallery, Erevan
Inv.no. 306

32
Interior with Flowers. *C*. 1918
Tempera on paper fixed on cardboard. 46.5 × 61 cm
Signed lower right: *Шагал* [Chagall]
Brodsky Memorial Flat, Leningrad
Inv.no. М Бр.Ж—152

33
The Circus. 1919
Oil on paper fixed on canvas. 34 × 47.5 cm

Signed lower left: *Chagall*
The Tretyakov Gallery, Moscow; gift of George
Costakis
Inv.no. П—46693

34
On the Rooster. 1925. Study
Oil on canvas. 22 × 22 cm
Signed lower right: *Marc Chagall*
Collection of Irina Ehrenburg, Moscow; formerly
collection of Ilya Ehrenburg

35
The Bride with Double Face. 1927
Oil on canvas. 99 × 72 cm
Signed and dated lower right: *Chagall Marc 1927*
Collection of Ida Chagall, Paris

36
The Blue Angel. 1930s
Gouache and mixed media on paper. 50.8 × 66 cm
Collection of Dr Armand Hammer, Los Angeles

37
Peyra-Cava Landscape with Eagle. 1930
Oil on canvas. 72 × 60 cm
Signed and dated lower right: *Chagall 930 Marc*
Collection of Valentine Chagall, Saint-Paul-de-Vence

38
Nude in Peyra-Cava Landscape. 1931
Oil on canvas. 72 × 60 cm
Signed and dated lower right: *Chagall 931 Marc*
Collection of Valentine Chagall, Saint-Paul-de-Vence

39
Bride with Blue Face. 1932—60
Oil on canvas. 100 × 81 cm
Signed and dated lower left: *Marc Chagall 1932—60*
Collection of Valentine Chagall, Saint-Paul-de-Vence

40
At Dusk (Entre chien and loup). 1938—43
Oil on canvas. 100 × 73 cm
Signed and dated lower right: *Chagall 1938—43*
Collection of Ida Chagall, Paris

41
Self-portrait with Wall Clock. 1947
Oil on canvas. 86 × 71 cm
Signed and dated lower left: *Marc Chagall 1947*
Collection of Valentine Chagall, Saint-Paul-de-Vence

42
The Lovers with Bridge. 1948
Oil on canvas. 99 × 47 cm
Signed along lower edge: *Chagall Marc*
Collection of Valentine Chagall, Saint-Paul-de Vence

43
Wall Clock with Blue Wing. 1949
Oil on canvas. 92 × 79 cm
Dated and signed lower right: *1949. Chagall Marc*
Collection of Ida Chagall, Paris

44
The Banks of the Seine. 1953
Oil on canvas. 79.5 × 68 cm
Signed and dated lower left: *Marc Chagall 1953*
Collection of Valentine Chagall, Saint-Paul-de Vence

45
Portrait of Vava. 1953—56
Oil on canvas. 95 × 73 cm

Signed and dated lower left: *Marc Chagall 1953—56*
Collection of Valentine Chagall, Saint-Paul-de-Vence

46
The Two Shores. 1953—56
Oil on canvas. 148 × 102 cm
Dated and signed lower right: *1953—56 Marc Chagall*
Collection of Valentine Chagall, Saint-Paul-de-Vence

47
Couple with Fiddler. 1956
Oil on canvas. 100 × 81 cm
Collection of Valentine Chagall, Saint-Paul-de Vence

48
The Midday Sun. 1958
Oil on veneer. 44 × 54.5 cm
Signed lower left: *Chagall Marc*
Collection of Valentine Chagall, Saint-Paul-de-Vence

49
The Painter at the Easel. 1959—68
Oil on paper fixed on canvas. 55.5 × 49 cm
Collection of Valentine Chagall, Saint-Paul-de-Vence

50
The Flying Cows. 1966
Oil on canvas. 116 × 89 cm
Signed lower right in white paint: *Marc Chagall*
Collection of Valentine Chagall, Saint-Paul-de-Vence

51
Equestrienne on Red Horse. 1966
Oil on canvas. 150 × 120 cm
Collection of Valentine Chagall, Saint-Paul-de-Vence

52
Portrait of Vava. 1966
Oil on canvas. 92 × 65 cm
Signed lower right: *Marc Chagall*
Collection of Valentine Chagall, Saint-Paul-de-Vence

53
Flowers (La Monnaie du pape). 1967—68
Oil on canvas. 100 × 81 cm
Signed lower left: *Chagall Marc*
Collection of Valentine Chagall, Saint-Paul-de-Vence

54
The Table in Front of Saint-Paul. 1968
Oil on canvas. 100 × 73 cm
Collection of Valentine Chagall, Saint-Paul-de-Vence

55
The Fisherman's Family. 1968
Oil on canvas. 92 × 64 cm
Signed lower right in black and white paints: *Marc Chagall*
Collection of Valentine Chagall, Saint-Paul-de-Vence

56
The Prophet Isaiah. 1968
Oil on canvas. 114 × 146 cm
Signed lower right: *Marc Chagall*
Collection of Valentine Chagall, Saint-Paul-de-Vence

57
King David. 1968—71
Oil on canvas. 116 × 89 cm
Signed lower right: *Marc Chagall*
Collection of Valentine Chagall, Saint-Paul-de-Vence

58
The Painter and His Wife. 1969
Oil on canvas. 92 × 65 cm

Signed lower right: *Marc Chagall*
Collection of Valentine Chagall, Saint-Paul-de Vence

59
Couple over Saint-Paul. 1970—71
Oil on canvas. 145 × 130 cm
Signed lower right: *Chagall Marc*
Collection of Valentine Chagall, Saint-Paul-de-Vence

60
The Artist and His Model. 1970—75
Oil on canvas. 65 × 50 cm
Collection of Valentine Chagall, Saint-Paul-de-Vence

61
The Village. 1970—75
Oil on veneer. 46 × 55 cm
Signed lower right: *Marc Chagall*
Collection of Valentine Chagall, Saint-Paul-de-Vence

62
Jacob's Ladder. 1973
Oil on canvas. 73 × 92 cm
Signed lower left: *Chagall Marc*
Collection of Valentine Chagall, Saint-Paul-de-Vence

63
The Reverie. 1973
Oil on canvas. 100 × 73 cm
Collection of Valentine Chagall, Saint-Paul-de-Vence

64
Song of Solomon (The Song of Songs). 1974
Oil on canvas. 46 × 55 cm
Signed lower right: *Marc Chagall*
Collection of Valentine Chagall, Saint-Paul-de-Vence

65
The Blue Village. 1975
Oil on canvas. 73 × 92 cm
Signed lower right: *Marc Chagall*
Collection of Valentine Chagall, Saint-Paul-de-Vence

66
The Family. 1975—76
Oil on canvas. 130 × 97 cm
Signed lower left: *Marc Chagall*
Collection of Valentine Chagall, Saint-Paul-de-Vence

67
The Tree of Jesse. 1975
Oil on canvas. 130 × 81 cm
Signed and dated lower right: *Marc Chagall 1975*
Collection of Valentine Chagall, Saint-Paul-de-Vence

68
Composition. 1976
Oil on canvas. 81 × 100 cm
Signed bottom centre: *Marc Chagall*
Collection of Valentine Chagall, Saint-Paul-de-Vence

69
Sunrise. 1976
Oil on canvas. 65 × 54 cm
Signed lower left: *Marc Chagall*
Collection of Valentine Chagall, Saint-Paul-de-Vence

70
Bouquet Before a Window. 1976
Oil on canvas. 92 × 73 cm
Collection of Valentine Chagall, Saint-Paul-de-Vence

71
Moses with the Tablets of the Law and the Golden Calf. 1976

Oil on canvas. 96.5 × 170 cm
Signed and dated lower right: *Chagall 1976*
Collection of Valentine Chagall, Saint-Paul-de-Vence

72
Half-moon over Vence. 1977
Oil on canvas. 130 × 81 cm
Signed lower right: *Marc Chagall*
Collection of Valentine Chagall, Saint-Paul-de-Vence

73
The Angel over Vitebsk. 1977
Oil on canvas. 81 × 100 cm
Signed lower right: *Marc Chagall*
Collection of Valentine Chagall, Saint-Paul-de-Vence

74
Phaeton. 1977
Oil on canvas. 195 × 130 cm
Signed and dated lower left: *Chagall 1977*
Collection of Valentine Chagall, Saint-Paul-de-Vence

75
The Painter over Vitebsk. 1977—78
Oil on canvas. 65 × 92 cm
Collection of Valentine Chagall, Saint-Paul-de-Vence

76
Child with Dove. 1977—78
Oil on canvas. 92 × 73 cm
Signed lower right: *Chagall Marc*
Collection of Valentine Chagall, Saint-Paul-de-Vence

77
The Circus. 1979—81
Oil on canvas. 100 × 81 cm
Signed lower right: *Marc Chagall*
Collection of Valentine Chagall, Saint-Paul-de-Vence

78
The Painter and His Bride. 1980
Oil on canvas. 116 × 89 cm
Signed bottom centre: *Marc Chagall*
Collection of Valentine Chagall, Saint-Paul-de-Vence

79
Bride and Groom in Front of Paris. 1980
Oil on canvas. 116 × 89 cm
Dated and signed lower right: *1980 Marc Chagall*
Collection of Valentine Chagall, Saint-Paul-de-Vence

80
The Artist's Memories. 1981
Oil on canvas. 116 × 89 cm
Signed lower right: *Chagall*
Collection of Valentine Chagall, Saint-Paul-de-Vence

81
Self-portrait and the Vase of Flowers. 1981
Oil on canvas. 73 × 54 cm
Signed and dated lower right: *Chagall Marc 1981*
Collection of Valentine Chagall, Saint-Paul-de-Vence

82
The Painter over Vitebsk. 1982
Oil on canvas. 92 × 60 cm
Signed lower right: *Chagall*
Collection of Valentine Chagall, Saint-Paul-de-Vence

83
The Painter at the Feast. 1982
Oil on canvas. 116 × 89 cm
Signed lower right: *Marc Chagall*
Collection of Valentine Chagall, Saint-Paul-de-Vence

84

The Bouquet of Flowers. 1982
Oil on canvas. 81 × 65 cm
Collection of Valentine Chagall, Saint-Paul-de-Vence

85

Bride and Groom of the Eiffel Tower
1982—83
Oil on canvas. 61 × 50 cm

Signed bottom centre: *Marc Chagall*
Collection of Valentine Chagall, Saint-Paul-de-Vence

86

The Large Circus. 1984
Oil on canvas. 130 × 97 cm
Signed lower right: *Chagall*
Collection of Valentine Chagall, Saint-Paul-de-Vence

GRAPHIC WORK
DRAWINGS

87

Butcher (Grandfather). 1910
Gouache. 34 × 24 cm
Signed in bottom right corner: *Шагалъ* [Chagall]
Inscribed by top right edge: *Мясник* [Butcher]
The Tretyakov Gallery, Moscow
Inv.no. П—46697

88

Study for *Rain*. 1911
Gouache and pencil drawing on cardboard
22.5 × 30 cm
The Tretyakov Gallery, Moscow
Inv.no. П—46698

89

The Jewish Wedding. 1910s
Pen-and-ink drawing on paper fixed on cardboard
20.5 × 30 cm
Collection of Zinaida Gordeeva, Leningrad

90

The Lovers
Pen-and-ink drawing. 23 × 18 cm
Signed lower right: *Chagall*
Art and History Museum, Pskov
Inv.no. 1027

91

Street in Vitebsk. 1914
Indian ink drawing. 17 × 25.5 cm
Signed lower right: *Chagall*
The Russian Museum, Leningrad
Inv.no. P—34736

92

Railway Station. Vitebsk. 1914
Indian ink drawing. 16.7 × 25.5 cm
Inscribed in bottom right corner: *Шагалъ Витебск 1914
годъ* [Chagall Vitebsk the year of 1914]
The Russian Museum, Leningrad
Inv.no. P—34737

93

The Wounded Soldier. 1914
Indian ink drawing. 22.6 × 13.3 cm (oval)
Signed and dated lower right: *Chagall 914*
The Tretyakov Gallery, Moscow
Inv.no. П—46699

94

Strollers. 1914
Pen-and-wash drawing heightened with white
22.3 × 17.2 cm
The Tretyakov Gallery, Moscow
Inv.no. 817 apx. rp.

95

Old Man with Cane. 1914
Indian ink drawing. 23 × 18.5 cm
Signed upper left: *Chagall*
The Tretyakov Gallery, Moscow
In.no. П—46700

96

Rabbi of Vitebsk. 1914
Indian ink drawing. 52 × 42.5 cm
Signed lower left: *Chagall*
Private collection, USSR

97

Man on Stretcher. 1914
Indian ink and gouache drawing. 19 × 32.5 cm
Signed and dated in bottom right corner: *Chagall 1914*
Radishchev Art Museum, Saratov
Inv.no. ВГ—261

98

Soldiers with Bread. 1914—15
Gouache and watercolour on cardboard. 50.5 × 37.5 cm
Signed lower right: *Шагалъ* [Chagall]
Collection of Zinaida Gordeeva, Leningrad

99

Pietà. 1914—15
Indian ink drawing heightened with white
16.2 × 32.2 cm
Signed lower left: *Chagall*
The Russian Museum, Leningrad
Inv.no. P—56290

100

Street. 1914—15
Indian ink drawing. 15.5 × 16.2 cm
Inscribed in bottom right corner: *Шагалъ Витебск 1914
годъ* [Chagall. Vitebsk, the year of 1914]
The Russian Museum, Leningrad
Inv.no. P—21971

101

Group. Vitebsk. 1914—15
Indian ink and pencil drawing heightened with white
24.2 × 23.3 cm
The Russian Museum, Leningrad
Inv.no. P—56291

102

Old Man and Woman. 1914—15
Indian ink drawing. 15 × 20 cm
Signed lower left: *Шагалъ* [Chagall]
The Russian Museum, Leningrad
Inv.no. P—21969

103
The Street. 1914—15
Indian ink drawing. Max. height 15.1 cm,
length 14.1 cm
Signed lower right: *Chagall*
The Russian Museum, Leningrad
Inv.no. P—21970

104
War. 1915
Pen-and-ink drawing heightened with white. 22 × 18 cm
Signed upper right: *Chagall*
Inscribed in picture: *Война 1914 Россія Сербія Белгія
Японія Франція Австрія* [War of 1914. Russia. Serbia.
Belgium. Japan. France. Austria]
Lunacharsky Art Museum, Krasnodar
Inv.no. 597

105
In Step. 1916
Pencil and gouache drawing. 20.3 × 17.5 cm
Dated and signed lower right: *1916. Марк Шагал* [Marc
Chagall]
The Tretyakov Gallery, Moscow
Inv.no. 9928 гр.

106—114
**Illustrations to Der Nister's two tales about
a little goat and a rooster. 1916**
(Vilna, Kletzkin, 1917, 8 drawings and cover design. In
Yiddish)
The Russian Museum, Leningrad

106
The Little House
Indian ink drawing. 12.6 × 10 cm
Inv.no. P—6935

107
Night
Indian ink drawing. 9.8 × 12.6 cm
Signed on bottom edge, right: *Шагалъ* [Chagall]
Inv.no. P—6936

108
Rooster on steps
Indian ink drawing. 13.9 × 9.7 cm (oval)
Inv.no. P—6937

109
Woman with Rooster
Indian ink drawing heightened with white. 9.8 × 9.2 cm
Signed bottom: *М. Шагалъ* [M. Chagall]
Inv.no. P—6938

110
Man in Bed and Rooster
Indian ink drawing heightened with white
14.2 × 14.9 cm
Inscribed below in Yiddish: *Granny is dead*
Inv.no. P—6939

111
Cover design showing goat and rooster
Indian ink drawing heightened with white. 25.8 × 9.3 cm
Signed lower right: *Шагалъ* [Chagall]
Inv.no. P—6940

112
Baby in Perambulator and Goat
Indian ink drawing heightened with white
12.7 × 15.5 cm
Inv.no. P—46496

113
Goat in the Wood
Indian ink drawing heightened with white
15.5 × 14.8 cm
Inv.no. P—46497

114
Goat and Perambulator
Indian ink drawing heightened with white on yellow
paper. 8 × 6.8 cm
Inv.no. P—46498

115
Two Heads. 1918
Indian ink drawing. 22 × 18 cm
Signed bottom centre: *Chagall*
Lunacharsky Art Museum, Krasnodar
Inv.no. 629

116
Man with His Head Reversed. 1918
Design for cover of the first monograph on Chagall
(A.Efros and Ya.Tugendhold, *The Art of Marc Chagall*,
Moscow, Ed.Gelikon, 1918. In Russian)
Pen-and-ink and pencil drawing. 29.1 × 22.2 cm
Signed lower right: *Шагал* [Chagall]
The Tretyakov Gallery, Moscow
Inv.no. 9920 гр.

117
War on the Palaces. 1918—19
Watercolour and pencil drawing. 33.7 × 23.2 cm
Inscribed in capitals in bottom right corner: *Война
дворцам* [War on the palaces]
The Tretyakov Gallery, Moscow
Inv.no. 22246 гр.

118
Greetings to My Native Country! 1953
Watercolour and gouache drawing. 61 × 48.5 cm
The Pushkin Museum of Fine Arts, Moscow
Inv.no 15818

119
Daphnis and Chloë. 1956
Gouache on cardboard. 105 × 75 cm
Signed and dated lower right: *Marc Chagall 1956*
Collection of Ida Chagall, Paris

120
Self-portrait with Palette. 1966
Executed on invitation to opening of Chagall paintings
at the Paris Opéra
Drawing in colour crayons
Signed lower right: *Марк Шагал* [Marc Chagall]
Autographed lower left: *Для И. С. Зильберштейна
дружески* [For I.S.Zilbershtein, with friendship] *Paris,
1966*
Collection of Ilya Zilbershtein, Moscow

121
Lyrical Self-portrait. 1973
Colour crayons and oil on paper. 28 × 23 cm
Inscribed in bottom centre: *Москва. Шагал* [Moscow.
Chagall] *1973*
Collection of Alexander Kamensky, Moscow

122
Little Goat. 1973
Executed in Leningrad
Pastel drawing. 65 × 85 cm
Inscribed upper left: *Leningrade;* lower right: *Рушкареву*
[For Pushkaryov] *Marc Chagall;* date lower left: *12/6
1973*
Collection of Vasily Pushkaryov, Moscow

AUTOGRAPHS
AND
DRAWINGS
ON BOOK PAGES

123
In Front of the Picture. 1959
Title-page of the review *Verve* dedicated to Chagall
(*Verve*, Revue artistique et littéraire, Tériade, Paris, vol.
8, nos. 33—34)
Autographed: *Для Ильи Самойловича Зильберштейн с
благодарностью и сердечным приветом. Марк Шагал*
[For Ilya Samoilovich Zilbershtein, with thanks and best
wishes. Marc Chagall] *Vence 1959*
Collection of Ilya Zilbershtein, Moscow

124
Figure Beneath a Tree. 1963
On the title-page of Meyer's monograph on Chagall
(Franz Meyer, *Marc Chagall. Leben und Werk*, Köln,
1961)
Signed below: *Марк Шагал* [Marc Chagall]
Autographed: *Для друзей Васе и Лиле на добрую
память* [For my friends, Vasya and Lilya, with fond
memories] *1963 Paris Marc Chagall*
Formerly collection of Lilya Brik, Moscow

125
Self-portrait with Flowering Branch. 1968
On the title-page of the volume of his monotypes
(Marc Chagall, *Monotypes*, Genève, 1966)
Drawing in colour crayons
Autographed: *Для Ларисы дружески* [For Larissa,
with friendship]; signed and dated lower left: *Marc
Chagall 1968*
Formerly collection of Larissa Zhadova, Moscow

126
The Little Fish. 1972
On the frontispiece of book on Chagall (A. Verner,
Chagall, New York, 1967)
Drawing in colour felt-pens
Signed lower left: *Chagall*
Autographed: *Для Аллы Бутровой на добрую память*
[For Alla Butrova, with fond memories] *Marc Chagall*
Dated upper right: *1972*
Collection of Alla Butrova, Moscow

127
Self-portrait with Wings. 1973
On the frontispiece of catalogue of Chagall eightieth
birthday retrospective in Zurich (1967)
Ball-point drawing
Autographed: *Спасибо еще раз рад быть средь вас
Марк Шагал Москва* [Thank you once again: I was
happy to be with you all. Marc Chagall. Moscow] *1973
8/6;* and *1967 Zürich*
Collection of Vsevolod Volodarsky, Moscow

128
Self-portrait with Heart. 1980
On the title-page of book on Chagall (Charles Sorlier,
Werner Schmalenbach, *Marc Chagall*, Paris, Draeger,
s.a.)
Drawing in colour inks and ball-point
Autographed: left, *St Paul de Vence France*, and *1979—
80 для поэта-друга Вознесенского на добрую память
Марк Шагал* [for my friend, poet Voznesensky, with
fond memories, Marc Chagall]
Collection of Andrei Voznesensky, Moscow

ETCHINGS

129—180
Illustrations to Gogol's *Dead Souls*
1923—27
Etching, aquatint, drypoint and roulette. 38 × 28.4 cm
(each sheet)
Each sheet signed lower right in pencil: *Marc Chagall*
The Pushkin Museum of Fine Arts, Moscow

129
The Arrival of Chichikov
Dedicatory inscription on the upper and lower edges, in
black ink: *Дарю Третьяковской галлерее со всей моей
любовью русского художника к своей родине эту
серию 96 гравюр, сделанных мною в 1923—925 гг. к
Мертвым Душам Гоголя для издателя Ambroise
Vollar в Париже. Париж 1927. Марк Шагал.* [With all
the love of a Russian painter for his native land I
present to the Tretyakov Gallery this series of 96
etchings for Gogol's *Dead Souls* that I made in 1923—
25 for the publisher Ambroise Vollard in Paris. Paris
1927. Marc Chagall]
Inv.no. 10639

130
Coachman Selifan
Signed lower left: *Marc Chagall*
Inv.no. 10644

131
Petrushka
Signed lower left: *Marc Chagall*
Inv.no. 10643

132
Chichikov and Manilov
Signed lower right: *Marc Chagall*
Inv.no. 10647

133
Chichikov at Manilov's
Inv.no. 10650

134
Courtyard at Korobochka's
Signed lower right: *Chagall*
Inv.no. 10655

135
Peasant Woman
Inv.no. 10686

136
Korobochka
Signed lower left in picture: *Chagall*
Inv.no. 10653

137
Chichikov at Korobochka's
Inv.no. 10656

138
Asking the Way
Signed in bottom left corner: *Marc,* and lower right: *Chagall*
Inv.no. 10657

139
Nozdrev in Tavern
Inv.no. 10660

140
The House Painters
Signed lower right: *Chagall*
Inv.no. 10661

141
Playing Cards (Nozdrev and Chichikov)
Inv.no. 10662

142
On the Way to Sobakevich's
Signed in bottom left corner: *Marc Chagall*
Inv.no. 10651

143
Sobakevich
Signed in bottom right corner: *M. Chagall*
Inv.no. 10671

144
The Coachmen on the Main Road
Signed lower left: *Chagall*
Inv.no. 10669

145
Uncle Mityai and Uncle Minyai
Signed in bottom left corner: *Chagall*
Inv.no. 10670

146
Chichikov Dreaming of the Governor's Daughter
Signed in bottom right corner: *M. Chagall*
Inv.no. 10666

147
The Arrival of Chichikov at Sobakevich's
Signed in bottom left corner: *Chagall*
Inv.no. 10667

148
At Sobakevich's: On the Way to the Table
Signed in bottom left corner: *Chagall*
Inv.no. 10673

149
Sobakevich (with Armchair)
Signed in bottom left corner: *Chagall*
Inv.no. 10668

150
Feodulia Ivanovna, Sobakevich's Spouse
Signed lower left: *Chagall*
Inv.no. 10672

151
Sobakevich's Feast
Signed lower left: *Chagall*
Inv.no. 10675

152
The Table at Sobakevich's
Signed lower left: *Chagall*
Inv.no. 10674

153
Chichikov and Sobakevich, Nodding Off
Signed lower left: *Chagall*
Inv.no. 10676

154
Chichikov and Sobakevich Discussing Business
Signed in bottom left corner: *Chagall*
Inv.no. 10677

155
The Arrival at Plyushkin's Village
Signed in bottom left corner: *Chagall*
Inv.no. 10679

156
Plyushkin Sweeping Up
Signed in bottom left corner: *Chagall*
Inv.no. 10682

157
Plyushkin's Study
Inv.no. 10687

158
Chichikov at Plyushkin's
Signed twice in the bottom corners: *Chagall*
Inv.no. 10688

159
Proshka Peeping
Signed lower right: *Chagall*
Inv.no. 10692

160
Pluyshkin and His Cook Mavra
Signed lower left: *Chagall*
Inv.no. 10683

161
The Fate of Grigory
Signed lower left: *Chagall*
Inv.no. 10689

162
Death of Pyotr Neuvazhai-Koryto
Signed lower left: *Marc Chagall*
Inv.no. 10698

163
Peasant Without Passport Before the Chief of Police District
Signed in bottom left corner: *Marc Chagall*
Inv.no. 10694

164
Chichikov, Petrushka and Selifan
Signed left, by lower edge: *Chagall*
Inv.no. 10711

165
Chichikov's Triumph
Signed twice, in bottom left corner and in picture: *Chagall*
Inv. no. 10690

166
Chichikov in Bed
Inv.no. 19654

167
Petrushka Holding Chichikov's Pantaloons, and Selifan
Signed lower left: *Chagall*
Inv.no. 10710

168
Drunken Petrushka and Selifan
Signed upper right: *Chagall*
Inv.no. 10707

169
Chichikov at the Governor's. Nozdrev Unmasks Chichikov
Signed in bottom left corner: *Chagall*
Inv.no. 10709

170
Inhabitants of the Town of N: Rumours and Gossips
Signed lower left: *Chagall*
Inv.no. 10727

171
Captain Kopeikin and Napoleon
Signed in bottom left corner: *Chagall*
Inv.no. 10724

172
Confusion in the Office
Signed in picture, by bottom right corner: *Chagall*
Inv.no. 10732

173
Chichikov Before Looking-glass
Inv.no. 10726

174
Chichikov and the Governor's Hall-porter
Signed lower left: *Chagall*
Inv.no. 10731

175
Coachman Selifan Watering the Horses
Signed in bottom left corner: *M. Chagall*
Inv.no. 10664

176
Funeral Procession
Signed in bottom left corner: *Chagall*
Inv.no. 10722

177
Death of the Procurator
Signed in bottom left corner: *Chagall*
Inv.no. 10720

178
Chichikov's Upbringing
Signed below, to the right: *Chagall*
Inv.no. 10717

179
Chichikov as Customs Official
Signed in bottom left corner: *Chagall*
Inv.no. 10729

180
Gogol and Chagall
Signed lower right: *Marc Chagall*
Used as frontispiece to *Les Ames mortes*, vol. 2

(Nicolas Gogol, *Les Ames mortes*, Paris, Tériade, 1948, 118 etchings)
Inv.no. 10695

181
Self-portrait, Smiling. 1927
Etching. 57.5 × 45 cm; 24.8 × 21.5 cm
Autographed bottom centre: *Абраму Марковичу Эфросу—одному из первых защитников моего искусства в России в знак благодарности и всегдашней любви к нему. Марк Шагал* [For Abram Markovich Efros, one of the first to defend my art in Russia, as a token of my thanks and undying affection. Marc Chagall.] *Boulogne—Paris. 927*
Private collection, USSR

182
Self-portrait in Hat. Late 1920s
Etching. 28.2 × 22.5 cm; 20.2 × 14.2 cm
Signed lower right: *Marc Chagall*
Private collection, USSR

183
The Cock and the Pearl
Illustration to La Fontaine's *Fables*. 1930
Etching. 38.5 × 29.5 cm; 29.5 × 22.6 cm
Signed lower left: *Chagall*
With dedicatory inscription for Pavel Ettinger
The Pushkin Museum of Fine Arts, Moscow
Inv.no. 108.518

184
Woman Acrobat and Clown. Late 1930s
From the *Circus* series
Etching. 25 × 19 cm; 16 × 10.5 cm
Signed lower right: *Chagall*
Collection of Inna Katanyan, Moscow; formerly collection of Julius Gens

185
The Lion. Late 1930s
From the *Circus* series
Etching. 25 × 19 cm; 16.2 × 10.8 cm
Signed lower right: *Chagall*
Collection of Inna Katanyan, Moscow; formerly collection of Julius Gens

186·
Before a Shopwindow. Late 1930s
Etching. 16.2 × 10.8 cm
Signed lower right: *Chagall*
Collection of Inna Katanyan, Moscow; formerly collection of Julius Gens

187
Composition based on early Khlebnikov poems. C. 1949
Commissioned from the artist by Ilya Zdanevich for his book
(Iliazd, *Poésie de mots inconnus*, Paris, Le Degré 41°, 1949. 1 drypoint and aquatint by Chagall)
Drypoint and aquatint. 16.2 × 12.7 cm
Signed lower right: *Chagall*
Collection of Alexander Parnis, Moscow

188
The Yellow Cock. Late 1960s
Etching and colour aquatint. 53.5 × 38.8 cm
Signed lower right: *Marc Chagall*
The Pushkin Museum of Fine Arts, Moscow
Inv.no. 121520

LITHOGRAPHS

189
Old Jew. 1914
Lithograph. 31.5 × 23 cm
Inscribed bottom centre in pencil: *Chagall. Jude*
The Tretyakov Gallery, Moscow
Inv.no. Π-46695

190
Bird on Moon. 1954
Colour lithograph. 71.2 × 52 cm
Signed and dated in picture, bottom left corner, in
lithographic crayon: *Marc Chagall 1954*
Signed lower right on edge: *Marc Chagall*
Printed by Charles Sorlier, Paris
The Pushkin Museum of Fine Arts, Moscow
Inv.no. 120445

191
The Lovers and Fish
Colour lithograph. 75.7 × 55.5 cm
Lithographic stamp in bottom right corner: *MARC
CHAGALL PINX*
Signed lower left on edge: *Marc Chagall*
Printed by Charles Sorlier, Paris
The Pushkin Museum of Fine Arts, Moscow
Inv.no. 120444

192
Honeymoon
Colour lithograph. 75.7 × 55.7 cm
Lithographic stamp in bottom right corner: *MARC
CHAGALL PINX*
Signed lower right: *Marc Chagall*
Printed by Charles Sorlier, Paris
The Pushkin Museum of Fine Arts, Moscow
Inv.no. 120443

193
Mother and Child. 1956
Lithograph. 65.5 × 50.2 cm
Signed lower right: *Marc Chagall*
The Pushkin Museum of Fine Arts, Moscow
Inv.no. 120085

194
Self-portrait: *Ma Vie*. 1956
Colour lithograph. 47.6 × 32 cm
Signed lower right: *Marc Chagall*
The Pushkin Museum of Fine Arts, Moscow
Inv.no. 120446

195
Profile and Red Boy. 1956
Colour lithograph. 47.8 × 32.5 cm
Signed lower right: *Marc Chagall*
The Pushkin Museum of Fine Arts, Moscow
Inv.no. 120086

196
The Circus. 1956
From the *Circus* series. 1956—62
Colour lithograph. 47.7 × 33.1 cm
Signed lower right: *Marc Chagall*
The Pushkin Museum of Fine Arts, Moscow
Inv.no. 120463

197
Clown and Acrobats
From the *Circus* series. 1956—62
Colour lithograph. 46 × 32.2 cm
Signed lower right: *Marc Chagall*

The Pushkin Museum of Fine Arts, Moscow
Inv.no. 120097

198
Equestrienne and Clowns
From the *Circus* series. 1956—62
Colour lithograph. 65.4 × 48 cm
Signed lower right: *Marc Chagall*
The Pushkin Museum of Fine Arts, Moscow
Inv.no. 121512

199
Circus Finale
From the *Circus* series. 1956—62
Colour lithograph. 73 × 53.5 cm
Signed lower right: *Marc Chagall*
The Pushkin Museum of Fine Arts, Moscow
Inv.no. 120459

200
Play of Acrobats
From the *Circus* series. 1956—62
Colour lithograph. 47.8 × 32.8 cm
The Pushkin Museum of Fine Arts, Moscow
Inv.no. 120451

201
Circus Appearance
From the *Circus* series. 1956—62
Colour lithograph. 46 × 32.2 cm
Signed lower right: *Marc Chagall*
The Pushkin Museum of Fine Arts, Moscow
Inv.no. 121395

202
Clown with Bouquet
From the *Circus* series. 1956—62
Colour lithograph. 46.2 × 32 cm
Signed lower left: *Marc Chagall*
The Pushkin Museum of Fine Arts, Moscow
Inv.no. 121396

203
Equestrienne
From the *Circus* series. 1956—62
Colour lithograph. 55 × 36.5 cm
Signed lower right: *Marc Chagall*
The Pushkin Museum of Fine Arts, Moscow
Inv.no. 121508

204
Heart of the Circus
From the *Circus* series. 1956—62
Colour lithograph. 58.3 × 75.4 cm
Signed lower right: *Marc Chagall*
The Pushkin Museum of Fine Arts, Moscow
Inv.no. 121511

205
Wandering Musicians
From the *Circus* series. 1956—62
Lithograph. 46 × 32.2 cm
Signed lower right:*Marc Chagall*
The Pushkin Museum of Fine Arts, Moscow
Inv.no. 120077

206
Circus Players
From the *Circus* series. 1956—62
Lithograph. 46.2 × 32.2 cm

Signed lower right: *Marc Chagall*
The Pushkin Museum of Fine Arts, Moscow
Inv.no. 120074

207
Clown and His Sweetheart
From the *Circus* series. 1956—62
Lithograph. 45.4 × 32.2 cm
Signed lower right: *Marc Chagall*
The Pushkin Museum of Fine Arts, Moscow
Inv.no. 120448

208
Offering. 1956
Lithograph. 45.5 × 32.5 cm
Signed lower right: *Marc Chagall*
The Pushkin Museum of Fine Arts, Moscow
Inv.no. 120076

209
Clown with Trumpet. 1957
Poster announcing Chagall's exhibition of engravings in
the Bibliothèque nationale, Paris
Colour lithograph. 71.8 × 50.2 cm
Signed lower right: *Marc Chagall*
The Pushkin Museum of Fine Arts, Moscow
Inv.no. 120458

210
The Flute Player. 1957
Lithograph on grey paper. 65.2 × 50.1 cm
Signed lower right: *Marc Chagall*
The Pushkin Museum of Fine Arts, Moscow
Inv.no. 120084

211
With Flowers in Hand
Lithograph. 38.1 × 28.2 cm
Signed lower right: *Marc Chagall*
The Pushkin Museum of Fine Arts, Moscow
Inv.no. 120078

212
Two Profiles. 1957
Lithograph. 39.5 × 28.2 cm
Signed lower right: *Marc Chagall*
The Pushkin Museum of Fine Arts, Moscow
Inv.no. 120079

213
Lithograph for catalogue of Chagall exhibition at the Musée des arts décoratifs in Paris (1959)
Lithograph. 28.4 × 38.2 cm
Signed lower right: *Marc Chagall*
The Pushkin Museum of Fine Arts, Moscow
Inv.no. 120080

214
The Artist. 1959
Poster announcing Chagall exhibition at the Musée des
arts décoratifs in Paris (1959)
Colour lithograph. 76.1 × 55 cm
Signed lower right: *Marc Chagall*
The Pushkin Museum of Fine Arts, Moscow
Inv.no. 120460

215
Still Life with Flowers. 1960
Colour lithograph. 74.2 × 58 cm
Signed lower right: *Marc Chagall*
The Pushkin Museum of Fine Arts, Moscow
Inv.no. 120096

216
Flying Couple with the Vase of Flowers
Colour lithograph. 67 × 53.5 cm
Signed lower right: *Marc Chagall*
The Pushkin Museum of Fine Arts, Moscow
Inv.no. 120089

217
The Pheasant
Colour lithograph. 59.1 × 76 cm
Signed lower right: *Marc Chagall*
The Pushkin Museum of Fine Arts, Moscow
Inv.no. 120461

218
Summer Evening. *C.* 1960
Colour lithograph. 75.7 × 52.7 cm
Signed lower right: *Marc Chagall*
The Pushkin Museum of Fine Arts, Moscow
Inv.no. 121510

219
Two Sirens. Not later than 1963
Lithograph. 56.7 × 37.9 cm
Signed lower right: *Marc Chagall*
The Pushkin Museum of Fine Arts, Moscow
Inv.no. 120075

220
Passion. Not later than 1963
Lithograph. 56.1 × 76 cm
Signed lower right:*Marc Chagall*
The Pushkin Museum of Fine Arts, Moscow
Inv.no. 120454

221
The Reverie. Not later than 1963
Lithograph. 46 × 32.5 cm
Signed lower right: *Marc Chagall*
The Pushkin Museum of Fine Arts, Moscow
Inv.no. 120449

222
In Front of the Picture. Not later than 1963
Lithograph. 46.2 × 32.7 cm
Signed lower right: *Marc Chagall*
The Pushkin Museum of Fine Arts, Moscow
Inv.no. 120450

223
Inspiration. Not later than 1963
Colour lithograph. 46.2 × 32.3 cm
Signed lower right: *Marc Chagall*
The Pushkin Museum of Fine Arts, Moscow
Inv.no. 121426

224
Lovers' Sky. Not later than 1963
On the theme *Memories of Vitebsk*
Lithograph. 56.5 × 76.4 cm
Signed lower right: *Marc Chagall*
The Pushkin Museum of Fine Arts, Moscow
Inv.no. 121515

225
Self-Portrait. Not later than 1963
On the theme *Memories of Vitebsk*
Lithograph. 75.8 × 56.1 cm
Signed lower right: *Marc Chagall*
The Pushkin Museum of Fine Arts, Moscow
Inv.no. 121518

226
Nude and Flowers. Not later than 1963
On the theme *Memories of Vitebsk*
Lithograph. 56.2 × 76.2 cm
Signed lower right: *Marc Chagall*
The Pushkin Museum of Fine Arts, Moscow
Inv.no. 121513

227
Children in Trees
On the theme *Memories of Vitebsk*
Colour lithograph. 47.3 × 59.3 cm
Signed lower right: *Marc Chagall*
The Pushkin Museum of Fine Arts, Moscow
Inv.no. 120094

228
Man with Double Profile and His Bride
On the theme *Memories of Vitebsk*
Colour lithograph. 74.7 × 56.5 cm
Signed lower right: *Marc Chagall*
The Pushkin Museum of Fine Arts, Moscow
Inv.no. 120088

229
Composition with Figure
On the theme *Memories of Vitebsk*
Colour lithograph. 57.3 × 41 cm
Signed lower right: *Marc Chagall*
The Pushkin Museum of Fine Arts, Moscow
Inv.no. 121424

230
Composition
On the theme *Memories of Vitebsk*
Colour lithograph. 57.2 × 42.2 cm
Signed lower right: *Marc Chagall*
The Pushkin Museum of Fine Arts, Moscow
Inv.no. 121428

231
Green Violin
On the theme *Memories of Vitebsk*
Colour lithograph. 60.2 × 48 cm
Signed lower right: *Marc Chagall*
The Pushkin Museum of Fine Arts, Moscow
Inv.no. 121400

232
Peasants
Colour lithograph. 77.1 × 59.8 cm
Signed lower right: *Marc Chagall*
The Pushkin Museum of Fine Arts, Moscow
Inv.no. 120462

233
Saint-Paul by Night
From the *Saint-Paul-de-Vence* series. 1957—62
Colour lithograph. 46.4 × 32.3 cm
Signed lower right: *Marc Chagall*
The Pushkin Museum of Fine Arts, Moscow
Inv.no. 120092

234
Sun in Saint-Paul
From the *Saint-Paul-de Vence* series. 1957—62
Colour lithograph. 62 × 46.6 cm
Signed lower right: *Marc Chagall*
The Pushkin Museum of Fine Arts, Moscow
Inv.no. 120457

235
Composition in Blue
Colour lithograph. 80 × 60 cm

Signed lower right: *Marc Chagall*
Dedicatory inscription below: *Для Андрея Вознесенского на добрую память. Марк Шагал* [For Andrei Voznesensky, with fond memories. Marc Chagall]. *1962—3*
Collection of Andrei Voznesensky, Moscow

236
To Mayakovsky from Chagall
From the *Vladimir Mayakovsky* series. 1963
Lithograph. 65 × 51.2 cm
Signed lower right: *Marc Chagall*
Formerly collection of Lilya Brik, Moscow

237
Sheet from the *Vladimir Mayakovsky series* 1963
Lithograph. 65.8 × 50.2 cm
Above, dedicatory inscription in red ink: *Лиличке на память* [For Lilichka, a keepsake]; below, in blue ink: *о Маяковском и Шагале* [about Mayakovsky and Chagall] *Paris 1963 M.Ш.*
Formerly collection of Lilya Brik, Moscow

238
Sheet from the *Vladimir Mayakovsky* series 1963
Lithograph. 65.2 × 44.1 cm
Signed lower right: *Marc Chagall*
Engraved inscription in picture reads: *Пришел к парикмахеру и сказал: «Причешите мне уши»* ["I came to the Barber and said: *Scratch my ears.*"—a quotation from Mayakovsky.]
Formerly collection of Lilya Brik, Moscow

239
Mayakovsky—70
Sheet from *Vladimir Mayakovsky* series. 1963
Lithograph. 65.4 × 47.2 cm
Signed lower right: *Marc Chagall*
The Pushkin Museum of Fine Arts, Moscow
Inv.no. 120083

240
The Artist
Colour lithograph. 65 × 40.2 cm
Signed lower right: *Marc Chagall*
The Pushkin Museum of Fine Arts, Moscow
Inv. no. 121423

241
Maternity
Colour lithograph. 59.9 × 78.6 cm
Signed in bottom left corner in lithographic crayon: *Chagall,* and lower right: *Marc Chagall*
The Pushkin Museum of Fine Arts, Moscow
Inv.no. 120455

242
Time
Colour lithograph. 56 × 41 cm
Signed lower right: *Marc Chagall*
The Pushkin Museum of Fine Arts, Moscow
Inv.no. 121427

243
The Walk
Colour lithograph. 64.7 × 50 cm
Signed lower right: *Marc Chagall*
The Pushkin Museum of Fine Arts, Moscow
Inv.no. 121399

244
Bridal Couple
Colour lithograph. 43.5 × 32 cm

Signed lower right: *Marc Chagall*
The Pushkin Museum of Fine Arts, Moscow
Inv.no. 121519

245
Circus Musicians
Colour lithograph. 31 × 36 cm
Signed lower right: *Marc Chagall*
Inscribed on lower margin: *Pour Rodion Щедрин на добрую память Марк Шагал. Ванс. 1965* [For Rodion Shchedrin, with fond memories. Saint-Paul-de-Vence. 1965]
Collection of Rodion Shchedrin, Moscow

246
Gladioli
Colour lithograph. 39 × 26 cm
Signed lower right: *Marc Chagall*
Inscribed on lower margin: *Для Майи с сердечным приветом. Марк Ш. Париж. 1966* [For Maya, with best wishes. Marc Ch. Paris. 1966]
Printed by Charles Sorlier, Paris
Collection of Maya Plissetskaya, Moscow

247
The Magic Flute. 1967
Colour lithograph. 76.1 × 55 cm
Signed lower right in picture, in lithographic crayon: *Marc Chagall*
Printed by Charles Sorlier, Paris
The Pushkin Museum of Fine Arts, Moscow
Inv.no. 120464

248
Musicians on Green
Colour lithograph. 54.4 × 43.9 cm
Signed lower right: *Marc Chagall*
Inscribed on lower margin: *Для А.В. (В.А.) Пушкарева на добрую память Марк Шагал* [For A.V. (V.A.) Pushkaryov, with fond memories. Marc Chagall.] *St. Paul 1968, 3/2*
Collection of Vasily Pushkaryov, Moscow

249
Composition
Colour lithograph. 55 × 41 cm
Signed lower right: *Marc Chagall*
Dedicatory inscription on lower margin: *Для Ларисы дружески. Марк Шагал* [For Larissa, with friendship. Marc Chagall] *St. Paul 1968*
Formerly collection of Larissa Zhadova, Moscow

250
The 'Antilopa' Passengers
Composition based on Ilf and Petrov's novel *The Little Golden Calf*
Lithograph. 51 × 36 cm
Signed lower right: *Marc Chagall*
Inscribed on lower edge: *Для Симоновых на добрую память. Марк Шагал* [For the Simonov, with fond memories. Marc Chagall]. *1970*
Formerly collection of Konstantin Simonov, Moscow

251
Window of the Studio (Still Life with Flowers and Two Figures)
Not later than 1973
Colour lithograph. 66.4 × 53.2 cm

Signed lower right: *Marc Chagall*
The Pushkin Museum of Fine Arts, Moscow
Inv.no. 120090

252
Couple with Flowers
Colour lithograph. 76.1 × 56.2 cm
Signed lower right: *Marc Chagall*
The Pushkin Museum of Fine Arts, Moscow
Inv.no. 121514

253
Profile and Trumpet Player
Not later than 1973
Colour lithograph. 76.6 × 56.9 cm
Signed lower right: *Marc Chagall*
Dedicatory inscription in the centre of lower margin, in ball-point: *Для Музея Пушкина в Москве. Марк Шагал. 1970* [For the Pushkin Museum in Moscow, Marc Chagall. 1970]
The Pushkin Museum of Fine Arts, Moscow
Inv.no. 121430

254
The Bay. Not later than 1973
From the *Saint-Paul Bay* series
Colour lithograph. 48 × 65.3 cm
Signed lower right: *Marc Chagall*
The Pushkin Museum of Fine Arts, Moscow
Inv.no. 120093

255
Woman with Bouquet on the Shore
Not later than 1973
From the *Saint-Paul Bay* series
Colour lithograph. 51.2 × 53.9 cm
Signed lower right: *Marc Chagall*
The Pushkin Museum of Fine Arts, Moscow
Inv.no. 120087

256
Rest. Not later than 1973
From the *Saint-Paul Bay* series
Colour lithograph. 46.1 × 64.2 cm
Signed lower right: *Marc Chagall*
The Pushkin Museum of Fine Arts, Moscow
Inv.no. 121507

257
Play of Harlequins. Not later than 1973
Colour lithograph. 56.6 × 39.8 cm
Signed lower right: *Marc Chagall*
The Pushkin Museum of Fine Arts, Moscow
Inv.no. 121506

258
The Flying Fish
Colour lithograph. 47.1 × 65.4 cm
Signed lower right: *Marc Chagall*
The Pushkin Museum of Fine Arts, Moscow
Inv.no. 121429

259
The Lovers and Bull
Ceramic platter with underglaze painting
22.5 × 27 cm. (oval)
Signed lower left along the rim: *Chagall*
Collection of Maya Plissetskaya, Moscow

ARCHIVAL MATERIALS

260

Letter from Chagall to Kandaurov*, dated 14 November 1911, with drawings of paintings he had sent from Paris to St.Petersburg for the 1912 *World of Art* Exhibition in Moscow. Chagall included suggestions as to how his pictures should be framed and hung.

Dear Sir,

Permit me to write to you that which I ommitted to say in my letter to Monsieur Dobuzhinsky. In sending three pieces to the *World of Art* Exhibition, I should like to exercise my right as an exhibitor and show two works without approval by the commission: *Interior (The Birth)* and *The Room*.

<div align="right">

Respectfully yours,
M. Chagall
Paris. Impasse du Maine 18 //

</div>

Inscriptions

To the right of the upper drawing:
No.1 [*Birth* 1911]
Yellow frame
Plain ochre

To the right of the middle drawing:
No.2 [*Interior II* 1911]
VERY BLACK frame of plain, unmoulded wood

To the right of the lower drawing:
No.3 [*Dead Man* 1908]
VERY yellow frame, SKY-COLOURED //
AS FAR AS POSSIBLE:
In view of the possible objections of the Russian censorship, to keep my works on show as far as you can.

HANGING:
Not in a small room nor in shadow; not opposite a window with direct light. Hang leaning forwards; it would be good if they were to one side of a window.

FRAMES:
Should be simple, no.2 could be recessed (in silvery-yellow ochre), 2 (very black), 3 (a lemon yellow)
Let me thank you in anticipation for everything Chagall.//

The third page of this letter carries two drawings; part of the right hand side has been cut away so that some of the right-hand drawing and its inscription have been lost
Above left-hand painting:

A trace of the previous frame has been left on this painting (no.3) and must be covered by the new yellow frame.

Below the painting:
simple, smooth frame of SKY COLOUR

Inscription below right-hand painting:
No.1 *Interior,* not to go before commission, simple wooden frame THICKLY painted.

Colour samples provided below:
No.1 ochre No.2 black No.3 yellow
<div align="right">lemon yellow //</div>

Letter on three sheets. Second sheet is used on both sides: one carries drawings of the three paintings and the other, colour samples.
TsGALI, f. 769, op.1, ed.khr.210, 3pp.

* Konstantin Kandaurov (1865—1930) was an artist, stage designer at the Maly Theatre in Moscow, and secretary of the *World of Art* Society. He was one of the founders of the Artists' Mutual Assistance Society. Organized yearly exhibitions for the Moscow *World of Art* guild of artists, the *Zhar-Tsvet* group and others.

261

Page with a list of works by Chagall intended for the *Year of 1915* Exhibition, of which Kandaurov was one of the organizers. Compiled by Ya.Tugendhold* with his comments.

<div align="right">42, Pliushchikha St Tel no 145-96</div>

Dear Konstantin Vasilyevich,
Here is a list of the Chagall pieces with titles.
<div align="right">Affectionately,
Ya.Tugendhold</div>

P.S. I would myself add one large picture of a Jew to the list. It is the most "conservative", in black and white but, nevertheless, a very powerful piece. If there isn't enough room it will be better to take out two to three of the smaller pieces but show the Jew. //

Marc Chagall
(Vitebsk, 29 Pokrovsky St)

1 184 Black and White
2 Study 190
3 Clock 190
4 Study 192
5 At the Table 123
6 194
7 195 Mandolin Player
8 196
9 197 Soldiers
10 198 Study
11 199 French motif
12 200 Prussian theme
13 201 In the Prison
14 202
15 203
16 204 Vitebsk Scenes
17 205
18 206
19 207 Boy
20 208 Woman Ironing
21 209 The Street Sweeper
210 22 At the Barber's
211 23 Farewells
212 24 Studies
213 25 Jew

Pages from Chahall's letter to Kandaurov
CAT. NO. 260

In the lower right corner of the text there is the following comment, linked by an arrow to the title *Soldiers* (no.9):

Perhaps it would be better to call this picture *Bread* (from considerations of an 'independent' character) rather than *Soldiers?*

Ya.T.

The three-figure numbers in the list are written in red ink, perhaps by a different hand. The text of the letter is written on one side of a folded sheet, the list in columns on the other.

TsGALI, f.769, op. 1, ed.khr. 262, p. 30

* Yakov Tugendhold (1882—1928) was an art critic. Before the Revolution he wrote regularly for *Apollon* about many Western and Russian artists (including Chagall). In 1918, with Efros, he wrote the first monograph devoted to Chagall's work, *The Art of Marc Chagall* (Ed. Gelikon, Moscow).

262
Letter from Chagall to Ettinger*, sent from Vitebsk on 2 April 1920

2 April 1920
Vitebsk

My dear Pavel Davidovich,

Thank you very much for your letters: I heartily beg you to forgive me for not replying straight-away. The only reason is that I am, on the one hand, incredibly absentminded and, on the other, I'm also busy. But the main thing is something else that doesn't allow me to put pen to paper. It's also probably because I'm finding it very difficult < ... > to get down to painting. Such are the times we live in and the position of the modern artist. I'm very glad that you have written to me: you will find that I shall send you much more by way of an answer—I just need to sit down and do it. You ask, first of all, if I have some materials about the art college and artistic life here, in the town and outside it. I don't think it would be of much interest to collect everything that's published in the local press for you. However, as head of the college and, by force of circumstance, of the province's local artistic activities, I will give you some specific information about the arts here. I had the idea of organizing the art college after I returned from abroad and was working on my Vitebsk series of studies. There were then still a great many lamp-posts, pigs and fences in Vitebsk, and its artistic talents lay dormant. Tearing myself away from my palette, I rushed off to Peter [sburg] and to Moscow and at the end of 1918 the college was founded. It accomodates 500 boys and girls of various ages, with varying abilities, and already of [indecipherable] trends. Early on, the professorial and administrative staff included (apart from myself) Dobuzhinsky, Puni, Boguslavskaya, Lyubavina, Lissitzky, Kozlinskaya, and Tilberg. Now there are Malevich, Ermolaeva, Kogan, Lissitzky, Pen, Yakerson (a sculptor) and me (apart from the special instructors). The groupings of 'trends' has now reached a critical point. They are (1) the young people around Malevich, and (2) the young people around me. We are both equally striving towards the left wing of art; however, we hold different views about such art's means and ends. To talk about this question now, of course, would take a long time. It's better to talk about it when we meet or to write a letter on the subject. I'll take the liberty, perhaps, of sending you my thoughts about this [modern Russian art] separately. I'll tell you one thing: I was born in Russia (and in the [Jewish] Pale of Settlement, moreover) and—though I trained abroad—I have a particularly sharp appreciation of all that's going on here in the arts (especially the fine arts). I remember all too painfully the brilliance of the original. To continue: the college has an art library (not very large, it is true); a joiners' workshop, studios of graphics, printing, decorative arts, and a moulding workshop, apart from the ordinary painting and sculptural studios; its own store of materials and its own < ... > bath-house. A college museum is being organized from the award-winning works at the students' shows and from their demonstration sketches. There is a student group and theatrical club at the college which recently, by the way, staged Kruchenykh's [Futurist opera] *Victory over the Sun* in the town, acting and painting the sets themselves. Now they're working on *Hung on the Cross*. A book about the college is being prepared. However, there's rather a problem with paper. That's roughly what is happening at the Vitebsk People's College of Art. Outside the college the Studio of Fine Arts is getting ready to erect the second monuments in Vitebsk, to Karl Liebknecht and Karl Marx (in time for May 1st); preparations are being made to decorate the town on May 1st, a district area school is being organized and a 'show-window of the arts' is being opened. The 10th of May Studio is beginning to acquire works by local artist with which to fill the museum of modern art.

They began to organize a City Museum last year but so far, unfortunately, it still mostly contains archaeological artistic materials rather than paintings; in this respect I have already asked both the Museums and Fine Arts Departments of Narkompros [People's Commissariat of Education] to send us pictures. Art schools have opened in the surrounding district towns of Nevel, Velizh and Lepel. There is also a State Studio of Decorative Art (for carrying out all commissions, which combines all painters and artists). Lectures on art are not a strong point. Lecturers do not come here from the capitals [i.e. Moscow and Petrograd] and there is no staff lecturer on art in the college. Help us: perhaps you will find such a person—let us know and send him to us. So far we've only

organized a few public meetings about art by ourselves.

The town, in short, has now fallen 'under the sway' of artists. They frenziedly argue about art and I'm worn out and longing to be 'abroad' < ... > When all's said and done, there is no more honourable place for an artist (at least for me) than behind his easel, and I'm dreaming of when I can do nothing but paint. Of course, I do a little drawing but it's not the same. As far as your request for various prints is concerned, I shall try myself to bring you some of them when possible. As concerns my own drawing for you, I feel very awkward about sending it and do not know if it will do. We should meet sometime and then it would possible for you to choose. I hope to come to Moscow (and Petrograd). They did ask me to organize an exhibition of my works but what's the point of organizing an exhibition of old works dating from before 1918 (and many of those have been sold and scattered)?

As you can understand: I also want to come on college business and other matters, and bring some works from Peter [sburg] to sell to the department as they requested. This is a vast letter. I've written enough. I'm waiting for your reply. I don't see Lissitzky, unfortunately, and cannot pass on your greetings—and anyway I couldn't < ... > Abram Markovich [Efros: Soviet art and theatrical specialist] will explain the situation to you. Did you by any chance hear what happened to my paintings at der Sturm [Der Sturm Gallery] in Berlin? Ber [Bir] went there, after all, and according to Lunacharsky's article, some information came back. By the way, Ber took a letter from the International Bureau to Walden (the editor and owner of der Sturm).

You can write to me either at the college or at 9 Zadurovsky St.

Greetings and best wishes,
Marc Chagall
2/IV 1920

Addition above first line of the letter:
Malevich will send you our publication (his small book) himself [*On New Systems in Art,* Vitebsk, 1919. In Russian]; I gave him your [post] card.

GMII, f.29, op.III, ed. khr.4675

* Pavel Ettinger (1866—1948) was an art specialist and collector. Over thirty years he regularly corresponded with Chagall. Twenty five of his letters to the artist are preserved in the Pushkin Museum's Archive. This correspondence began in 1920, on Ettinger's initiative, and has been published in full by A.Shatskikh in *Proceedings of the Pushkin Museum of Fine Arts* (GMII), Issue No. 6, Moscow, Sovietsky Khudozhnik, 1980, p. 191—216 (in Russian).

263
Photographs from the S.Michoels Archive. [Solomon Michoels was actor and later director at the Jewish Kamerny Theatre.] Taken during the preparation of *Mazeltov,* a play based on Sholom Aleichem's story, in 1921 at the Jewish Theatre in Moscow
a) Michoels in the role of Reb Alter, with Chagall who designed his costume and make-up for this part
b) Scene from *Mazeltov*
TsGALI, f.2693, op.1, ed. khr.20

264
Chagall and Michoels among the actors of the Jewish Theatre. Photograph taken during the theatre's tour in Berlin in 1928—29
TsGALI, f.2693, op.1, ed.khr.280

265
Letter from Chagall to Ettinger from Paris, dated 10 March 1924

10/3 24
Dear Pavel Davidovich,
As you can see, I have not forgotten you and, from time to time, you can hear my voice < ... > Though I'm afraid that, little by little, I'm < ... > being forgotten < ... > It's not hard to see why. I've already been here, in the native land of painting, for a long time. What can I say about myself? I could say a great deal < ... > but all the same I must be more brief. Here in France they are gradually beginning to take notice of me, and my works are shown in the leading Paris galleries. Native French publishers are gradually inviting me to do engravings as well. Recently I took part in a Paris exhibition of engravers [*Deuxième exposition des peintres-graveurs indépendants,* Paris, Gal. Barbazanges-Hodebert]. Now I'm busy working for Ambroise Vollard (the friend of Cézanne, Renoir, Dégas and others); I'm doing 75 large etchings for him, for Gogol's *Dead Souls.* A new translation is being printed in a luxury edition at the Imprimérie Nationale; I also did a large etching for his *Thirty Artists* album, which included Matisse, Maurice Denis, Bonnard, Rouault, Utrillo, Picasso, and others [*Acrobat with Violin* in *L'album des peintres-graveurs,* Paris, Ambroise Vollard, 1924 (not publ.)]. However, there is no time to do anything for Cassirer who will soon publish some new lithographs that I did while in Berlin [Marc Chagall, *Mein Leben: 20 Radierungen,* Berlin, Paul Cassirer, 1923. Portfolio, 20 etchings and drypoints]. I'm very sad that my graphic works do not perhaps reach Russia. I should think that if an institution placed an order or request then Cassirer would send a set, including the etchings, the portfolio *My Life,* and the lithographs. Let Russia have them as well.

How are you? and what's happening in the arts? I'm now holding a separate exhibition in Brussels [*Marc Chagall,* Brussels, Gal. La Centaure, 1924, 50 works].
Then in Vienna [did not take place] and in Paris in the autumn [*Œuvres de Marc Chagall 1909—1924,* Paris, Gal. Barbazanges-Hodebert, 1924, 115 works].

You are almost the only person I write to in Moscow since others have almost forgotten me and it's unlikely that they're interested in me < ... > And I just can't direct my 'passion' to < ... > someone who's indifferent...
I shall be very happy if you sometime think of passing through.

Please accept my greetings and best wishes,
truly yours, Marc Chagall

GMII, f.29, op.III, ed.khr.4676

266
Letter from Chagall to Ettinger from Paris, late 1926—early 1927

[December 1926 to January 1927, Paris]
Dear Pavel Davidovich,
How are you? You know that I'm almost cut off from Russia. No one writes to me and I have 'no one' to write to. It's as if I hadn't been born there < ... > You are the only one to whom I write a word in Russian. Must I really become a French artist? (I would never have thought it.) And I don't seem to fit in there. But I often remember my own Vitebsk and the fields I knew < ... > and that special sky. To show you how France treats me I'm sending you just a short piece from the papers. There's no sense in sending more, but here at least is something about my last two exhibitions of engravings and paintings [*30 peintures de Marc Chagall*, Paris, Gal. Katia Granoff, 14 June to 5 July 1926; *Marc Chagall: travaux de l'été*, at the same gallery, 22 November to 11 December 1926, 16 paintings and gouaches]. I heard that Benois, for example, went to Russia and wrote about the Russians in Paris without even mentioning me. My pictures have been taken all over the earth but in Russia, probably, they don't think about my exhibition and weren't interested in it < ... > I do books for French publishers but the Russians don't need my work < ... >
That's how the years pass.
Even *Dead Souls* won't reach Russia. Because it's a subscription edition.
So, you see, I'm complaining < ... > But about whom? myself? < ... > [You ask] what I'm doing now—
Pictures that go as soon as my signature is dry. The book of Prophets for Vollard with 100 engravings [*Bible*, Paris, Tériade, 1956, 105 etchings in two volumes]. Then La Fontaine, more than a hundred large watercolours, and more than a hundred drawings of the *Circus*, all for Vollard [La Fontaine, *Fables*, Paris, Tériade, 1952, 100 etchings and two cover etchings; *Cirque Vollard*, 1927]. Apollinaire's *Alcools* for N[ouvelle] R[evue] F[rançaise] [not published]. My head is spinning from all this work or, to be more precise, from what needs to be done.
Recently I had a room to myself in the Salon of

French Painting in Antwerp. But that's enough about me.
The Seven Sins, a book of my engravings, has been published and also *Maternity* [*Les Sept péchés capitaux*, Paris, Simon Kra, 1926, 15 etchings; *Maternité* by Marcel Arland, Paris, Au Sans-Pareil, 1926, 5 etchings]. But how can I send books that are already difficult to get hold of, and with whom?
I'd very much like to.

GMII, f.29, op.III, ed.khr. 4679

267
Inscription dedicated to Abram Efros in André Salmon's *Chagall* (Les Maîtres nouveaux, 4, Paris, Chroniques du jour, 1928, 1 etching for frontispiece). Presented to Efros in Paris in 1928:

To my dear Abram Markovich Efros, one of my first friends. Greetings to him and my native land. Marc Chagall.

Boulogne 1928

268
Letter from Chagall to Ettinger from Paris, dated 18 February 1931

18/II 1931. Paris, 5 Avenue des Sycomores (XVI°), Villa Montmorency, Auteil 22-69
Dear Pavel Davidovich,
I shall be very glad to give your person some samples. Just let him ring earlier, and then you will see how I remember those, alas, few people who remember me. I will be away on a long journey after 1 March but will return by May, when my book and certain new pictures should be 'put on show', i.e. the exhibition connected with the book *Ma Vie* which should come out when I return in May [*20 tableaux récents et quelques dessins de jeunesse inédits par Marc Chagall*, Paris, Gal. La Portique, 13—30 June 1931; Marc Chagall, *Ma Vie* traduit de russe par Bella Chagall, préface de André Salmon, avec 32 dessins de jeunesse de l'auteur (Collections Ateliers, 3), Paris, Librairie Stock, 1931, 32 drawings]. Let him turn up then, by the way.
I'm happy to sometimes get news about my native land because I miss it enormously, and all the more so that they think me 'a stranger' there. As proof of how they treat me here I'm sending you an article written by a former authority* on Vollard's exhibition** which particularly disturbed him and them. You see, neither where you are nor here can my compatriots stand me < ... > It would be good if you could inform artistic circles in my own country of this article and my situation < ... >

Best wishes.
Write, don't forget, I always welcome it.
P.S. About the exhibition in Brussels. They're busy there. However, I would like them to delay it until 1932 when, perhaps, the exhibition

could move to Paris; for 1907 to 1932 will make it—25 years that your humble servant has been engaged in what we call 'Art'.

Truly yours,
Marc Chagall

GMII, f.29, op.III, ed.khr.4681

* Chagall is referring to Benois' article 'Book Illustration'.
** Paris, Gal. Bernheim-Jeune, *La Fontaine par Chagall:* 100 gouaches to illustrate 100 fables by La Fontaine, 10—21 February 1931. Catalogue with preface by Vollard: "J'édis les Fables de La Fontaine et je choisis Chagall comme illustrateur."

269

Letter from Chagall to Alexander Benois in Paris, March 1935

Paris 1935 mars
Dear Alexander Nikolaevich,
I am not usually in the habit of writing to art critics. Criticism is 'independent' after all. But you are a Russian—and so this question also immediately touches a sore spot. Do not think that I'm complaining about anything, although over the years I have developed the appearance of one who complains. However, do believe me: I perhaps have certain private reasons for this that, as a person of different background, you would not be familiar with. And, it seems, in essence that you and I cannot agree: we are people and artists of two different generations and artistic outlooks. One might say that we have 'little to talk about'—were it not that I remember your delightful lines of another time: then all around us and within us was delightful (I lost them in Russia and would gladly read them again one of these days)//
But much has happened since then. After all, before that period (1914) you didn't know about me; everything that I did abroad between 1908 and 1914 was left behind there, and then I was 'another' person there, whom you would not have 'recognized'. It's very painful to me, that you may only think that I was, or am, not 'in earnest'. It's a pity that I do not have with me a copy of my book *Ma Vie*—You would then see if I was born on this earth to not 'be serious', to 'joke' and to 'fool around' < ... > Especially when, as a boy, I 'chemically' saw our Russian painting from the time of Stasov up to the Revolution and after it. No, we will never, it seems, agree with Russian artists in our artistic language, but nevertheless I was born in Russia, and nevertheless I'm overflowing with ('undivided') love for her, and I was// and am, alien to all regimes: the Old Russia, Soviet Russia and the emigration. But I don't want to end this letter on a 'plaintive' note. Quite the opposite: I am grateful to you for the many tender words in your article.
And I would like to think that some time in the future the work of certain Russians living abroad will be seriously used to help the mother country and her art.

I remain respectfully yours,
with best wishes,
Marc Chagall

On two pages. The first is used on both sides, the second on one side only.
TsGALI, f.938, op.1-2, ed.khr.311, to Benois

270

Letter from Chagall to Ettinger from Paris, dated 29 August 1936

1936, Aug. 29
Dear Pavel Davidovich,
I'm sitting at the 'dacha' and I remembered you. Altogether, in this village you remember our native land all the time.
You see a tree and think, but our trees aren't like that: the sky's different, and everything is different. And as the years pass these comparisons begin, as they say, to play on your nerves < ... > As the years pass, you feel more and more that you are yourself a 'tree' that needs the land, rain and air it's used to < ... > And I begin to think that somehow, I hope, I'll soon manage to come home and draw new strength from my native land and do some painting there. Most of all I want to break with Vollard. After all, he still hasn't published the books I did long ago, *Dead Souls* and La Fontaine's *Fables*, and the Bible I began years ago is still in preparation < ... >
Well, what's happening with you? what's new? How are things with the arts in the mother country? I would like to receive an art journal, any one.—To have any kind of contact, because I'm otherwise too forgotten and alienated. Write to me any time. Nobody writes to me apart from you.

Best wishes,
Yours truly Marc Chagall

GMII, f.29, op. III, ed.khr.4684

271

Letter from Chagall to Ettinger from Paris, dated 4 October 1936

4 Oct. 1936 Paris
Dear Pavel Davidovich,
I was so happy to receive from you the letter and booklet-magazines about art, which gave me an idea of what is being done in the arts in my beloved country. Thank you. So how can I show my gratitude? This Vollard character won't let a thing out of his hands so that I could send you something. Are there any books or journals published here that would interest you? It would be a pleasure to send them to you. You write that you will (?) soon be 70. When exactly? Let me know so that I can send you my sincere greetings in 'good time' < ... > Next year I myself will already have been alive for 50 years and working for 30. And if there is something that comforts me as I think of this, it

is my passion for my native land, which in its own way has permeated my art and of which I am always thinking. Though I'm considered 'international' by the world, and the French include me in their sections, I think of myself as a Russian artist and the thought gives me so much pleasure < ... > Best wishes. Thank you that you don't forget. I'm gradually getting ready for my trip [to the USSR]. It will, I hope, refresh and renew my art. But I will not go, like others, because of the 'crisis' < ... >

Not for the money, but for my soul < ... >

> Best wishes and do not forget.
> Yours truly, Marc Chagall

New address: 4 Villa Eugene Mannel, Paris XVI

GMII, f.29, op.III, ed.khr.4685

272

Letter from Chagall to Ettinger from Paris, 1937

Paris 1937

Dear Pavel Davidovich,
Haven't heard from you for a long time. How are you? I recently sent you two art booklets published by Braun. I hope you received them. Now as you know, there is an international exhibition here [Paris, *L'Arts et techniques dans la vie moderne*, 1937], and to see it properly you must wear out a pair of shoes. My first visit, of course, was to the Soviet Pavilion and each time I want to get a feel of my home country, I go there < ... > I've done nothing in the way of decorative panels for the exhibition. I'm a 'foreigner' after all. The Spanish Pavilion invited the Spaniards Picasso and Miró who live all the time in Paris. Their pavilion was wonderful in the way of art.

In connection with the international exhibition I've somehow been showing a great deal in different places. In October I'll have an individual exhibition of watercolours [*Gouaches de Chagall*, Paris, Gal. Renou et Colle, October—November 1937].

You know, according to his passport your 'humble servant' will be a full fifty years old this year. And next year will mark 30 years of work, if we reckon from the painting *Death* of 1908 [Pr. collection, France]. During such (cheerless) minutes I'm only thinking of my wonderful country—since all my life what I have been doing is to depict her through my art as best I could.

Some day, perhaps, the capital of art will become Moscow not Paris and the Chagalls of the future will be happy. Their lives will not then be split in two. By the way: you could perhaps tell those who are interested that my aged teacher, the painter Pen, has died in Vitebsk. He kept several of my works (a painting, watercolours, drawings and, among others, a portrait I did of him [1918; oil on canvas; whereabouts unknown]: why not let a museum have them, if they want.

> Best wishes.
> Yours, Marc Chagall

GMII, f.29, op.III, ed.khr.4688

273

Letter from Chagall to Benois in Paris, February 1938. At the top Benois added:
(to the left) Could not, and did not want to, answer since I did not have the address
(to the right) Early February

1938 Paris

Dear Alexander Nikolaevich,
I'm sending you this little catalogue as one of those who have witnessed my progress as an artist < ... > And believe me, how much more pleasant it would be, in my fiftieth year and after 30 years of work, to be at home, and to exhibit and work a little there. And this despite my thinking of the general interests of Art (and not of my own wishes). [My attitude to] Expressionism in Germany was evidence of that//
as later the Surrealism of Breton and Co here, which rejected me (as I did them).

> I hope you are well.
> Yours truly,
> Marc Chagall

< ... >

Written on the outside leafs of a folded sheet.
TsGALI, f.938, op.2, ed.khr.311

274

Letter from Chagall to Benois in Paris, dated 6 February 1940

Paris 6/II 1940

Dear Alexander Nikolaevich,
How moved I was by your article [Aleksandr Benois, "Chagall Exhibition (Galerie Mai)", *Posledniya Novosti*, 3 Feb. 1940]. Never has the writing of any foreigner abroad, whoever they might be, so touched me.

Thank God that you are passionate, partisan even, and who knows—perhaps you are now the only person to be so in the Arts. That's why I'm proud that you have written about me. Please God, may I only justify it.—I'm glad you recognized that I am not 'posing', and have not turned 'snobbish' and so on. I come, after all, from a poor people. //
I remember too well my father's calloused hands and the hopelessness of his life and work. So how could I, engaged in such 'light work', 'give myself airs'. It seems I demand a lot of myself < ... > as I do from others as well—you agree that I'm just a little aware of my *métier* in art. Yes, indeed. But as you noticed, it is impossible to find 'laws and rules' in what I do. So much the worse (and more painful) for me. Still I do not feel myself a

'child' but fully conscious of what I'm doing. // You said much that is true, because you spoke honestly. At present, they have (for the time being!) taken our country away from us and will not let us breathe her air. Yet, despite all my tribulations, I have not broken my inner ties with her all through these years. So your profound Russian words have been a support and, believe me, I very rarely write others such replies.

<div style="text-align: right">

Most sincerely and thankfully yours,

Marc Chagall
</div>

On one side of three sheets.

TsGALI, f. 938, op. 2, ed. khr. 311, to Benois

275

Letter from Chagall to Ettinger from New York, dated 30 April 1945

<div style="text-align: right">

30/IV 1945

42 Riverside Dr [ive] New York
</div>

Dear Pavel Davidovich,

I was so glad to receive your letter. It's very difficult here to settle down and put something in writing. I'm taking the opportunity of this friendly help to send these lines. You probably know of my personal tragedy—on 2 September 1944 I lost the one who gave my life meaning and was my inspiration. Now my life is as full of tragedy as it was earlier 'easy' and cloudless. I don't know what to do. Nevertheless I'm still on my feet and continue working and, as they say, am 'successful'. For the moment I'm staying 'in safety' here in America. I've shown each year at the Pierre Matisse Gallery. My illustrated books with hundreds of engravings—Gogol's *Dead Souls*, La Fontaine's *Fables* and the Bible—were not published during Vollard's lifetime although a printing of the engravings was made. He didn't leave a will. I still don't know what's happened to them in Paris now. The New York Museum of Modern Art and a Chicago museum [The Art Institute of Chicago] are preparing a large retrospective of my work in November of the next season. Apart from some small publications issued earlier, a large book with a text by Lionello Venturi is coming out in English with 100 reproductions [Lionello Venturi, *Marc Chagall*, New York, Pierre Matisse, 1945]. I < ... > have illustrated a number of books, among them my wife's book which will come out first in Yiddish, with 25 of my drawings [Bella Chagall, *Brenendicke Licht*, New York, 1945; Eng. edn., *Burning Lights*, New York, Schocken Books, 1946, 36 drawings; Fr. edn., *Lumières allumées*, tr. Ida Chagall, Geneva, Ed. des Trois Collines, 1948, 45 drawings]. Now I live with my daughter Ida Gordey who is herself a very sensitive painter and, to her joy, quite unlike papa < ... > Her admirable husband

Michel Rappaport-Gordey is now going on business to Paris for two months. His parents were saved, thank God, as were his dear aunt Leah Bernstein and uncle Osip. However, his son is in captivity... What has been happening with you? I'm very glad of your news and will be happy if you don't forget to write again. With heartfelt affection, I wish you, and all my native land, happiness.

<div style="text-align: right">

Yours truly, Marc Chagall
</div>

P.S. I did a ballet here earlier (the decor, costumes and sets for *Aleko*, based on Pushkin with music by Tchaikovsky). They staged it at the Opera here.

GMII, f. 29, op. III, ed. khr. 4689

276

Letter from Chagall to the Soviet author Ilya Ehrenburg, dated 30 April 1945

New York, 42 Riverside Dr [ive], 1945 30/IV
Dear Ilya Ehrenburg,
I'm taking this opportunity to write these few words to you and tell you what, as I read your works, I have so often and for so long wanted to say. I am so happy for you < ... > and, believe me, for myself also. After all your 'biography', it seems to me, is indeed also partly mine. Didn't we both at one time live and educate ourselves in that same Paris; and, working abroad, didn't we both each in his own way breathe something of our native land into Art—.
And then, not following my example, you nevertheless took deep breath, absorbing the air and spirit of that country's majesty. You have become so useful to her, so very useful! You have actively and greatly helped her in this desperate war: it was thrust upon her but, at the same time, has raised our motherland to an unbelievable eminence and she has saved the world.
Allow me, as I greet you here, to pass on my heartfelt greetings through you to my native land with my love and constant devotion to her,

<div style="text-align: right">

Marc Chagall
</div>

TsGALI, f. 1204, op. 2, ed. khr. 2364

277

Letter from Chagall to Ilya Ehrenburg from New York, dated 15 August 1946

Dear Ehrenburg,
It's a pity that I won't see you. As I wrote, I am leaving for America between the 20th and 22nd. I shall come back in the spring (?autumn) in time for the retrospective exhibition of my works (1908—47) that has been organized by the Museum of Modern Art in Paris [*Marc Chagall*, Paris, Musée National d'art Moderne, 17 October to 22 December, 67 works]. For your information, there has been no reply to all the requests sent, by

telegram and otherwise, by the director of the New York Museum of Modern Art for the loan of certain of my old pictures (there aren't any others there) from Russia. Thus my native land is not represented in either the catalogue of the New York Museum of Modern Art nor now in the Chicago Museum [the Art Institute of Chicago] (November to January). The Director of the Paris Museum will shortly make requests for the said paintings. I don't know if he will be answered by the same silence (I'm letting you know, in case you can drop a word in the right place) < ... >

By the way, at the beginning of the war I gave a painting for American aid to Russia //
and two years ago I gave another two ('wartime') paintings through friends of Michoels and Feffer [Jewish poet] when they were in New York, and through the [Soviet] consul E. Kiselev. They were sent to Moscow. I haven't received any answer or information about their fate.

At one time I sent a letter to the [Soviet] Committee for Artistic Affairs etc. and finally to its Chairman, in which I then expressed the desire to go and do some new works (my health is weaker now) and exhibit it here and there after the retrospective exhibitions. I didn't get any reply. That is why, despite my constant love and devotion, I consider myself unfairly offended.

Kindest regards.
Very best wishes to your wife,
Marc Chagall

One sheet written on both sides.
GMII, f. 41, op. 1, ed. khr. 71

278
Letter from Chagall to Ettinger written on board a ship sailing from Marseilles to New York, dated 22 November 1947

22 Nov 1947
On board ship
Dear Pavel Davidovich,

How are you? I'm writting from the ship that is carrying me back to America. I'm going there to 'wind up' everything so as to return once and for all to France in a few months' time.

A large retrospective exhibition of my work over almost 40 years, 1908—47, is now on show in Paris [Marc Chagall, Paris, Musée National d'Art Moderne, 17 October to 22 December, 67 works].

As the press are saying, it has been an enormous success. It is the first time they have ever made an exhibition of a living artist in an official Museum, not to say a Russian artist. And although I have been forced to live and work far from my native land, I remain loyal to her in my heart. I'm glad that I could in this way be of some little help to her. And I hope

I'm not considered a foreigner in my motherland. Am I right?

The exhibition at the end of December will be in the Amsterdam Museum [Marc Chagall, Amsterdam, Stedelijk Museum, 80 works including the poem À Marc Chagall by Paul Eluard and selections from Chagall's Ma Vie]. Then from February 1948 it will be in a London Museum (Tate Gallery) [Marc Chagall, 4 to 29 February, 66 paintings and 80 graphic works]. Before, it was in America [Marc Chagall: Recent Paintings, Gouaches for A Thousand and One Nights, New York, Pierre Matisse Gallery, 8—26 April 1947]. Please pass this letter on: my native country will probably be pleased about it. It's unnecessary for me to tell you that it would be a great day for me if such an exhibition were to be shown in my native land. It's true that 3/4 of the pictures belong to museums and collections in various countries.

42 Riverside Dr. New York City, USA

P.S. Did you receive my large album in Russia? A colour publication with 17 of my pictures, Editions du Chêne, Paris, with a poem by Paul Eluard, publ. in 1947 [Léon Degand, Marc Chagall: Peintures 1942—1945, Poème de Paul Eluard, Paris, Editions du Chêne, 1947, 16 col. pl.].

My illustrated books are:
1) Gogol and the Fables of La Fontaine (former publisher, Vollard) will be produced in the next few years by Verve publishers in Paris [Nicolas Gogol, Les Ames Mortes, 2 vols., Paris, Tériade, 1948, 118 etchings; La Fontaine, Fables, Paris, Tériade, 1952, 100 etchings and two cover etchings].

I must still do a whole series of other books, including one Russian one [Ilyazd (pseudonym of Ilya Zdanevich), Poésie de mots inconnus, Paris, Le Degré 41°, 1949, 1 drypoint and aquatint by Chagall]. Write to me anytime. Best wishes.

Yours truly,
Marc Chagall

GMII, f. 29, op. III, ed. khr. 4692

279
Letter from Chagall to Ettinger from New York, dated 12 July 1948

1948, 12 July
Dear Pavel Davidovich,

How are you? I was so happy to receive your letter a few months back and learn that you are well. You are the only one who writes to me from Russia and each time it makes me glad. I was in Paris not long ago. So you did receive the catalogue of my retrospective exhibition which was organized at the National Museum of Modern Art [Marc Chagall, Paris, Musée National d'Art Moderne, catalogue

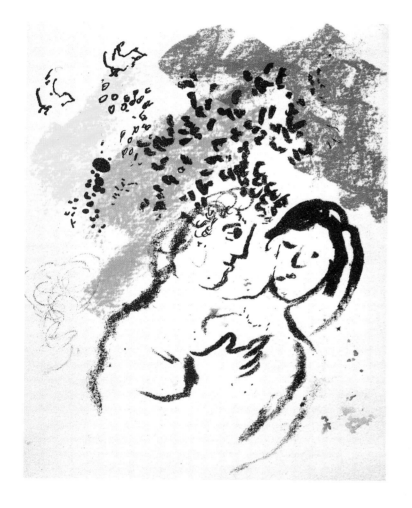 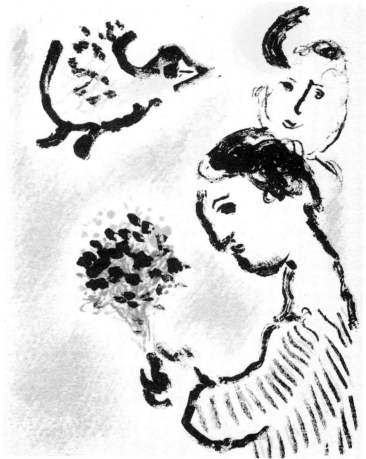

Postcards with Chagall's lithographs sent by the artist
to Alexander Kamensky in 1970 and 1979—80

CAT. NOS. 286, 287

with cover illustration, preface by Jean Cassou]. They showed paintings, engravings and theatre designs from 1908 to 1947. The same exhibition was then transferred and put on in the Amsterdam museum [Stedelijk Museum] and finally, not long ago, in a London museum (Tate Gallery). They produced decent catalogues. Now, by invitation, I am showing at the Venice Biennale where they have provided me with a large room [Venice, XXIV Biennale, June to Sept. 1948: room in French pavilion showing 37 paintings and drawings, and illustrations for *Dead Souls*, La Fontaine and the Bible, catalogue text by Lionello Venturi]. They inform me that I have been awarded an international prize for graphics (for *Dead Souls* and other books). In August I leave for France.

I'm glad that I am benefitting my country as far as I am able, though far away. I have now remained faithful in my art to my native land for 40 years and, it seems to me, until now they have never held exhibitions of a Russian artist (and one who is still alive moreover) in the museums of Europe and America. Don't imagine that it makes me any more confident about my art. No, each time I approach my work like a novice although, alas, I am already (it appears) 60 years old.

Dear Pavel Davidovich. Write to me anytime about yourself, and whether you have received my letter. I wish you all the best,

Yours truly,
Marc Chagall

< ... > *Dead Souls* with 100 etchings will be printed at the Imprimérie Nationale in Paris for *Verve* publishers. I hope that at least one copy will reach Russia. In the autumn an album of the *Arabian Nights* with colour lithographs will be published in New York by Pantheon [12 original colour lithographs by Marc Chagall for *Four Tales from the Arabian Nights*, New York, Pantheon Books, 1948, each plate signed by Chagall].

GMII, f. 29, op. III, ed. khr. 4694

280
Telegram from Chagall in New York to Ehrenburg, dated 25 December 1949 sending Christmas greetings (in English)

For years you were close to me in Paris Now I love you as part of my motherland Heartiest wishes

Marc Chagall and Ida
GMII, f. 41, op. 1, ed. khr. 79

281
Letter from Chagall to Ehrenburg, dated October 1955

1955, October
Dear Ilya Grigorievich,
Thank you very much for the photo. Yes, it is a self-portrait [*At the Easel*] dating, I think,

from 1914—15 when I was in Vitebsk after Paris. The second 'sister' also. I'm still here and would be glad to see you.

Yours truly,
Marc Chagall

GMII, f. 41, op. 1, ed. khr. 72

282
Greetings card with a lithograph by Chagall from *Burning Lights* by Bella Chagall. Sent from Switzerland by Chagall to Ehrenburg
GMII, f. 41, op. 1, ed. khr. 77

283
New Year's greetings from Chagall to Ehrenburg, 1967, on a home-made postcard with a lithograph by the artist
GMII, f. 41, op. 1, ed. khr. 78

284
Greetings card of Chagall's lithograph *Angel with Trumpet*, sent to Natalya Efros, the widow of Abram Efros, in the early 1960s
Private collection, Moscow

285
Letter from Chagall to Yuri Adamchuk, a senior research associate at the Kurchatov Institute of Atomic Energy in Moscow. Sent from Saint-Paul-de-Vence on 19 June 1966 in response to the request to organize an exhibition of Chagall's works at the institute

Vence (Alpes Maritimes),
France 1966 19/6
Dear Yuri Vladimirovich,
I have received your letter. I was very moved that you—your institute of atomic energy— want to organize an exhibition, at least of reproductions of my works. You asked me to send you such reproductions. I would in addition also with great pleasure send you some books and catalogues but, as it happens, it is physically a little difficult for me to do so. It would be better if you entrusted someone to come to me to whom I could give all that I can offer you. To do this you must write beforehand or call by telephone. I live in Vence [Saint-Paul-de-Vence] and occassionally in Paris. I think, by the way, that they know my address and phone number at the embassy. Thank you once again for your interest in me. It is all the more pleasant for me because I have always, it seems, remained faithful to the spirit of my native land although, like many other 20th century artists of the world, I have lived in Paris almost all my life—far away from the motherland.

Most sincerely,
Yours,
Marc Chagall

Collection of Yuri Adamchuk, Moscow

286
Letter from Chagall to Soviet art historian Alexander Kamensky, written on a postcard with a colour lithograph of the artist and sent from Saint-Paul-de-Vence in 1970

1970

Dear Alexander Abramovich
(I rarely remember peoples' first names and patronymics but I have your letter in front of me).

Thank you so much for sending me your book about Art in the Soviet Union. Unfortunately, I do not read Bulgarian. However, having read your letter I can imagine your style.

I now have a large exhibition in Paris at the Grand Palais. Four pictures were sent from Russia. Of course, I would be glad if they saw it here [i.e. in the USSR].

My best wishes,
Marc Chagall

If you have seen my pictures (other than those in the Tretyakov or the Russian Museum in Leningrad, or in the collections of Costakis, Ehrenburg, the former Gordeev collection or that of Mme Efros) I would be glad to have photos.

Collection of Alexander Kamensky, Moscow

287

Letter from Chagall to Kamensky, written on a postcard with a colour lithograph by the artist and sent from Saint-Paul-de-Vence in 1979—80

St Paul de Vence 1979—80

Dear Kamensky,

Thank you for your letter and greetings. In a few days time it will be New Year. I wish you, everyone else and my native land happiness. You tell me you're writing a new book. I wish you success. My wife also sends her greetings.

Best wishes,
Marc Chagall

Collection of Alexander Kamensky, Moscow